The Sons and Daughters of Los

In the series

Wide Angle Books

edited by Erik Barnouw, Ruth Bradley,
Scott MacDonald, and Patricia Zimmermann

The Sons and Daughters of Los

Culture and Community in L.A.

EDITED BY

David E. James

TEMPLE UNIVERSITY PRESS

PHILADELPHIA

Temple University Press, Philadelphia 19122
Copyright © 2003 by Temple University, except
 Introduction and Chapter 12 © 2003 David E. James
All rights reserved
Published 2003
Printed in the United States of America

⊗ The paper used in this publication meets the requirements of the American
National Standard for Information Sciences—Permanence of Paper for Printed
Library Materials, ANSI Z39.48-1984.

Library of Congress Cataloging-in-Publication Data

The sons and daughters of Los : culture and community in L.A. / edited by
David E. James.
 p. cm. — (Wide angle books)
 Includes bibliographical references.
 ISBN 1-59213-012-7 (cloth : alk. paper) — ISBN 1-59213-013-5 (pbk. : alk. paper)
 1. Los Angeles (Calif.)—Social life and customs. 2. Los Angeles (Calif.)—
 Intellectual life. 3. Los Angeles (Calif.)—Social conditions. 4. City and town
 life—California—Los Angeles. 5. Popular culture—California—Los Angeles.
 6. Arts—California—Los Angeles. 7. Arts and society—California—Los Angeles.
 I. James, David E., 1945– II. Series.
 F869.L85 S65 2003
 306'.09794'94–dc21 2002028939

011711-P

978-1-59213-013-9 (pbk. : alk. paper)

and Los drew them forth, compelling the harsh Spectre
Into the Furnaces & into the Valleys of the Anvils Death
And into the mountains of the Anvils & of the heavy Hammers
Till he should bring the Sons & Daughters of Jerusalem to be
The Sons and Daughters of Los
 —William Blake, *Jerusalem*

Contents

Acknowledgments

Early stages of the research for this volume were assisted by funding from a grant from the James Irvine Foundation to the Southern California Studies Center at the University of Southern California. We thank the Foundation and also Professor Michael Dear, Director of the Center, for their support. From this project's inception, Professor Dear's initiative and many forms of generosity have been crucial. We also thank Mr. Bernard Stanley Hoyes for permission to use his print, "Block Party Ritual," © 2002 for our paperback cover; this serigraph was pulled at Self-Help Graphics as a special project for the Grand Performances 2002 Summer Concert Series.

Sande Cohen, Tomás Benitez, and Harry Gamboa Jr. were especially generous when the project most needed them. We particularly thank Erika Suderburg and the other reviewer (who chose to remain anonymous) who initially evaluated the manuscript; their enthusiasm for the project overall and their very valuable suggestions for correction and improvement aided us enormously. We would also like to thank Elizabeth Yoder for her intelligent and sensitive copyediting.

Prefatory notices of this kind commonly acknowledge in some more or less perfunctory fashion the editor of the press who has overseen the publication. In this case, however, that acknowledgment must be very specific and categorical. Everyone connected with this project is deeply indebted to Micah Kleit, the Temple University Press editor who first accepted it and has since guided it through to completion. As will become evident, the essays collected in this book generally (though not in all instances) run counter to the orthodoxies of the discipline in which they find themselves. As a consequence, until we encountered Mr. Kleit, everyone we contacted refused to consider publishing it; no university press would even look at the manuscript. Had it not been for his courage and initiative, this particular work of the "Sons and Daughters of Los" would never have seen the light of day. Thank you, Micah.

Published with the assistance of the
Southern California Studies Center
of the University of Southern California

David E. James

1 Introduction:
The Sons and Daughters of Los

In the initial stages of the project whose results are collected in the present volume, we approached popular culture in Los Angeles using as a heuristic the idea of "grassroots cultural organizations." By this we had in mind the more or less ad hoc instances where people who were marginal to the city's established cultural institutions came together to share their poetry, painting, dance, and other forms of art, and in so doing created communities that then developed lives and momentums of their own.[1] Conceived in dissatisfaction with both industrial and other publicly sanctioned forms of culture, they generally produced themselves as demotic alternatives to establishments that they perceived to be alienated and compromised. Within the frame of this guiding orientation, the associations we explored were diverse in respect to both their internal organization and their eventual relations with the dominant cultural institutions. Growing from the initial efforts of very small groups, in some cases only one or two people, they were originally independent and autonomous, at least to the degree to which these concepts can presently be meaningful. But as they developed wider constituencies, they inevitably became affiliated in various ways with the kind of organizations with which they had before been in conflict, both public—such as city, state, and federal agencies—and private—such as foundations and corporations. Despite these affiliations, their creativity remained to some degree refractory, still honed on a stone of critical alterity.[2]

With the exception of the Vedanta Center (an earlier and somewhat differently conceived initiative), the associations we examined were formed in the tide of populist social contestations mobilized in the 1960s and were mostly shaped by the ideas in which social and political identity were conceptualized and lived in this period, that is, through struggles for civil rights by ethnic and sexual minorities. The local emergence and self-assertion of these political identity groups were of course part of national movements; and indeed, the remarkable ethnic diversity and other demographic features of Los Angeles ensured that they were also often affected by global issues, especially by population shifts and changing patterns of migration. On the other hand, the

more immediate motive in their creation was usually an interest in a particular cultural form, often a medium with a distinctive and integral relationship to the development of the specific social group. For example, though African Americans in the city have made public art in the form of murals for many years, the combination of indigenous and European elements in the traditions of mural painting developed in post-revolutionary Mexico became a primary reference point in the assertion of a Mexican American identity in Los Angeles.

Even if they were locally forged and were not quite so thoroughly constitutive, similar relations have obtained between other groups and specific mediums. Performance art, for example, has proven particularly valuable for women and for gays and lesbians. So the current flier distributed by a performance collective that is the subject of the one of the essays below announces: "This workshop is for gay men to gather together and create community through performance."[3] Sometimes a given medium and the institution that developed around it proved valuable for different groups at different times; thus, when the poetry center Beyond Baroque became a focus for minority poets, part of its constituency changed from what it had been in preceding periods when it revolved around beat and punk subcultures. And though most of the associations studied here based themselves on mediums with less rather than more concurrent commercial viability, sometimes these and parallel communities have flourished by employing the art forms of the culture industry itself—film, television, and recorded music. Visual Communications (VC), the Asian American community cinema considered in Chapter 12 is such an instance. Like all attempts to create popular practices of commercial cultural forms, VC and similar popular cinemas have to construct themselves both within and against the immense social authority and economic resources of the industrial usage of the mediums in question, so they have been especially precarious, though by the same token their achievements remain of special interest.

But whatever the relative importance of their immediate aesthetic or social motivations, the organizations examined in this volume all have in common a foundation in integral human usefulness, the noninstrumental exercise of the creative faculties. All were created by people, some of them oppressed or otherwise marginalized and disenfranchised, who found cultural activity to be a means of self-realization and communal discovery. All were sustained as popular activities in which people developed forms of symbolic self-expression and joined with others of similar interests. Within the communities they formed, art was not engaged primarily as the production of commodities, so its role in increasing the value of invested capital or in preserving the system of capitalism as such was negligible. Even though their existence has been besieged and importuned by a rampant market economy, they have known from the beginning what William Blake, as he lived through the emergence of the commodification and industrialization of culture in the late eighteenth century, came at last to understand: "Where any view of Money exists Art cannot be carried on, but War only."[4] Nor were their practices initially supported by the institutions of the established museum and conservatory cultures, for since their interests were no more purely aesthetic than they were purely social, they could not be coerced into the defensive, putatively extra-social reservations premised

on aesthetic autonomy. Initially, they were opposed to both the sublation of popular participatory culture into *haut bourgeois,* fetishized real estate and the entertainment industries' commercialization of it into standardized, marketable commodities. Their point of origin and their ongoing aspiration was thus popular activity prior to both poles of the contemporary "high/low" bifurcation of cultural possibilities and prior to both forms of reification by which social creativity is assimilated into complementary fractions of capital.

Sailing without regard to the Scylla and the Charybdis of the high/low binary, popular cultural activity finds itself and its constituencies outside both arms of corporate culture—the industry and the museum—and as a consequence, it has hardly developed a theoretical armature of any general social leverage or persuasiveness. A full theoretical elaboration of such a contrary model of contemporary popular culture cannot be attempted here, and any assessment of the implications of the communities (anticapitalist? proto-socialist?) that such an elaboration might subtend must remain provisional. On the one hand, the complexities of both crucial terms—"culture" and "community"—bespeak the huge social transformations of the period of advanced capital.[5] A comprehensive encounter between the two terms would have to include the way they have been constructed in the fields of sociology, social and cultural anthropology, urban geography, and the various minority studies areas as well as in the specific disciplines of poetry, art history, performance art, video, and other artistic mediums. On the other hand, the available data about actual community cultural projects is extremely limited; and indeed, the present project should be understood as a contribution to the collection of primary material upon which more generalized hypotheses about new forms of progressive popular culture could be elaborated.

Though specific theoretical presuppositions are implicit and sometimes explicit in each of the essays below, the alternative theories of popular cultural production they project are subordinate to the historical details, the aesthetic achievements, and the varying social possibilities of the individual case studies. Any attempt to deduce or synthesize a general theory of a genuinely popular culture from them would necessarily involve a critique of the institutions and the theoretical apparatus that presently legitimize and naturalize capitalist culture as a whole. In lieu of such a general theory and propaedeutic to it, here we will only sketch the environment in which the sodalities studied below came into being, the cultural conditions in the city in which they were created, and hence give some concrete grounding for their various innovations and interventions.

Such a geographical focus on Los Angeles may well initially appear to be Quixotic if not misguided, for the city is famous for being the center of industrial culture—the capital of the culture of capital—and, at least until recent developments in museums and art schools reversed this, hostile to autonomous art. But what has appeared to be the city's categorical anomalousness is in fact a compounded prototypicality that gives the present project a more-than-regional significance. For if the specific urban and spatial structures developed in Los Angeles are, as many claim, the model for future cities, and if the culture industries located in it have a global hegemony, then the conditions that variously shape, inhibit, but also nurture the emergence of truly popular cultural

communities in Los Angeles may reasonably be considered to exemplify a general situation, and the specific institutions and histories examined below have implications about alternatives to capitalist culture more generally. Here, then, we will be concerned with a pattern of homologies and other relations between social space and culture in a city whose drastic reconfiguration of both appears to be historically prototypical.

Whether despising Los Angeles or celebrating it, whether understanding it (as they used to) as an exception or (as they now do) as a paradigm for future conurbations all over the world, geographers have recognized it as a distinctly new kind of metropolis. The great nineteenth-century cities, they argue, were each composed of a vertically expanding core surrounded by dependent rings. But Los Angeles developed as an agglomeration of separate communities dispersed across the desert plains between the San Gabriel Mountains and the Pacific Ocean. There successive waves of immigration—Spanish invaders in the colonial period, then Anglos and other Europeans from the Midwest and the South, Blacks and Mexicans, and most recently, Asians—created distinct enclaves, many of them internally homogenous and largely segregated from each other. Together these formed, not the radial melting pot of the modern city, but a polynucleated postmodern megalopolis.

In the phrase of Robert M. Fogelson, one of its pioneering historians, the Los Angeles that became a great city did so as "a fragmented metropolis."[6] Its fragmentation only intensified over the last third of the twentieth century when it became ethnically and culturally one of the most diverse cities in the nation. Changes in U.S. immigration laws in the mid-1960s, combined with the city's expanded role as a center for Pacific Rim capital and with the Reagan administration's neo-imperialist ventures in Meso-America that made it the premier port of entry for immigrants, simultaneously transformed the city's demographic structure. But fragmentation had characterized its development from the beginning; and awareness that phased immigration, voracious peripheral growth, and horizontal rather than vertical development was producing an unprecedented galaxy of unintegrated satellites is itself anything but new. Postmodern geography now proposes a "Sixty-Mile Circle" of "at least 132 incorporated cities" or "the most differentiated of all cities," "a combination of enclaves with high identity, and multiclaves with mixed identity ... perhaps the most heterogeneous city in the world."[7] But before World War II, well before Los Angeles became so conspicuously a microcosm of global diaspora, the 1939 WPA guide to California described it as "nineteen suburbs in search of a city"—already a tripling of the "six suburbs in search of a city" noted in 1920s witticisms.[8] And, summarizing in the midst of the urban expansion, for the rubric to his 1946 chapter on the "Los Angeles Archipelago" of "social and ethnic islands, economically interrelated but culturally disparate"—still the best analysis of the historical evolution of the city—Carey McWilliams quoted one Charles A. Stoddard, who in 1894 had noticed that "Southern California is made up of groups who often live in isolated communities, continuing their own customs, language, and religious habits and associations."[9]

Reinforced by the long history of anti-labor politics that hindered transethnic working-class consciousness and solidarity, the social dispersal that allowed immigrant groups

to settle in relatively homogeneous and autonomous clusters produced a distinctive segregation. Though historically these communities all too commonly become visible to the hegemony at moments of racial or cultural strife—the anti-Chinese riots of the 1870s, for example, or the military's terrorization of zoot-suiters in the 1940s, and the uprisings of Blacks in the 1960s and Latinos in the 1990s—all the while, within themselves they have nurtured and sustained local traditions of enormous and distinctive vitality. The barrios of East Los Angeles and the neighborhoods of South Central L.A. (where African Americans have preserved the customs of the rural South and even echoes of Africa), and more recently the "little" Asian cities of Tokyo, Manila, Taipei, Saigon, and so on have all lived as vibrant and substantially self-sustained cultural milieus. Re-establishing some of the elements that formed the land- and city-scapes of other spatialities—the family structures, the customs, and the festivals, but also the creative rhythms of street behavior and social living—these communities have fashioned themselves between the cultural patterns of their originals and those of their new environment, forging a new local life for often globally distant identities.[10]

Spatiality in Los Angeles is thus structured between two primary vectors: a centripetal pull toward the Hollywood/downtown core, which has always been and remains the focus of the civic, economic, and transport networks of the basin; and the centrifugal pull generated by the semiautonomous industrial and residential enclaves. If the segregated peripherality of these enclaves precluded their full integration and representation in the city and full participation in its rewards, it also compensated by allowing a spontaneous culture to flourish and to mediate in some measure the social traumas that pervade the postmodern city—for which, again, Los Angeles is recognized as the prototype.

The global movement of capital that impelled many of the population flows that created the city also devastated its social fabric. In the past quarter-century, massive if selective deindustrialization and the growth of precarious low-income jobs, especially in the service and tourist industries, have been compounded by white-collar crime; virulent police corruption and brutality; and the exploitation and destruction of the land, water, and air. Trickling down to the lives of working-class people, these socioeconomic developments manifest themselves in unemployment and underemployment, poverty, homelessness, and alienation; in crises in public health, housing, and education; and in suspicion and conflict among sexualities and ethnicities. With the world-historical victory of neoliberalism, similar and in some cases much worse forms of intertwined social destabilization, atomization, and massification have become globally pandemic. But the paucity of attempts to address them in Los Angeles have been no less extreme than the economic developments that produced them. Paralyzed by what has been called "a collective or civic aversion to dealing with social, economic and political problems," local governance has not begun to address the erosion of the older forms of urban community adequately. Instead, "governments and populace have colluded in a decline of the commonwealth . . . the collapse of community."[11]

In this, again, the city is a paradigm of the widespread lived experience of loneliness, alienation, and social impotence; of the cultural attenuation and anomie that are now more intense and inescapable than even during the upheavals and dislocations of high

modernity. Then, at least, however corrupted its actual instantiations may have been, socialism as a political philosophy sustained the ideal of a nonexploitative human commonality, whether projected as popular participatory control over local life or as a future classless society. But now it is the market, abetted wherever possible by military power, that administers the world; and free-market fundamentalism appears locally, not in communal social projects, but as *privatization*. In the telling image of one popular analyst, we now go "bowling alone"; for, as a more abstract one reminds us, the "gravest and most painful testimony of the modern world, the one that possibly involves all other testimonies to which this epoch must answer . . . is the testimony of the dissolution, the dislocation, or the conflagration of community."[12]

Though this crisis in community is a cultural crisis in all senses, it has been enacted especially dramatically in the industrialization of older forms of culture and in their transformation into the business of entertainment during their assimilation by, and integration into, first finance and then corporate capital. Summarily designated as "Hollywood," the corporate entertainment industry now comprises virtually all forms of film, television, and recorded music and all their various satellites, spin-offs, franchises, and surrogates, their pimps and proxies. These industries have now extended to the spheres of politics, sport, religion, and other distinct areas of public life, reconstructing them within its own values and priorities, commodifying what once were popular activities and turning them, too, into entertainment. The traditions that inform the culture of popular participation may be implicitly or residually present in industrial culture, but only as they too are reduced to entertainment.

The resulting divided culture, the culture of separated, monopolized industrial production and of popular consumption, is the culture with which Los Angeles has become globally synonymous; and locally it is so overwhelmingly powerful that the forms of popular cultural practices in the city that are the present concern have become virtually invisible. For Hollywood's ubiquitous and all-pervasive presence in Los Angeles makes its attractions and rewards the context for all popular cultural activity. So great is the gravitational pull of the industry's stars and its star system that all other arts are forced to revolve around it. The structural core-periphery tensions that shape the city geographically and economically thus generate parallel determinations within its culture: the minority arts of the local communities in Los Angeles are created in the tension between the centrifugal pull of independent and indigenous aspirations and the centripetal pull of corporate capitalist culture. In Los Angeles, culture and geography are reciprocal: the social tensions of cultural marginality are isomorphic with the city's spatiality.

Until the 1950s, "Hollywood" designated simply the companies that manufactured films and recouped their expenses and profit in theatrical ticket sales. But since then, their production has simultaneously diversified and consolidated what before were several separate industries, while, especially with television, distribution sites have metastasized throughout the range of once-public places running from homes and schools to prisons and hospitals. The limits of the film text itself have eroded and fused into all its marketing extensions—sequels, T-shirts, theme-parks, lunch boxes, toys, comic books,

video games—the miasma of hype that makes it hard to imagine, let alone glimpse, any space outside the business.

This apotheosized culture-as-capital is identified with Los Angeles more completely than an art form was ever before associated with a single place. Infants together in the first decade of the century when the movies were little more than a cottage industry, the city and the industry fostered each other's growth to maturity. Late in 1907, the Selig company built a stage on Olive Street for the shooting of *The Count of Monte Cristo*, and two years later the company established a permanent base in the city. Other companies followed, including a troupe of Biograph players to shoot the local epic *Ramona* and the Keystone Comedy Company. By 1912, more than seventy production companies in Los Angeles employed three thousand people. During the teens of the twentieth century, the manifest advantages of the region's year-round sunshine and topographical variety persuaded even more companies to relocate to the region, and eventually some of them merged into larger combines that joined film production and distribution—the vertical integration of the industry. By mid-decade the industry's annual payroll had reached $20 million, and the identification of Hollywood the medium and Hollywood the city was established, with 60 percent of U.S. films being produced there.[13] In the post–World War I years, the studios surpassed the French, Italian, and British film industries to become the single most important source of production; and by the 1930s, the American film industry was dominant throughout the world. Even Carey McWilliams's unusual rhetorical excess does not seem an inappropriate summary of the city's debt to the medium: "If ever an industry played the Fairy Prince to an impoverished Cinderella, it has been the motion-picture industry in relation to Los Angeles."[14]

After World War II and Hollywood's second major global expansion, the other branches of the entertainment industries were assimilated to it. Though the rise of television coincided with a series of crises in the 1950s that forced the industry to restructure, in the early 1970s it again reinvented itself. Generating subsidiary industries as well as accelerating the development of other labor-intensive craft industries in the area, Hollywood attracted all the other components of the broadcasting industry. Since then, the television industry has itself expanded enormously, and the two industries are now completely integrated, not only with each other but also with the popular music industry, whose move west became conclusive in the 1980s. The strength of the industry's infrastructure and the abundance of creative and technical workers in the area supported the economic explosion of the 1990s, lifting Southern California out of the slump caused by cutbacks in the defense industries. With the expanded need for products to fill the new multichanneled global television systems of the decade, by the turn of the twenty-first century the annual business of the entertainment industries based in Los Angeles had grown to $40 billion, with more people in Los Angeles working in Hollywood than in electronics and aerospace combined.

The concentration of control over these media industries by a small number of corporations increased rapidly during the 1990s, paralleling the longer-standing globalization of the market. Japanese corporations began to invest heavily in the industry in

the late 1980s, with Sony buying Columbia Pictures in 1989 for $3.4 billion, and Matsushita buying MCA (Universal) in 1990 for nearly $7 billion.[15] Though film production had been controlled by a handful of major studios since the 1930s, by the late 1990s the six largest of them accounted for 90 percent of theatrical revenue, and all but 16 of the 148 features Hollywood released in 1997 were produced by only six firms. By that time, six firms also effectively monopolized more than 80 percent of the country's cable television, and only four companies controlled one-third of all radio station income.[16]

Especially after the deregulation of the communications industries in the 1996 Telecommunications Act, the elimination of restrictions on corporations moving across different branches of the communications industries led to enormous increases in conglomeratization. Just to take one locally important example, the Walt Disney Company, with annual revenues of only $25.4 billion (by comparison, General Electric, owner of NBC grossed $129.9 billion in 2001): among Disney's movie holdings are Walt Disney Pictures, Touchstone Pictures, Hollywood Pictures, and Miramax Film Corporation; it owns the ABC television network, together with the Disney Channel, Soap Net, all divisions of ESPN, and 80 percent of A & E and the History and Biography Channels. In addition to Disneyland itself, its theme park holdings include Disney World, Disney Cruise Line, and Disneylands in Paris, Tokyo, and one planned for Hong Kong. As well as extensive holdings in book publishing, it owns half of *U.S. Weekly, Discover,* and *ESPN* magazines; fifty radio stations; 741 Disney stores; and extensive theatrical interest.[17] This list is just a selection, and diversification of an equivalent or greater extensiveness has been documented for AT&T, Sony, AOL/Time Warner, Vivendi Universal, Viacom, and one or two more of the integrated communications and entertainment cartels.

Some indication of the momentum of this consolidated corporate ownership of American culture is revealed in the periodic summaries by one of its most important analysts, Ben Bagdikian. When he published the first edition of his book *The Media Monopoly* in 1983, fifty corporations dominated mass media in the United States. By the second edition in 1987, the fifty companies had shrunk to twenty-nine; by 1997 that number had been further reduced to ten; and by 2000 he found that only six dominant firms controlled more of the industry than the combined fifty seventeen years earlier.[18]

Manufacturing the culture that is marketed and consumed all over the world, the Los Angeles entertainment industry has become the vehicle, not so much of an American imperialism as of the imperialism of capital itself, inflating into a global omnipotence the implications of the Supreme Court's 1915 diagnosis that "the exhibition of moving pictures is a business, pure and simple, originated and conducted for profit, like any other spectacles."[19] Just one instance of this voraciousness may suffice: the case of *Jurassic Park*. The film was not only "accompanied by over 1,000 products identified as official Jurassic Park merchandise, distributed by 100 official Jurassic Park manufacturers around the world," but the Jurassic Park logo from the merchandising was displayed *in the film itself* in the park's gift shop; thus, the "film itself was a tie-in," intradiegetically displaying its combined merchandising, product placement, and other forms of economic proliferation.[20]

Though cultural activity has always been subject to economic transactions, only in the recent past have the culture industries themselves become so thoroughly integrated with each other, with all other forms of material production, and with the state. Training the world in consumerism, entertainment becomes capital's mode of operation. As Theodor Adorno, writing half a century ago in Los Angeles, noted, culture has amalgamated with advertising.[21] Or as a Coca-Cola marketing chief more recently remarked, it is the medium in which capital operates: "The culture that comes out of L.A.—films, television, recorded music, concerts—is the popular culture of the world and it is through that culture that we communicate with the consumers of Coke."[22]

Guy Debord and others among the Situationists, the French philosophers who have provided the most profound analysis of the assimilation of human life into this cultural-economic system, designated it as the *Spectacle*. In the "Society of the Spectacle," the immediate relationships among people appear to have been replaced by relations between people and images, an imaginary relationship that also has the effect of concealing the actual social relations created by the capitalist system's production of material wealth. The symbol and fulcrum of this condition, Los Angeles is thus the Capital of the Spectacle, and the comprehensive form of the city's economic, spatial, social and cultural alienation is ontological: "The spectator feels at home nowhere, for the spectacle is everywhere."[23] Though the ruin of community, the alienation of the imagination, and authentic social relations that constitute the Spectacle now affect almost everyone in the world, they affect people in Los Angeles especially powerfully and comprehensively. At once a cynosure and an *ignis fatuus,* and alternately enriching and depleting all other arts in the city, Hollywood attempts to frame all cultural practice in Los Angeles in its own economic imperatives and entrepreneurial ambitions; life there is enthralled by it.

To designate as "popular culture," not Hollywood itself, but practices outside and opposed to it, contravenes what has become the term's dominant usage, its reference to the consumer culture produced by capitalist industries. This recent transformation and narrowing of the concept of popular culture is not accidental, but rather it has accompanied parallel transformations and narrowings in the cultural field as a whole. Commodity culture's colonization of all areas of life—the individual psyche, the public realm, the political process, and indeed all forms of art—now appears to be so complete that, it is often argued, any popular practice outside it is impossible if not inconceivable. Responding to the preoccupation of the cultural field by capital, many journalists and academics have made corresponding investments. Whereas early attempts to legitimate the study of what was then called "mass culture" approached it as sociological or ethnographical data, more recent methodologies employ aesthetic criteria that allow for newly positive understandings of its social role. So though the fact of the structural integration of the dominant forms of contemporary culture in the general operations of capital is indisputable, its implications are widely disputed. More or less determinist positions like those of Adorno and the Situationists mentioned above, for example (that are rooted in Hegelian analyses of capitalism's intrinsic alienation and so propose that cultural domination and exploitation follow necessarily

from the economic structure of the entertainment industries) have become key points of reference, usually negative ones, in contemporary debates over the social implications of the mass consumption of culture produced by corporate interests.

On the one hand, it is argued that corporate culture, especially broadcast television, has been pivotal in the disintegration of the democratic process, the collapse of community, the rise of the New Right, and the emergence of a universal cynicism.[24] But as with all other forms of capitalist production, the culture industries' constant need to reconstruct themselves produces disjunctions and contradictions that render the overall system unstable and vulnerable to intervention by the people involved in its various stages. So on the other hand, other commentators emphasize the possibilities that the industrial production of entertainment does not preclude authorial self-expression during the process of its manufacture, nor does mass consumption of it preclude the audiences' parallel assertion of their own identity and creativity, specifically their ability to mobilize their own critical, against-the-grain reception of its intended messages. When such creative responses to entertainment become socially extensive, they produce fan cultures that may elaborate the imaginary identifications we all make with others who share our tastes into virtual or even real communities that become to various degrees independent of the original mass media sources. The Grateful Dead and Star Trek fan cultures are among those most often cited as sustaining such communities. Indeed, an entire academic discipline, Cultural Studies, now exists, premised on the moments of autonomy and alterity that the system as a whole allows and thus on the supposition that resistance to capitalist culture is marshaled within its own processes.

Though the Cultural Studies literature is now so immense that every position on the question of the relation between culture and political economy in these industries can somewhere be found in it, its main tradition derived from the work of the Birmingham Center for Contemporary Cultural Studies in the 1970s and 80s. The Birmingham group initially formulated itself around the investigation of the more or less delinquent activity of specifically working-class subcultures: dress, hairstyles, dance movements, and so on—the traditional field of anthropology or sociology rather than of aesthetics per se. It proposed that these subcultures reflected the transformed class tensions of advanced capitalist society and were, at least partially, ritually symbolic continuations of earlier and more overtly political working-class social contestations. In this formulation, popular culture was understood to comprise "Resistance Through Rituals";[25] that is, specifically working-class opposition to the dominant culture, which in Britain at that time was still the culture of the bourgeois and the aristocratic establishment, not yet melted into air by the entertainment industry.

The primacy of this working-class resistance to a dominant culture was largely lost in the Americanization and "postmodernization" of the Birmingham project that produced contemporary Cultural Studies. Occurring during the Reagan/Thatcher era's assaults on trade unions and all other forms of working-class self-organization, the transformation of the discipline entailed parallel offensives; the term "popular culture" was decisively relocated from the working-class oppositional subcultures to the entertainment industry, which in the United States (and increasingly so in Britain and the rest

of the world) had itself become the dominant culture. Its exclusive reference became the consumer culture manufactured by corporate industries rather than street-level attempts to resist or transform it, let alone to sustain alternatives to it. Popular culture was now produced by corporate capital, not by the people. As the term acquired the market definition of popular, its specific associations with the working class and hence the possibility that culture could focus structural social resistance were dumped. In a period where the significant crises in capitalism were explained as crises in over-production, to be assuaged by increasing the consumption of commodities of all and every kind, the academic study of culture followed suit by deploying itself primarily around the consumption of commodity culture.[26] The academy became yet another stage where capitalist culture as a whole was legitimated and naturalized; affirming, rather than interrogating the status quo, Cultural Studies amalgamated with advertising.

Though the present work does not assume that any autonomous sphere of popular culture, whether specified as the activity of an ethnic or sexual minority or as some fraction of the working class understood more generally, may now exist outside the gravitational field of the culture industries, it is oriented to those popular practices that attempt to produce themselves outside their priorities and processes and thus outside the field that Cultural Studies now demarks. Though they are surrounded by, and inevitably linked to, Hollywood, the initiatives considered in this book are displaced from it in multiple ways, but especially in being pursued as essentially amateur practices; and almost all are in mediums that the entertainment industry has not completely colonized.

Hollywood and Los Angeles, the industry and the city, culture and geography form the context, comprise the cloth on the edges of which participatory popular cultures weave new forms of community. In this they mark the continuation of the cultural resistance that began when the arts were first industrialized in the print business of eighteenth-century England. William Blake earned a meager living for himself and his wife on the edges of this industry, but he devoted himself to the composition of epic poems that he illustrated and engraved himself, the two of them coloring the printed sheets by hand. In these poems, Blake detailed a mythology describing the emergence of the modern world system—the specters of science, imperialism, the industrial revolution, and commodity culture—but also envisioning revolutionary republican attempts to humanize it. He coined the name *Los* for his central figure, an anagram for *Sol,* the sun, that also punned on the *loss* that surrounded him. Blake imagined Los as a blacksmith, hammering out a vision of a fully human, fully emancipated commonality. In the furnaces of his imagination, Los labored to build Jerusalem, or Liberty, by producing a genuinely popular culture, a Republican Art such as could be made at home like Blake's own, or one owned and exhibited by the general public, like early Renaissance frescoes—or modern murals.

Some two hundred years later, the word *Los* became current among working-class Latinos, many of them displaced from their homelands by the global forces of capital and empire, as the name for the city in which they made their homes, a city where they hoped to find liberty and fellowship and which they sometimes illuminated with exquisite, spontaneous frescoes.[27] From one of the first to the most recent scenes of crucial cultural resistance, the Sons and Daughters of Los continue to contend in their furnaces.

Notes

1. My own role and investment in this project followed from previous work in the study of popular culture, particularly independent cinema, and in the study of Los Angeles. This introduction draws on several of my previous publications, especially *Power Misses: Essays Across (Un)Popular Culture* (London: Verso Books, 1996), and on a history of non-studio filmmaking in Los Angeles currently in process, parts of the introduction to which I have adapted here. Agreement with the principles expressed in this introduction should not be ascribed to the other contributors.

2. Constrained by both space and hindered by the difficulties of finding scholars willing to commit their time to topics of this kind, our survey is by no means exhaustive in its account of cultural communities that have either existed in the recent past or are presently coming into being. Prominent among the omissions are the Social Public Art Resource Center (SPARC), the Wallenboyd and the Boyd Street Theaters, the Los Angeles Center for Photographic Studies, various public television initiatives, and Pasadena NewTown. Of new organizations, the many forms of community that are growing around the Internet (the Los Angeles Alternative Media Network, for example) are beyond the scope of the present volume, as are organizations specifically responsive to very recent immigration, such as the Mayan organization, IXIM, and the Salvadoran American National Association. On these last, see Nora Hamilton and Norma Stoltz Chinchilla, *Seeking Community in a Global City: Guatemalans and Salvadorans in Los Angeles* (Philadelphia: Temple University Press, 2001), 66–67. Our concerns here include attention only to those grassroots community movements that developed specifically around cultural activities; for the role of parks, neighborhood and homeowners associations, community newspapers, public libraries, and the like in creating communities in Los Angeles, see *Metamorphosis Project White Paper Number One, The Challenge of Belonging in the 21st Century: The Case of Los Angeles* (Annenberg School for Communication, 2001, <http://www.metamorph.org/vault>). Another major omission here is the many communities that have formed around music. These include classical music, ranging from the "Evenings on the Roof" of the 1940s and the "Monday Evening Concerts" (for which see Dorothy Crawford, *Evenings On and Off the Roof: Pioneering Concerts in Los Angeles, 1939–1971* [Berkeley: University of California Press, 1995]) to the music and sound events organized by Cindy Bernard, initially the late 1990s at the Sacred Grounds coffee house in San Pedro and then at the MAK Center for Art and Architecture at the Schindler House in West Hollywood. And they include more popular practices of music, of which the Los Angeles Punk movement in the 1980s and South Central Hip-Hop in the 1990s are the most important recent examples. These latter were not examined here because mostly (though not entirely) they developed in nightclubs, record labels, or informal tape distribution mechanism that grew on the edges of, or within, the music industry itself.

3. "Highways Spring 2002 Schedule," notice for "Gay Men's Performance Workshop."

4. "The Laocoön," *The Complete Poetry and Prose of William Blake,* ed., David V. Erdman (Garden City, N.Y.: Doubleday, 1982), 272.

5. For user-friendly introductions to these concepts, see Raymond Williams, *Culture* (London: Fontana, 1989); and Anthony P. Cohen, *The Symbolic Construction of Community* (New York: Tavistock Publications, 1985).

6. Robert M. Fogelson, *The Fragmented Metropolis: Los Angeles, 1850–1930* (Berkeley: University of California Press, 1993).

7. Edward W. Soja, *Postmodern Geographies: The Reassertion of Space in Critical Social Theory* (London: Verso, 1989), 224; Charles Jenks, *Heteropolis* (London: Academy Editions, 1993), 17 and 32.

8. *WPA Guide to California* (New York: Pantheon Books, [1939]1984), 208; Kevin Starr, *Material Dreams: Southern California Through the 1920s* (New York: Oxford University Press, 1990), 84.

9. Carey McWilliams, *Southern California: An Island on the Land* (Salt Lake City: Peregrine Smith, [1946] 1973), 314.

10. The notion of "cultural bifocality" or pluralism is now more germane than older assimilationist models of acculturation; see Hamilton and Chinchilla, *Seeking Community in a Global City*, 9.

11. Greg Hise, Michael J. Dear, and H. Eric Schockman, *Rethinking Los Angeles* (Thousand Oaks, Calif.: Sage Publications, 1996), 11.

12. Robert D. Putnam, *Bowling Alone: The Collapse and Revival of American Community* (New York: Simon & Schuster, 2000); and Jean-Luc Nancy, *The Inoperative Community* (Minneapolis: University of Minnesota Press, 1991), 1.

13. David Bordwell et al., *The Classical Hollywood Cinema: Film Style and Mode of Production to 1960* (New York: Columbia University Press, 1985), 123. By 1922, 84 percent of U.S. films were made here.

14. McWilliams, *Southern California*, 341.

15. Five years later, Matsushita sold 80 percent of MCA to Seagrams for $5.7 million. These figures are taken from Colin Hoskins, Stuart McFadyn, and Adam Finn, *Global Television and Film: An Introduction to the Economics of the Business* (Oxford: Clarendon Press, 1997), 23. For a complete analysis of the effect of the corporatization of the media system, see Robert W. McChesney, *Rich Media, Poor Democracy: Communication Politics in Dubious Times* (Chicago: University of Illinois Press, 1999).

16. Figures in this paragraph are from McChesney, *Rich Media, Poor Democracy*, 17–18.

17. Selected from listings in "The Big Ten," *The Nation*, 274, 1 (7 January 2002), 27–32.

18. Ben H. Bagdikian, *The Media Monopoly*, 6th ed. (Boston: Beacon Press, 2000), xxi.

19. *Mutual Film Corporation v Ohio Industrial Commission*. See Richard Koszarski, *An Evening's Entertainment: The Age of the Silent Feature Picture, 1915–1928* (Berkeley: University of Californian Press, 1994), 199.

20. Janet Wasko, *Hollywood in the Information Age* (Austin: University of Texas Press, 1994), 205.

21. See Max Horkheimer and Theodor W. Adorno, *Dialectic of Enlightenment*, trans. John Cumming (New York: Herder & Herder, 1972), 161: "So completely is [culture] subject to the law of exchange that is no longer exchanged; it is so blindly consumed in use that it can no longer be used. Therefore it amalgamates with advertising."

22. Quoted in Andrew Jaffe, "The Hollywood Threat to Madison Avenue," *Los Angeles Times*, 11 September 1991, B7. The article reported that the Coca-Cola Company had retained Michael Ovitv and his Creative Artists Agency to "put it in touch with 'global pop culture.'"

23. Guy Debord, *The Society of the Spectacle*, trans. Donald Nicholson-Smith (New York: Zone Books, 1995), 23.

24. Some recent examples of such wholesale critiques include Pierre Bourdieu, *On Television*, trans. Priscilla Ferguson (New York: New Press, 1998); and Jeffrey Scheuer, *The Sound Bite Society: Television and the American Mind* (New York: Four Walls Eight Windows, 1999). Robert D. Putnam has argued that television watching is negatively correlated with civic participation and social involvement: "Television . . . is bad for both individualized and collective civic engagement, but it is particularly toxic for activities that we do together. . . . Just as television privatizes our leisure time, it also privatizes our civic activity, dampening our interactions with one another

even more than it dampens individual political activities" (*Bowling Alone,* 229). On the other hand, some recent empirical evidence from Los Angeles is equivocal about the negative effects of television, finding that whereas it had a direct negative effect on the relatively privileged west side of the city, it had "indirect positive effects" among the largely immigrant populations of East Los Angeles; see *Metamorphosis Project White Paper Number One,* 34.

25. See Stuart Hall and Tony Jefferson, eds., *Resistance Through Rituals: Youth Subcultures in Post-war Britain* (Birmingham, U.K.: Center for Contemporary Cultural Studies, 1976).

26. As Nicholas Garnham has noted, the emphasis in affirmative Cultural Studies on cultural consumption rather than production "has played politically into the hands of a right whose ideological assault has been structured in large part around an effort to persuade people to construct themselves as consumers in opposition to producers"; see "Political Economy and Cultural Studies: Reconciliation or Divorce," *Critical Studies in Mass Communication* 12, no. 1 (1995): 65.

27. On the urban writing of working-class Latinos in Los Angeles, see Susan A. Phillips, *Wallbangin': Graffiti and Gangs in L.A.* (Chicago: University of Chicago Press, 1999). The city is designated as "Los" on a map on page 151. As part of his *California Trilogy,* James Benning made a wonderful film in 2001 about Los Angeles that prominently featured its Latino citizens; he titled it *Los.*

Bill Mohr

2 Peripheral Outlaws:
Beyond Baroque and the
Los Angeles Poetry Renaissance

In the encyclopedic history of post–World War II little magazines entitled *A Secret Location on the Lower East Side,* the notion of community as a primary mode of literary identity is invoked by many of the featured editors, several of them the most significant poets of our time.[1] In their brief recollections of their experiences in the small press world, "community" remains undefined, a gesture used to conjure a nostalgic glimpse of the glory days of baby-boom idealism. But however unfocused the idea might be for these writers, community formation was one of the central concerns of non-university poets in this country between the end of World War II and the beginning of the Gulf War.

Poet and critic Michael Davidson was one of the first to examine the relationship between poets and concepts of community during this era, emphasizing in his book *The San Francisco Renaissance* that while a poetry of place was important for Jack Spicer, Robert Duncan, Gary Snyder, and other major figures of the movement, nothing could have happened "without the sustaining fact of community—the circles, salons, and bars in which artists could invent out of the earthly city a heavenly city of fulfilled potential."[2] The sustained invention of community, however, often involves an aspiration toward social autonomy that immediately conflicts with the kinds of valorization provided by bourgeois culture. And poets at the margins on the West Coast during this period often required more than salons and bars to overcome their isolation and other disadvantages.

In the much smaller and more fragile beat poetry scene that evolved in Los Angeles during the mid-1950s, the poets who emerged during the turmoil of the Vietnam War dedicated themselves to a different intersection of social settings and alternative institutions. I will argue that the struggle to form and define a community and to articulate its relationship with the erratic circumferences of often-improvised poetics was

especially crucial to the majority of poets living in the city. Their need to articulate an artistic identity beyond individual authorship became an almost constitutive thirst, in large part because the entertainment industry dominated cultural production in Southern California.

In no other major region of the United States have poets had to confront on a daily basis the cultural and economic repercussions of the entertainment industries whose hegemony is so complete that, as Horkheimer and Adorno argued, they no longer feel the need "to justify the rubbish they deliberately produce."[3] While Horkheimer and Adorno's claim that "under monopoly all mass culture is identical"[4] and other aspects of their critique of "the culture industry" overstated their case as a deliberate provocation, poets in Los Angeles did not see such an analysis as much of an exaggeration, and their attempt to contest the commodification practices of the culture industry resulted in a distinct set of alternative communities and institutions.

I will examine in particular Beyond Baroque, a literary arts organization established in a storefront building in Venice, California, in 1968 that nourished the development of several communities of poets in Los Angeles as they were interwoven with several other subcultures. I will focus on these communities and on their practical, quotidian address to the contestation over canon formation long before it became a crucial matter of debate in the academy. Finally, I will also consider how these poets' proximity to the film and music industries has contributed to their peripheral status within American poetry.

Many alternative literary arts organizations have flourished at various points in the past half-century: St. Mark's Poetry Project in New York City; the Loft in St. Paul, Minnesota; and the now-defunct Intersection in San Francisco are some of the main ones. All of these are known for their workshops and reading series, and St. Mark's became famous for its production of mimeographed publications, but only Beyond Baroque brought together a multitude of complementary literary activities as a means of generating community during its development into a poetic cynosure in Southern California. When Beyond Baroque shifted from its original site to its current location in 1979, the task involved moving a small press library of several thousand titles, Compugraphic typesetting and paste-up equipment, and a stockpile of back issues of its own publication as well as more than a hundred metal folding chairs that provided the basic seating infrastructure for its workshop and reading audiences, to all of which was soon added a literary bookstore.

Although Beyond Baroque's reading series and workshops continue to serve as its most publicly visible means of attracting poets, its distinctiveness among alternative literary organizations derives from its early emphasis on incorporating as many aspects of literary production as possible at one site. From 1975 to 1985, in particular, Beyond Baroque provided the poets in Los Angeles with the opportunity to have a poem critiqued on Wednesday night, test the revision out loud at an open reading during the weekend, typeset and paste it up for publication during the following week, and subsequently bring it back from the printer to be shelved at the library and sold at the bookstore. The impact of these syndetic activities on the formation of poetic communities

in Los Angeles manifested itself in the almost kaleidoscopic permutations engendered by each individual's distinct sequence of participation. Beyond Baroque presented very little in the way of impediments to an artist's decision about how mature she or he was as an artist, and its institutional projection into the development of the community continually favored potential rather than enactment. Perhaps most importantly, poets minimized the notion of institution even as their accumulated palimpsests of place reinforced their community.

In analyzing the emergence of poetic scenes or schools, one must be vigilant in calculating the disparity between artistic institutions and individual artists, for it is all too easy to be seduced by casual transitions between these categories. For example, Christopher Beach's recent examination of postmodern poetry, *Poetic Culture*, announces that its "focus [is] on a dynamic tension that informs all aspects of contemporary poetic culture—the tension between the level of community and the level of the institution."[5] Beach claims that communities, "which evolve organically out of the needs of the particular groups of poets," are "a mediating link between individuals and institutions."[6] But his suggestion that poetic communities are organic is made without providing any historical context of the implications of such a claim. The yearning for *gemeinschaft* implicit in his claim cannot be detached from the contingencies of social resources available to poets. The dichotomy between individual and institution, which Beach suggests is almost reductively distinct, occurs because he defines institutions as a "form of social organization structured by some force outside the immediate control or jurisdiction of the poets themselves."[7]

One obvious problem is that some organizations that possess many of the features of an institution are also legal entities operated and directed by members of a community. In the literary world, these institutions would include such places as St. Mark's Poetry Project, the Loft, and Beyond Baroque. One of several major problems I have with Beach's definitions is that he does not consider that a community's first function could be to serve as a mediating link between individuals in one community and those in other contiguous communities without any particular emphasis on institutional affiliation.

In contrast with Beach, British sociologist Anthony P. Cohen emphasizes the function of the boundary in comprehending the meaning of a community. Cohen argues that community suggests "simultaneously both similarity and difference," that is, the people within a community have similar desires and expectations to such a degree that they perceive themselves distinct "in a significant way from members of other putative groups."[8] Cohen points out that the boundary is the crucial element that embodies this sense of discrimination, but says that "not all boundaries, and not *all* the components of *any* boundary, are so objectively apparent. They may be thought of, rather, as existing in the minds of their beholders. This being so, the boundary may be perceived in rather different terms, not only by people on opposite sides of it, but also by people on the same side."[9] The understanding of a boundary in this way permits the heterogeneity of a community to become visible to outsiders, and to reduce the oversimplifications that the apparent homogeneity of a community can attract in the analytic process.

Cohen's analysis allows us to take into account the fluidity of social life and how human beings are capable of negotiating several boundaries simultaneously. "Community is how we learn culture," Cohen insists, and how we learn to "be social."[10] This process is, therefore, one of the major elements that must be addressed if we are to consider the question with which Cary Nelson concludes his very fine examination of marginalized poets: What is "the social meaning of a life lived on poetry's behalf?"[11] I would like to suggest that the social meaning Nelson envisages is intimately connected by the desire of poets to form communities with porous boundaries, and this strategy complicates any community that is contiguous with a popular culture aggregated on behalf of other cultural economies and ecologies.

The emergence of several different poetry communities in Southern California during the past fifty years has passed almost unnoticed. A wide range of seemingly comprehensive and all-inclusive texts, from Alan Golding's *From Outlaw to Classic: Canons in American Poetry* to Jed Rasula's *The American Poetry Wax Museum*,[12] almost completely overlook the existence of a polyphony of communities in this region. Beach's book gives two-thirds of a paragraph to the region: "Los Angeles has quietly emerged as an important center of West Coast poetry, where a form of populist performance poetry variously called 'Standup Poetry,' 'Easy Poetry,' or 'Long Beach Poetry' has combined stand-up comedy and post-Beat poetry exemplified by Charles Bukowski."[13]

Setting aside for the moment the slightly dubious conflation of Los Angeles and Long Beach, I would observe that perhaps no better indication of a community boundary could be offered than Beach's assessment of a quiet evolution. For if this scene quietly became important, it certainly did not seem quiet to those who participated in it. Beach's observation not only establishes that there is obviously a boundary between that scene and those outside but also how considerable a distance separates even an apparently congenial critic from the entrance points to the other side of that boundary.

Beyond Baroque's establishment, development, and survival has been the result of the work and constitutive aspirations of a large number of editors and writers—more than can adequately be described in this article. I will trace some of the most stalwart contributions to Beyond Baroque's growth as various programs flourished, declined, and occasionally experienced a renaissance. Before I begin, however, I need to emphasize that Beyond Baroque hardly constitutes the first attempt to create a poetic community in Venice, let alone in Southern California.

The beat poetry scene in Venice during the 1950s had been vivid enough to catch the attention of Donald Allen, the editor of *The New American Poetry*,[14] the most significant anthology of what eventually became known as postmodern poetry in the second half of the twentieth century. Allen included in his volume the work of Stuart Perkoff, who tried to form an alternative community of poets and collage artists in Venice West.[15] The scene eventually dissolved in the aftermath of hard drug use and the pressures of governmental bureaucratic hostility, but its history is an important segment in the larger contestation between an underground arts world and the increasingly corporatized existence of cold-war America.

Nor did communal poetic activity disappear from Los Angeles between the disintegration of Venice West and the first stirrings of activity at Beyond Baroque. The Watts Writers Workshop served as a gathering place for African American poets who were not merely responding to the massive urban ghetto rebellions that stunned the city and the nation in the mid-1960s but were attempting to generate their own versions of earlier poetic revivals such as the Harlem Renaissance. This workshop involved many genres and was not limited to poetry. Though one of the plays developed in the Watts Writers Workshop, *Big Time Buck White,* ended up getting a Broadway production, the poetic legacy of the Watts Writers Workshop remains its most significant accomplishment. Many of the poets who emerged from it, including K. Curtis Lyle, Kamau Daáood, and Quincy Troupe, are still writing today.

Beyond Baroque: The Early Years

In the years after the dissolution of Venice West, Venice was much more isolated from Los Angeles than it is today, and the neighborhood maintained a reputation as one of the more disreputable, if not tougher parts of the city. Marina del Rey, the world's largest man-made small craft harbor, was still on the drawing boards, and the southern edges of Venice meandered into fields dotted with wild mustard that stretched to the Ballona Wetlands. Its northern border was marked by a defunct amusement park on a pier that was frequently set on fire by transients and amateur arsonists. The community adjacent to the north, Ocean Park, was hardly distinguishable from Venice even in the early 1970s, when Ocean Park's main street had several rescue missions. But Venice also distinguished itself from the other nearby coastal communities in that it was home to the most substantial neighborhood of African Americans and Latinos on the West Side. The Oakwood section of Venice, in fact, remains the only Southern California minority neighborhood that is close to the beach.

In early 1968, George Drury Smith's life gave only the slightest hint that he would become the progenitor of a literary renaissance in a community already known for its bohemian tolerance of artists and cultural cast-offs. Born in 1927 near Dayton, Ohio, Smith had only occasionally visited Venice on weekends while he was working as a district training supervisor for Pam Am in Los Angeles between 1955 and 1957. He lived in Chicago, Dallas, and San Francisco for the next six years. In 1965 he got a teaching credential and began working as a language instructor in the Santa Monica school district while also working on a masters degree at UCLA.

When Smith was 40, both his grandmother and his mother died, and he decided to use his inheritance to launch an experimental literary magazine. This was a project he had seriously considered as early as 1964, when he had gone so far as to do a mock-up of a cover and a title page accompanied by an editorial introduction. His second attempt began at offices at 73 Market Street in Venice, but in July he chose to establish permanent headquarters by purchasing a lot with two buildings on West Washington Boulevard just north of its intersection with Venice Boulevard.[16] Across the street was

ILLUSTRATION 2.1.
George Drury Smith at
Beyond Baroque, 1974.
Photograph by Bill Beebe.
Courtesy of the author.

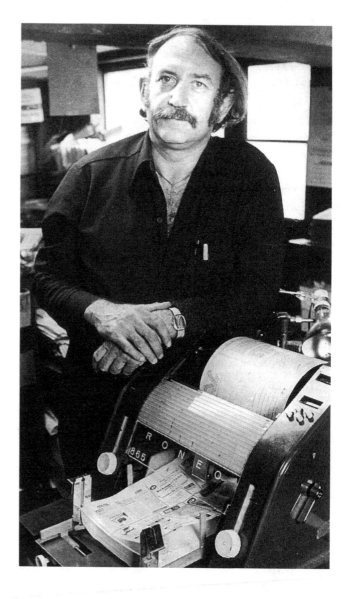

a junkyard called Ma Klein's Appliances and a lesbian bar, and down the street was Brandelli's Brig, a bar frequented by pool-playing bikers.

Beyond Baroque's front building was three stories high; in the rear was a one-story "pagoda-style" building that had once served as an old railroad station on Venice Boulevard. The larger building was "a wreck," according to Smith. "It had no running water, and all of the windows were broken."[17] He steadily worked to fix the building, a task that proved far easier than launching a commercially successful experimental literary magazine. The initial issue of *Beyond Baroque,* a name Smith says came to him in a dream,[18] failed to make much of an impact, especially in terms of subscriptions.

Needing to generate some revenue, Smith started a prepublication service called Bay-rock Publications, which included an IBM compositor. He also decided to open the western half of the first floor of the front building once a week to the public, which in Venice at that time included everyone from aspiring musicians and drug addicts (not necessarily distinct categories) to individuals so removed from any identifiable classification that they could only be described as drop-outs from the hippie culture. Every Thursday evening was devoted to "Happenstance": "There is no format and there are no rules. This is conceived as a poetry reading and rap session where anything can happen. Why not come, relax, chat, do your thing, while drinking coffee. You don't have to read anything, but most people do sooner or later."[19]

Venice was certainly not the only place in Los Angeles where such invitations were being issued to young people embroiled in artistic experimentation in hopes of renewing the beats' challenge to suburban tract culture. Sunset Boulevard in Hollywood was also the staging ground for confrontations between police forces and those who espoused street life and improvisatory dancing to rock music. In 1967 a young poet named Frank

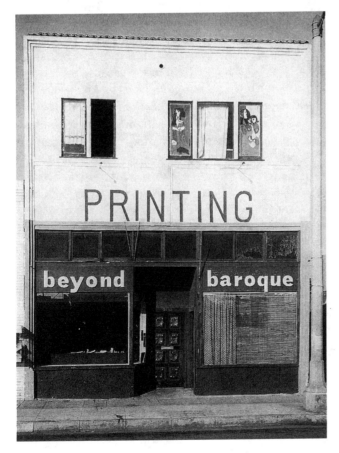

ILLUSTRATION 2.2.
Beyond Baroque, 1974.
Photograph by Bill Beebe.
Courtesy of the author.

Souza had opened up a coffeehouse with a performance space called The Bridge on Kenmore Avenue. Joseph Hansen, a concisely ironic poet who went on to write the David Brandstetter mystery series, started a poetry workshop that quickly developed a reputation for blunt, savvy criticism. John Harris, a poet who had been born in China and spent part of his childhood there with his missionary parents, found Hansen's feedback bracing, and his poetry quickly improved.

When Souza closed The Bridge, Hansen and Harris searched for another place to continue the workshop. Harris heard about Beyond Baroque from a newspaper announcement, and together they went to Beyond Baroque on a Thursday evening. The free-form, "let it all hang out" attitude of the Happenstance evening did not blend well with the more craft-oriented poetics of Hansen and Harris, and their first evening there quickly escalated into a caustic flurry of boasts and rebukes over the virtues of spontaneity and revision, which Smith resolved by opening his front-room space to Hansen and Harris on Wednesday evenings.[20]

Although the Thursday evening event soon ceased its informal presentation, its titular energy certainly continued to influence how individuals found their way to Beyond Baroque. Like many of the young poets who would arrive at Beyond Baroque during its first ten years, Jim Krusoe was the first in his family to attend college and also had a disaffection with the society that provided that education. After graduating from Occidental College, Krusoe moved to Venice, wrote poetry, and worked at various jobs, including a stint as a field worker for the health department of Los Angeles County. His first encounter with Beyond Baroque occurred in 1969 as he was moseying to the store to buy a quart of blue paint for a table he had picked up at Ma's Appliances. He noticed a store with five vacuum cleaners in various stages of assembly perched on its front windowsill accompanied by a sign in black and gold lettering: Beyond Baroque. "I walked by this print-shop sort of place, on West Washington. It looked intriguing, so I stuck my head in to see what was up. There was George, up to his neck in these little snippets of paper, pasting up the second issue of the magazine. We started up a conversation, found out we had similar tastes, and I wound up volunteering to help him read manuscripts."[21] Krusoe went on to do far more than screen the increasing influx of manuscripts. From the inception of the Friday night reading series in 1971, he chose and introduced poets with a deft aplomb in which even his compliments contained an implicit critique of the poet's work. Perhaps most importantly for Beyond Baroque, Smith decided in the mid-1970s to make Krusoe the assistant editor in charge of both Beyond Baroque's *NEW* magazine and a new book publishing venture.

By 1970, Smith's original intention to start an experimental literary magazine focused on fiction found itself expanding to include the work produced by poets at the Wednesday night workshop as well as poets from the larger Venice community like Lynn Shoemaker. Shoemaker had dropped out of a Ph.D. program at the University of California at Davis in part because of his disenchantment with academic poetry. By 1968, he was living in Venice and becoming involved in the resistance against the draft and the Vietnam War.[22] He also joined the all-volunteer staff of the *Free Venice Beachhead*, a monthly

newspaper devoted to revoking the annexation of Venice by Los Angeles and the establishment of a counter-culture city. The secession movement never reached fruition, but throughout the 1970s the desire to return to Venice's original autonomy reinforced the artistic groundswell. Shoemaker became the managing editor of the third issue of *Beyond Baroque,* which was guest-edited by Hansen and Harris and focused on the "New Venice Poets." This issue included not only members of Beyond Baroque's workshop but also Jack Hirschman, who had recently lost his job teaching at UCLA and was living on Quarterdeck Street in Venice, and John Haag, a community organizer.

A year later Shoemaker edited a follow-up anthology, *Venice 13,* which focused only on work from the Beyond Baroque workshop.[23] Smith served as the printer for this book but was not himself the publisher. The major addition to the lineup was Harry Northup, an actor born in Kansas in 1940 who had moved to Los Angeles in 1968 after several years working in New York and who eventually appeared in many films directed by Martin Scorsese and Jonathan Demme.

Smith was diligent about mailing out press releases for all Beyond Baroque's activities. Northup's inclusion in *Venice 13* and the announcement in a newspaper of his participation in its publication reading caught the attention of Leland Hickman, a poet and actor who had also recently moved to Los Angeles. Northup and Hickman had known each other in New York but had lost touch with each other, and Hickman surprised Northup by showing up at the reading.[24] By late 1971, Hickman, too, began attending the Wednesday workshop and sharing portions of his long poem, *Tiresias,* which quickly became recognized in the workshop as a major work-in-progress. During workshops, Hansen often cited Hickman's "Lee Sr. Falls to the Floor," which had originally appeared in the *Hudson Review* and had been selected for the *American Literary Anthology* in 1968, as an exemplary poem that younger poets should study for the lyric recoil of its dramatic imagery:

> his breathing unthrobs
>
> Rerun that. The fumes
> tremble in the terrifying heat
> Lee Sr. falls to the floor
>
> Rerun that Lee Sr crumples
> angular on linoleum
> gasps in the kitchen glare
>
> Rerun Lee Sr falls down
> in jockey shorts A wooden
> chair topples on its side smacks
> the floor back goes
> his balding head clawed
> by ache
>
> Rerun the gasp[25]

In the course of this four-page poem, each successive amplification of Hickman's cinematic imperative reveals the starkness of his father's accidental death, but the resignation expressed at the end of the poem was only temporary.[26] His long poem, *Tiresias,* involves a journey home as harrowing as anything in the plays of Eugene O'Neil or Sam Shepard.

Far more sexually explicit than Ginsberg's *Howl,* Hickman's long poem provided Beyond Baroque's Wednesday night workshop with a chance to assert itself as a public group when many of its members attended Hickman's first sustained reading of portions of the poem at Papa Bach Bookstore in October of 1971. The attendance of the Beyond Baroque workshop community at that reading, in fact, signaled the beginning of many links between the workshop and Papa Bach, which was primarily known at the time for its double feature of draft counseling and the best selection of Marxist literature in Los Angeles. The workshop and the store went on to become far more involved with each other's fate. Workshop leader John Harris eventually owned the store, and he expanded the size and scope of the store's new magazine, *Bachy.* Hickman became its editor for ten issues. He would later build on the experience he gained there in handling a large-page publication when he began his own magazines, *Boxcar* and *Temblor.*

New issues of *Beyond Baroque* were slow to be assembled, and between them Smith began to publish small saddle-stitched pamphlets of mainly local literary news together with a few poems, which he called *NewLetters.* By 1972, Beyond Baroque had incorporated as a nonprofit foundation and was using bulk-rate postage to distribute a significant chunk of *NewLetters'* print run of 1,500 copies. These issues not only served to publicize events at Beyond Baroque and at independent bookstores such as Papa Bach's, but they also gave detailed directions on how to get to Beyond Baroque.[27]

The Friday night poetry reading series for which Beyond Baroque became most famous was quite sporadic in its early years, and attendance was unpredictable. Jim Krusoe remembers six people showing up to listen to Kenward Elmslie, and "three of them left at intermission."[28] Other events, however, were more indicative of the future: Jack Hirschman's readings on September 25 and October 24, 1972, brought a heavy response. This galvanized attention so much that a few months later Smith noted in *NewLetters* that "recent presentations at the Center have found people crouched in the doorway, hoping to hear a note or a word, and perhaps gain entrance after intermission."[29] Audiences eventually proved so indefatigable that loudspeakers had to be placed outside the building so that the crowd on the sidewalk could hear the poems being read inside. Of course, the phrase "hoping to hear a note" reminds us that Beyond Baroque's early programming was not simply literary or restricted to the contemporary. A music series directed by Smith focused on performances of Early Modern compositions and attracted an audience quite distinct from the poetry crowd. In addition, Smith curated the exhibitions of visual art that rotated in tandem with the seasonal reading series.

Smith managed to accomplish all this while working at other jobs to support himself, jobs that fortunately brought him into contact with individuals who supported Beyond Baroque at critical moments. One of his jobs was doing production and edito-

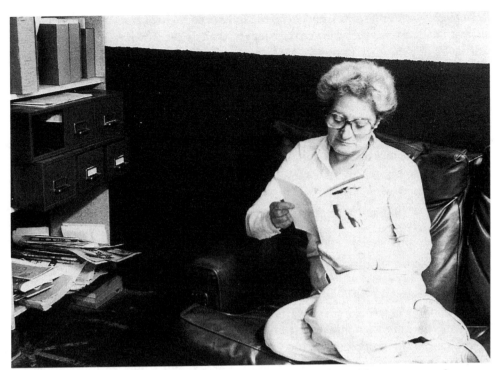

ILLUSTRATION 2.3. Alexandra Garrett, editor and indefatigable supporter of
Beyond Baroque. Photograph by, and courtesy of, George Drury Smith.

rial work for a local weekly newspaper, *The Argonaut,* whose publisher, David Asper
Johnson, allowed him to use its photo-typesetting equipment to set issues of *New-
Letters.*[30] Although the National Endowment for the Arts (NEA) was eventually to
have a major impact on arts funding in the United States, Beyond Baroque received
little grant support during its first five years, marking a substantial distinction between
it and other community-oriented literary projects of the same period. The Poetry Proj-
ect at St. Mark's-in-the-Bowery, for instance, was begun with federal money, in part
because it located itself at a place that already had larger social recognition and cog-
nizance as a cultural site.[31] In contrast, Beyond Baroque was begun in a converted store-
front, and its total assistance from government agencies in its first five years was less
than a thousand dollars.

The survival of Beyond Baroque during these early years largely happened because
of the devotion of volunteers such as Alexandra Garrett, a reticent poet who had been
the only woman in Tom McGrath's poetry workshop in Los Angeles during the 1950s
and who had worked as an editor and major fundraiser for *Coastlines* in its final years.
Garrett contributed thousands of hours to Beyond Baroque and was the founder of
Beyond Baroque's small press library, which is the largest such public, non-university
collection on the West Coast.

In 1974 Smith applied for, and received, an Expansion Arts grant from the National Endowment for the Arts, which enabled him to open up the larger back room of Beyond Baroque's first floor to accommodate larger audiences for readings. The grant money that became available was in part due to the recession between 1973 and 1975, which was so severe that the federal government finally attempted to ameliorate its effects by employing individuals in arts activities for the first time since the Works Progress Administration.

Smith's transformation of Beyond Baroque from a for-profit publishing venture to a nonprofit arts center enabled him to snag some funds from the Comprehensive Employment and Training Act (CETA) and use them to hire several people for tasks around Beyond Baroque. One of them was a young poet from Florida, Exene Cervenka, who recalls that when she arrived in Los Angeles in 1976, "I'd never lived in a city before, and didn't know ... what I was going to do except keep on writing, which I'd been doing for seven years. So I got a job (CETA)typesetting at Beyond Baroque and a place upstairs. I didn't have anything. No stereo, no radio, no TV. . . . All I had in my apartment was a clock. . . . The workshops were *the* place where you could have your stuff read and commented on honestly. No pretense—people either liked it or they didn't, and they told you *why*."[32]

A handsome musician and poet from Baltimore who called himself John Doe began attending the workshops about the same time as Cervenka, and by 1977 they had moved together to Hollywood and with Billy Zoom and Don Bonebreak formed a band they called "X." Their Beyond Baroque roots revealed themselves in their first show at the Whiskey rock club on Sunset Boulevard in July 1978: the lyrics to their songs were only partially decipherable through the mesh of punk-inspired riffs, but afterwards I heard them tell Jim Krusoe that one of the songs they performed included lines from his first chapbook, *Notes on Suicide*.[33]

A "Golden Age" of Los Angeles Poetry

By the mid-1970s, Beyond Baroque's publication projects had split into two: one publication retained the eponymous title, while *NewLetters* evolved into *NEW* magazine. *NEW* also changed its appearance: instead of a 32-page issue that was erratically pasted-up, it was printed on newsprint in runs of 16,000 copies in 1976; and its circulation eventually peaked at 25,000.[34] Bundles of *NEW* were placed around the city at restaurants, bookstores, and record stores for free. When Beyond Baroque received a grant to produce full-length poetry books, the same strategy was adopted, though the paper was of a bit higher quality.[35]

The Linocomp typesetting equipment that Cervenka worked on had been acquired through an NEA grant in 1975, and the machine was in constant use by poets in the community. Jack Grapes and Michael Andrews, for instance, were running a reading series at the Alley Cat restaurant in Hermosa Beach and were producing perfect-bound anthologies, each featuring a cluster of poets. Like Harry Northup, Grapes had arrived

in Los Angeles in 1968 in hopes of making a career out of acting. He had grown up in New Orleans, home of *The Outsider* and Loujon Press, which had selected Los Angeles poet Charles Bukowski as "Outsider of the Year" in 1963 and had published the first substantial collection of his work, *It Catches My Heart in Its Hands*. As a young poet, Grapes had corresponded with Bukowski, but he had moved to Los Angeles, not because of a desire to live in proximity with his poet-hero, but because he had a part in a television pilot. However, the poetry community proved to be the most important part of his artistic development. He began to attend the Beyond Baroque poetry workshop around 1973. "The poetry community—working with a community of poets—renourished my identity as an actor. I re-connected with myself as an artist again, and I felt grounded. It made a difference to my work as an actor to belong to a community of poets," Grapes recalls. He also makes a distinction in the kinds of social relationships that this workshop encouraged. "The thing about the Beyond Baroque poetry workshop was that it wasn't about being a star. As opposed to acting in commercials, the poetry work felt grounded in the soul, in an organic, centered, truthful place. The odd part was that it wasn't long after I made this change that I went out on interviews and I got parts."[36] Grapes quickly became not just a participant in the Wednesday night workshop but one of the poets who defined the community that was solidifying around Beyond Baroque. He met another poet and photographer, Michael Andrews, who had a letterpress that he used to issue broadsides on paper almost as thick as corn tortillas; and together they formed Bombshelter Press, a reference to the structure that housed the letterpress.

Perhaps the youngest and most ambitious poet to show up during the early part of Beyond Baroque's second decade was Dennis Cooper, who had started a little magazine, *Little Caesar*. Cooper was enamored with the New York School of poets, especially the second and third generations emerging from the St. Mark's Poetry Project and Anne Waldman's *World* anthologies, whose work blended Frank O'Hara's famous "I do this, I do that" jaunty poetics with more than a touch of diaristic self-promotion. Cooper's eclectic editorial blend of punk and popular music, film criticism, and a huge swath of casually deft poetry attracted a vociferous readership and led him to establish Little Caesar Press. Although Cooper had financial resources in personal family money far surpassing any other Los Angeles poetry editor, he still had to do an immense amount of the production labor himself. At that time, Cooper was probably the fastest two-fingered typist on the West Coast, and he poured vast amounts of time into typesetting issues and books that caught the high tide of independent bookstores such as George Sand, Chatterton's, Either/Or, and Intellectuals & Liars that stocked and sold small press productions. Many independent bookstores had at least intermittent poetry reading series, and the emergence of the Woman's Building as a significant site of literary production contributed to a growing sense of critical artistic mass assembling itself in Los Angeles.

The response of *Los Angeles Times* critic Robert Kirsch in the late spring of 1979 to the anthology I edited and published through Momentum Press, *The Streets Inside: Ten Los Angeles Poets*, seemed to provide additional confirmation that clusters of poets were assembling in Los Angeles who were sympathetic to each other's texts and poetics and

who, Kirsch observed, appeared to know each other, based on textual references and dedications of individual poems. However, Kirsch indicated that categorizing these poets was not going to be an easy task. "Call them no-school," he proposed—and no other reviewer has ever written a more accurate sentence. Kirsch also made it clear that this group of poets had achieved substantial significance: "If this were San Francisco, where such things are more readily recognized," he wrote, "this would be called a golden age of Los Angeles poetry."[37] Kirsch's death in the early 1980s was probably the single most devastating blow the Los Angeles poetry scene ever suffered, for there was never again a voice at the *Times* that spoke up so generously on behalf of Southern California's poets.[38]

"Coming Attractions": Beyond Baroque and the "Little Caesar" Generation

By the late 1970s, the renaissance of poetry in Southern California was not limited to Venice—Long Beach, for example, was beginning to develop its own scene. But between 1974 and 1979, the reading series at Beyond Baroque under Jim Krusoe blossomed. More and more poets, including figures such as the then relatively unknown Alicia Ostriker, began to show up for the workshop and to find enough encouragement there to participate in the Friday night reading series. The small amount of space for all these events, though, continued to pose a major problem, and the need for a single building that could house all Beyond Baroque's activities and accommodate the increasing audiences propelled the search for another location.

Ironically, the passage of Proposition 13 in 1977, which devastated school budgets and led to the eventual decline and virtual demise of the Southern California region's Poets-in-the-Schools program, also provided Beyond Baroque with an alternative plan for expansion.[39] The shortage in city government revenues forced the closing of various city agencies and structures, including the Old Venice City Hall, which had been built around 1907 and which served Venice until it was annexed by Los Angeles in 1927. In late August 1978, the city administrative board recommended that Beyond Baroque's application to use and maintain the space be accepted.

The move was made during the following summer, and an official "gala opening" occurred in late October 1979 with a weekend that included poetry readings by Kate Braverman and Wanda Coleman and a Renaissance music concert the following night. The transition to the Old Venice City Hall was marked by several major organizational shifts. On September 30, George Drury Smith resigned as president and chairman of the board of trustees, and James Krusoe resigned as vice-president.[40] After ten years of unceasing struggle, Beyond Baroque had found a home that could provide enough space under one roof for all of its activities, and Smith felt his task was complete.

Although this new space was less than a half-mile away from the original site in Venice, the move marked a major shift in Beyond Baroque's social and poetic emphasis. If working-class poets had dominated the development of Beyond Baroque's first

ILLUSTRATION 2.4. Beyond Baroque's home on Venice Boulevard in the Old Venice City Hall. The reading room and performance space is to the right of the main entrance. To the left is the small press library and bookstore. Upper stairs to the right is the main office. Photograph by, and courtesy of, Bill Mohr.

decade, the second decade was marked by the presence of a new wave of poets from the middle class whose families were familiar not just with college but with private colleges. Cooper took over the Friday night reading series from Jim Krusoe, who had managed to nurture it to a vibrant pitch without any budgetary support whatsoever. Cooper, on the other hand, was able to guarantee poets from out of town a reading fee, although the need for Beyond Baroque to show income from its events in order to apply for grants required that the days of free admission be relinquished. Charging admission for the first time in Beyond Baroque's history did not create a crisis. But Cooper's shift in programming and his unwavering loyalty to the perpetrator of an egregious act of plagiarism did eventually cause significant splits in the community.

Another split on the administrative side had serious consequences for Beyond Baroque's relationship with third-world and minority communities in Los Angeles. In 1977 Manazar Gamboa, a poet on parole from San Quentin, showed up at Beyond Baroque, working as a volunteer. By 1979, he had become administrative vice-president, and when Smith resigned as president, Gamboa took over and immediately made several significant changes. *NEW* magazine became *Obras,* and the reading series concentrated on third-world readers. Attendance declined precipitously, but even more foreboding was Gamboa's lack of action in applying for grants.[41] The board of directors decided to

replace him with Jocelyn Fisher, who had been working as the librarian. The aftermath of this transition included a schism within the workshop community, with some members claiming rights to the name "Venice Poetry Workshop" and moving it next door to the Old Venice Jail, which had been taken over by the Social Public Art Resource Center (SPARC).[42]

Fisher started another publication, *Poetry News,* which lasted for almost twenty issues. One of its most controversial articles was by Dennis Cooper and addressed the mounting factionalism in Los Angeles poetry. Cooper remonstrated the "first generation" of Los Angeles poets for being unwilling to analyze their poetic situation and was rather dismissive of their stature within American poetry.[43] His assessment was considerably off the mark on several points, especially in his derogatory assertion that these poets were virtually unheard of outside Los Angeles County, and reveals more about Cooper's own ambition than about the complex situation that the Beyond Baroque poets confronted. Perhaps the most salient figure Cooper neglected was the Los Angeles poet whose presence had the greatest international impact, but who never read at Beyond Baroque. Cooper's omission of Bukowski from his article was particularly egregious given the fact that Bukowski was not simply a poet but had also edited a poetry magazine, *Laugh Literary,* and had been one of the three editors of the first significant anthology of Los Angeles poets in the 1970s.[44] Whether or not many of Beyond Baroque's first generation of poets were directly influenced by Bukowski's deceptively minimalist prosody, the fact remains that many of them took an oblique courage from his triumph as a working-class poet and found reinforcement in his choice of labor itself as worthy subject matter. As David James has pointed out, Bukowski's success "ensured that the characteristic poetic voice of the city would be decisively working class."[45] A simple contrast between the covers of a magazine such as Bill Mohr's *Momentum* and Cooper's *Little Caesar* provides a blunt distinction between the first and second generations of Beyond Baroque poets. *Momentum* featured work order and unemployment claim forms on its cover, whereas Cooper's covers emphasized glamorous figures of popular culture. Cooper's comment becomes absurd within the context of Bukowski's success, not to mention that Bukowski's own favorite poets, such as Gerald Locklin and Ron Koertge, had had notable small press success in the area since the late 1960s.

The notion that nobody north of Oxnard or east of San Bernardino or Riverside had heard of the first generation of Beyond Baroque poets would be laughable if it had not been so effective in allowing Cooper's efforts to be framed as the most important period of Beyond Baroque's history, which is implicitly the message of his biographical note in Paul Hoover's *The Postmodern Poets.*[46] Certainly, the former co-editors of *The Lamp in the Spine,* Patricia Hampl and Jim Moore, who lived in Minnesota, would look askance at Cooper's poetic cartography, given that they had published a half-dozen of the leading Los Angeles poets in their magazine during the early 1970s and that these poets were intimate friends with other poets in Los Angeles who had published in magazines ranging from *The Paris Review* to *The Hudson Review.*

Cooper's flippancy generated more consternation than he probably expected, in part because his apparently sincere belief in the diminutive status of the older generation of Los Angeles poets did not waver even in the face of obvious contradictory evidence.

Momentum Press, for instance, had reached far beyond than the ears of the literati of Santa Barbara: its publications were being ranked with the best that the major New York publishers could offer; and six months before Cooper made his comment, Leland Hickman's *Great Slave Lake Suite* had been nominated as one of the five best books of poetry published in the United States during 1980. Cooper's analysis also completely fails to take into account the international reputation that Los Angeles poet Paul Vangelisti had achieved through his editorial projects with his magazine *Invisible City*, which he co-edited with John McBride in San Francisco, and their Red Hill Press, not to mention with his own anthologies of Los Angeles poets.

Cooper felt that controversy was healthy, but many in the scene who had emerged as poets either through the workshop or by giving publication readings at Beyond Baroque felt that he was succumbing to the aura of East Coast hierarchies in which poets were ranked according to their publications and fame rather than being appreciated and acknowledged for the quality of their work itself, even if it were only being published in magazines that were primarily edited in Los Angeles. The focus, then, on appearing in local magazines was fundamentally a desire to confront the mass culture machine with as much activity as possible. If the goal of these industries was to saturate the national market with its commodities, the desire of one portion of the poets in Los Angeles was to issue a direct challenge to hegemonic social and economic practices by emphasizing the local first with activity that featured an artistic element that is very difficult to market.

In contrast to the big screen with Dolby sound, poetry as a genre insists that silence serve as the primary agent for the emotional manipulation of an image and that this silence simultaneously enact itself in a communal debate over how it should be recorded and represented on the page and in performance. Often only audible in the white space that a reader encounters as she reads to herself, this conversation about the silence surrounding and permeating a poem is all the more radical in a town that packages sound tracks at maximum volume.

"Poetry," David James argues, is "of all the arts the least useful to the film industry, and in its recent forms least compatible with its ethos" and "has recognized the impossibility of its profitable marketing by constructing itself in antithesis to everything assumed by Hollywood."[47] At least part of the strategy on the part of poets in Los Angeles in choosing to work in a city that embalmed itself in the pathos of its own industrial entertainment was to remind those in Hollywood, who assumed that everyone had their price, that their home ground served as an organic site of resistance. In Los Angeles the best minds of this generation were not destroyed by madness, but rather, they were engaged in a proliferation of cultural work that refused to succumb to two quite different but equally manipulative ideologies of the imagination: Hollywood, and the "establishment versus avant-garde" binary of East Coast-West Coast literary rivalries. The poets in Los Angeles were less interested in how the poets elsewhere perceived them than in how their activities as poets served to confront the city with a community that preferred to keep the definition of that term as open and empty as possible. The poets at Beyond Baroque's workshop as well as the workshops that spun off from it took pride in not being easily classified.

By this time, poets were arriving in Los Angeles for a variety of reasons. Charles Harper Webb moved to Los Angeles in 1981 after a long career in the Seattle area as a rock musician. Webb had been publishing in dozens of little magazines ever since 1971, and he had also edited a little magazine, *Madrona*. Hollywood was certainly part of the lure for others, such as Suzanne Lummis and Michael Lally. Lally worked primarily as a television actor, while Lummis has written critically acclaimed stage plays as well as establishing herself as a potent actress. Lewis MacAdams moved to Los Angeles from Bolinas and became involved with a variety of ecological causes, including the founding of the Los Angeles River Project.

Other poets would arrive who were less sympathetic to the home-made poetics of Los Angeles. Doug Messerli moved his Sun & Moon Press to Los Angeles because his significant other got a major curatorial job at the Los Angeles County Museum of Art. Years earlier, John Martin of Black Sparrow Press had stated publicly that Los Angeles had only one significant poet: Charles Bukowski. Martin eventually moved his operations to Santa Barbara and then to Santa Rosa. Messerli, an enormously successful small press publisher who views the bulk of the local scene as provincial, took up Martin's vacated post in Los Angeles as skeptic-in-residence.

Other people were arriving in Los Angeles as refugees from state-sponsored terror approved by an evil axis of C.I.A operatives, illegal weapons smugglers, and perjurers in the Oval Office. These crimes did not pass unnoticed by Los Angeles poets any more than did Allende's murder in Chile in 1972. If poets in Los Angeles such as Ron Koertge and Jack Grapes were becoming known for a jaunty, self-deprecating sense of humor, others included in their stand-up repertory a refusal to succumb to the big chill that seemed to erase directly political poems from many of the little magazines and anthologies of the mid-1980s. More typical of the reaction in Los Angeles to the turbulence of the time would be Aleida Rodriguez's poem, "I've Got Something Personal Against the Bomb" or Eloise Klein Healy's "El Playon De Chanmico":

> Where are the human beings?
> There are some dead people by the road.
> There are some dead people by the volcano
> and it has been silent for years.
>
> Where are the human beings
> at El Playon de Chamnico?
> There is no smoky plume
> to frighten them.
> The earth is not quaking.
> No fresh stone flows
> on the lava bed.
>
> Where are the human beings
> to bury the dead
> who mold into one another
> a piece at a time
> . . .

There is a soccer game
and aren't they going?
There is Mass today
and won't they be praying?
. . . .
See, they have their arms
around each other

by the side of the road.[48]

Beyond Baroque continued to struggle financially. It did acquire a new typesetting machine, a Compugraphic 7500 that made publishing a great deal easier since everything that was keyboarded was recorded on a floppy disc, but the number of typefaces did not significantly increase. The building itself deteriorated. The smell of mildew permeated the entrance hall. Mice ran with impunity across the workshop floor and hopped into trash cans in daylight in search of crumbs from discarded chip bags until two young cats were brought in by Alexandra Garrett, and they eventually stemmed the infestation. Other rodents were more determined.

Beyond Baroque attempted to organize a poetry component for the 1984 Olympic Arts Festival, but U.S. Secretary of State George Schultz led an attack on UNESCO, which would have provided a large chunk of the festival's funding. When the United States withdrew its funding of that sponsoring organization, poetry became the only major art form not to participate in the Olympic Arts Festival. Compared with the horror Schultz unleashed in Central America, the cancellation of a poetry festival is hardly a criminal act, yet the connection between the two is not negligible. Such rejection did not deter the poets in Los Angeles from speaking out. "Flowers for Nicaragua" in 1986, for instance, was one of many benefit readings which occurred in support of the Sandinista government.

Cooper departed for New York in 1984, and none too soon as it turned out. If Beyond Baroque were a stock on Wall Street, it could be said that Cooper sold the day before the market crashed. The budgets at Beyond Baroque may not have seemed abundant at the time, but in retrospect they came to be viewed as rivers of milk and honey. In 1985 the Literature Program of the National Endowment for the Arts chose to award the Poetry Project at St. Mark's in New York a grant and rejected Beyond Baroque's application. Rumors circulated in Los Angeles of displeasure of NEA officials at the sight of political posters at Beyond Baroque concerning anti-nuclear weapon demonstrations. Regardless of the reason, Beyond Baroque faced the most severe crisis of its existence. The band X gave a benefit concert that cleared more than $10,000, which kept the organization going, though in a rather dilapidated condition. When news arrived of the NEA decision not to fund Beyond Baroque, poet Jim Cushing wrote an article in which he described Fisher's office: "A square area of plaster the size of a bulletin board has fallen off the wall, exposing the boards. Beneath this ruin is a green plastic wastebasket full of rainwater. A sign over her desk reads, 'Metaphors be with you.'"[49]

The poets who rallied to save Beyond Baroque were not rewarded. Although a poet, Dennis Phillips, was the primary administrative person from 1985 to 1988, the general

cultural shift toward prose and the novel that was occurring on a national level found Beyond Baroque's poetic community too exhausted to offer substantial resistance when the organization also tilted in that direction. Benjamin Weissman, a prose writer who displayed little knowledge of contemporary poetry and who was openly disdainful of many of the oldest poets associated with the original Beyond Baroque workshop, maintained control of the reading series until almost the mid-point of the 1990s. But even as the poets associated with Kirsch's "golden age" floundered, survival brought Beyond Baroque an odd kind of fame. By the late 1980s and early 1990s, it had begun to be recognized as such an important institution that a multitude of writers as prominent as Ann Beattie, Charles Baxter, and Raymond Carver gave readings to standing-room-only audiences. Weissman certainly did not exclude poets from his series, but readings by the oldest members of Beyond Baroque's poetic community became rarer and rarer as well-established figures such as John Ashbery, Philip Levine, Mark Strand, and Edward Hirsch were given precedence in snagging the slots left over after fiction writers were selected. Weissman's tenure was marked by Beyond Baroque's growing reputation among nationally recognized writers as one of the best places to read on the West Coast, and audiences continued to embrace the reading series. His dismissal by Beyond Baroque's next president, D. B. Finnegan, served to release long-dormant resentments and festering disputes within the poetic community, and eventually it led to outright power-play politics and to Finnegan's resignation. Weissman himself left within a year, and Beyond Baroque limped along under the direction of Tosh Berman, son of the famous collagist, Wallace Berman.

The backdrop for this bleak period was the disappearance, one by one, of the bookstores that had been most supportive of the small presses in Los Angeles: Intellectual & Liars, Papa Bach, George Sand, and Chatterton's. The *Los Angeles Times* announced in 1985 that it would no longer run reviews of poetry books; what little was reviewed, such as *Poetry Loves Poetry*, the anthology of Los Angeles poets from Momentum Press, failed to address the extraordinary diversity of work being done in Los Angeles by poets such as Doren Robbins, Michael C. Ford, Wanda Coleman, Laurel Ann Bogen, David Trinidad, and Amy Gerstler. Between 1980 and 1985, the magazines and small presses that had provided a core group of Los Angeles–area poets their primary visibility ceased operation: *Bachy, Invisible City*/Red Hill Press, *Momentum*/Momentum Press, and *rara avis,* which was edited by Aleida Rodriguez and Jacqueline DeAngelis, faltered without completing all of the projects they yearned to produce.

Poet-actor Harry Northup responded by starting a reading series at the Gasoline Alley coffee house on Melrose Avenue and eventually launched a poets' cooperative with Holly Prado, Cecilia Woloch, James Cushing, and Phoebe MacAdams named Cahuenga Press. New magazines did sprout up: Rob Cohen's *Caffeine* adopted Beyond Baroque's strategy from the 1970s and distributed its post-punk pages free throughout Los Angeles. Leland Hickman began a ten-issue run of *Temblor,* a magazine crafted by a master typesetter whose years of editorial labor provided a major forum for the maverick experimental poets featured in Ron Silliman's *In the American Tree.*[50] Jim Krusoe coaxed Santa Monica Community College into starting a literary magazine called *Santa*

Monica Review, which quickly established itself as one of the best blends of fiction and poetry in the country. In the late 1980s, Suzanne Lummis began an enduring and very successful annual series of readings, The Los Angeles Poetry Festival; and with Charles Webb, she edited an anthology, *Stand Up Poetry,* which formally presented this school of poetry in several editions.[51]

At any number of points in the past ten years, Beyond Baroque has been on the verge of drastically reducing its programming or of closing its doors altogether, but somehow the organization has managed to endure. During the past four years, in fact, under the gritty leadership of Fred Dewey, Beyond Baroque has begun to achieve a renewed sense of its poetic legacy through a combination of extremely inclusive programming and the resurrection of its publishing activities. Once again, poets were the ones who contributed immensely to the groundswell of survival and subversive fruition, with Brooks Roddan and Jack Skelley both providing major assistance.

Throughout all this turmoil, however, the Wednesday night workshop continued to provide younger poets with a means of establishing themselves, and in 1993 a Thursday night poetry workshop was added. One of the major voices to emerge from the workshop in the early 1980s had been Michelle T. Clinton, who went from workshop participant to workshop leader to anthology editor.[52] Beyond Baroque was hardly the only show in town by now; the second half of the eighties was distinguished by the emergence of poets from minority communities in Los Angeles, some of whom appeared on compilations of spoken word recordings produced by Harvey Kubernik. Kamau Daáood, one of the original members of the Watts Writers Workshop, was now perceived as an elder statesman.

The Passionate Improvisation of "Decisive Blows"

The transformation of a local publishing project into one of the nation's major alternative literary centers involved an extraordinary amount of commitment on the part of the discrete communities that nurtured its maturation. This history demonstrates that the layers of a literary community involve a diversity of poetics and material practice that often threaten the sense of shared values and hopes. In particular, Beyond Baroque at the midpoint of its history was a primary site for the social contestations of local identity and national literary ambition that were problematized by the small press movement of the 1960s and 70s. The overwhelming majority of poets in Los Angeles scorned and derided those who yearned for the kind of fame that the world of popular culture proclaimed as its insatiable goal. Nevertheless, being located in the first postmodern city in the United States, a city in which the entertainment industry provides lucrative jobs and generates a seductive ideology of rampant adulation, the contestation over the purpose and focus of Beyond Baroque, and its significance to the community that sustained it in its early years remains inevitable. Beyond Baroque's history and its tangential relationship to popular culture is especially complicated because one cannot easily separate the survival of Beyond Baroque from the support of individual

artists whose work in the film and music industries has achieved popular recognition. The odd twist is that mass culture is perceived as globally significant, yet the poetry produced in the same city from which this mass art comes, and which continues to resist the centrality of those industries, is considered provincial.

The strategies that all of these poets managed to test out during the past half-century have probably reached their limit, but the goal of many of them remains in concord with Holly Prado's advice: "To turn our gold into ordinary ground, the best possible solution."[53] The question of how to distribute the transformed visions and investigations of poets to communities of readers will require a multitude of unfamiliar answers. "These are days when no one should rely on his 'competence.' Strength lies in improvisation," argued Walter Benjamin. "All the decisive blows are struck left-handed."[54] Passionate improvisation is the primary virtue that has enabled poetry to flourish in a city whose critics often completely overlook its abundant resistance, and the poets whose passion refuses to quit improvising have accomplished one irrefutable task: within the backlit history of the cold war, Los Angeles now has a literature belonging to more than isolated detective heroes or to German exiles, and the prolific communities of poets during this period will provide aspiring writers with a way to measure their own struggles with an increasingly unstable city. The poets to come in Los Angeles will most likely continue to arrive from unexpected places with nothing to assure them of their legitimacy other than their own audacity; but they will at least have the advantage of an impetuous tradition of vibrantly deceptive marginality in Los Angeles.

Notes

Author's Note: I was a member of the Board of Directors of Beyond Baroque in its most recent period of operations, but the initial drafts of this paper and the arguments it makes were formed and articulated before I accepted the position.

1. They include Ron Silliman, Lyn Hejinian, Charles Bernstein, and Bruce Andrews. See Steve Clay and Rodney Phillips, *A Secret Location on the Lower East Side: Adventures in Writing, 1960–1980* (New York: New York Public Library and Granary Books, 1998).

2. Michael Davidson, *The San Francisco Renaissance: Poetics and Community at Mid-Century* (Cambridge, U.K.: Cambridge University Press, 1989), 16.

3. Max Horkheimer and Theodor W. Adorno, *Dialectic of Enlightenment* (New York: Continuum, 1998), 121.

4. Ibid.

5. Christopher Beach, *Poetic Culture: Contemporary American Poetry between Community and Institution* (Evanston, Ill.: Northwestern University Press, 1999), 5.

6. Ibid., 6.

7. Ibid., 5–6.

8. Anthony P. Cohen, *The Symbolic Construction of Community* (Sussex, U.K.: Ellis Horwood; and London: Tavistock, 1985), 12.

9. Ibid., 12.

10. Ibid., 15.

11. Cary Nelson, *Repression and Recovery: Modern American Poetry and the Politics of Cultural Memory 1910–1945* (Madison: University of Wisconsin, 1989), 246.

12. Alan Golding, *From Outlaw to Classic: Canons in American Poetry* (Madison: University of Wisconsin, 1995); Jed Rasula, *The American Poetry Wax Museum* (Urbana, Ill.: National Council of Teachers of English, 1996).

13. Beach, *Poetic Culture*, 36.

14. Donald Allen, *The New American Poetry* (New York: Grove Press, 1960).

15. On Perkoff, see John Arthur Maynard, *Venice West* (New Brunswick, N.J.: Rutgers University Press, 1995).

16. George Drury Smith, unpublished personal chronology.

17. Ibid.

18. Ibid.

19. George Drury Smith, *The Newsletter*, no. 2, March/April 1969.

20. Steven M. Miller, "About the Venice Poetry Workshop," in *Echo 681*, ed. Jessica Pompeii, Holiday Mason, and Sarah Maclay (Venice: Beyond Baroque Books, 1998), 136–38.

21. James Cushing, "Beyond Baroque's Poetic License Expired," *Los Angeles Reader*, 12 March 1985, 8.

22. Interview with Lynn Shoemaker, 23 May 1999.

23. Lynn Shoemaker, *Venice 13* (Venice, Calif., 1971). This anthology also included work by Luis Campos.

24. Interview with Harry Northup, 8 June 1999.

25. Poem reprinted by permission of Mandeville Special Collections Library, U.C.S.D.

26. George Plimpton and Peter Ardery, *The American Literary Anthology / 2: The Second Annual Collection of the Best from the Literary Magazines* (New York: Random House, 1969), 132–35.

27. Beyond Baroque *NewLetters*, vol. 2, no. 4, winter 1972/73, 3. The necessity of printing directions to Beyond Baroque with an explicit warning ("It is advised that you follow these directions exactly unless you already know where we are") illustrates the relative unfamiliarity of Venice to most people in Los Angeles at that time. The struggle to build an audience for a reading series was in part a project in geographical education.

28. Cushing, "Beyond Baroque's Poetic License Expired."

29. *NewLetters*, vol. 2, no. 4, p. 5.

30. Smith, unpublished chronology.

31. Anne Waldman, ed., *Out of This World: An Anthology of the St. Mark's Poetry Project (1966–1991)* (New York: Crown, 1991), 3–4.

32. Cushing, "Beyond Baroque's Poetic License Expired."

33. James Krusoe, *Notes on Suicide* (Santa Monica, Calif.: Momentum Press, 1976).

34. Smith, unpublished chronology.

35. Although many literary organizations develop a reputation for concentrating on their own constituency, the startling thing about the six writers chosen for these volumes in a free, open competition was that none of them was closely associated with Beyond Baroque. These poets included Eloise Klein Healy, Maxine Chernoff, and Watts Writers Workshop member K. Curtis Lyle.

36. Jack Grapes, interviewed by Bill Mohr, 23 February 1999.

37. Robert Kirsch, book review of *The Streets Inside: Ten Los Angeles Poets*, edited by Bill Mohr (Santa Monica: Momentum Press, 1978), in *Los Angeles Times*, 27 April 1979. The ten poets included Leland Hickman (1934–1991), Jim Krusoe, Holly Prado, Deena Metzger, Peter Levitt, Kate Braverman, Eloise Klein Healy, Harry Northup, and Dennis Ellman. I failed to write

an introduction that might have provided some context for my choices, but although I admired much of the work done by Bukowski and the younger poets such as Ron Koertge and Gerald Locklin associated with him, I was determined to show that poets who focused on the lyrical long line and had a substantial interest in the prose poem were at work in Los Angeles.

38. Robert Kirsch's son did provide one of the few exceptions to this observation. Ten years after his father had praised *The Streets Inside,* Jonathan Kirsch wrote a very commendatory review of *Temblor* magazine, which was edited by Leland Hickman, the lead-off poet in *The Streets Inside.*

39. The Southern California Poets-in-the-Schools program began to flourish around 1974 under the direction of Holly Prado. By 1978 the program was providing some means of artistic employment for more than a dozen poets in Southern California, including nascent performance artist and eventual Beyond Baroque Wednesday night workshop director Bob Flanagan.

40. Smith, unpublished chronology.

41. James Krusoe, interviewed by Bill Mohr, 2 January 2000.

42. *Net Weight: An Anthology of Poems from the Venice Poetry Workshop,* 1981. No editor or publisher is listed, though workshop participants Joe Safdie and Israel Halpern are credited with typesetting the book at NewComp Graphics. The book was published "with the assistance of Beyond Baroque Foundation" (24).

43. Dennis Cooper, "The New Factionalism," *Poetry News,* no. 5, February 1981.

44. Charles Bukowski, Neeli Cheri, and Paul Vangelisti. *Anthology of L.A. Poets* (Los Angeles: Laugh Literary/Red Hill, 1971). Bukowski also wrote a several-page introduction to the collection, which I have heard quoted at many informal talks over the course of the years.

45. David James, "Poetry/Punk/Production: Some Postmodern Writing in L.A.," in *Power Misses: Essays Across (Un)popular Culture* (London: Verso, 1996), 191.

46. Paul Hoover, *The Postmodern Poets* (New York: Norton, 1994), 602. "He [Cooper] also helped establish a lively Los Angeles poetry scene in the early 1980s through his coordination of the reading series at Beyond Baroque in Venice, California." On the contrary, the reason poets as varied as Leslie Scalapino, Ted Greenwald, and Patricia Hampl could read in the Los Angeles of the late 1970s was the incredibly lively scene created by the hard work of Krusoe, Vangelisti, Hickman, Harris, Hansen, and many others.

47. James, "Poetry/Punk/Production," 195.

48. Eloise Klein Healy, "El Playon de Chanmico," from *Poetry Loves Poetry,* ed. Bill Mohr (Santa Monica, Calif.: Momentum Press, 1985), unpaginated book, poem #236. Reprinted by permission of Eloise Klein Healy.

49. Cushing, "Beyond Baroque's License Expired."

50. Ron Silliman, *In The American Tree* (Orono, Maine: National Poetry Foundation/University of Maine Press, 1986).

51. Charles Harper Webb, *Stand Up Poetry* (Iowa City: University of Iowa Press, 2002).

52. Michelle T. Clinton, Sesshu Foster, Naomi Quinonez, eds., *Invocation: L.A. Urban Multicultural Poetry* (Albuquerque, N.M.: West End Press, 1989).

53. Holly Prado, *Feasts* (Santa Monica, Calif.: Momentum Press, 1976).

54. Walter Benjamin, *Reflections,* ed. Peter Demetz, trans. Edmund Jephcott (New York: Schocken Books, 1978), 65.

Laura Meyer

3 The Los Angeles Woman's Building and the Feminist Art Community, 1973–1991

Los Angeles, more than any other city, played a defining role in the evolution of the feminist art movement in the 1970s. Flowering out of the liberation and protest movements of the 1960s—anti-war protests, civil rights and Black Power, and women's liberation—the women artists' movement comprised a diverse coalition of artists, educators, and critics who sought to redefine the relationship between art and society. Feminist artists viewed art as both a social process and a symbolic framework that could be used to confront broadly political and deeply personal issues. Many pursued an activist agenda, intervening in public spaces and institutions to address issues of social justice and democracy. Feminist artists also analyzed the relationship between public representations of gender and self-image, critiquing the dominant culture's representations of women and re-imagining the possibilities of female identity through art.

Although New York has remained the largest center of mainstream art commerce and exhibition since the end of the Second World War, Los Angeles—in part because of its lack of an entrenched art-world infrastructure—offered women artists in the 1970s greater freedom to invent new models for artistic production and reception. Los Angeles witnessed the growth of a thriving cluster of galleries and museums in the late 1950s and 60s and attracted the attention of the international art establishment with the emergence of so-called "finish fetish" art or "the L.A. look"—polished, shimmering objects fashioned from new industrial plastics and paint finishes developed for the defense and aerospace industries during World War II and the Korean War.

By the late 1960s, a vibrant, if young, art scene had joined Hollywood's film studios, the television industry, and the popular music industry in making Los Angeles the capital of what the Situationists called "the Spectacle." The popular media and the developing art establishment in Los Angeles both became important targets of feminist intervention. Southern California feminists also worked to develop independent, female-

governed organizations for educating women artists and for producing, displaying, and critiquing women's art.

One of the principle philosophical underpinnings of the feminist art movement was the goal of creating a mutually supportive community of women artists. In opposition to the popular mythology of the lone (usually male) creative genius, the leaders of the feminist art movement contended that broad-based community support was a necessary condition of creative productivity, and they set out to build the kind of support systems—both material and psychological—that women artists historically had lacked.[1] Most of the goals and strategies of feminist artists in the 1970s—including political activism, a collaborative approach to art making, and an emphasis on autobiographical and sexual subject matter—revolved around the central goal of affirming women's personal experiences, desires, and oppression as a valid subject and source of art. Nationally and internationally, women artists established cooperative exhibition spaces, activist organizations, and other networks to provide support and a sense of community to previously isolated colleagues. The Los Angeles Woman's Building (1973–1991) was by far the longest-lived and most influential of these feminist art communities.

Given the range and scope of the activities carried out during the Woman's Building's eighteen years of operation, it would be impossible to provide a comprehensive account of its history and impact in the space of this essay.[2] Rather, I will offer an abbreviated analysis of its genesis and then examine in some detail several projects sponsored there. These include, among others, the televised protest performance *In Mourning and in Rage* (1977), a national exhibition network generated under the aegis of the *Great American Lesbian Art Show* (1980), and a special issue of the Woman's Building newsletter dedicated to the problem of racism in the women's movement (*Spinning Off*, May 1980). The diverse goals and needs of the artists working at the Woman's Building as well as shifting political and economic conditions continually challenged the organization to redefine the meaning and role of a "feminist artists' community."

Communities traditionally have been defined by social scientists as geographically bounded spaces in which groups of people live and interact over the course of a lifetime. The shifting group of feminist artists that orbited the Woman's Building, however, might better be defined as an "imagined community" based on a shared sense of identity and purpose and mediated by shared artistic and textual reference points.[3] Los Angeles is a notoriously diffuse metropolis, its far-flung neighborhoods crisscrossed by freeways and divided by miles of physical distance as well as by ethnic and socioeconomic barriers. From its two locations within the ill-defined "downtown" region of the city (initially on Grandview Avenue near MacArthur Park, and subsequently on North Spring Street at the far end of Chinatown), the Los Angeles Woman's Building represented an effort to construct a community within a perceived void. But the most effective means of accomplishing that goal and the target audience were often a matter of controversy. Building co-founder Sheila de Bretteville visualized the Woman's Building as a beacon for the general public, personified as a "woman on the street" who would reach out and embrace people from around the city.[4] Performance artists Suzanne Lacy and Leslie Labowitz, among others, used the Woman's Building as a base from

which to launch feminist interventions into the city's physical and institutional struc-
tures, including the media. Other Building members maintained a more separatist vision,
wishing to preserve the Building as a safe haven from mainstream society. Theorists of
lesbian social community have emphasized that for lesbians and gay men, in particu-
lar, a community of peers often takes the place of family as the primary support net-
work and source of self-definition.[5] The projects discussed in this essay, viewed as case
studies, help illuminate the varied goals of the Woman's Building's constituents and the
ways in which art making, as a social process and as a symbolic framework, both
betrayed fractures amongst the Building's membership and mediated bonds between
Building members, as well as other women in the wider community.

The Feminist Art Programs at
Fresno State and CalArts

The earliest prototype for the feminist art community that developed at the Woman's
Building was an educational program for young women artists founded at Fresno State
College in 1970. The Fresno Feminist Art Program was the brain-child of Judy Chicago,
whose 1976 autobiography, *Through the Flower*, describes the profound alienation she
felt as a young woman artist in Los Angeles in the 1960s, when nearly all critically and
commercially successful artists were men, and the cool, industrial look of finish fetish
art dominated the Los Angeles gallery scene. After graduating from art school at the
University of California in Los Angeles, Chicago achieved national recognition exhibit-
ing minimalist geometrical sculpture made with industrial materials. In retrospect,
however, Chicago felt that her modest success had been won only at the cost of aban-
doning her real artistic interests and suppressing her sense of gender identity. As she
subsequently analyzed her defensive response to the male-dominated art world:

> In an attempt to compensate for the often uncomprehending responses [of men], the woman
> artist tries to prove that she's as good as a man. She gains attention by creating work that
> is extreme in scale, ambition, or scope. . . . She resists being identified with woman because
> to be female is to be an object of contempt. And the brutal fact is that in the process of
> fighting for her life, she loses herself.[6]

Chicago conceived of the Feminist Art Program as an "antidote" to her education at
UCLA and the recurring bias she confronted as an emerging artist in the sixties.

The program's first project was to remodel an off-campus studio space where Chicago
and her fifteen female students could "evaluate themselves and their experiences with-
out defensiveness and male interference."[7] In direct opposition to the formalist orien-
tation that prevailed at most art schools, Chicago structured her classes around con-
sciousness-raising sessions. She and her students tackled emotionally charged issues,
including ambition, money, relationships with parents and lovers, body-image, and sex-
uality, "going around the room" so that each woman had the opportunity to share her
experiences and feelings. Consciousness-raising was a way of brainstorming ideas for

artwork; it also encouraged the young women students to confront their personal sit-
uations as part of a larger cultural pattern that could be analyzed and changed. Pro-
gram participant Faith Wilding later recalled the process:

> As each woman spoke it became apparent that what had seemed to be purely "personal"
> experiences were actually shared by all the other women: we were discovering a common
> oppression based on our gender, which was defining our roles and identities as women. In
> subsequent group discussions, we analyzed the social and political mechanisms of this
> oppression, thus placing our personal histories into a larger cultural perspective. This was
> a direct application of the slogan of 1970s feminism: The personal is political.[8]

One theme that emerged with disturbing frequency in group discussions was the preva-
lence of violence and sexual exploitation in women's lives. The young artists confronted
and responded to sexual violence in their artwork. In an early student performance
described in Chicago's autobiography, for example, a male character violently extracts
"service" from a female figure with a milking machine and then drenches her body with
the bloody contents of his bucket. Faith Wilding confronted social attitudes about men-
struation in a tableau entitled *Sacrifice,* in which a wax effigy of the artist, heaped with
decaying animal intestines, lay before an altar of bloody feminine hygiene products. One
of the first public performances to address the topic of rape, *Ablutions,* was created by
Chicago, Suzanne Lacy, Sandra Orgel, and Aviva Rahmani in Los Angeles in 1972 in
response to discussions that began at Fresno.

 Chicago and her students used art to foster an empowered sense of sexual identity.
Confronting a cultural tradition in which female sexuality is frequently figured as pas-
sive (in "virtuous" women) or else dangerous and shameful (in sexually assertive
women), program participants invented myriad "cunt" artworks, "vying with each
other to come up with images of the female sexual organs by making paintings, draw-
ings, and constructions of bleeding slits, holes and gashes, boxes, caves, or exquisite
jewel pillows," and thus reclaiming a derogatory sexual epithet as a symbol of pride.[9]
Cay Lang, Vanalyne Greene, Dori Atlantis, and Susan Boud formed a performance
group, the "Cunt Cheerleaders," donning satin cheerleader costumes and chanting
light-hearted and transgressive cheers to women such as the following, which they per-
formed for program guest Ti-Grace Atkinson upon her arrival at the Fresno airport:

> Split beaver, split beaver,
> Lovely gooey cunts.
> Split beaver, split beaver . . .
> We come more than once.
>
> Your cunt is a beauty,
> We know you always knew it,
> So if you feel like pissing,
> Just squat right down and do it!
>
> I hold no pretenses when I pee,
> I kiss the earth and the earth kisses me.[10]

The young artists in the Feminist Art Program also experimented with nontraditional media, including glitter and lace, sewing and crochet-work, costume, performance, and film, thus asserting the validity of so-called feminine "craft" materials and techniques as art. When the program relocated from Fresno to the California Institute of the Arts thirty miles north of Los Angeles in the fall of 1971, the expanded group's first project involved remodeling a dilapidated house near downtown and transforming it into a series of fantasy environments. Called *Womanhouse*, it explored women's traditional roles in the home with a mixture of love, humor, irony, and rage. Installations such as Faith Wilding's crocheted igloo-shaped shelter, nicknamed the "Womb Room," and the lavish sculpted feast laid out in the collaborative "Dining Room" embodied an idealized dream of comfort and intimacy in the home. A more ambivalent vision of domesticity and family relationships surfaced in the "Nurturant Kitchen," created by Susan Fraser, Vicki Hodgetts, Robin Weltsch, and Wanda Westcoast, in which molded foam-rubber fried eggs covered the ceiling and marched down the walls, gradually transmuting into sagging, exhausted breasts. Kathy Huberland's "Bridal Staircase" stood as a stark warning, with a starry-eyed bridal mannequin descending blithely toward a drab gray dead-end.[11]

Womanhouse was the first large-scale feminist art exhibition in the United States, and it inaugurated a new phase in the feminist art movement. The installation was open to the public for a month, from January 30 through February 28, 1972, and attracted some ten thousand visitors. To kick off the exhibition, the newly formed bicoastal women artists' network, West-East Bag (W.E.B.), held its inaugural conference there. The national art press and the popular media also gave *Womanhouse* extensive coverage, ranging from a film documentary broadcast on public television to stories in *ArtNews* and *Time* magazine.[12]

As the Feminist Art Program emerged from its isolation, the concept of feminist art and the notion of a community based on a shared female identity drew passionate responses. Since the 1970s, debate over the significance of so-called "female imagery" and the true meaning of feminist art has divided feminist critics. One strand of criticism, which reached a peak in the 1980s, holds that the emphasis some early feminist artists placed on autobiographical subject matter and so-called feminine media simply reinforces "essentialist" stereotypes. In the words of art historian Griselda Pollock: "So long as we discuss women, the family, crafts or whatever else we have done as feminists we endorse the social givenness of woman, the family, the separate sphere."[13] Critics also increasingly voiced skepticism that women with different socioeconomic backgrounds, racial and ethnic identifications, and sexual orientations could be reasonably lumped together into an identity-based community, and whether it was productive to try do so. Yet it is not accurate to dismiss the feminist artwork of the 1970s as simplistically "essentialist." The use of alternative media, autobiography, and performance allowed women artists in the 1970s to broach previously unspeakable topics, and their pioneering activism laid important groundwork for the critical strategies (and debates) of subsequent feminist theorists and artists as well as other political art and identity-based art movements.

A Woman in Public: The Feminist Studio Workshop
and the Grandview Building

The success of *Womanhouse* and a rising groundswell of feminist art activism in Los Angeles in the early 1970s contributed to a perceived need for a more permanent institutional presence for women artists in Los Angeles. Chicago soon grew disillusioned with the situation at CalArts after the Feminist Art Program resumed its activities on campus and was forced to submit to the administrative supervision of its host institution. She and two other CalArts faculty members, art historian Arlene Raven and designer Sheila de Bretteville, began laying plans for an independent women's art school, the Feminist Studio Workshop. Initially they held informal classes in de Bretteville's living room. By late 1973, however, they had a large enough student base to lease a two-story downtown building from the former Chouinard Art Institute, sharing rent and managerial responsibilities with Womanspace, a new cooperative gallery for women artists, and several other feminist organizations and businesses, including the Los Angeles chapter of the National Organization of Women, the Associated Feminist Press, a branch of Sisterhood Bookstore, and women-operated galleries and performance venues. In addition to Chicago, de Bretteville, and Raven, several other instructors joined the Feminist Art Program staff, including performance artist Suzanne Lacy (who had trained with Chicago and de Bretteville at Fresno and CalArts and who also counted CalArts faculty member Alan Kaprow as an important influence), graphic designer Helen Alm Roth, art historian Ruth Iskin, and writer Deena Metzger.

The Woman's Building opened on November 28, 1973, at 743 South Grandview Avenue, two blocks from MacArthur Park, a heavily used downtown recreation area. Restaurants and small stores, many of them operated by Guatemalan and other Central American immigrants, encircle the park, while the surrounding streets combine apartment buildings and houses with other local businesses. The mostly Spanish-speaking locals were not especially likely to visit the Woman's Building, but the park and surrounding restaurants attracted a mixed group of Angelenos from other parts of the city. The neighborhood was also familiar to artists and art students, with the Otis Art Institute situated on the far side of the park, in addition to the historical link with Chouinard. Inaugural festivities were attended by an estimated five thousand people, many of them artists and former Chouinard staff and students.[14]

A poster advertising the opening of the Woman's Building pictured a throng of spirited young women flocking to the Building entrance, embodying the founders' hope that the organization would function as the hub of a vital women's community.[15] When the Feminist Studio Workshop inaugurated its full-time degree program at the Building, professors intentionally avoided the hierarchical structure of traditional educational institutions, instead modeling classes on the consciousness-raising format (see Illustration 3.1). Former student Cheri Gaulke remembers that everyone, including the teacher, sat in a circle, which struck her as "the ultimate symbol of the Woman's Building, of feminist process, that kind of equality."[16]

ILLUSTRATION 3.1. Feminist Studio Workshop, first day group meeting, Fall 1974. Photograph from the Woman's Building Slide Collection and Digital Image Archives, Otis College of Art and Design Library, Los Angeles, Calif.

Students were encouraged to pool their skills and resources with women from other classes so that writers, painters, and printers might work together on the same project. Some of the initial class assignments involved repairing and remodeling the building itself, a tradition that Chicago had begun in the Feminist Art Program at Fresno State and continued at *Womanhouse*. The group effort of constructing their own studio spaces, the collaborative art-making process, and the pleasures and anxieties of learning about one another in consciousness-raising sessions all helped foster a cohesive and intimate sense of community. As Gaulke explains, "Your personal life was the subject [of your art], or was a part of [it]. . . . You weren't just there to develop your creativity, your intellect, but also your emotional self."[17]

Woman's Building co-founder Sheila de Bretteville played an especially important role in defining its public role during this period, promoting the ideal that feminist art should intervene in the physical and social spaces of the community to create a more egalitarian and inclusive society. De Bretteville explained that she "saw the Building as Woman in public. It's almost as if the Building was a living creature in my mind as a woman on the street. And she was going to be . . . honored . . . and she would [bring] the feminine with her into the public realm."[18] Seeking to promote social equality through her artwork, De Bretteville developed design formats that, in her words, would invite the "participation of the broadest possible audience without the privileging of power."[19]

ILLUSTRATION 3.2. Sheila de Bretteville hanging up her *Pink* poster in the streets, 1975. Photograph from the Woman's Building Slide Collection and Digital Image Archives, Otis College of Art and Design Library, Los Angeles, Calif.

De Bretteville's mixed-media design, *Pink* (1974), for example, produced for an exhibition at the Whitney Museum in which participants were asked to "say something about color," incorporates handwritten comments, photographs, and mementos offered by two dozen women of various ages and backgrounds. Invited by de Bretteville to consider "what pink meant to them and their vision of women," contributors offered poignant responses: "Scratch pink and it bleeds." "Pink is childish. I'm not pink now." "The color of pink is used mostly in saying: I Luv You!!!!" "Bazooka bubble gum that makes your throat sore when you first chew it because it's so sickeningly sweet." "The soft inside pink flesh vulnerable." "I hated pink."[20] Using a grid format with thirty-six squares, de Bretteville allotted an equal amount of space to each respondent, purposely leaving several squares empty to encourage museum-goers to add their own thoughts. She also hung a poster version of the project in various neighborhoods around Los Angeles, inviting passersby to contribute their responses (Illustration 3.2). De Bretteville implemented a similar nonhierarchical format for her design of the literary review published by the Woman's Building, *Chrysalis, A Journal of Women's Culture*. Each contributor to the journal had a two-page spread, with open spaces for readers to contribute their responses or additions to the material published.

In the Feminist Studio Workshop, de Bretteville encouraged her students to address the connections between the physical and emotional spaces of the city. For one assign-

ment, students made maps of Los Angeles and indicated the locations where they felt good or bad, where they felt threatened or supported. Next, they made posters showing how they would make a place in the city different. One student persuaded the RTD bus line to display her posters on buses traversing the city.

In her administrative capacity at the Building, de Bretteville facilitated various forms of exchange between Feminist Studio Workshop students, other Woman's Building users, and a broad community of women in Los Angeles and nationwide. Among her first priorities was the acquisition of a printing press for the Feminist Studio Workshop so that students and other Building participants could self-publish. She also helped initiate a program of continuing education classes, thus allowing area women to take classes or to teach them without being full-time students or faculty. In the spring of 1974, she conceived a series of conferences that brought together participants from across the nation. The first of these conferences, "Women in Design" (March 20–21), featured nationally known architects, designers, teachers, and editors whom de Bretteville invited to open a national dialogue on feminist strategies among women who "work in public, visual and physical forms." Writers Deena Metzger, Holly Prado, and Deborah Rosenfeld organized a conference for women writers, "Women and Words" (March 22–23), which brought together luminaries including Kate Millett, Jill Johnston, Meridell LeSueur, and Carolyn See and resulted in an ongoing national writers series funded by a grant from the National Endowment for the Arts. The Performance Conference (March 24–27), organized by Suzanne Lacy, Ellen Ledley, Candace Compton, Roxanne Hanna, Signe Dowse, and Nancy Buchanan, featured workshops and performances by both emerging and nationally known artists, including Joan Jonas, Pauline Oliveras, Barbara Smith, and Bonnie Sherk, among many others, and established the Woman's Building as an international center of women's performance art. Attended by hundreds of people, these events raised the Woman's Building's public profile and helped establish professional and personal networks that persisted long after the conferences ended.[21]

Suzanne Lacy, a conceptual performance artist and Feminist Studio Workshop instructor, expanded de Bretteville's model of audience collaboration to create large-scale "performance structures" designed to intervene in the physical and institutional spaces of the city. Lacy has also cited Alan Kaprow, who taught at CalArts in the 1970s, as a significant intellectual forebear for his idea that "everyday" actions and "happenings" could be art.[22] While she was at the Woman's Building, Lacy collaborated with Leslie Labowitz to found Ariadne, a Social Art Network, bringing together a broad affiliation of women in the arts, media, government, and the feminist community to create major collaborative artworks addressing specific social issues. For example, in *Three Weeks in May*, denoting the three-week period in 1977 during which the event unfolded, Lacy persuaded the Los Angeles Police Department to release statistics on the occurrence of reported rapes, a subject that was generally kept secret from the public. The visual centerpiece of the project was a pair of 25-foot maps of Los Angeles mounted in the busy City Hall shopping mall. The first map recorded daily rape reports; for each rape designated in red, Lacy added nine fainter pink "echoes" representing the estimated nine in ten rapes that go unreported. The second map listed

resources, including telephone hotlines, hospital emergency rooms, and counseling centers, that offered services for women who had been raped. Lacy enlisted the participation of the city police, the news media, local politicians, and other artists, staging more than thirty events over the course of the project, including a press conference, self-defense workshops, a rape "speakout," and a series of art exhibitions and performances.[23]

Lacy next collaborated with Labowitz to create *In Mourning and In Rage* in December of 1977. Troubled by the sensationalized news coverage of a series of brutal rape-murders by the so-called Hillside Strangler, Labowitz and Lacy staged a performance protesting the murders and the media's sensationalist practices, while simultaneously exploiting the public information system to broadcast the event on television and in the newspaper (Illustration 3.3). The performance began at the steps of City Hall with the arrival of a hearse and accompanying motorcade. Nine monumental mourning figures, draped in black from head to toe, one for each murdered woman, emerged to confront the audience. By obscuring the performers' faces, paradoxically, the artists symbolically restored a sense of dignity to the murdered women. While the press had published photographs and titillating details about the personal lives of the victims, several of whom were prostitutes, their draped surrogates, in their very sameness and iconic generality, highlighted the women's shared humanity. Staged as a media event for politicians and reporters, the performance was designed, as Lacy has recounted, "as a series of thirty-second shots that, when strung together in a two-to-four-minute news clip, would tell the story we wanted told."[24] The performance led to several public policy changes, including city sponsorship of free self-defense training for women and the publication of rape hotline numbers by the telephone company.

Performance art, as it was developed by Lacy and many others at the Woman's Building, became a powerful tool for activism, for confronting stereotypes and effecting symbolic self-transformations, and, perhaps most importantly, for establishing a sense of community among women. Performance groups based at the Building took their work into a variety of public venues around the city. Calling themselves "The Waitresses," for example, Jerri Allyn, Leslie Belt, Anne Gauldin, Patti Nicklaus, Jamie Wildman-Webber, and Denise Yarfitz staged guerilla events in restaurants and other public spaces, employing satire to dramatize and critique women's traditional service roles. One of their featured characters was the Waitress Goddess Diana, who wore a soft-sculpture costume with a dozen cascading breasts. Another character, Wonder Waitress, came to the aid of harried restaurant workers, confronting impatient customers and intervening with nasty employers.

Feminist Studio Workshop graduates Nancy Angelo, Candace Compton (later replaced by Vanalyne Greene), Cheri Gaulke, and Laurel Klick founded the Feminist Art Workers performance group in 1976 and embarked on a cross-country road trip the following year as self-styled missionaries of feminist education. Their performances in community centers, universities, and coffee houses, usually conducted in exchange for food or on the basis of "sliding-scale" audience contributions, highlighted the group's infectious sense of camaraderie.[25] These and other activist performance groups

ILLUSTRATION 3.3. Susan Lacy and Leslie Labowitz, *In Mourning and Rage,* 1975. Photograph from the Woman's Building Slide Collection and Digital Image Archive, Otis College of Art and Design Library, Los Angeles, Calif.

founded in the 1970s were the precursors of contemporary activist groups such as the Guerilla Girls and the Women's Action Coalition (WAC).

The reinvention of performance art as a political statement and as a tool for community building was one of the most important legacies of the Los Angeles Woman's Building. Steven Durland, former editor of *High Performance* magazine, considers the performance work done by Chicago, Lacy, Labowitz, and others at the Woman's Building the best artwork produced during the 1970s and credits it with giving new life to the performance idiom:

> Not only did they take the form and politicize it, but they [oriented it toward] autobiography. Now that's used by artists from cultures outside the mainstream for self- and group-affirmation. It's a way of letting people know that they aren't alone. . . . In performance art, most of what had come before was formal experimentation. Had feminist art not come along, the form would probably have died a natural death.[26]

The feminist performance art of the 1970s gave rise to many of the strategies developed more broadly by artists in the 1980s, including autobiography, political activism, the transformation of self through multiple personae, and the appropriation and critique of mainstream culture.[27]

A Building of One's Own:
Separatism and the Spring Street Building

De Bretteville's vision of the Woman's Building as a "woman in the street," as com-
pelling as it was, did not meet the needs of some of the women who came to the Build-
ing in search of community. Many young women who enrolled in the Feminist Studio
Workshop or attended other events at the Building yearned to create a safe, support-
ive "family." They preferred to distance themselves from the larger community, having
experienced their families of origin, their schools, workplaces, or neighborhoods as hos-
tile environments. De Bretteville recalls making the startling realization that her vision
was completely at odds with what many of her students wanted: "I had all these notions
about what the Woman's Building was, which in many ways was about women in pub-
lic. And then when I got there and created it and was with these women, I saw that
what they wanted was a private place. . . . the women came for a home."[28]

The split between those who envisioned the Woman's Building as a beacon for the
public and those who saw it as a safe haven came to a head in 1975, when Chouinard
decided to sell the Grandview Building and the organization was forced to relocate. De
Bretteville hoped to find another downtown location that would be spacious enough
to accommodate a broad range of activities. Other women lobbied for a smaller space
in a more remote location near the beach or in the country. Chicago located a second-
story space in Pasadena, a small city at the northeast edge of Los Angeles, to which the
group gave serious consideration. Ultimately, however, de Bretteville held out for a
large building in downtown Los Angeles, and in the summer of 1975 the Feminist Stu-
dio Workshop and other Building tenants moved to 1727 North Spring Street (Illus-
tration 3.4).[29]

Paradoxically, the ambitious decision to lease the largest and most centrally located
building possible for the Woman's Building probably contributed over the long run to
the organization's increasing isolation. The only large downtown building the organi-
zation could afford was located in an industrial district that lacked the lively neigh-
borhood atmosphere of the original Grandview location even though it was just a few
miles away. Next to the railroad tracks and the nearly dry Los Angeles River, the
Woman's Building now shared quarters with windowless warehouses and a few scat-
tered manufacturing plants. Many of the non-art tenants were forced to leave for want
of foot traffic. The Feminist Studio Workshop and its extension program persisted as
the key groups in the Woman's Building. Members also ran a gallery program, an
Annual Women Writers Series, the Women's Graphic Center, and the Los Angeles
Women's Video Center. At various times during its years on Spring Street, the Woman's
Building housed a bookstore, a thrift store, a café, and the offices of *Chrysalis* and
Women Against Violence Against Women.[30] Nevertheless, the Building held a less vis-
ible position in the non-feminist, non-art Los Angeles community than it had at the
Grandview Building.

The wish to create a safe, supportive haven at the Woman's Building also sometimes
outweighed the desire to take an activist role in public during this period. For lesbian

ILLUSTRATION 3.4. Outside the front door, Spring Street Building, 1975. Photo-
graph from the Woman's Building Slide Collection and Digital Image Archive,
Otis College of Art and Design Library, Los Angeles, Calif.

women in particular, the notion of community often meant something different than it
did to heterosexual women. Straight women more often tended to move in and out of
the Woman's Building community, devoting time to their families, boyfriends, and other
community involvements during their time away from school or work at the Building.
For many lesbian members, on the other hand, the Building provided an all-encom-
passing social network. Cheri Gaulke, who entered the Feminist Studio Workshop as
a self-identified heterosexual and came out as a lesbian three years later, remembers that
"the community of women around the Woman's Building . . . became my spiritual com-
munity, my emotional community, my political community. It became everything to
me."[31] Terry Wolverton, another graduate of the Feminist Studio Workshop, who later
served as an administrator at the Building, concurs that "the need for reflection and
support was a hugely motivating factor [and] often involved leaving behind old bonds.
. . . Heterosexual women had more expectation of crossing back and forth over those
borders. For lesbians there was less desire or possibility of slipping back and forth."[32]
To identify with the lesbian community at the Woman's Building often meant risking
the disapproval or outright rejection of one's family and previous social circle.

 The Feminist Art Programs at Fresno State and CalArts and the Feminist Studio Work-
shop had always included many lesbian participants, but lesbian issues did not develop

into a central focus of discussion at the Woman's Building until the late 1970s. In 1977, Building co-founder Arlene Raven, who also co-directed the Center for Art Historical Studies with Ruth Iskin, invited artists who thought their artwork might contain lesbian content to a series of discussions that resulted in the formation of the Natalie Barney Collective.[33] The collective undertook the Lesbian Art Project in order to "discover, explore, [and] create lesbian culture, art, and sensibility; make visible the contributions of lesbians to feminist human culture; [and] create a context for that work to be understood."[34] Events sponsored by the Lesbian Art Project included consciousness-raising groups, a "gay-straight dialogue" at the Woman's Building, gallery exhibitions of artwork by lesbians, a video-taped dialogue among lesbian artists, open houses, salons, performances, and a series of social events, including a lesbian fashion show and several all-women dances.[35]

After the Natalie Barney Collective disbanded, several new projects focused on lesbian identity and issues emerged. The Lesbian Creators Series, initiated by Raven, brought lesbian artists to speak at the Woman's Building. Terry Wolverton organized a long-term performance project titled *An Oral Herstory of Lesbianism*. The *Oral Herstory* project began as a series of discussion sessions structured around consciousness-raising and journal writing. It culminated in a performance featuring more than a dozen vignettes addressing the tremendous diversity of lesbian experience as well as the shared struggles faced by lesbian women (Illustration 3.5).

FEMINA: An IntraSpace Voyage, another performance that grew out of the Lesbian Art Project, sheds particular light on the sense of vertigo many women felt on claiming a place in the lesbian community at the Woman's Building, a decision that often meant leaving behind old ties, perhaps forever. Based on a science fiction story by Terry Wolverton, FEMINA incorporated dance, song, and personal stories shared by each performer to dramatize the departure and journey of a group of women who determine to leave earth for a distant, unexplored destination called "Femina." Life as they know it has become physically and emotionally untenable; the voyagers are haunted by visions of apocalyptic wars and earthquakes, manifesting "the voice of destruction [that] shrieks like some terrible monster at the way we choose to love . . . our art . . . our voices, our bodies."[36] Despite the suffering they have endured on earth, however, it is painful and frightening to turn away from the past. Mustering their courage for the journey, the women ritualistically "bid goodbye to everything and everyone they have ever known," even "the selves they have been on earth."[37] Lingering over the things they will miss most, one performer poignantly laments the loss of "the touch of [her] mother's hand . . . the sound of rain . . . the laughter of children."[38]

Wolverton explained in a press release that *Femina* was "not about build[ing] an enormous piece of hardware and blast[ing] off," in contrast to the popular futuristic Hollywood films of the day such as *2001, Star Wars*, or *Close Encounters of the Third Kind*. Instead, by "working on *Femina*, [the performers] learned that the Universe is not separate from our selves, our own bodies."[39] The symbolic journey to Femina functioned as a metaphor for the performers' collective undertaking to construct a new community and a new sense of identity.

ILLUSTRATION 3.5.
Sue Maberry and Chutney
Gunderson performing
"High School Crush,"
from *An Oral History of
Lesbianism,* directed by
Terry Wolverton, 1979.
Photograph from the
Woman's Building Slide
Collection and Digital
Image Archive, Otis Col-
lege of Art and Design
Library, Los Angeles,
Calif.

During the development of the performance, Wolverton encouraged the participants to suspend disbelief and to embrace their imminent departure, as far as possible, as a physical and psychological reality. The force of their collective fantasy shook some *Femina* participants so profoundly that they actually decided to leave the project, too frightened to continue. One woman wrote an apology to Wolverton, "I know no other way to explain it except that I am scared. I am on such shaky ground here in L.A. and I cannot disrupt the existence I've created for myself so far."[40] Another tearfully informed Wolverton that she had to finish school and therefore couldn't leave earth for Femina.

Although these emotionally extreme responses may seem irrational from our present perspective, they provide insight into the life-altering impact the Woman's Building community had for many women. Cheri Gaulke remembers feeling a similar sense of instability, even fear, during her earliest months there. For her performance in *An Oral Herstory of Lesbianism,* Gaulke recounted the story of her first visit to the Building in

the summer of 1977. At that time, she still identified herself as a heterosexual. She had cut her hair very short, she explained, as

> part of my sort of radical identity. And I remember I walked into the Woman's Building and there were all these women with . . . very, very short hair, like shaved heads like me. . . . And I freaked out because . . . I recognized something that was very scary, that I'd sort of been flirting with but hadn't realized in a conscious way. So I immediately went back to Minneapolis, grew my hair, died it red, you know, took back the feminine persona again."[41]

Despite her apprehension, Gaulke enrolled in the Feminist Studio Workshop in the fall. Her fears resurfaced on the first day of classes:

> I remember the very first . . . thing we did when we got in this big room of about 50 women in a circle, you were supposed to turn to the woman next to you and share some story, or something that happened to you before you came. And I remember thinking that the woman next to me was insane. I was absolutely terrified and I thought she was, like, an ax murderer. . . . I still know her and she—I think she's a nice person now. But there was something about this new environment that just was—There was an unleashing of self that was just absolutely terrifying.[42]

By fostering a sense of community among women artists, feminists, and lesbians, the Woman's Building lent women the strength to develop aspects of their identity that were condemned or denied by mainstream society.

Seeking to assert a positive image of lesbian identity and to increase the public visibility of lesbian artists, in 1980 the Woman's Building sponsored a series of exhibitions in collaboration with the Gay and Lesbian Community Services Center under the umbrella title The Great American Lesbian Art Show (GALAS).[43] The series had a tripartite structure, including an invitational exhibition in Los Angeles honoring ten acclaimed lesbian artists, a national network that facilitated local lesbian art shows in cities across the nation, and a slide registry to document the artwork exhibited in the national GALAS network.[44] In addition to the invitational exhibition, events in Los Angeles included eight regional shows; a number of performances, film screenings, and poetry readings; and a lesbian graphics show. The whole project was oriented toward helping lesbians, and especially lesbian artists, forge a sense of connection within a large creative community.

Although a few writers had assayed a theoretical approach to the issue, there was no clear consensus about what "lesbian art" might look like.[45] The work included in the invitational exhibition ranged from minimalist abstraction to explicit photographs of women's genitals and women making love. (The representations of female genitalia drew the most criticism from the mainstream press.)[46] Yet the artists concurred that the art-making process played a crucial role in establishing a sense of personal and sexual identity. Harmony Hammond described the connection between her artwork and her inner life in a catalog statement about her wrapped ovoid sculptures:

> To make art that has meaning, it is essential to make art that is honest. . . . It is essential that I do not cut off any part of myself. . . . I came out through my art and the feminist move-

ment. That is, the work gave form to my lesbian feelings as it gives form to all my feelings and ideas.[47]

The Great American Lesbian Art Show offered one of the first visible demonstrations of widespread support and solidarity amongst lesbians, and especially lesbian artists, in an otherwise largely hostile society. There were many risks involved in staging the exhibition for artist-participants and viewers alike.[48] A poignant statement in the GALAS Guidebook, "We Are Everywhere," reminded readers:

> It is vital to remember that for each one of us present, there are hundreds of lesbians who have not identified themselves, or who have chosen not to live publicly as lesbians. Their reasons may be rooted in fear of personal or social consequences, or perhaps even ignorance of the options that exist for a lesbian lifestyle. It is our hope that the word of the GALAS project will reach these women, that their lives will be touched by the proud affirmations expressed in lesbian creative work.[49]

At the Horizon of Identity Politics: Feminist Identities, Feminist Communities

The Woman's Building faced many new challenges during its second decade. Feminist theory and activism in the 1980s increasingly emphasized the differences among women, especially in regard to issues of race, class, and sexual orientation. Although administrators at the Woman's Building worked to implement programming aimed at a diverse group of women, the organization faced criticism for failing to address the concerns of some women in the community, especially women of color. Indeed, the very notion of a community based on a supposedly common female identity came into question during this period.[50] Additionally, the destabilizing effects of criticism from the political left was compounded by blows from the political right. Under the administration of President Reagan, who took office in 1980, federal funding for the arts was cut drastically and the Woman's Building lost an important source of financial revenue. Shifting political and economic trends also had a devastating effect on the Feminist Studio Workshop, which ceased full-time operations in 1981 due to falling enrollments. Terry Wolverton assessed the mood in the 1980s: "Suddenly, if women were going back to school, they were going into MBA programs, not into experimental feminist art programs. In the seventies, there was a certain ease in choosing a marginalized stance. In the eighties, there was the feeling that you wouldn't survive."[51]

By 1981, the three co-founders of the Woman's Building had ceased full-time involvement with the Building and a second generation of leaders—including Wolverton, Gaulke, and Sue Maberry, all of whom had studied with the original core faculty in the Feminist Studio Workshop—took over the task of professionalizing the Woman's Building to meet the challenge of survival in the 1980s. Maberry devised a strategy to develop a profitable typesetting and design business at the Women's Graphic Center, making use of the last part of a substantial government grant to purchase type and a letterpress.

After completing a professional fundraising training program, Terry Wolverton took on the task of extending the Building's base of support to include corporations and professional women, some of whom might previously have felt alienated by the Building's radical image.

Many of the most dedicated members who worked to keep the Woman's Building afloat during the inhospitable backlash years of the 1980s were lesbian women. As lesbians played an increasingly important role at the Building, gay women and straight women jockeyed for control of informal social policy as well as event programming. Both lesbians and straight women felt alienated at times. In the early years of the Feminist Studio Workshop, before lesbian-oriented groups began to organize, gay women in particular often felt outnumbered and unacknowledged. Conversely, as the lesbian presence at the Building became increasingly politicized, heterosexual women sometimes felt unwelcome. Lesbian members feared that straight members weren't as committed to the survival of the Building as they were. There were also disputes over guidelines for social behavior at the Building—Could heterosexual women bring their husbands and boyfriends to Building events, or would that impinge on others' wish to maintain a female-oriented environment? Was it acceptable for lesbian lovers to kiss in public, or would that discourage walk-in visitors to the Building?[52] Throughout the history of the Woman's Building, nevertheless, there were sizable constituencies of both straight and lesbian women and a sufficient balance of power that problems could be addressed from within the community.

Women of color, on the other hand, always occupied a minority position at the Woman's Building. Feminists from outside the Building staged an organized challenge to white women's dominance there in 1980, when two activist groups, Califia and Lesbians of Color, confronted the planning committee of the Great American Lesbian Art Show. Representatives from the two groups voiced concern that all six members of the GALAS planning committee were European American and that their publicity network did not extend beyond the white community. In response to these criticisms, the GALAS collective expanded its existing outreach to minority women's groups and also reserved two exhibition spaces in East Los Angeles and South Central Los Angeles in order "to provide Black lesbians and Latina lesbians an opportunity to exhibit their art work in their own communities, as part of the GALAS regional network."[53] The GALAS invitational exhibition at the Woman's Building, which showcased the art of ten lesbian artist "role-models," ultimately included work by one African American artist, Lula-Mae Blocton, and one Latina, Gloria Longval.

After GALAS closed, members of the Woman's Building adopted a number of strategies aimed at improving race relations and making the organization a more multicultural institution. Terry Wolverton, who had co-coordinated the GALAS committee's efforts to develop better networks with women of color, initiated a "white women's anti-racism" consciousness-raising group, partly in response to complaints by women of color that they were tired of trying to help white women overcome their racism. The Building increased its sponsorship of exhibitions, writing workshops, and other events featuring work by women of color as well as emphasizing cultural exchange. For example, the 1986

"Cross-Pollination" exhibition, including the work of local artists Carol Chen, Michelle Clinton, Sylvia Delgado, Nelvatha Dunbarm, Diane Gamboa, Cyndi Kahn, Linda Lopez, Linda Nishio, May Sun, Mari Umekubo, Pattsi Valdez, and Linda Vallejo, as well as artists from other parts of the nation and the world, was particularly successful in attracting a broad audience and boosting the careers of several emerging artists.[54]

Despite successful efforts to showcase work by artists and writers of diverse ethnic backgrounds, however, there is no evidence that Building membership among women of color increased substantially during this period. Another strategy for increasing ethnic diversity at the Building involved hiring women of color for various staff positions. This approach often backfired when the new employees found themselves in the demeaning position of carrying out the vision of longtime Building members (most of whom were white), without holding much autonomous power.

The history of race relations at the Woman's Building is complex and sometimes difficult to assess. Women of color constituted a small but significant portion of the Woman's Building's membership from the beginning, and many more participated in events at the Building but did not become members. Many white feminists, additionally, considered the fight against racism an important aspect of the feminist cause. Yet women of color often reported deep ambivalence about their experiences at the Woman's Building (and in relation to the women's movement more generally). For example, as the only Asian American participant in the *Oral Herstory of Lesbianism,* Chris Wong used her performance, *Yellow Queer,* to address the discomfort she felt with white feminists who viewed her as a novelty and an icon: "I was the first Yellow Queer most of these girls had ever seen / So they had to like me / because I was the only one they had." Nevertheless, the experience of participating in the performance was "one of the most incredible processes," according to Chen, who credited the project with giving her "the support [she] needed to acknowledge [her] ancestry."[55]

The May 1980 issue of the Woman's Building newsletter, *Spinning Off,* a special issue addressed to "Racism in the (White) Women's Movement," gives voice to the experience of women of color at the Woman's Building, who sometimes faced patronizing assumptions on the part of white feminists about what others should do or believe "for their own good." In an essay calling for women of color to "confront white feminists," for example, Ariene Inouye-Matsuo argues that European-American feminists' ignorance of cultural differences often fosters a false sense of superiority:

> Asian women [working with white feminists] have expressed feelings about being perceived as young, naïve little sisters who lack maturity and sophistication and therefore do not have to be taken seriously. Although Asian women are generally less verbal and tend to avoid conflict, these racist attitudes are not justified.[56]

The Comision Feminil Mexicana, a Mexican-American feminist group that was invited to submit a statement to the newsletter, likewise stressed the barriers imposed by insensitivity to differences in class, race, and religious background:

> One of the problems about the term feminism is that it's been so associated with the Anglo community that anyone that doesn't meet their criteria, whatever that is, gets left out. If

you look at the early woman's movement, Anglo women were demanding . . . to get out of the house . . . or equal pay and access to executive positions. Most of our women are heads of households demanding jobs, period. . . . When we talk about abortion or sterilization, our perspective is again different, this time because of our religious upbringing. Because people don't look at that, we get told we are not feminist. We get neglected.[57]

Summing up the position of many, Betty Gilmore expressed the need "to see Third World women at the Building . . . in important roles . . . treated with the respect they do not often receive."[58]

The precarious financial situation of the Woman's Building throughout the 1980s presented an additional source of instability. In the late 1970s a downtown artists' district had appeared to be on the rise, but the scene fizzled out in the 1980s, some say because of a lack of sustained commitment on the part of the city's Community Redevelopment Agency. The defunct Los Angeles Theatre Center, for example, had been intended as the centerpiece of a gentrified Spring Street, a vision that never materialized. Many small theaters and arts spaces, including *High Performance* magazine, the Factory Place, Boyd Street Theaters, and Wallenboyd, either relocated or ceased operations during the 1980s. Los Angeles Contemporary Exhibitions, which opened in 1978, remained one of the few alternative performance venues in Los Angeles.[59]

Faced with a political backlash against alternative cultural institutions and drastically reduced government funding, the staff of the Woman's Building struggled to develop a business model that could generate corporate and individual revenues without compromising the organization's integrity. The Building's leadership proved remarkably resourceful in this regard. The Women's Graphic Center, with Sue Maberry serving as business manager and Susan King as artistic director, provided an especially important financial foundation for the Woman's Building during its second decade, generating revenue from typesetting and design services commissioned by various women's groups, museums and galleries, and local businesses. The Graphic Center also served a vital community-building function in the Building, the neighborhood, and the city, proving a popular resource for local artists and amateur designers. Groups of local schoolchildren, for example, were invited to develop their design skills there; and many of these children returned year after year, developing ongoing relationships with project leader Cheri Gaulke and others at the Building.

Among the most successful community activities generated by the Women's Graphic Center was Gaulke's "Postcard Project." Funded for three consecutive years (1985–88) by the California Arts Council, the Postcard Project enabled non-artist participants to learn the skills to design and print a postcard featuring a personal heroine or role model. During the final year of the project, several participants also designed posters that were displayed on city buses. The festive and elegant Vesta Awards, produced by Terry Wolverton with members of the board of directors to honor women for their achievements in the arts, also became a popular community event that attracted generous donations from individual and corporate sponsors.

By the mid-eighties, the Woman's Building had recovered substantially from the loss of the Feminist Studio Workshop in 1981 and a membership low of two hundred, grad-

ually adding classes, exhibitions, and other programming, and rebuilding membership to more than six hundred in 1985. However, the recovery proved temporary. The computer revolution and the advent of computer-generated design dealt the Woman's Building a major financial blow, forcing the Women's Graphic Center out of business in 1987. A growing divide between the few dedicated member administrators struggling to keep the institution afloat and the board of directors, who were removed from day-to-day operations, also took a toll. Finally, the Building was partly a victim of its own substantial success in generating institutional support for women artists in the art establishment. With increasing opportunities in the wider art world, young women artists in the 1980s became increasingly hesitant to associate with an institution they feared might appear to confer upon them a marginalized status.

Unable to come clear of its financial difficulties and with no clear consensus about its operating philosophy, the Woman's Building closed its doors in July of 1991. As Gaulke reviewed the status of the feminist art movement in 1991, shortly after the Building closed, she said, "There [was] a real crisis in determining what the feminist art strategy [was]. . . . In deciding to close the public space, the board acknowledged that we don't know."[60]

The Woman's Building made an indelible mark on the city as well as the global art scene during its eighteen years in downtown Los Angeles. The Building largely achieved its institutional goals, "to raise consciousness, to create dialogue, and to transform culture," as Arlene Raven legendarily formulated them. The Woman's Building provided a physical and social framework where artists and other women found the intellectual and emotional support to redefine their sense of identity, analyzing and challenging the dominant culture's often derogatory and exploitative images of women. From this supportive base, women at the Building intervened in the city's institutional machinery, including the popular media as well as the art world infrastructure, to help create a more democratic and more humane urban community. Even beyond the borders of the city and beyond the years when it operated there, the Woman's Building had a profound impact on the way artists and viewers understood the relationship between art making, identity, and community. Los Angeles is poorer for its loss.

Notes

1. Linda Nochlin documented the historical lack of institutional support for women artists in her provocatively titled essay, "Why Have There Been No Great Women Artists?" *Artnews* 69, no. 9 (January 1971).

2. More than 1,500 images of people, activities, and events at the Woman's Building between 1973 and 1991 are available on the World Wide Web. See the Woman's Building Digital Image Archive, <http://www.womansbuilding.org/wb/>. Another valuable resource is the Woman's Building Oral History Project, comprising interviews with more than thirty former Woman's Building members conducted by Michelle Moravec (available upon request from the Woman's Building Board of Directors). The most comprehensive written account of the Woman's Building available to date is Michelle Moravec's doctoral dissertation, "Building Women's Culture" (University of California at Los Angeles, 1998). A memoir of her years at the Woman's Building by former

executive director Terry Wolverton, *Insurgent Muse: Life and Art at the Woman's Building*, is forthcoming from City Lights Publishers in 2003.

3. Benedict Anderson suggests that nations are imagined because in even the smallest, members will never know most of their "fellow-members." This differs from the situation at the Woman's Building, where the membership of five hundred or so women probably recognized one another by sight and in many cases had close relationships. But insofar as the community around the Woman's Building was constructed out of a desire to create identity, a sense of togetherness, and a shared vision for the future, it can be viewed as a symbolic community (*Imagined Communities: Reflections on the Origin and Spread of Nationalism* [London: Verso, 1983]). Verta Taylor and Nancy Whittier's concept of a "social movement community," defined as "a network of individuals and groups loosely linked through an institutional base, multiple goals and actions and a collective identity that affirms members' common interests in opposition to dominant groups" is also a useful model for the community that developed around the Woman's Building ("Collective Identity in Social Movement Communities: Lesbian Feminist Mobilization," in *Frontiers in Social Movement Theory*, ed. Aldon D. Morris and Carol McClurg Mueller [New Haven: Yale University Press, 1992], 107).

4. Sheila de Bretteville, interview by Michelle Moravec, Woman's Building Oral History Project, 12 August 1992.

5. See Kristin G. Esterberg, *Lesbian and Bisexual Identities: Constructing Communities, Constructing Selves* (Philadelphia: Temple University Press), 1997. Also see Deborah G. Wolf, *The Lesbian Community* (Berkeley: University of California Press), 1979; Taylor and Whittier, "Collective Identity," 104–29.

6. Judy Chicago, *Everywoman* 2 (7 May 1971): 25.

7. Faith Wilding, *By Our Own Hands: The Women Artists' Movement, Southern California, 1970–1976* (Santa Monica, Calif.: Double X, 1977), 11.

8. Ibid, 35.

9. Faith Wilding, "The Feminist Art Programs at Fresno and CalArts, 1970–1975," in *The Power of Feminist Art: The American Movement of the 1970s, History and Impact*, ed. Norma Broude and Mary D. Garrard (New York: Harry N. Abrams, 1994), 35.

10. *Everywoman* 2 (7 May 1971). Courtesy of Judy Chicago, Feminist Art Program at California State University at Fresno, 1970–71.

11. Photographic documentation of *Womanhouse* is available in a catalogue, *Womanhouse*, designed by Sheila de Bretteville. Photographs of the installation can also be seen in Faith Wilding's book about the early years of the feminist art movement, *By Our Own Hands*, 24–29; and in Arlene Raven's essay, "Womanhouse," in *The Power of Feminist Art*, 48–65.

12. In addition to the catalog, documentation of *Womanhouse* included a 40-minute documentary film by Johanna Demetrakas, reviews in *Time* (20 March 1972), *New Woman* (April/May 1972), and the *Los Angeles Times* (17 January 1972), among other publications, and a one-hour television special on KNET-TV, Los Angeles, produced by Lynn Litman in 1972.

13. Griselda Pollock, *Vision and Difference: Femininity, Feminism, and Histories of Art* (London: Routledge, 1988), 9.

14. Lucy Lippard described the opening of the Woman's Building in a contemporary issue of *Art in America*. See "The L.A. Woman's Building," in *From the Center: Feminist Essays on Women's Art* (New York: E. P. Dutton, 1976), 96–100. Reprinted from *Art in America* 62, no. 3 (May–June 1974).

15. See Wilding, *By Our Own Hands*, 62.

16. Cheri Gaulke, interview by Michelle Moravec, Woman's Building Oral History Project, 6 August 1992.

17. Ibid.

18. Sheila de Bretteville, interview by Michelle Moravec, Woman's Building Oral History Project, 12 August 1992.

19. Ibid.

20. Sheila de Bretteville, quoted in Liz McQuiston, *Women in Design: A Contemporary View* (New York: Rizzoli, 1988), 22.

21. Wilding, *By Our Own Hands,* 79–80.

22. Suzanne Lacy, interview by Laura Meyer, 19 December, 2001.

23. See Moira Roth, *The Amazing Decade: Women and Performance Art in America, 1970–1980* (Los Angeles, Astro Artz, 1983), 114–15. Also see Suzanne Lacy, *Three Weeks in May,* unpublished documentation commissioned by Studio Watts Workshop, 1980.

24. Suzanne Lacy, "Affinities: Thoughts on an Incomplete History," in *The Power of Feminist Art,* ed. Broude and Garrard, 267.

25. Cheri Gaulke, interview by Michelle Moravec, Woman's Building Oral History Project, 6 August 1992.

26. Steven Durland, quoted in Jan Breslauer, "Woman's Building Lost to a Hitch in 'Herstory,'" *Los Angeles Times,* 7 January 1992.

27. Terry Wolverton makes this point, compellingly, by way of response to some critics' position that 1970s feminist art was unsophisticated in comparison to the poststructuralist critiques of gender favored in the 1980s. Terry Wolverton, "The Women's Art Movement Today," *Artweek* 21, no. 5 (8 February 1990).

28. Sheila de Bretteville, interview by Michelle Moravec, Woman's Building Oral History Project, 12 August 1992.

29. Ibid.

30. *The First Decade: Celebrating the Tenth Anniversary of the Woman's Building* (Los Angeles: The Woman's Building, 1983), 4, quoted in Moravec, "Building Women's Culture," 173.

31. Cheri Gaulke, interview by Michelle Moravec, Woman's Building Oral History Project, 6 August 1992. Gaulke explains that although "that's going to sound like a cult or something, it was really just a bunch of individuals struggling to figure out who they were with each other."

32. Terry Wolverton, interview by Laura Meyer, 1998.

33. Natalie Barney was an American lesbian expatriate who hosted a famous artistic and literary salon in 1920s Paris.

34. Lesbian Art Project manuscript, 24 May 1978, cited in Moravec, "Building Women's Culture," 132.

35. See Terry Wolverton, "The Lesbian Art Project," *Heresies* 7 (Spring 1979).

36. Terry Wolverton, FEMINA: An IntraSpace Voyage, unpublished script (voice of Dyana Siberstein/"SeaNee").

37. Ibid.

38. Ibid.

39. Lawrence Christon, "Feminism Lifts Off at Woman's Building," *Los Angeles Times,* 28 May 1978, calendar section.

40. Wolverton kept this letter with her archival materials from *Femina,* where I later found it.

41. Cheri Gaulke, interview by Michelle Moravec, Woman's Building Oral History Project.

42. Ibid., 6.

43. Tyaga was the principal organizer of the event, and the GALAS collective also included Bia Lowe, Louise Moore, Jody Palmer, Barbara Stopha, and Terry Wolverton. Lowe curated the invitational exhibition, and Tyaga organized the national GALAS network.

44. The artists featured in the invitational exhibition were Lula Mae Blocton, Tee Corinne, Betsy Damon, Louise Fishman, Nancy Fried, Harmony Hammond, Debbie Jones, Lili Lakich, Gloria Longval, and Kate Millet.

45. One of the first efforts to theorize lesbian art was Arlene Raven and Ruth Iskin's essay, "Through the Peephole: Toward a Lesbian Sensibility in Art," *Chrysalis* 4 (1977): 19–28.

46. In an otherwise enthusiastic review in *Artweek*, Neal Menzies dismissed Kate Millet's photographs and Debbie Jones's mixed media sculptures as unclear, poorly crafted, and vulgarly exhibitionist, relegating them to the "my vagina, my art" category (*Artweek* 11, no. 20 [24 May 1980]: 1).

47. Harmony Hammond, [GALAS] *Guidebook* (Los Angeles: Woman's Building, 1980).

48. The Boston GALAS exhibition was carried out entirely "underground" and only advertised by word of mouth, after the coordinators "spent impossible months finding spaces for the show and then being turned down due to sudden fits of homophobia." They also worried that work in the show might be damaged or destroyed. Nevertheless, the group deemed the event a great success, with sixty artists and twenty-five performers participating, successful fundraising activities, and positive coverage in the gay and lesbian press (Boston GALAS exhibition coordinator, letter to Terry Wolverton, 1980).

49. Terry Wolverton, "We Are Everywhere," [GALAS] *Guidebook*.

50. Cherrie Moraga and Gloria Anzaldua, eds., *This Bridge Called my Back: Writings by Radical Women of Color* (Watertown, Mass: Persephone Press, 1981). "In April, 1979, we wrote: We want to express to all women—especially to white middle class women—the experiences which divide us as feminists; we want to examine incidents of intolerance, prejudice and denial of differences within the feminist movement. We intend to explore the causes and sources of, and solutions to, these divisions. We want to create a definition that expands what 'feminist' means to us" (introduction, xxiii).

51. Terry Wolverton, cited in Jan Breslauer, "Woman's Building Lost to a Hitch in Herstory," *Los Angeles Times*, 7 January 7, 1992, sec. F.

52. Cheri Gaulke, who entered the Feminist Studio Workshop as a heterosexual and later came out as a lesbian, remembers that straight women sometimes felt persecuted at the Woman's Building, in an ironic reversal of experience outside. When she decided to participate in workshops for the Oral History of Lesbianism, at least one woman threatened to boycott the play if Gaulke was in it. Midway through the project, however, Gaulke decided that she was a lesbian, so the crisis was averted (Cheri Gaulke, interview by Michelle Moravec, Woman's Building Oral History Project, 6 August 1992).

53. GALAS Press Release, 7 February 1980.

54. "Cross Pollination," April 16, 1986, Woman's Building Collection, Archives of American Art, Smithsonian Institute, quoted in Moravec, "Building Women's Culture," 202. The first "Cross Pollination" exhibition was curated by Josine Ianco-Starrels, Samella Lewis, and Candace Lee at the Woman's Building in June 1979.

55. "An Oral Herstory of Lesbianism," *Frontiers* 4, no. 3 (1979), 52–53.

56. Arlene Inouye-Matsuo, "Confront white feminists," *Spinning Off* (May 1980): 1.

57. "Creating a Vehicle for Change: Comision Feminil Mexicana," *Spinning Off* (May 1980).

58. Betty Gilmore, "Racial Prejudice Is a Serious Social Disease," *Spinning Off* (May 1980).

59. Jan Breslauer, "Woman's Building Lost to a Hitch in 'Herstory,'" *Los Angeles Times*, 7 January 1992, sec. F.

60. Ibid.

Eric Gordon

4 Fortifying Community: African American History and Culture in Leimert Park

I've known rivers:
I've known rivers ancient as the world and older than the
Flow of human blood in human veins.
> —Langston Hughes, "The Negro Speaks of Rivers" (1921)

"The Concepts We Hold in Our Minds"

The poet Kamau Daáood has referred to Leimert Park, the small retail enclave in South Central Los Angeles, as a river. Centered at the intersection of 43rd Street and Degnan Boulevard, the roughly six blocks of shops, art galleries, restaurants, and bars has, in the last several years of the twentieth century, become a pivotal site in the production of Afro-centric, community-based art in Los Angeles. The small, seemingly insignificant storefronts that line Degnan Boulevard carry with them meaning far surpassing their daily operation—they are, in effect, capsules of memory and history for a community of African American artists and activists. They contribute in the construction of an African American community in Los Angeles—one that is built on both cultural and geographic connections.

What makes the area unique is its self-conscious reconstruction of the city's black history. Many of the storefronts have a direct lineage to previous African American areas in Los Angeles—Babe's and Ricki's Inn is a transplant from Central Avenue; the World Stage, a performance and jamming space, is intimately linked with the art and philosophy of the Watts Writers' Workshop. Like a river, the fluid history of black Los Angeles, a history that has occupied several spaces of the city, now streams through the geography of Leimert Park. This self-conscious effort is contingent on several factors. Although existing as a contemporary manifestation of social and cultural circumstances, the area is dependent on a particular historical mythology that is mobilized through various acts of performance and commerce.

History is woven into the spaces of Leimert Park through an active, self-conscious process. And it is in the work of historical appropriation that urban community is built. Each space is dependent on its historical referent, and each historical referent is dependent on the space that makes its memory accessible. Without becoming a museum or a collection of urban monuments, Leimert Park uses the history of African Americans in Los Angeles to produce a community that is both grounded and generative.

Constructing community in Los Angeles is like building a sandcastle at high tide—the sheer amount of images and space that make up the raw material of the city is never stable enough to secure any reasonable foundation. Once something appears stable, it is immediately washed away by a new flood of cultural signifiers. For this reason, community, in the contemporary cultural climate, must be a careful process of assembling, deconstructing, and reworking—with a mind to geographic space, social history, and the media images that produce them both. In this essay, I will discuss how this process works in Leimert Park.

The one-and-a-half-acre green space of Leimert Park, dedicated on November 17, 1928, was the focal point for a community project planned and developed by Walter H. Leimert. The project was intended to accommodate moderately affluent white urbanites desiring to relocate into the suburbs—only "17 minutes by auto" from Exposition Park Stadium, the University of Southern California, and downtown, boasted the project's promotional flyer.[1] The area surrounding the park, as explained in Greg Hise's detailed history of its planning documents, was an early prototype of a planned community—the type now ubiquitous in Los Angeles. It was to embody the kind of "natural" urban setting for which Los Angeles was building a reputation, and it was to accommodate a greater amount of people and expand the possibilities of home ownership to a larger (white) population. Developers appropriated wider and shallower lots to enhance privacy and permit more varied housing designs. This creative division of lots also allowed for more affordable prices, thus opening the door to a new class of homeowner. Because of unofficial housing covenants, this area was completely off limits to non-whites, thus creating the new American suburb, one increasingly open to the lower- middle class but situated within a very specific ideological framework of racial exclusion.

This brief history of the area offers a kind of ironic standpoint from which to see the contemporary shifts and planning currently taking place in Leimert Park. Once representative of the democratization of white suburban growth in Los Angeles, considered urban by most standards, the area now embodies a very different but equally self-conscious view of community building. Situated within the largely black and economically impoverished Crenshaw District and just to the East of the middle-class African American suburb of Baldwin Hills, the community of Leimert Park is now engaged in a reconfiguration of the American dream once wishfully indicated in its landscape. Far from the utopia of the white garden city, the dream is now focused on the idealism of community art and the possibilities of multiculturalism existing within a black foundation.

As one walks down Degnan Boulevard on a Saturday afternoon, it is difficult not to notice the ways in which people are using public space. In a highly uncharacteristic fash-

ILLUSTRATION 4.1. Sidewalk artist: An artist on Degnan Boulevard working on a large-scale mosaic. Photograph by Eric Gordon.

ion, especially for Los Angeles, there are people hanging out on the sidewalk, talking about art, politics, and nothing in particular (Illustration 4.1). Unlike most *public* spaces in the city, the position of the pedestrian is not solely dictated by commerce. The public spaces of the sidewalk are more apt to be used in this way because of the relative political awareness of the shop owners; no one seems to mind a little loitering; in fact, it is likely encouraged. This setting is partially symptomatic of the kinds of storefronts that occupy the main drag of Leimert Park. Along Degnan Boulevard one can visit the Museum in Black, a store devoted to Afro-centric artwork and clothing, and The World Stage, a performance and rehearsal space owned by the poet Kamau Daáood (once co-owned by the late drummer Billy Higgins). Around the corner is 5th Street Dicks, a coffee house offering outdoor chess until 4 A.M. every night; The KAOS Network, an educational and performance space run by filmmaker, teacher, and photographer Ben Caldwell; and Babe's and Ricki's Inn, a blues club recently relocated from Central Avenue (Illustration 4.2).

All the places mentioned above are recent additions to Leimert Park. Long considered an African American arts colony, the space was not widely known or frequently visited by people living outside the area until relatively recently. It was not until after the 1992 L.A. uprisings that there existed the social, political, and cultural motivation for the dramatic renewal currently taking place. A political urgency coupled with the nation's watchful eye on the African American "urban condition" led to the kind of self-conscious community building currently manifest in the area. Brian Breye, the owner of

ILLUSTRATION 4.2. World Stage: Performance Space on Degnan Boulevard. Photograph by Eric Gordon.

Museum in Black, told *Black Enterprise* magazine that "this part of the city is one of the only areas in the U.S. with such a high concentration of educated blacks and black businesses. It's on the move and rising, and there's a lot of pride in the community."[2]

This pride, in what the *Washington Post* calls a "full body immersion in black culture and aspirations,"[3] has played a pivotal role in defining the area from both inside and outside. Leimert Park has garnered a certain amount of recognition as a positive community space in the otherwise perceived war-torn area of South Central Los Angeles. It has taken on the burden of attempting to represent a different side of South Central. For this reason, the people living and working in the community must simultaneously concern themselves with everyday commerce and with media marketing. Ruth Nuckolls, a 62-year-old optician who has owned and operated Leimert Park Eyewear for twelve years, told the *Washington Post*, "We're constantly having to disprove these old myths. Any little thing that goes wrong, people say, 'That's why I don't do business with black people.' They can forgive Macy's, the Broadway and the May Company, but they can't forgive any mistake that we might make."[4]

The anxiety about doing business with black people that Ruth Nuckolls points to is indicative of the need for a kind of exhibitionism in developing community within an area like Leimert Park. A "positive" space like Leimert Park operating within a "negative" space like South Central, necessarily draws attention to itself and carries with it, whether intentionally or not, a burden of representation. To form community (generally an internal process), in the case of certain minority populations, organizers must

be concerned with how they are perceived from the outside. Leimert Park was, in the first place, partially necessitated by the negative media portrayals of South Central Los Angeles, and it was likewise concerned with turning that media image around.

The media seems all too hungry for human-interest stories about the area because it provides entertaining news for a voyeuristic population desperate to peer into a world unknown to them. In a *Los Angeles Times* article about a San Fernando Valley physician who regularly attends Project Blowed (a rap workshop held at the KAOS Network on Thursday nights), this becomes abundantly clear.[5] The story explains that Dr. Sherman A. Hershfield uses rap as therapy for a seizure condition he recently developed and how the regular attendees, although once suspicious of the elderly white doctor, now consider him a pleasant novelty and are very supportive of his efforts. The article is not at all reproachful of the area, but it exemplifies the ways in which Leimert Park is constantly subject to the scrutinizing gaze of the mainstream media, forcing the area to exist as both local community and public service announcement for black life in Los Angeles.

In its everyday functioning, the material history of the area collides with the way it is generally perceived. Kamau Daáood, poet and co-owner of The World Stage, described this process to me in an interview:

> One of the things that happened here in Leimert Park is that when we began to take over all these spaces down the block—artists came in without the help of community redevelopment, cultural affairs, or corporate sponsoring. It was just people scraping together some money and liberating these old storefronts, slapping paint on the walls, and turning them into dance studios or art galleries or performance spaces. When we began to do that, what you saw happening was a coffee house that is open until 4 o'clock in the morning, chess tables out front of the coffee house in "South Central" with people outside sipping on coffee and playing chess at 3 o'clock in the morning. You have after-hours jazz playing upstairs and jazz playing around the corner. Then brave souls from other communities begin to filter into these places. After awhile you look around and you see that you've got people from all over the city down in Leimert Park at 2 or 3 o'clock in the morning blowing away all those myths about how unlivable our communities are.[6]

Business and perception, art and the marketplace, all come together in Leimert Park. As the area struggles for an identity, it fights or embraces popular perception in order to boost its chances for success. "Not only had the media colored how the outer world looked at the community," Daáood continued, "we were looking at the same TV's, and we began to believe the hype ourselves. . . . The concepts that we hold within our minds—they're worth more than anything, just the concepts we hold in our minds." These problems are common to the project of community building in Los Angeles. Because of the atomized and dispersed geography of the city, people don't only identify with the neighborhoods in which they live. The act of spatial identification is potentially much broader reaching because of the ways in which neighborhoods like Leimert Park are scrutinized from the outside. In some ways, while potentially destabilizing of the community (as Daáood points out), the multifarious representations of Leimert Park construct the neighborhood as an exportable concept.

The French philosopher Henri Lefebvre, in his book *The Production of Space*, suggests that the meaning of urban space is not solely determined by its materiality. Instead, meaning is produced through the representation of urban history, through variegated modes of social practice and through the interpenetration of lived experience and conceived environments. Lefebvre proclaims that "no space disappears in the course of growth and development."[7] Likewise, when a community is consistently shuffled around the city because of racially and economically determined circumstances, some self-motivated and others imposed, the history of the social space left behind is always exacted upon the current space. In Leimert Park, this is quite apparent. With only a six-block configuration of retail establishments, the social space of Leimert Park is made meaningful through a complex interpenetration of various African American urban and artistic histories.

Accordingly, I will look to Central Avenue as a precedent to the cultural construction of Leimert Park, with a special emphasis on the recently deceased Horace Tapscott, who began his career on Central Avenue and finished it in Leimert Park. Then I will look to the Watts Writers' Workshop and the historical significance of the 1965 Watts uprisings to situate the kind of poetry and spoken word performance currently happening in Leimert Park. Kamau Daáood, the owner of The World Stage, got his start in the Watts Writers' Workshop in the late 1960s and has continued teaching and writing poetry as part of the community. Finally, I will conclude by briefly discussing the role of Hollywood and new media technologies in the continuing struggle for community identity in the area. These kinds of historical investigations are necessary in writing any history of the present. Especially with the turbulent past (and present) of African American communities in Los Angeles, the story of Leimert Park needs to be told as one both burdened and liberated by its history.

Remembering the Avenue: "There was gold coming out of Central Avenue"

Nothing may be forgotten and nothing remembered may remain unchanged.
 —Siegfried Kracauer, letter to Ernst Bloch on June 29, 1926[8]

When I asked Kamau Daáood if he saw a connection between Leimert Park and Central Avenue, he said, "We just don't build out of a vacuum. We build on the shoulders of the things that have come before us, in one way or another. Even if we're reacting to it and trying to get away from it—we build on those shoulders."[9] Accordingly, the historical and social significance of Leimert Park, as a location of culture as well as residence and commerce, must be traced back to Central Avenue.

In the early part of the century, L.A.'s black population was confined to a small area in South Los Angeles concentrated along Central Avenue. Because of racist housing covenants that began prior to 1900, the widely expanding black population of Los Ange-

les was forced into a small area along Central Avenue just south of downtown. In 1919 the California Supreme Court ruled the covenants illegal, but the institutionalized racial segregation and housing discrimination just got worse. Homeowner associations joined together on the principal of not selling their properties to blacks. During the inter-war period, these associations grew in numbers to create one large ghetto stretching approximately thirty blocks down Central Avenue and several blocks east to the railroad tracks.[10] Other pockets of black concentration grew in a few other areas along Jefferson, Temple Street, and in the southern suburb of Watts. Neighboring all these areas were pockets of white resistance that, in the name of property values, fought hard to maintain the clear delineation between white and black L.A.

Early on, Central Avenue was recognized as the heart of black culture in Los Angeles. Many of the businesses and buildings along the Avenue, as it was called, remained white-owned, but in relation to every other neighborhood in Los Angeles, black-owned businesses thrived there. The symbolic marker of this boom in black-owned business was the opening of the Sommerville Hotel in 1928. This Central Avenue landmark, later renamed the Dunbar Hotel, carried great significance for the meaning of Central Avenue and black Los Angeles in general. Owned by the prominent black dentist John Sommerville (the first black to graduate from USC), the relatively elegant four-story structure signified the possibility of luxury for African Americans. "The Sommerville was among the finest hotels for blacks in the country and helped fuel the notion that in Los Angeles a black person could find a better living situation than anywhere else in the United States."[11]

The Sommerville greatly assisted the survival of the music scene on Central Avenue because up until its opening, visiting black musicians had nowhere to stay. Restricted from renting rooms in downtown hotels, musicians traveling to Central Avenue to play in one of the many clubs were left with few options for temporary boarding—mostly people stayed with friends or fans willing to open up their homes. Throughout the 1930s, as the Avenue gained recognition for its vibrant jazz scene, the hotel built a reputation as the symbol for L.A.'s black nightlife. Jazz luminaries such as Nat King Cole and Duke Ellington would pass through town and stay there; regular jamming sessions and meetings in the hotel lobby elevated the structure to a practically mythical status. After the stock market crash in 1929, John Sommerville was forced to sell his hotel to an investment group who kept the structure in place but renamed it the Dunbar Hotel. Although no longer black-owned, the hotel continued to be an integral part of the neighborhood. The Dunbar Hotel remained the spiritual center of the Avenue for decades and is one of the only buildings from the original strip still standing today.

Central Avenue continued to thrive throughout the 1940s. By this time, blacks constituted 4.3 percent of the population of Los Angeles, with the majority of the community centered around the Dunbar Hotel on Central and Forty-second.[12] The Avenue had garnered enough of a reputation that every big touring musician jumped at the chance to play there. Musicians from all over the country came to play for a few nights, a few weeks, or maybe even to stay for good. Many people were intrigued by the relative freedom and creativity on the Avenue, as opposed to other areas in the country.

As Buddy Collette, a multi-instrumentalist and lifelong resident of Los Angeles declared: "Central Avenue was a place where you could bring your own ideas to the stage, to the audience, whatever they sounded like. You were not being judged because you didn't sound like this or that. On Central, if someone had a different approach it was well accepted."[13]

Despite the reality of ghettoization, the prominent mythology of Central Avenue within the black community was one of open space and expansion. Central was a place where people could try new things out, where they could explore their creativity without having to feel the pressure of an established scene. But after World War II, despite its continued musical vibrancy, Central Avenue's prime had passed. Massive layoffs in the defense industry and the subsequent rapid decline of disposable income had a severe impact on the patronage of the clubs. Concurrently, the Los Angeles Police Department (LAPD), under police chief William H. Parker, boosted its aggressive stance toward Central Avenue's nightlife. "Under previous police chiefs ... Central Avenue's boisterous, interracial night scene had simply been shaken down for tribute; under Parker—a puritanical crusader against 'race mixing'—nightclubs and juke joints were raided and shuttered."[14] As the attacks on clubs grew worse, patrons and musicians were less likely to spend time in these volatile nightspots. Beyond police pressure, the loosening of housing covenants in neighboring areas, especially the Crenshaw district to the west, proved extremely influential in Central's decline. When given the opportunity, most longtime residents of Central Avenue opted to relocate in an attempt to move up the social ladder. Finally, one of the strongest unifying factors of Central Avenue, the musicians' union Local 767, was in the process of breaking up. With the increased openness of Hollywood unions, many black musicians left the Central Avenue union for the opportunity to integrate into the mainstream. Soon after, Local 767 was dissolved. The increased openness of race relations and social policies contributed greatly to the decline of this vibrant community. Central Avenue was constructed out of necessity—as a means of coping with a culture and a city that wanted nothing to do with African Americans. As soon as there were possibilities for assimilation, the community quickly eroded.

Despite the adverse conditions that necessitated its existence, Central Avenue is remembered as an ideal space, symbolizing a unity to black life in the city. As the African American population continues to geographically shift and socially diversify throughout Los Angeles, the nostalgia for a cohesive community is embodied in the "origin myth" of Central Avenue. The history of black Los Angeles is tied to this romanticized place in history that was forced into existence by racist laws and a frightening antagonism toward race mixing. The reality created under these adverse conditions is in some ways still seen as a place to return to. Horace Tapscott said of the Avenue:

> [It] brought a lot of people together musically, artistically. I think Central Avenue is just as legendary a place as the Great White Way that they speak about. It had all of the musicians, the artists, that helped make the music of this country what it is today. That's what Central Avenue gave to this community, all these people, and they'd be right there on Central Avenue gathering together. It was like a bonanza. There was gold coming out of Central Avenue.[15]

The myth of Central Avenue has played an integral role in the current manifestation of Leimert Park—not in the form of a self-conscious reconstruction of the area's geography and architecture, but instead in the form of a psychological and cultural connection to the Avenue. Horace Tapscott is perhaps the best illustration of this cultural shift, as his life paralleled the move from Central Avenue to Leimert Park.

Tapscott was one of the most under-recognized and influential figures on the Avenue. In 1943 he and his mother moved there from Houston, Texas. Arriving in Los Angeles at the age of nine, Tapscott was thrust immediately onto the music scene. "I got down on Central Avenue, and I started seeing things unfold in front of me," Tapscott recalled. "The first place we went, before I got to my house, my mother told the driver to stop the car. Our suitcase was still in the trunk. And I said, 'This is where we live?' She said, 'No, this is not where we live. I want to introduce you to your first music teacher.'"[16]

Tapscott's experience was not unusual. According to several testimonies from Central Avenue musicians, they received pressure from their parents to immediately get involved in the music scene. Jazz was a means of cultural preservation; it was at the core of life on the Avenue; it was the adhesive of a community literally under attack from all sides. Tapscott understood this. He recognized the interplay between music and community, making this the foundation of his art on Central Avenue, in Watts, and finally, in Leimert Park.

Known by everybody as "Papa," Tapscott refused the more prestigious life of a touring musician with Lionel Hampton's band in the late 1950s for the less-glamorous life of a community artist. "With his talent, they said, he could have hit worldly heights. Instead he stayed and made 'community artist' a noble profession."[17] He left Hampton's band because he felt like he wasn't able to do his own thing. He felt pulled in directions he wasn't happy about going. "That's why I got off the road to start my orchestra," he said, "to preserve black music. I wanted to preserve and teach and show and perform the music of black Americans and Pan-African music. To preserve it by playing it and writing about it and taking it to the community. And that to me was what it was about, being part of the community."[18]

Tapscott's orchestra was called the Pan Afrikan People's Arkestra—a teaching and performance group he began after leaving Hampton's band. The Arkestra was slow in getting started due to a lack of funding and support, but in 1965, during the Watts uprisings, Tapscott was noticed for his unique approach to community art. He and his Arkestra traveled the streets of Watts on a flatbed truck, playing their music. Crowds danced in the street as Tapscott rode by—assuredly creating an ironic juxtaposition of joviality and destruction. This dramatic contradiction was immediately picked up by the media. It was the perfect television sound byte to embody the anger, guilt, and confusion in the popular consciousness.

Tapscott's actions during the uprisings gave him the distinction he needed to receive state and federal funding for the Arkestra. He wasn't threatening; instead, he symbolized a cultural vibrancy in Watts that public funding organizations were wont to support. The Pan Afrikan People's Arkestra created a windfall of funds into Watts. After the uprisings, large sums of money were funneled into the area to finance all kinds of

arts organizations. The Watts Writers Workshop, which I will discuss in the next section, was made possible through public money as well.

After receiving financial support, Tapscott and his Arkestra became a staple of the L.A. jazz scene—pushing the concept of performance in new directions. He gathered expert and novice musicians, poets, and singers to perform together in a kind of pedagogical and ultimately inclusive jazz orchestra. According to Jocelyn Stewart's article in the L.A. *Times,* "The Arkestra was created as a vessel of memory, meant to house the culture of a people."[19] During each performance, Tapscott would say to the audience, "This belongs to you."

The symbolic significance of Central Avenue and its connection to Leimert Park is traceable through the career of Horace Tapscott. His move from Central Avenue to Watts to Leimert Park parallels the trajectory of the idealized locations of cultural production in L.A.'s African American history. Despite the circumstances leading to the Avenue's existence, it survived within popular memory as an ideal space where community and art were absolutely inseparable. The same is true for Watts, and currently a similar idealization is being built in Leimert Park. Tapscott, who made his career on giving back to the community, is a major figure in manifesting the cultural connections between history, geographical spaces, and art. These connections are made quite obvious in The World Stage.

Kamau Daáood was a close friend of Tapscott's, so when he and Billy Higgins opened The World Stage back in 1989, Tapscott became a regular performer. In fact, he helped define the space.

> The first music to grace this place was Billy Higgins and Horace Tapscott—in a duet. They put the first vibe in this place. Billy and Horace were very integral parts of the beginning of this place, which brings a lot of history. Billy Higgins is said to be the most recorded drummer in history. Horace Tapscott, of course, coming out of Central Avenue and his rootedness in this community. The grassroots of this place is just legendary. That men of this stature would come to this space and use it as a base to operate from and to teach from and share from, is very unique.[20]

The meaning assigned to The World Stage by Daáood is integrally connected to Central Avenue and the work of Horace Tapscott. The interesting difference, however, is that Central Avenue was a forced situation, whereas Leimert Park is a self-conscious grassroots attempt to recreate that type of community.

For Daáood, Central Avenue was like a river. "There were places all up and down Central Avenue, and the lifestyle in the community was based around the life on Central Avenue." In his poem entitled "Leimert Park," he extends the metaphor.

> You see, there are trees in Leimert Park
> Under which old men do divinations with the bones of dominos
> Degnan, a river, a new Nile on whose banks young poets sharpen their hearts
> On the polyrhythms of Billy Higgins' smile
> On the World Stage where Tapscott's fingers massage your collective memory[21]

Langston Hughes wrote, "My soul has grown deep like the rivers."[22] Daáood uses this powerful symbol of history and memory to define both Central Avenue and Leimert Park. This is telling in a number of ways: it links Daáood's work to a long tradition of African American poets, and it offers an interesting insight into a particular cultural conception of African American community—a community with an indispensable connection to a troubled, often mythologized history. When I pressed him on the subject, Daáood qualified his reference to Degnan, calling it a short river. "I think the seed and concept is there and the thriving is there to bring art back into the lives of everyday people in the community. The ebbs and flows of Central Avenue run through the spaces of Leimert Park."[23]

The real space of Central Avenue is not entirely subsumed within the space of Leimert Park. Since 1996 the Cultural Affairs Department of Los Angeles has sponsored the Annual Central Avenue Jazz Festival. The summertime weekend festival takes place on Central Avenue between 42nd and 43rd Streets. Beginning at the foot of the Dunbar Hotel, the closed-off street is lined with food, art, and music booths. Each year a large outdoor stage is set up for live jazz with old locals. During the 2000 festival, Buddy Collette and the Latin jazz combo the Estrada Brothers were present. Although filled with old standards, the line-up included a good deal of Latin jazz as a means of acknowledging the demographic shift of the area. The prime function of the street festival is to celebrate African American history, but it maintains a very contemporary feel. Not simply a look back, the festival makes a conscious attempt to revitalize the contemporary space of the Avenue, emphasizing the positive role of music in the historical and contemporary construction of community in Los Angeles. A letter in the 2000 festival program from Adolfo V. Nodal, the general manager of the city's Cultural Affairs Department, explicitly stated this purpose: "Along with bringing sheer enjoyment and entertainment, we will demonstrate once again how music can serve to promote civic pride and community spirit."

This once-historic stretch of Central Avenue is now an empty shell of its past. Many of the storefronts are closed, the clubs are all gone, and the nightlife is virtually nonexistent. What remains is a powerful memory fueled by the occasional street fair and by individual figures that keep reminding us of the area's history. Figures like Horace Tapscott (to whom the 2000 festival was dedicated) and Buddy Collette, who worked as the festival's artistic director, have been pivotal in maintaining the symbolic identity of Central Avenue. Since the decline of the Avenue in the 1950s, it seems as though it has never ceased creating community. It has just been relocated. Along the unassuming block of Degnan in Leimert Park, the ghosts of Central Avenue are very much alive.

In August of 1997, when Babe's and Ricky's Inn, the last great blues club on Central Avenue, relocated to the heart of Leimert Park, this dislocation was made clear. The 80-year-old owner, Laura Mae Gross, otherwise known simply as "Mama," took over the old Atlantic Club at 5229 Central Avenue back in 1963, renamed it after her nephew and her son, and kept the blues alive on Central as long as possible. Because of the virtually nonexistent nightlife on the Avenue, the club was forced to close its doors in 1993.

With the help of several fund-raising benefits, Mama and her partner Jonathon Hodges were able to move the club to Leimert Park. With the Central Avenue street sign from the original location hanging in the new space, Babe's and Ricki's Inn is a living homage to the Avenue, and a firm marker of Leimert Park's future.

Central Avenue remains the foundation of the "river" currently running through Leimert Park. It is the historical referent, the origin myth, of a contemporary African American community defined by the intersection of neighborhood and art. This is not to say that the meaning of Leimert Park is not affected by other cultural referents as well. Perhaps the most telling lineage can be traced to the cultural production of Watts following the 1965 uprisings.

Watts Happening in Leimert Park

What shall it avail our nation if we can place a man on the moon but cannot cure the sickness in our cities?
> —McCone Commission Report (1965)

There are many ways to build a wall, and as many ways to level it and remove it.
> —Budd Schulberg, Introduction to *From the Ashes: Voices of Watts* (1967)

On the night of August 11, 1965, the hot summer streets of Watts exploded in what would become one of the worst race uprisings in the nation's history. Beginning on the corner of 116th Street and Avalon Boulevard, a small police scuffle with a local resident caused five days of civic disorder in South Los Angeles. As buildings burned, black anger escalated and white fear mounted, while the media struggled madly to put a label on the seemingly never-ending destruction. KTLA's helicopters flew relentlessly over the area, desperately attempting to define the ruckus and assuage the fear. While the city burned, the media argued over definitions, calling the event everything from a riot to a revolution. A CBS Radio affiliate in Los Angeles said, "This was not a riot. It was an insurrection against all authority." CBS Television called it a "revolt." KMPC Radio in Los Angeles referred to it as a "virtual insurrection probably unmatched since the Civil War." The pressure to supply answers was monumental for the media, whose constant and often inappropriate coverage was blamed for escalating the conflict.

Beyond the pressure to name what was going on, the media was also searching for answers as to *why* it was going on. Could it be blamed on some acrimonious black people or unusually hostile white people, or was it the result of police brutality, unemployment, poverty, and institutionalized racism? And why did it happen in Los Angeles and not one of the East Coast ghettos where the conditions seemed manifestly more desperate? One opinion, voiced by the well-known black pastor Reverend H. H. Brookins, created quite a stir in the media. "Other cities are old and have lived with

the problem longer. . . . Where the most hope is built up, the awakening to reality hurts the worst." Those standard myths of Los Angeles, fueled in part by the history of Central Avenue, created a rift between reality and perception that, according to Brookins, resulted in a cruel awakening to the racial strife in sunny Southern California.

The contradiction is most pointedly made evident in Chester Himes's classic novel *If He Hollers Let Him Go* (1942), in which a black dock worker struggles with the rampant racism in Los Angeles. The trope of the city's contradictory racial landscape existed long before the Watts uprisings, so the event itself merely gave evidence to a condition already brewing within the consciousness of black Los Angeles. "Los Angeles hurt me racially as much as any city I have ever known," Himes said. "The only thing that surprised me about the race riots in Watts in 1965 was that they waited so long to happen."[24]

LAPD Chief Charlie Parker, in an interview conducted for the 1965 *CBS Reports* special "Watts: Riot or Revolt?" said "Many Negro leaders agree with me that Los Angeles is the finest place in the world for the Negro because he has the greatest opportunity here on a broad basis than he would anywhere else in the world. So you have the paradox—where things were the best, that's where the riot occurred."

Simply left at that—a perplexing paradox—Chief Parker pushed the notion of the troubled L.A. Negro unable to appreciate his pleasant surroundings. Unlike Brookins' sentiment that the utopian mythology of Los Angeles made the harsh realities of black life even more severe, Parker insinuated that conditions truly were "the best" in Los Angeles and that the uprisings were simply the result of some maladjusted individuals. His comment was an attempt to steal attention away from the structural problems that cause economic and racial strife in the city. Capitalizing on popular white fears, Parker's "paradox" contributed to the construction of racial politics in the city, one that blamed the victims of poverty and racism for their dissatisfaction.

But the media response to the event was widely varied. Although Chief Parker had a rather prominent voice in the coverage, considerable airtime was given to surprisingly oppositional voices that contested the easy answers. The CBS special "Watts: Riot or Revolt?" (1965), for instance, offered the opinions of angry kids from Watts and somewhat evenhandedly represented their indictment of white people for causing the conflict. This kind of coverage needs to be seen in correlation, however, with the more reactionary KTLA special "Hell in the City of Angels," in which Mayor Yorty declared:

> One after-effect may be that the great number of responsible Negro citizens in our community will take a new look at what's been going on with some of the agitators and will get over on our side because I think they realize now that it isn't just the Caucasians that are in jeopardy. It's law and order in the community. And this effects them severely because they live in the area.

By positioning the responsible Negro in opposition to the agitator, Yorty created a civic model that pivoted on the individual and disregarded public responsibility for the uprising. The two positions, as illustrated in the McCone Commission report on one hand, and Yorty and Parker on the other, are in obvious conflict with each other. This conflict,

I suggest, intensified the social need for artists of all sorts to intervene in the area's cultural production immediately following the uprisings. The widely varied discursive construction of the event left room for artistic interpretation and, in fact, necessitated that interpretation. The conflicted dialogue evidenced in the media coverage could not be resolved simply through the material reconstruction of neighborhoods. There was an obvious need for understanding—a need that could only be satisfied through a kind of grassroots cultural production.

This need was cultivated both by white guilt and fear from the outside and by a desire to be heard from the inside; the result was a momentary cultural acceptance and even celebration of African American voices. The period of the late 1960s, catapulted by the uprising, created a kind of cultural discourse that continues to this day. The post-uprising culture that flourished in Watts in the form of music, poetry, and theater marks a significant shift in black cultural production. Assisted by public money, it was a form of cultural production that recognized the connection between geography and personal expression. Many black organizations, including Horace Tapscott's Arkestra, were granted state and federal funds. Money came from the private sector as well; liberal-minded philanthropists from all over the city thought Watts to be a worthy (and trendy) investment.

Perhaps the most influential of these organizations was the Watts Writers' Workshop, a workshop for new writers started by the screenwriter and novelist Budd Schulberg. Schulberg, most famous for writing the screenplay for *On the Water Front* (1954), felt compelled to do something about what he saw happening in Watts.

> What was I to do? As an American writer, still oriented toward social fiction, I felt an itch, an irresistible urge to know. I held to the old-fashioned notion that an author has a special obligation to his society, an obligation to understand it and to serve as its conscience.... The responsible American writer makes it his duty to report on his corner of the nation. Los Angeles is my corner. I was raised here.[25]

With this guilt, or sense of responsibility, Schulberg left his protected environment of Beverly Hills to begin a creative writing class in Watts. He started with a posted notice on a Westminster bulletin board that read, "Creative Writing Class—All Interested Sign Below." No one signed up. Week after week Schulberg waited for students, but to no avail—his conspicuous whiteness was becoming more and more paralyzing. "What to do? Give Up?" Schulberg writes. "Admit that a white man, no matter how altruistic he believes his motives to be, has no place in a black ghetto?" Schulberg was very aware of his position in Watts. He knew that people would be distrustful of him—and rightfully so:

> White was "Travelin' Sam Yorty" the Mayor and his Police Chief Parker, against whom the people of Watts seemed to feel a hatred similar to the feeling of the Jews for Hitler and Himmler. White was the color of the Enemy that held you in and blocked you off and put you down and kept you there at the business end of the billyclub and the bayonet point.[26]

Finally, after a month of waiting, Schulberg found his first student—a 19-year-old boy named Charles Johnson. Johnson, as with everyone else in the neighborhood, was sus-

picious of Schulberg's motivations, but he was intrigued by the prospect of telling sto-
ries. "I'm just me," Schulberg told Johnson, "a writer, here to see if I can find other
writers."[27] After a three-hour conversation, Johnson was eventually convinced to join
the class and became the charter member of the Watts Writers' Workshop. Shortly
thereafter, more people signed up for the class, and the Workshop became a reality.

What began as a small class in a Westminster office turned into something that
exceeded most people's expectations. Soon the little space in Westminster was no longer
big enough to house the workshop; the group moved to a humble coffeehouse in Watts
called Watts Happening. The coffeehouse was located on 103rd Street between Wil-
mington and the railroad tracks and was funded by the Southern California Council of
Churches and the U.S. Department of Housing and Urban Development.[28] Because of
the burgeoning need for expression and the historical lack of cultural institutions in the
area, when it opened in October of 1965, this small transformed furniture store quickly
became the center of the local art scene. Writers and artists of all sorts began to meet
there regularly to share their work.[29]

By the time the Writers' Workshop joined the already accumulating crowd at the cof-
feehouse, it had earned the status of group celebrity. By early 1966, the workshop
amassed local and national media attention and became something of a marker for the
area's social progress.

This progress was again countered by increases in run-ins with police. Officers of the
LAPD were constantly harassing the writers and making unsubstantiated arrests.[30] One
of the main instances was the arrest of Leumas Sirrah, a young poet named to receive
the first Watts Writers' Award at the Westminster Assembly Hall. The day after the cer-
emony, Leumas was arrested for armed robbery. But it happened that this alleged crime
took place at the exact time Leumas was receiving his award. This instance of police
corruption led to the expansion of the Workshop into the Frederick Douglass House,
a nine-room house where writers lived and worked. In Schulberg's words, the LAPD

> may be credited with an assist in the founding of the Frederick Douglass Writers' House
> that has risen from the ashes on Beach Street, a few blocks down from Westminster in the
> heart of Watts. [It was] during a period in which I often found myself roused in the small
> hours for the latest emergency, that I came to full awareness of what I had begun. It had
> been naïve or callow to think that I could go to Watts for three hours of a single afternoon
> once a week. A creative writing class in Watts was fine, as far as it went, but it didn't go
> very far for writers who were homeless, who had to pawn typewriters, who fainted from
> hunger in class. Most of these writers would fall apart because they had no address, no base,
> no center, no anchor.[31]

The Douglass House was to serve as that anchor. It became the foundation of the work-
shop—creating a safe place for people to work and create. As Schulberg suggests, a cre-
ative writing class in Watts was not the same as one in Beverly Hills. For many people,
it was not just a subtle addition to an already meaningful life—it became the founda-
tion for personal growth. The writing that took place in the workshop was not really
in dialogue with a tradition of previously established poetry and prose; it truly did rise
"from the ashes." Like music on Central Avenue, to these writers, it was the only thing

that reminded them that they were alive. Anthony Hamilton explains his experience with the workshop: "I found out I could do something. And it was nothing more but write a poem."[32] It was that simple. The workshop was not about great writing, although that certainly happened; it was about introducing the concept of expression to a community long stripped of this privilege.

The Watts Writers' Workshop became something of a phenomenon, nurturing talent like Harry Dolan (the playwright), Marla Gibbs (the actress), and Anthony Hamilton (the musician from the Watts Prophets). According to Hamilton, "The Watts Writers' Workshop was one of the greatest workshops that's ever been on the West Coast.... It was like a hospital. You would see people stagger in, and you'd watch 'em for two or three weeks, and you'd see 'em walk out with their shoulders back and their head high, and they would be into something."[33]

The Writers' Workshop functioned as therapy for some people—people who had never even conceptualized themselves as writers were all of a sudden writing things down and sharing them. Kamau Daáood, who joined much later, called it a "tool for self-discovery." In 1968 when it opened a Westside branch in the Crenshaw district, he heard about it on the radio and decided to check it out. "I was already writing," he said, "but it was very unconscious." He never considered himself a writer until he found out that there were people who wrote. "You get a vague notion of writers," he said, "and I'm writing, so maybe that has something to do with me."[34]

For a lot of people, the workshop simply introduced the concept of personal expression. It was a community organization that encouraged an exciting kind of creativity. "It was a very rich environment," Daáood said, "it was very much like those cutting sessions you used to hear about in the early days of bebop, when the cats would come to the stage and they had to keep their stuff to a certain level or they'd get booed off. It was that kind of prodding and competitiveness. But there was a lot of helping and nurturing and bonds that took place, so it wasn't a vicious kind of competitiveness."[35]

By mid-1966 the workshop garnered massive media attention—the BBC requested readings, and several American television and radio stations requested appearances and press conferences with individual writers. NBC funded a documentary about the Workshop entitled *The Angry Voices of Watts*. Broadcast on the first anniversary of the revolt, Angry Voices "received more attention, provoking more phone calls and mail" than anything since "the telecast of the Johnson election."[36] Continuing with this media barrage, Columbia Records contracted some writing from the Workshop for an LP to be hosted by Sidney Poitier entitled "From the Ashes."[37] This in conjunction with Budd Schulberg's book by the same name helped construct a new identity for Watts—one that transcended the actuality of poverty and urban decay. However, despite this newly conceived global identity, the local existence of poverty was still very much a reality. The history of Watts, especially in the way that it is appropriated into the history of Leimert Park, is very much contingent on the negotiation between these local and global identities.

Despite all this attention, the Workshop completely disbanded before 1970. In the paranoid political climate of the late 1960s, the workshop was considered to be a subversive, militant organization that posed a threat to the government. The FBI planted agent provocateurs to keep track of its activity. Eventually, the Douglass House was

burned to the ground by one of these informants, and the Workshop was left penniless. In Daáood's words, "That was around the time that a lot of stuff started falling apart. And a lot of the original members had gone on. A lot of times, things just begin to dissipate. The Watts Writers' Workshop actually ended up becoming a group of people rather than an organization. And many of them kept in close contact—even today."[38]

The Watts Writers' Workshop established a community of artists in Watts and in the Crenshaw area that outlived the organization itself. The individual words of the writers in the Workshop changed the perception of post-1965 Watts from the National Guard–studded streets to an active arena of spiritual and cultural struggle. Because of the barrage of media attention, these writers became a central component in the nation's consciousness of racial conflict. Watts embodied the struggle; furthermore, the Workshop embodied Watts. Words of anger, resentment, and desire were broadcast across the nation as a form of street reportage. In addition to the powerful images of burning buildings, the nation was able to hear the angry musings of inside voices. The Workshop writer Harry Dolan, in his short prose piece "Will There Be Another Riot in Watts?" concludes with these words:

> And then—and then, God help us, for a man blind with injustice does not value worldly goods, for themselves alone, and so he will destroy and destroy and destroy until the ache in his soul has burned out.... No, there will be no riot in Watts; possibly, just possibly, Armageddon.[39]

Dolan draws attention to the severity of the issue, claiming that the uprising was more than just a fit of passion; it was just one of many symptoms of the cultural blindness toward "injustice." Dolan's words were important in giving a voice to the opposition to that injustice—not necessarily because his prose was so magnificent, but because his contentious words actually achieved a forum.

There were a few individual success stories to arise from the Workshop, but the real success was the tradition of poetry and verbal expression it helped to launch. The history of the Workshop is more indebted to the act of writing than to what was actually written. Like a kind of performance art, the writing that took place in the Workshop was a performative gesture that gave a voice to a community previously muted by racism.

And these are the voices that make up the history of Leimert Park. One could easily write a history of buildings and demographic shifts, but to truly understand the cultural geography of the area, it is important to trace the lineage of the art that defines the community. Kamau Daáood, who was trained in the Workshop, is now training young poets at The World Stage. "The workshop here is very strong," Daáood said of The World Stage. "The older members who were in the Watts Writers' Workshop with me, when they come in here, they say this is like the grandchild of the Watts Writers' Workshop." What has happened in Leimert Park, especially since the 1992 uprisings, is a reintroduction, in the style of the Watts Writers, to the power of location. There is a realization that identity is specifically tied to geography. When the dangers of "South Central" are reported nightly on the news, the work of defining one's own geography takes on a very profound importance in the pursuit of defining oneself.

Conclusion: New Media and the
Exhibition of Community

*You have all these rich communities here in Los Angeles, all these
diverse cultures and backgrounds, but the coloring of our minds stops
the exchange.*

—Kamau Daáood[40]

Hollywood has the ability to hide geography. The images that are produced within the
mainstream Hollywood system are less about the individual spaces represented than
about the global system of capitalist production that produces them. For instance,
Hollywood films are shot all over the world, but they are generally perceived as being
from Hollywood—as existing within an aspatial location of production. This aspatial-
ity of Hollywood is often conflated with the larger city of Los Angeles, thus creating a
difficult and contentious relationship between the global (Hollywood) and the local
(community). Local communities in Los Angeles are often created, therefore, in resis-
tance to global influences. Such is the case with Leimert Park.

This dynamic is best illustrated in the performance and teaching space of the KAOS
Network, a small storefront founded by Ben Caldwell in 1984. As an independent film-
maker, photographer, and teacher, his intention was to start a community-based media
institution that could serve as an alternative voice to Hollywood. Within a few months,
this became a reality. Video 3333 was located in a small storefront just around the cor-
ner from where KAOS currently stands (see Illustration 4.3). The idea was to introduce
neighborhood kids to the power and art of media, allowing them to produce film and
video, music, and graffiti art within the safe space of the studio. In 1990, after moderate
success, Caldwell moved to his current location and changed the name to the KAOS Net-
work.[41] As well as being an exhibition site for video art, painting, and photography, and
a performance site for poetry and hip-hop, the KAOS Network now operates as a com-
munity classroom. Caldwell teaches several classes a week on sound mixing and video
production. The second story of this small storefront is packed with high-end computers
and mixing boards—enough to teach hands-on classes of up to a dozen students at a time.

As with other locations in Leimert Park like The World Stage, the KAOS Network
is simultaneously devoted to performance and pedagogy. In the tradition of commu-
nity art, these things can never be separated. Community art, according to Daáood "has
a tendency to have much more potential then 'larger' art forms because commercial art
is driven by money and artistic decisions are made on the profitability of the project."[42]
By creating art concerned with pedagogy and not motivated by profit, the KAOS Net-
work is able to operate on a local level, thus actively engaging in the process of creat-
ing local meaning.

Out of KAOS, Caldwell pioneered a program for teenagers called "video imaging,"
where he allows kids to videotape themselves and watch it. Caldwell said of this
project—"It's a means for kids to see themselves instantly. They objectively see how
other people see them, [and] also [it's a chance] to be themselves and have fun. I call it

ILLUSTRATION 4.3. Video 3333: The innocuous storefront from which Caldwell runs the KAOS Network. Photograph by Eric Gordon.

a self-esteem machine."[43] Caldwell has used video conferencing technologies to link people of South Central to other parts of the world. He sees the possibility of these technologies working within Los Angles as well. "We can link gang members in the street to each other, to families, organizations, even other cities and nations. They can reach their goals through media. We've all just got to update our brains, and think of media as a new tool."

In fact, media has been the tool all along. From the music of Central Avenue to the writing of the Watts Writers' Workshop, some form of media or another has consistently transformed the local spaces of the city to the global spaces of imagination and culture. Ben Caldwell's emphasis on the use of new media as a means of exhibitionism is part and parcel of the same process that has streamed in and out of the history of Leimert Park.

I began this essay with a discussion of the need for local communities in Los Angeles to be exhibitionists. A community must exhibit itself, through the lens of local art or mainstream media, in order to produce and maintain itself. Leimert Park, through the work of several committed individuals, is actively engaged in this process. History, geography, and their media images are carefully integrated into the everyday life of the space. As a result, the community that is put on display is never stagnant—never fixed in a definition (see Illustration 4.4). It is always becoming; it is always garnering new meaning as it produces itself for exhibition each and every day.

In the early twentieth century, African Americans arriving in Los Angeles were forced to live along Central Avenue because of housing covenants. By the 1950s, when most

ILLUSTRATION 4.4. Vision: Community on display in Leimert Park.
Photograph by Eric Gordon.

other ethnic minorities were given some leeway in integrating into white neighborhoods, African Americans were the most vociferously excluded. Community, therefore, was forced into prominence by white racism. The same is true of the kinds of cultural production stemming from Watts after 1965. Leimert Park, although not built under the equivalent forced circumstances, is actively engaged in a similar construction of the local. As Budd Schulberg said upon seeing Watts in August of 1965, "There are many ways to build a wall and as many ways to level it and remove it." Perhaps the best way to level the walls of racism is to fortify anew. In Leimert Park, racism is confronted by fortifying community from the rubble of past barriers. The result is a walled community, but one that is constantly questioning the material from which the walls are erected.

Notes

Epigraph: Langston Hughes, *"The Negro Speaks of Rivers,"* in *The Collected Poems of Langston Hughes* (New York: Knopf, 1965).

1. Greg Hise, *Magnetic Los Angeles: Planning the Twentieth-Century Metropolis* (Baltimore: Johns Hopkins University Press, 1997), 15.

2. Gil Robertson, "Inside Leimert Park," *Black Enterprise* (June 1997): 336.

3. Esther Iverem, "At the Intersection of Art and Hope: The people of South-Central L.A.'s Leimert Park Village Are Building a Culture Community," *Washington Post,* 12 December 1997, D1.

4. Ibid.

5. Edward J. Boyer, "The Self-Prescribed Therapy of Dr. Rapp," *Los Angeles Times,* 3 April 2000, B1.

6. Kamau Daáood, personal interview, 19 April 1999.

7. Henri Lefebvre, *The Production of Space,* trans. Donald Nicholson-Smith (Oxford, U.K.: Blackwell Publishers, 1974), 88.

8. Quoted from Dagmar Barnouw, *Critical Realism: History, Photography and the Work of Siegfried Kracauer* (Baltimore: Johns Hopkins University Press, 1994).

9. Kamau Daáood, personal interview, 19 April 1999.

10. Lawrence B. de Graff, "The City of Black Angels: Emergence of the Los Angeles Ghetto, 1890–1930," *Pacific Historical Review* 39 (1970): 335.

11. Quoted from *Central Avenue Sounds,* a collection of testimonials from musicians with firsthand experience of Central Avenue. It documents the avenue from the beginning to its revitalization in Watts to its decline in the 1950s. See Clora Bryant et al., *Central Avenue Sounds: Jazz in Los Angeles* (Berkeley: University of California Press, 1998), 9–10.

12. De Graff, "City of Black Angels," 347.

13. Bryant et al., *Central Avenue Sounds,* 163.

14. Lonnie G. Bunch, "A Past Not Necessarily Prologue: The Afro-American in Los Angeles," in Norman Klein and Martin J. Schiesl, *Twentieth Century Los Angeles: Power, Promotion, and Social Conflict* (New York: Regina Books, 1989), 119.

15. Bryant et al., *Central Avenue Sounds,* 302.

16. Ibid., 289.

17. Jocelyn Stewart, "The Last Days of Horace Tapscott," *Los Angeles Times,* 24 March 1999, B1.

18. Bryant et al., *Central Avenue Sounds,* 301.

19. Stewart, "Last Days," B1.

20. Kamau Daáood, personal interview, 19 April 1999.

21. Kamau Daáood, "Leimert Park," from the CD entitled *Leimert Park* (Mama Foundation, 1997). Courtesy of the author.

22. Langston Hughes, "The Negro Speaks of Rivers." In *The Collected Poems of Langston Hughes* (New York: Knopf, 1965).

23. Kamau Daáood, personal interview, 19 April 1999.

24. Quoted in Gerald Horne, *Fire This Time: The Watts Uprising and the 1960s* (New York: Da Capo Press, 1997).

25. Budd Schulberg, *From the Ashes: Voices of Watts* (New York: Meridian Books, 1966), 2.

26. Ibid., 6.

27. Ibid., 9.

28. Anthony Hamilton, Interview for the "Watts '65 Project," Southern California Library, 1 October 1990.

29. The writers from the workshop published in Budd Schulberg's *From the Ashes* include: Harry Dolan, Alvin A. Saxon Jr., Jeanne Taylor, Jimmie Sherman, Guadalupe de Saavedra, Johnie Scott, Vallejo Ryan Kennedy, Ernest A. Mayhand Jr., James Thomas Jackson, Fannie Carole Brown, David Reese Moody, Edna Gipson, Emmery Evans, Blossom Powe, Sonora McKeller, Harley Mims, Leumas Sirrah, and Birdell Chew.

30. Schulberg, *From the Ashes,* 19.

31. Ibid., 19.

32. Hamilton, Interview for the "Watts '65 Project."

33. Ibid.

34. Kamau Daáood, Personal interview. April 19, 1999.

35. Ibid.

36. "Accomplishments of Douglas House," October 1967, folder 4010, box 469, Rockefeller Archives; *New York Times*, 20 February 1967.

37. This title was taken from a book by the same name, edited by Budd Schulberg in 1967, of prose, poems, and plays from many of the Watts Writers.

38. Kamau Daáood, Personal interview, 19 April 1999.

39. Harry Dolan, "Will There be Another Riot in Watts?" In *From the Ashes*, ed. Budd Schulberg (New York: Meridian Books, 1966), 35.

40. Kamau Daáood, Personal interview, 19 April 1999.

41. Video 3333 still exists as the artist-in-residence branch of KAOS.

42. Kamau Daáood, Personal interview, 19 April 1999.

43. Ben Caldwell, Personal interview, 5 April 1999.

Claudine Isé

5 Considering the Art World Alternatives: LACE and Community Formation in Los Angeles

Introduction: Alternative and Artist-Run Exhibition Spaces

Since 1978, Los Angeles Contemporary Exhibitions (LACE) has served as one of the premiere nonprofit spaces for the exhibition of cutting-edge contemporary art in Los Angeles. During the past twenty-five years, LACE has presented the work of more than five thousand artists in three thousand exhibitions, from conceptual, performance, site-specific, and multidisciplinary art, to work that experiments with digital and interactive media. LACE was one of the first spaces in Los Angeles to regularly exhibit video and performance art, and has housed other community cultural initiatives. A crucial array of local and international artists have exhibited work at LACE, often at the starting points in their careers.

This essay traces the origins and development of LACE and gives an account of the communities that have formed around it. Throughout this essay, I will explore the idea of "community" as it pertains to artists in Los Angeles who have participated in exhibitions or programs at LACE. I will focus primarily on the first decade of LACE's existence when the organization was, by all accounts, in its creative and financial heyday. During this time, LACE was a center of community activity, bringing together artists with diverse aesthetic interests and approaches along with members of the general public who were interested in experimental contemporary art. LACE's founders, a core group of twelve artists from various ethnic and socioeconomic backgrounds and aesthetic interests, started the organization as a means of providing increased exhibition opportunities for artists throughout the Los Angeles region. They aimed to create a space

for exhibiting all types of media, with an emphasis on the experimental and innovative. Artists who worked with LACE were critically engaged in questioning the modernist canon, and their underlying aesthetic and political impulses had found a center, if you will, that actively promoted experimental forms of art.

The communities that formed around LACE have been primarily made up of artists, writers, musicians, and performers. These communities of artists often intersected with other communities, such as the Chicano working-class community; punk rock performance artists, poets, and musicians; homeless artists; students and other youth; AIDS activists; and free-speech advocates. LACE's ongoing activities included exhibition programming, symposia, "town hall" style meetings, and community access programs, all of which helped delineate various communities and bring them together. In its early years, LACE was known for attracting diverse crowds to its opening receptions and exhibitions—L.A. artists and punk rock musicians, poets, and writers as well as Eastside gang members, straight-laced museum types, and ordinary working people.

The artistic communities that formed around LACE were largely identified through their interest and involvement in alternative art practices, in particular, video and performance art. Artists who exhibited work at LACE were given a rare opportunity to push the boundaries of traditional artistic media and were encouraged to make art that was socially or politically provocative. For example, Karen Finley, a member of the "NEA Four," presented "Yams Up My Grannie's Ass" at LACE in 1986. In this notorious performance piece, Finley smeared yams across her nude buttocks while relating the story of a drugged-out youth abusing his grandmother during a Thanksgiving holiday dinner (Illustration 5.1). Her work, along with that of three other artists, subsequently scandalized the NEA; and the four artists' grant awards were rescinded on the grounds of "indecency." A heated national dialogue surrounding "obscene" art, the role of government funding of the arts, censorship, and freedom of speech culminated in the *Finley vs. the NEA* Supreme Court case. Hence, LACE served as a key local exhibition site for art that subsequently ignited national agitation.

Although the artistic communities that formed around LACE have shared an interest in presenting experimental work in various media, beyond that the commonalties fragment into a range of competing and sometimes conflicting interests. From the moment of its inception to the present day, LACE has been an ideologically contested space. The organization's core group of founders frequently disagreed over the nature and direction LACE should take and the specific communities it should serve. From the beginning, the question of what an artist-run "alternative" space should or could be spurred passionate debates among its founders, and LACE has consistently been both praised and criticized for carrying out its original goal of fostering a uniquely experimental space open in unprecedented ways to the creative process.

The rise of alternative and artist-run exhibition spaces during the mid-1970s and 1980s coincided with the rise of postmodernism as an aesthetic and cultural category, which itself reconfigured conceptions of both exhibition space and artistic communities. With respect to exhibition space, performance art and site-specific installation art increased, a development that shifted the locus of creative activity from the lone artist

ILLUSTRATION 5.1.
Karen Finley, "Yams Up My Granny's Ass" (17 October 1986), performance still. Image courtesy of and copyright © Los Angeles Contemporary Exhibitions.

to a shared creative and interpretive process between artist and audience. Artists began to critically examine the spaces where their art circulated, and often to subvert the privileged role that museums and commercial art galleries played in canonizing culture. With respect to artistic communities, the new emphasis on the personal and everyday aspects of artistic production, along with the determination that art should cease being an elitist activity, prioritized the art of marginalized communities.

For example, to commemorate its ten-year anniversary in 1988, LACE presented an exhibition titled "Re: Placement" (March 3–April 17, 1988). Co-curated by then-executive director Joy Silverman and former LACE director Marc Pally, the exhibition aimed for a wide-ranging critique of "the institutions that 'present, preserve and develop the arts'—including itself."[1] Artist Liz Larner created "Corner Basher," a motorized ball-and-chain mechanism that swung around and bashed into the gallery's walls. Visitors could control the action through a dial mounted on a nearby wall panel. Artist Jeffrey Vallance cut four holes in the gallery walls and covered them with glass, mounting the view with a gilt-plated frame. For L.A. Times arts writer Suzanne Muchnic, the show revealed "LACE's dirty underwear: an elevator shaft, a janitor's closet, a dark storage area and a room of electrical equipment. Vallance shows us what makes the building run behind its public face, but he also pulls off a wry commentary on the Renaissance notion of painting as a window on the world."[2] "RE: Placement" explored the ways artists criticize and analyze institutional frameworks and systems within the

art community, including those alternative spaces that often provided the sole forums for this type of questioning and critique.

In his 1988 essay "Historic Issues of Artists' Organizations," Renny Pritikin, former executive director of New Langton Arts in San Francisco, describes the history of spaces like LACE as "one of a constant interweaving of reactions to issues within the larger culture, including especially that culture's political developments."[3] The impetus to create alternative and artist-run exhibition venues emerged out of a range of 1960s-era democratic movements, such as the Students for Democratic Society, whose ideas about self-determination, consensual decision making, participatory democracy, and separatism provided the founding principles on which these organizations were based. Pritikin also notes that "one of the more successful analyses to come out of this field in its early moments was this identification of the artist's role in the art world as disenfranchised, passive, victimized; this was a political condition; and that the way to address this oppression was to create autonomous, effective artist-centered and artist-controlled organizations."[4]

Paralleling the rhetoric of the Civil Rights Movement, artists were identified as a minority or subaltern and in some ways oppressed community, struggling to achieve political agency like minority ethnic communities. As a result, wrote Pritikin, "artists' organizations dedicated to the support of particular cultures were founded, and artists' organizations founded by white middle-class artists embraced a greater openness to a wider array of art-making practices, especially of a political nature, than any previous arts organizations."[5] Joy Silverman, LACE's executive director from 1983 to 1990, noted that the goals of artists' organizations during this time "were about serving artists first and foremost, and serving the needs of artists, first and foremost. Artists would have a say on every level."[6] The idea was that "alternative" spaces should be established so that an artist's survival did not depend solely on the sale of objects on the art market.

A Pre-History of LACE: The CETA Artists Program

LACE was founded in 1977 by an eleven-artist collective originally hired by the Comprehensive Employment Training Act (CETA) community arts program in the city of El Monte, near East Los Angeles. About a year later, several others joined the group while others left, so that the thirteen CETA artists who ultimately founded LACE included Bill Fisher, Robert Gil de Montes, Harry Gamboa Jr., Gronk, Richard Hyland, Joe Janusz, Marilyn Kemppanien, Sarah Parker, Ron Reeder, Alexandra Sauer, Barry Scharf, David Scharf, and Nancy Youdelman. Dan Flaming, assistant director of the El Monte Service Center at the time, remembers a "fairly humanistic effort underway in terms of human services."[7] A summer mural painting program was inaugurated, with the aim of encouraging youths to paint murals rather than graffiti on walls. Many significant local artists, especially from California State University at Los Angeles (CSULA), led the year-round mural program. Additional artists were hired from the Otis Parsons School of Design, CSULA, and California State University at Fullerton. Collectively, the

artists decided to open a small community gallery in the El Monte Service Center. "The idea was that the artists would be a source of information about the community, to the community. [The gallery] was meant to kind of mirror the community to itself," says Flaming.

The artists had weekly meetings to make decisions about the gallery and its programs by democratic consensus vote. Artists also presented their work to each other on a weekly basis, receiving constructive comments and sometimes harsh criticism from their peers. The fact that CETA program artists were from widely diverse socioeconomic backgrounds with varied artistic interests contributed to the frequently argumentative debates. While Gamboa Jr. and Gronk, for example, were already well known both internationally and within the L.A. Chicano community for their performance work in the Asco collective (described later in this essay), many of the other artists were students from Otis, Fullerton, and other local art schools. An inconsistency in the county's salary scale produced a pay-scale discrepancy. The group debated the issue and made a collective decision to channel portions of higher salaries into a collective fund from which all of the artists could draw to purchase materials and art supplies. It did not go smoothly. Ron Reeder recalls, "We had these horrible meetings every week, trying to get thirteen artists to agree on one thing. We were voting on what color toilet paper to have. It got to be this political infighting. But it was an interesting study in politics."[8]

Problems between CETA artists and the city of El Monte arose when several murals painted by CETA artists angered some in the local community. The most controversial instance occurred when Gronk and Robert Gil de Montes painted a mural on the exterior of a shoe store depicting a revolutionary Mexican woman with bandoleros crossing her chest, carrying a rifle. In her other hand she held a bleeding rose. Although the shoe store's owner, who was himself Hispanic, liked the mural, many of the other local business owners took offense, believing that the mural was intended to stir up insurgency. The mural was quickly whitewashed.

Ironically, it was a far less politically charged mural—a mural that was ultimately never executed—that caused the city of El Monte to take drastic action. Rob Reeder and Joe Janusz came up with an idea for a mural to be painted on the back of an El Monte movie theater that satirized political infighting within the community. It was to depict Godzilla looking down on the Valley Mall while El Monte citizens, instead of banding together to fight the monstrous threat, split in chaos. What a divided El Monte needed, Reeder recalls, was "a swift kick in the pants.... The Chicanos were one group, the businessmen were another.... The white people considered themselves to be original settlers ... [with] all this bickering and infighting constantly." Reeder and Gil de Montes received permission from the theater owner to move forward and took their proposal to El Monte's design review board and city council. The design review board rejected the idea and the city council voted to ban mural painting altogether.[9]

In the Fall of 1977, after the El Monte Service Center gallery had been open for approximately a year, the CETA artists decided they wanted a larger exhibition space to accommodate an increasingly adventurous artistic agenda. Flaming found a 7,700-square-foot space located above a bridal shop in the abandoned Victor Clothing building

ILLUSTRATION 5.2. LACE Building, 230 S. Broadway, Los Angeles.
Photograph by Harry Gamboa Jr., © 1977–1979 Harry Gamboa Jr.

on 240 South Broadway in downtown Los Angeles. The space used to house a taxi dance
hall, fully equipped with a bar and sparkly ceiling (see Illustration 5.2). Harry Gam-
boa Jr., who at that point had just been hired as a CETA artist and who was assisting
in the building's renovation, remembers that when he first saw the Broadway space it
had been abandoned for fifteen years with the windows left open. It needed a lot of
work. "There was possibly a foot and a half high of soot extending 7,700 square feet.
All of the walls were bare. It looked like a lunar surface."[10] Apart from Joe Janusz, Bill
Fisher, Richard Hyland, and Ron Reeder, the artists had little or no background in con-
struction work; nevertheless, they carried out the renovation from scratch, extending
the spatial work and character of the artistic collective.

Culture Clash: Early Conflicts During
LACE's First Years

The first exhibition presented in the newly renovated LACE gallery was a group show
titled "LACE Artists" (January 9–28, 1978). Marilyn Kemppainen, one of the thirteen
co-founding artists, came up with the name for the space: Los Angeles Contemporary
Exhibitions, with the acronym LACE, a reference to the gallery's geographical location

within the downtown bridal shop district. At that time the thirteen CETA artists had equal authority and were considered co-directors, taking turns in organizing exhibitions. Gamboa had hoped that LACE would be a space where the work of Chicano artists would be regularly exhibited, but he says he remembers only a few exhibitions in LACE's history that specifically met those goals. He recalls:

> I had a show called "No Movie" [May 2–31, 1978, featuring a performance by the Chicano artists group Asco[11]] which turned out to be the only Chicano show they ever had there. I felt it was successful because the show was able to bring in more of a Chicano community together with the broader community. These kinds of things just didn't happen back then. You just could not get separate groups together, due to racial tension, social tension. You couldn't get people to go east of La Brea and west of the L.A. river.[12]

The vibrant mix of different communities was one of the primary reasons why LACE's early exhibition programs were so innovative, fresh, and exciting. Yet the "culture clashes" sometimes resulted in tension and conflict. It was cultural utopia or mindless anarchy, depending on your point of view.

Gamboa, for example, remembers one exhibition in particular as the apotheosis of the alternative ethos, the Dreva/Gronk show assembled by Gronk, "Dreva/Gronk 1968–1978/Ten Years of Art and Life" (March 9–19, 1978), a collaboration between

ILLUSTRATION 5.3. NO MOVIE Exhibition at LACE; pictured left to right, works by Patssi Valdez and Harry Gamboa Jr. Photograph by Harry Gamboa Jr., © 1977–1979 Harry Gamboa Jr.

ILLUSTRATION 5.4.
LACE Exhibition Recep-
tion, 1979; pictured left
to right, Cindy Herron,
Harry Gamboa Jr.,
Gronk, Willie Herron.
Image courtesy of and
copyright © Los Angeles
Contemporary Exhibi-
tions.

Gronk and Milwaukee artist Wiz Dreva based on their artistic life over the previous
decade:

> It brought people in from all walks of life—wealthy, famous types of people to gang mem-
> bers to people that were in the early punk scene. At one point there were four punk bands
> playing simultaneously in the four corners of the building. Gronk had put a lot of work on
> the wall and everybody stole it. . . . The police came in and cleared everybody out. I thought
> it was a big success because the mix of people included writers and different types of peo-
> ple that could talk about LACE to a wider public. Because the event was such an incredi-
> ble spectacle, [the newspapers] all wrote about it.

For Dan Flaming and some of the other artists, on the other hand, property damage
didn't signify a healthy spirit of anarchy or savvy media-manipulation. It was simply
disrespectful:

> There was red wine thrown all over the white walls. The place smelled bad. . . . Physical
> damage of the space really took the other members aback. So there were definitely differ-
> ences in people's sense of how we ought to conduct ourselves. . . . Trashing the place did
> not fit the model.

The different perspectives point to much larger fundamental ideological and political
differences between the Chicano artists and the artists coming from middle-class or art
school backgrounds; and inevitably the thirteen artists' very different socioeconomic
backgrounds, sets of experiences, skills, and goals often led to conflicts among them.
For Gamboa, these conflicts were in part expressive of racial tension and different cul-

tural trajectories. Not all of the artists had participated in the gallery structure, and therefore they did not attract or seek the typical gallery audience. Gronk and Gamboa, in fact, frequently circulated exhibition flyers at bus stops, seeking workers, students, and the people of the streets.

Dan Flaming's memories confirm a certain uneasy coexistence between the Chicano and non-Chicano artists. When Gronk painted a mural in El Monte, it was met with puzzlement by some of the non-Chicano artists, who did not readily view the mural as art. The Anglos were also perplexed by what they saw as "morbid" cultural celebrations like Day of the Dead, or the determined nonmaterialism of Gronk's work on handkerchiefs, which seemed self-consciously amateurish. Pinpointing valid countercultural artistic practice within this shifting political landscape, then, was much easier to debate than to practice.

Ironically, it was precisely the act of melding art and life, and politics and aesthetics, that motivated Gronk, Harry Gamboa Jr. and the Chicano art movement as a whole.[13] "Chicano art," writes Philip Brookman, "evolved in opposition to the predominant cultural matrix of museums, galleries, universities, and publications. Artists working within or parallel to the Chicano Movement developed an ideology of cultural realism, reflecting the social, rather than the perceptual, nature of art."[14] This ideology and accompanying realist aesthetic existed in contrast to the ideas motivating conceptual art, which was still the reigning influence in artistic practice at that time.

Gamboa's previous involvement in protests such as the infamous 1970s Chicano Moratorium—an anti-war protest after which *Los Angeles Times* journalist Reubén Salazar was killed by a tear gas projectile fired by a sheriff's officer—caused him to reassess the relationship between art, politics, media, and everyday life. The tactical results were both aesthetic and spatial. The politicized theater he envisaged was to generate public hysteria, if not myth; and the politicized artist should seize unconventional spaces such as private homes and the streets for alternative art precisely because marginalized groups were systematically denied a physical venue or building. In late December 1972, Gronk, Herrón, and Gamboa defiantly spray-painted their names on all of the entrances to the Los Angeles County Museum of Art (LACMA) after a museum curator there responded negatively to their inquiries about the inclusion of Chicano artists in the museum's exhibitions. Their spray-painted signatures were a seminal moment in Los Angeles art history—three simple, yet profoundly radical gestures that were whitewashed less than twenty-four hours later.

It is not difficult to see why the Chicano artists would view LACE's move toward becoming a mainstream nonprofit institution with deep suspicion. As a result of their sophisticated understanding of the complex political interrelationships across art, media, activism, and everyday life, Gronk and Gamboa believed mainstream institutional space to be merely the placeholder of the status quo. To counter the status quo, LACE would have to risk reputation, safety, and donors. Gamboa and Gronk wanted LACE to be as open and experimental as possible; whereas Reeder, Flaming, and some of the other artists believed strongly that, in order to develop and grow, LACE had to maintain clear and well-structured administrative and programmatic goals. The main tension, then,

coalesced around progressive artistic practice and nonprofit institution format, where a board of directors and conventional fundraising rules would provide a viable future for the organization.

Recollections diverge about how LACE ultimately opted for a more traditional non-profit format. Marc Pally, who assumed the post of gallery manager in 1978 and in the following year became LACE's first executive director (a post he held until 1983), noted that in order to receive grants and other essential funding it was critical not only that LACE remain artist-run, but that it also be well administered: "We had a banker on the board of directors, we had very reputable people on the board, we had a major accounting firm do our taxes every year *pro bono,* we had very sound books, etc."[15] In contrast, Gamboa recalls the move as something of a hostile takeover. LACE's bylaws subjected the artists to the rule of the gallery director, who could and apparently did fire everybody upon assuming the post.

Despite growing tensions among the CETA artists, LACE continued to blossom into a showcase for cutting-edge contemporary art, with an emphasis on performance and video. During Marc Pally's tenure (1979–1983), LACE featured exhibitions by a number of important artists who were at that time at the starting points of their careers: Eric Bogosian ("Men Inside," a performance on January 26, 1982); Paul McCarthy ("Monkey Man," a performance at Down Town Los Angeles [DTLA] on May 19, 1980, and "Humanoid," a piece where McCarthy created a humanoid that was cared for, fed, cleaned, and protected by a group of individuals); Mike Kelley ("The Parasite Lilly," a performance at LACE on May 9, 1980; and "Confusion: A Play in Seven Sets, Each Set More Spectacular Than the Last," January 17–18, 1983, a narrative performance at the Pilot Theatre); Tony Oursler ("TV Shows/Diamond Head and Loner," January 19 and 26, 1980; and "The Tony Oursler Show," October 9, 1983, a showcase of Oursler's videotapes); and Lari Pittman's first solo exhibition ("Sunday Painting," June 9, July 9, 1982). Other exhibitions included "Video At LACE" (October 20–21, 1979), featuring a marathon viewing session of fifteen artist's works, as well as open events like "Bring Your Own Film Night" (September 12, 1980).

Pally remembers that for a few years there was a "huge" downtown commercial art scene and a thriving downtown cultural scene in general, of which LACE was the linchpin. Cirrus Gallery, located in the same spot as it is today, on Alameda Avenue, was one of the first downtown commercial galleries. During this time, *High Performance* magazine shared space with LACE in the Victor Clothing building on the fifth floor. Pally notes that although they were neighbors, LACE and *High Performance* didn't often collaborate, except in one memorable instance where the two organizations coproduced a major performance festival series called "Public Spirit/Live Art L.A." (Part One: May 9–25, 1980, and Part Two: October 1–31, 1980).

Also during this time, the downtown Woman's Building provided an important showcase for feminist art. The Wallenboyd Building near the Midnight Mission on skid row was a significant focal point of downtown activity during the early to mid-1980s. It housed the Wallenboyd Theater, a center for experimental theater and performance art pieces; the Stella Polaris Gallery and the Brantner Design Center, owned by Cheryl

Brantner, presented jazz and classical concerts there. When the building changed owners and rents were raised in 1985, however, Brantner's rent almost tripled, and she moved her company to the Westside and reduced her involvement in producing musical performances. The Stella Polaris Gallery moved to Beverly Hills and later closed its doors permanently. For similar reasons, the Wallenboyd Theater closed in November 1988.

Another critical nexus of the downtown scene was Al's Bar, located on 712 Traction Avenue, east of Little Tokyo. Al's was run by Marc Kreisel, one of the early pioneers of the downtown loft scene in Los Angeles. He bought a saloon formerly owned by Alfonso Vasquez for $4,000 in 1979 to help create a sense of community downtown: "a place where artists could get together and socialize," Kreisel explained to a *Los Angeles Times* reporter in 1989. He also envisioned the bar as "a money pump" that would help pay the costs of running a gallery. Al's Bar sponsored the nearby American Gallery, a cooperative venue set up by Los Angeles artists to exhibit their work. Al's featured performances of theatrical plays and musicals during evenings that were dubbed "Al's National Theater," as well as a "No Talent Night" every Thursday, which Kreisel described as "a kind of Gong Show of the avant-garde" in which off-the-street performers could do anything they wanted short of breaking the law.[16]

Like so many other cultural institutions that thrived during the early 1980s, LACE "was a wonderful marriage between an institution and a moment in time," says Marc Pally. One of LACE's biggest strengths was its ability to attract Westside art patrons to downtown grunge. The prevailing spirit gave art in L.A. a certain muscularity, empowering artists and gallery people and generating the feeling that the area could ultimately create a scene as robust as Soho.

In 1983 Joy Silverman succeeded Marc Pally as executive director of LACE. Silverman emphasized LACE's role within the surrounding community, arguably with more success than any other LACE director before or after her. For Silverman this meant forging links between the immediate downtown scene and the Los Angeles community at large: "I wanted to bring some sense of community to a place that found it difficult to make community.... So one of the first projects that I did was the Cotton Exchange Show. It was about bringing together a community in a variety of different ways."

For the "Cotton Exchange Show—106 West 3rd Street" (April 27–June 2, 1984), more than two hundred artists, working in all media, transformed an abandoned commercial building on 106 West 3rd Street into an art environment. This ambitious, monumentally scaled exhibition brought together local businesses, community redevelopment agencies, homeless people, service providers on Skid Row, downtown artists, and artists from throughout the city. As a result, "a gigantic sense of community formed," Silverman recalls. "There were marriages that came out of it, there were partnerships of all different kinds." The organizers combined the exhibition with LACE's ongoing events, such as open studio tours and an annual festival of downtown arts organizations. LACE held the Cotton Exchange Show opening at its 240 South Broadway Building. Approximately three thousand people attended the opening, which featured performances by a number of well-known bands just gaining a foothold in the music industry and performances by prostitutes and homeless artists, all in an effort

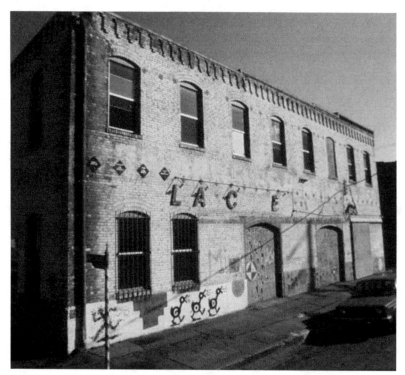

ILLUSTRATION 5.5. LACE Building, 1804 Industrial Street, Los
Angeles. Image courtesy of and copyright © Los Angeles Contem-
porary Exhibitions.

to recognize the fact that "community" meant something larger than just the art com-
munity and its own relatively narrow interests.

In 1986 LACE moved to 1804 Industrial Street, a two-story, 13,200-square-foot
facility located in the heart of the downtown produce district (Illustration 5.5). The
building was largely paid for by a loan from the Community Redevelopment Agency
(CRA).[17] This venue had more than twice the space of the Broadway site. Silverman
saw the new space as complementing—indeed, furthering—her vision for the organi-
zation, which was "to give equal representation to every form of media." In a 1986
interview with the Los Angeles Times, Silverman explained the relocation as "a move
to where many artists now are," and as "a way to make LACE more easily accessible
to artists and their audiences. This is a highly populated artists' area, and it's right off
the freeway."[18]

A sprung floor was installed on a 3,000-square-foot performance space, along with a
500-square-foot video screening room designed and built by artist Jim Isermann, the first
of its kind in Los Angeles. The new facility included 3,000 square feet of exhibition space
and free street parking, obviously a crucial element in attracting Angelenos from vari-
ous locations throughout the city. LACE also opened a 500-square-foot bookstore, which

soon became an acclaimed venue for artists who published books, book-works, and other products as well as an educational source for audiences who wanted to learn more about the experimental work. LACE opened a cafe and created work/living apartments for four artists. Silverman also noted the desire to include a laundromat for local homeless people, but the CRA mandated artists' housing and studio space instead.

LACE, the Video Art Community, and Its Relation to Industrial "Hollywood" Culture

LACE became a vibrant community center, with the facilities to foster an impressive range of activities. The expanded facility allowed the organization to host weekly screenings of experimental films through the organization Filmforum, which had lost its own permanent exhibition space. Such programming complemented and enhanced LACE's already-established reputation as one of the premiere showcases for video art in Los Angeles and across the country. LACE then debuted two new programs, "LACE On-Line," which offered professional video editing facilities at a low cost, and a grant program for multidisciplinary projects.

LACE inaugurated the new Industrial Street space with an exhibition curated by artists John Baldessari and Bruce Yonemoto titled *TV Generations* (February 21–April 12, 1986) (Illustration 5.6). The show explored the ways artists have addressed the culture of television and electronic media. Yonemoto, chair of LACE's video committee at the time, told the *Los Angeles Times* that the exhibition intended to "reconceptualize TV so we can redefine the relationship of the viewer to the content [of TV] and see that it can have a different meaning than it does in our living rooms. . . . In order to change the way we look at TV or what we expect from it, we have to disassociate ourselves from the relationship or somehow rupture that relationship."[19]

The *TV Generations* exhibition provides a specific example of how communities formed by grassroots popular culture—such as the artists' communities growing with LACE during this time—redeploy industrial cultural practices, that is, those of Hollywood. The film, television, and music industries, collectively referred to as "the entertainment industry," dominate the Los Angeles cultural landscape. LACE, with its "regularly scheduled programs" of experimental visual art, music, video, and film, demonstrated that avant-garde or "alternative" artistic communities were developing a range of sophisticated strategies for deconstructing and critiquing mainstream media culture and the entertainment industry as a whole, a fact that the Asco collective had also demonstrated a decade and a half earlier. In his interview with the *Los Angeles Times,* Yonemoto noted that many of the artists he selected for the *TV Generations* exhibition were involved in "actively trying to discredit TV, showing it is a monolithic structure which manipulates our lives for economic or sociological control."[20] They were, in effect, counter-programming mainstream media culture.

TV Generations exemplified the many ways in which artists' communities used video and other media formats to critique and dis-empower television as a dominant cultural

ILLUSTRATION 5.6.
TV Generations exhibition, installation view: works by Jim Shaw. Image courtesy of and copyright © Los Angeles Contemporary Exhibitions.

force. More specifically, LACE's reputation as a mecca for video art also established a community of video artists whose goal was to question, critique, and subvert the dominant ideologies fostered by the television and film industries. To allow for the presentation of even more video art, starting in February of 1986, LACE began to continuously program video art in its 25-seat screening room during its regular business hours. Anne Bray, LACE's video program coordinator, who organized all of the organization's video activities during this time, said that although the Long Beach Museum of Art had been showing video art for a decade, "video artists either had to be working for the entertainment industry or connected with a school to produce their work. We're providing a way to show videos and a means of making tapes so the medium can flourish here."[21] The new space allowed for the separation of video art from the temporary exhibitions, and thus a thriving cultural center was established.

Unlike the mainstream entertainment industry, LACE's submission process was open and democratic. In order to show videos in the screening room or main gallery, artists were told to submit a sample tape to the six-artist video committee who made selections. Submissions were accepted from anywhere in the world. In an interview with the *Los Angeles Times*, Bray estimated that LACE's move to its new location dramatically increased the audience for video art. "Probably ten times as many people have come through to see videos than before the move [to Industrial Street],"[22] she noted. Bray also observed the effect that LACE's video program had on the Los Angeles art scene and the community at large. The video openings were lively and well-attended, and the

audience often requested further details about the productions, from camera models to aesthetic technique. In essence, the video programs offered not only an alternative city venue but a more intimate interaction with the video work itself.

Silverman emphasized that one of the major factors in establishing LACE as an integral part of the urban fabric was the fact that it provided a space for the creation and presentation of so many disparate art forms at once—visual arts, dance, performance art, even literature and new music. "Here, in one place, were all of these different communities of artists," she says. "There was a lot of collaboration at the time, too, in terms of performance work. Visual artists collaborating with new music composers, choreographers, performance artists. They could all feel like they were being treated equally in our space."

LACE and the Homeless Community

Silverman, a lifelong advocate for freedom of expression in the arts who describes herself as "extremely politically active," also upgraded LACE's position as a community forum for political discussion. She formed the L.A. Coalition for Freedom of Expression, held at LACE, and Artists Against Homelessness, a fund to redress and include the downtown community. "I started a bunch of programs that I tried to keep out of the limelight, that served the community but weren't about LACE first and foremost. It was about community first and foremost." Though low-profile, Silverman's agenda was to serve the community in ways not exclusively beneficial to LACE.

LACE's Skid Row Artist's Fund provided artists with up to $25 monthly in art supplies. In 1990, LACE added an adjunct feature to the program, "Art From the Streets," which provided rotating lobby exhibitions for homeless artists. Coordinated by Adriene Jenik, LACE's video curator at that time, the program was intended to demonstrate that homeless people were creative and could make "serious art." Roark Art Supplies downtown provided supplies below wholesale to LACE, which then distributed the supplies to homeless artists on a monthly basis.

Supplemented by a $5,000 grant from the city's Cultural Affairs Department, LACE began offering weekly art classes taught by visiting artists at the Homeless Outreach Program offices in the summer of 1990. The Homeless Outreach Program also provided storage space for homeless artists to keep their art and supplies.[23] "We began the artists' fund basically because of where LACE is situated," Jenik told the *Los Angeles Times* in 1990. "Skid Row and [its] community members are certainly a part of our community."[24] She characterized LACE's ultimate goal as helping the Skid Row artists attain a space of their own. Most of these artists had been meeting regularly at "Another Planet," a well-known Skid Row cultural center formed by several homeless artists in an unused garage, but the building burned down in August 1989, leaving homeless artists without a space to create, to come together, and to exchange ideas and support as a community.[25]

An exhibition of work by homeless artist Frank Parker at LACE helped to identify and delineate the large pool of creative talent right outside LACE's doors.[26] Parker was

one of more than thirty artists who participated in the Skid Row Artists' Fund. His studio space consisted of a large concrete and brick storage space adjacent to an unused loading dock in an old building in the Skid Row area. He worked as a handyman in exchange for this small studio/living space located in the old Wallenboyd Building. There Parker created a number of mixed-media pieces made from Scotch tape and colored telephone wire woven together, some of which could be worn as jewelry, along with larger sculptures made from found objects such as rusted mattress springs.

Silverman notes that LACE staffers also worked behind the scenes with homeless service organizations to provide basic, non-art-related needs to the surrounding community. Even though homeless encampments lay in the middle of the produce district, families were going hungry. LACE spoke to local produce merchants, who, upon realizing the situation, quickly donated food. Despite the unrecognized vibrancy of the homeless community—they published their own newsletter, *The City*, for example— it lacked a liaison like LACE to match providers and provisions with those in need. Silverman points out that LACE's involvement in the Homeless Artists Fund and other homeless outreach programs was never highly publicized until after she resigned from LACE in February 1990. "Nobody knew about that stuff except the individuals that I asked to fund it, the art supply place, and the homeless people themselves, except when we displayed their work, or when the homeless writers coalition wrote outside on LACE's walls for a few months," says Silverman.

Reports published in the *Los Angeles Times* cited LACE's deep financial woes under Roberto Bedoya's short-lived tenure in 1990-91 as the reason that LACE was eventually forced to cut the Homeless Artist Outreach Program from its roster. In an effort to save the Skid Row Artists Fund, a group of homeless artists and writers staged a benefit performance of the play "That Final Hit" at LACE on July 6, 1990. Unfortunately, it was to no avail; without Silverman at the helm to maintain LACE's commitment to the program, the Homeless Artists Fund disappeared, and the community dynamic died.

When asked why the strong sense of community that LACE once fostered seems to have dissipated in the years following her tenure, Silverman surmises that, when she oversaw LACE's multidisciplinary arts programming, "it was never just about bringing people in from other cities and giving them this big venue. It was about always giving back to the community in which we lived. Well, [the leadership that came after Silverman] abolished just about everything. They got rid of the video screening room, they got the new building [on Hollywood], everything." The lesson to be learned from this is that without the physical space designated for various programs, exhibitions, and community activities, the structural support for artistic activity and community building inevitably perishes.

The (Multi) Culture Wars: LACE Weathers the 1990s

In February 1989 Silverman took a sabbatical from her directorship at LACE, and approximately one year later, she resigned in order to start the National Campaign for

the Freedom of Expression. Under her leadership, by 1989 LACE had grown from an annual operating budget of $90,000 to nearly $800,000.[27] Three months after Silverman's official resignation, LACE's board hired Roberto Bedoya, a poet, playwright, and former president of the National Association of Artists' Organizations, as the new executive director. His appointment was viewed as a response on the part of LACE's board to criticisms of underrepresentation of people of color. In an interview with the *Los Angeles Times,* Bedoya stated that his appointment was "a signal. It's no longer a Euro-centric world, or a Euro-centric Los Angeles, and LACE has been behind in recognizing that. I think my appointment says, 'Here is Roberto Bedoya, a person in charge of a multidisciplinary arts organization, and he's a person of color. . . . It has to do with giving more people access to the organization. If you want to have more (multicultural artists) represented in your programming, you do that by putting their peers in decision-making positions."[28]

A scant seven months later, however, LACE was in deep financial and organizational crisis. LACE's entire, eight-person paid staff drafted a two-page memorandum to the board stating their lack of confidence in their director, which they described as "a desperate call for action." In it, LACE staffers warned of a cash-flow crisis, a looming missed payroll, and "an untenable budget and little to no fiscal management" on Bedoya's part that served to worsen "a time of great flux and instability" for the now-struggling alternative arts center. The memo was seen as a direct assault on Bedoya. "Roberto's response [to the financial crisis] has been to further isolate himself and, as a result, LACE," the *Los Angeles Times* reported the letter as stating. "It has become the consensus of the staff that Roberto is not prepared to successfully fulfill the position of executive director. We are unable to watch passively."[29]

Nine days after the board received the memo, Bedoya was fired. In the wake of his exit, LACE was forced to slash its 1991 projected spending budget, which had dropped from a 1989 high of $800,000 under Silverman's direction to $585,000 in 1991. Two full-time staff positions were cut, including the job of video coordinator, Adriene Jenik. Several weeks prior to that, LACE's performance coordinator, Erica Bornstein resigned to take a position at the Venice arts center Beyond Baroque and half of LACE's full-time work force of six had been eliminated by layoff or resignation.[30]

In an article titled "Mending a Tattered LACE," *L.A. Times* reporter Allan Parachini cited several factors that contributed to LACE's precipitous decline, including being without a fundraising director for nearly a year, which led to donor pull-outs and missed grant application deadlines. LACE's yearly benefit art auction failed to meet donation expectations. The recession economy sapped donor activity, and government financial support from the NEA and state arts councils rapidly diminished, a casualty of the congressional culture wars. And without an endowment, LACE and similar organizations had to raise their entire annual budget during the calendar year in which the funds were spent. "I gave it the best that I had," Bedoya told the *L.A. Times.* "I can't solve the anxieties of a dwindling support system."[31]

In 1991 Bedoya was replaced by Gwen Darien, who had previously served for eight and a half years as deputy director of New York's PS1, an internationally known contemporary arts center.

The NEA Culture Wars and the Move to Hollywood

During Darien's tenure, the culture wars over the National Endowment for the Arts reached a boiling point. In April 1992, after receiving a programming brochure for LACE's upcoming exhibitions and programs, the NEA asked LACE to delete "any acknowledgment of Endowment support" from materials associated with three of the projects mentioned, each of which had erotic and/or homosexual themes. These projects and events included the "Valentine's Erotica Bash," the "Spew 2: National 'Zine Convention" (a conference on underground magazine publishing that LACE's brochure described as including a "queercore contingent"),[32] and "A Tribute to Tom of Finland," an exhibition featuring the work of an artist known for his explicit homosexual imagery. The NEA letter came in the wake of NEA Chairman John E. Frohnmayer's firing in February of 1992, after Republican Patrick J. Buchanan made the NEA a campaign issue by targeting several grants that were awarded to projects with sexual themes.

Darien told the *L.A. Times* that the NEA's request represented an attempt to "target certain minorities." She stated that LACE was not using NEA funds for the three programs and pointed out that LACE's grants were for "ongoing support," not for particular projects, and thus the NEA's argument that the three events in question were never "specifically identified or described" in LACE's grant application was irrelevant. Darien also said that in its letter the NEA did not mention the panel discussion on Comic Art in the 1990s, which was also listed in the brochure and did not use NEA funds. She charged that the NEA's request represented an attempt on the NEA's part to distance itself from artistic works that "are about dissent and minority voice."[33]

Although it is beyond the scope of this essay to provide a history and full account of the politically motivated "culture wars" that engulfed Congress, the NEA, and artists' organizations throughout the country during this time, the effect that these congressional "witch hunts" had on alternative and artist-run organizations like LACE should be mentioned. In the late 1970s, the NEA played a crucial role in funding smaller arts organizations, often by providing initial seed money. But the culture wars and the subsequent slashing of the NEA's budget had a chilling effect upon many American cultural institutions. To some degree, the controversies had a beneficial effect on organizations like LACE because it "rallied the troops" on the liberal side and focused much-needed attention on their programs while also spurring audience attendance. But in the long run, the harm far outweighed the benefit. The recession economy in the early 1990s meant that corporate grants and private arts funding decreased drastically, making the loss of NEA grant opportunities even more critical. The economic downturn also wiped out a number of commercial galleries, including most of those located downtown.[34]

During this time, alternative and artist-run organizations like LACE began to rethink their missions and reprioritize future initiatives. Many stopped describing themselves as alternative spaces altogether and instead began referring to themselves as "contemporary arts centers." As Darien told the *Los Angeles Times* in 1994, "Alternative has a specific meaning—reacting against something, and reacting is a limiting concept. One of the things we do is to provide alternatives to museums, which collect art, and to gal-

leries, which sell art. We provide a forum for experimentation, but experimentation doesn't mean simply reacting. It's building something as well."[35]

Across the board, artists' organizations were making serious efforts to reach out to audiences from the broader community, beyond what one writer characterized as "the small, hip world of the arts."[36] Other alternative spaces like San Diego's Sushi, San Francisco's Life on the Water, and New Langton Arts also found themselves faced with rapid declines in financial and operational wherewithal. LACE's problems were also exacerbated by the sharp decline in audience attendance for its exhibitions and programs, in large part based on the decline of the downtown community and the growing perception that the downtown area was dangerous and crime-infested. An article in the *Los Angeles Times* even argued that "what hurt LACE more than the actual crime was the perception of crime."[37] As businesses in the surrounding area began to shut their doors and downtown development stagnated, LACE found itself increasingly isolated, with very few restaurants nearby open at night and even fewer places for LACE patrons to congregate before and after events. After the closing of spaces such as the Factory Place, Wallenboyd Theater, and Boyd Street Theater in the 1980s, followed by the Woman's Building on North Spring Street and the Los Angeles Theatre Center's resident company, LACE was a geographical island. The West Coast Soho was not to be.

In response to this problem, in 1993 Darien approached the CRA and received $75,000 to renovate a building on Hollywood Boulevard, which formerly housed the Newberry School of Beauty. The proposed location was on a block owned by the city's Department of Transportation, near a park being developed by the CRA, the Gay and Lesbian Community Center, and perhaps most importantly, the new location of the Re: Solution Gallery of the Los Angeles Center for Photographic Studies (LACPS), which relocated from the similarly crime-ridden MacArthur Park area at the same time—though ironically, the crime rate in Hollywood at that time was higher than it was downtown.[38] Darien felt that rather than build a new community, which is what LACE had attempted to do downtown, the new location already came with its own community of pedestrian shoppers and moviegoers. The presence of LACE and LACPS would augment an existing community rather than create a new one.

LACE's new building was part of the CRA's Hollywood Redevelopment Project, a one-billion-dollar plan bordered by La Brea, Fountain, Western, and Franklin Avenues. The project also included American Cinematheque, a nonprofit center for film and video that remodeled the Egyptian Theatre for its headquarters, and the Hollywood Entertainment Museum, located next to the Galaxy movie theater complex further down on Hollywood Boulevard. Since the establishments on Hollywood Boulevard did not have much retail potential, the CRA looked for an arts organization that would infuse fresh vitality and a new audience base into the area. In 1994 LACE and the Re: Solution Gallery secured five-year leases with renewal options.

In January of 1995 Darien announced her resignation as executive director, citing differences with LACE's board over the organization's goals along with her desire to take time off after an illness and to pursue other career options in New York. Almost a year later a search committee selected New York-based video artist Brian Karl as her successor. Karl lasted only twenty months, resigning in April 1997 to pursue independent

projects in writing and film. During his tenure, Karl revived LACE's commitment to music and film as well as improving the quality of its yearly "Annuale" show. He also increased private contributions, audience attendance, and the overall number of shows.[39]

Karl was succeeded by Irene Tsatsos, a curator and nonprofit arts administrator formerly based in Chicago and New York, who had coordinated the 1997 Whitney Biennial. Tsatsos's hiring represented a major shift in LACE's administrative direction. Board members decided that the organization would no longer be primarily artist-run but director-run, ostensibly to optimize fundraising possibilities. For the first time, the organization's curatorial and programmatic vision would rest almost exclusively with one individual rather than with a committee of artists. The presence of a director who was also primarily responsible for curatorial matters would, the board believed, foster "an institutional presence" for the organization, while creating a "cohesive curatorial vision,"[40] supplemented by two new advisory councils comprised of a group of artists to occasionally consult with the executive director.

LACE Today: Neither Artist-Run nor Alternative, Can It Still Be Considered an Artists' Space?

The announcement that programs at LACE would no longer be curated by artist-dominated committees provoked a mini-storm of controversy. "Artists Mourn the Death of a Great Space" was the headline of a press release issued by a group of ten performance artists and critics. The press release accused LACE of abandoning its mission, no longer serving the interests of artists. They also accused LACE of decreasing the emphasis on video and performance art that had historically distinguished it and provided its organizational identity.

"LACE is no longer an artists' space," charged artist Jacki Apple in the press release she helped draft. Speaking to the *L.A. Times* in October of 1998, Apple noted that LACE had "become very corporate. Fine, OK, if that's what you are. But don't claim to be radical and community-based. You shouldn't raise money on the basis of the organization's history. Don't exploit the artists."[41] Apple was referring to a January 1998 benefit for LACE that raised the ire of some participating artists who felt that LACE had abandoned its original commitment to the presentation of performance art. Tsatsos argued that the most interesting new work crossed disciplinary borders, so it no longer made sense to adhere to strict categories as a means of differentiating artistic practice.

Today LACE is no longer an artist-run organization. In 1997 its board voted to suspend the organization's bylaws stipulating that 51 percent of the board members must be artists. The director-curator (Tsatsos) assumed the duties previously executed by committees of artists and staff program coordinators. Gary Mezzatesta, LACE's board president, told the *Los Angeles Times* that LACE found it increasingly difficult to enlist artists as board members in the wake of LACE's financial troubles. Although not a member of LACE's board, art collector and philanthropist Peter Norton issued a pointed response to the controversial press release:

As much as you may regret that LACE is now being led predominantly by business people, rather than artists, responsibility for the decline of LACE in the past rests squarely on the shoulders of the community of artists that LACE was created to serve. Simply put, the community of artists was unwilling or unable to do the heavy lifting necessary to keep LACE thriving in its old mold. If LACE declined and nearly failed, it is because the artists' community failed LACE.[42]

Whether one comes down on the side of dissident artist Jacki Apple or of LACE's board, it was clear that as LACE was entering its twentieth year of existence, the idea that an exclusively "artist-run" space was the only viable model for an arts center devoted to the free expression of art and ideas had lost most of its credibility.

With the dissipation of a strong artists' community focused around LACE came the erosion of an ideology that arose within a particular historical moment—an ideology claiming that artist-run organizations were inherently more democratic and innately responsive to a community of artists in a collaborative, democratic fashion. This is not to say that LACE as it exists today is no longer artist-friendly or democratic in nature. LACE's mission has always been to present cutting-edge work by contemporary artists that might not otherwise be seen elsewhere; and although its programs often feel less innovative and timely, and certainly less culturally urgent, LACE continues to be guided in spirit by its original directives: to provide a space for artists' projects that would not be possible elsewhere. The realities of today's cultural and fiscal climate mean that LACE has no choice but to rethink its identity on a number of levels, even as the organization continues to uphold the goals and values on which it was founded.

Today communities of artists continue to take matters into their own hands by carving their own exhibition opportunities seemingly out of thin air. Quite popular are so-called "roving" exhibition spaces that take place over a weekend or even a single evening in various hotels or other locations throughout Los Angeles.[43] These guerrilla spaces find a less-temporary complement in the small but thriving commercial gallery scene in certain pockets of the city like Chinatown and Echo Park that is more interested in community-building than in selling art (although they admit that succeeding at both would be just fine). Clearly, L.A.'s artists are as ingenious and uncompromising as ever in their pursuit of unrestricted artistic expression. The difference is that Los Angeles artists today are no longer relying solely on LACE and a few other smaller organizations to help them get there.

Notes

Acknowledgment: I would like to thank Karen Voss for her very valuable editorial work on this essay.

1. Zan Dubin, "Art News: LACE Turns Analytical Eye on Itself," *Los Angeles Times,* 28 February 1988, Sunday Home Edition, Calendar, 95.

2. Suzanne Muchnic. "Art Review: San Diego Exhibit Adds to an L.A. Gallery All Torn Up Over Its 10th Birthday," *Los Angeles Times,* 9 March 1988, 8.

3. Renny Pritikin, "Historic Issues of Artists Organizations," in *LACE: 10 Yrs. Documented* (Los Angeles: LACE, 1988), 14.

4. Ibid.

5. Ibid.

6. Joy Silverman, former executive director of LACE, interview by Claudine Isé, 30 March 2000. Unless otherwise cited, all quotes from Silverman are taken from this audiotaped interview.

7. Dan Flaming, interview by Claudine Isé, 31 March 2000. All quotes from Dan Flaming are taken from this audiotaped interview.

8. Ron Reeder, interview by Claudine Isé, 30 March 2000. All quotes from Ron Reeder are taken from this audiotaped interview.

9. Reeder and Janusz did eventually end up exhibiting a scale drawing of the mural in LACE's second exhibition, "Small Scale Proposals For Large-Scale Works" (February 7–28, 1978).

10. Harry Gamboa Jr., interview by Claudine Isé, 1 March 2000. All quotes from Harry Gamboa Jr. are taken from this audiotaped interview.

11. Before becoming involved with LACE, Gronk and Gamboa were members of Asco (Spanish for nausea), a group of Chicano artists that also included Patssi Valdez and Willie Herón, and sometimes Robert Gil de Montes and Teddy Sandoval. Active in East Los Angeles between 1971 and 1985, the group used improvisational performance and guerrilla theater tactics, including humor, shock, and satire. They agitated around the underrepresentation of Chicano artists in museum collections and exhibitions, turning to the streets of the barrio for exhibition space and provoking the press. They documented all their street performances to construct "a parallel world in which Chicano events took place as if they were being covered by the mainstream media" (Richard Griswold del Castillo, Teresa McKenna, and Yvonne Yarbro-Bejarano, eds., *Chicano Art: Resistance and Affirmation, 1965–1985* [Los Angeles: Wight Art Gallery, University of California, Los Angeles, 1991], 286).

12. Gamboa's recollection that "No Movie" was "the only Chicano show (LACE) ever had" isn't entirely accurate. In 1980 LACE organized "Espiña" (September 6–27, 1980), an exhibition by Los Angeles Chicano artists that included two- and three-dimensional works and performances by Carlos Almarez, Elsa Flores, Louie Perez, Teddy Sandoval, John Valadez, and Linda Vallejo.

13. For a comprehensive examination of the Chicano Art Movement and its political, aesthetic, social and historical implications, see del Castillo, McKenna and Yarbro-Bejarano, eds., *Chicano Art*, 1991.

14. Philip Brookman, "Looking for Alternatives: Notes on Chicano Art, 1960–90," in del Castillo, McKenna, and Yarbro-Bejarano, eds., *Chicano Art*, 184.

15. Marc Pally, interview by Claudine Isé, 29 March 2000. All quotes from Marc Pally are taken from this audiotaped interview unless otherwise cited.

16. Scott Harris, "Al's Bar—A Stage for the Eclectic," *Los Angeles Times*, 27 November 1989, Metro 1.

17. Zan Dubin, "Artists Relocating to Bigger Downtown Space," *Los Angeles Times*, 20 February 1986, Calendar 1.

18. Ibid.

19. Ibid.

20. Ibid.

21. Zan Dubin, "LACE: A Mecca of Video Art," *Los Angeles Times*, 22 October 1986, Calendar 1.

22. Ibid.

23. Shauna Snow, "Skid Row Artists Experiencing a Renaissance," *Los Angeles Times,* 4 June 1990, F-10.

24. Ibid.

25. Ibid.

26. "Art From the Streets: Frank Parker," 4 June–29 July 1990.

27. Allan Parachini, "Mending a Tattered LACE," *Los Angeles Times,* 9 April 1991, Calendar 1.

28. Shauna Snow, "Roberto Bedoya: A New Face at LACE—and a New Direction," *Los Angeles Times,* 17 May 1990, Calendar 2.

29. Parachini, "Mending a Tattered LACE," Calendar 1.

30. Ibid.

31. Ibid.

32. Diane Haithman, "NEA Wants Name Off 3 LACE Shows," *Los Angeles Times,* 8 April 1992, Calendar 1.

33. Ibid.

34. Today there are a number of significant commercial galleries located downtown, particularly in the Chinatown area.

35. Suzanne Muchnic, "Old Hollywood's New Artistic Jolt," *Los Angeles Times,* 12 June 1994, Calendar 5.

36. Jan Breslauer, "They Still Need Their Space; Things are a lot less bohemian and a lot more community-oriented as facilities and artists scramble to survive changing times," *Los Angeles Times,* 13 June 1993, Calendar, 8.

37. Rauzi, "Getting Frayed on the Fringe," 12.

38. Ibid.

39. Specifically, Karl upped private contributions from next to nothing to 10 percent of the gallery's then-$250,000 budget while tripling LACE's membership to 450. He also increased the number of annual visitors by a quarter, to 12,000, and doubled the number of shows, hosting 35 performances, 18 exhibits and 15 video installations.

40. Suzanne Muchnic, "LACE Toasts Colorful Past, Eyes the Future," *Los Angeles Times,* 28 July 1998, Calendar F-7.

41. Suzanne Muchnic, "As LACE Shifts Course, Rifts Grow Wider," *Los Angeles Times,* 2 October 1998, Calendar F2–F20.

42. Ibid., F20.

43. These include programs organized and curated by the artist-run groups Popular Mechanics, One Night Stand, and Three Day Weekend (organized by artist Dave Muller and often held in his Echo Park studio). Living room galleries continue to spring up all over Los Feliz and Silverlake. Additional spaces include Echo Park's Ojala, Delirium Tremens, and Fototeka, all located in one block on the corner of Echo Park Boulevard and Scott Street.

Sande Cohen

6 Not History: Remarks on the Foundation for Art Resources, 1977–1998

This essay weaves the Foundation for Art Resources (FAR) into the contours of the philosophy of history.[1] I take seriously the obligation to give an account of this cultural formation that created, and still creates, specific connections—cultural, intellectual, social, and aesthetic—that cross the various "art-worlds" of Los Angeles. Freely mixed below are conceptual issues about historical representation and alternative cultural formations, located in a critical and philosophical context. FAR is charted within conflictual dynamics about artists' roles and art's relation to public criticism.

I cannot think of a compelling cultural critic who does not locate significant aspects of the past thirty years or so of art and criticism in some sense of doubt, regret, and disillusionment. The arts and humanities are very much embedded in such narratives in terms of art's social engagement and its amelioration of social processes. I have just read a smart critic, a committed empiricist who is not allergic to theory, who writes of a "general atmosphere of revenge" pervading all the "art-worlds";[2] and while that is not the narrative of FAR, I have to notice such ambient temperatures and basic social conditions of making and representing art. How can one represent alternative culture, given the dominance of stars and blockb[l]uster shows mixed with criticism that calls for community and the bucolic, all in the name of beauty? How can one cast alternative culture in verbal modes that do not violate the practices of those who strive to make a difference, or where art is not made to be shown except to engage the critical acuity of its audience, which is not the audience's self-satisfaction, but an engagement with its doubts and skepticism?

Questions of Representation—Alternative and Normal

Whereas historical representation concerns the normalization of cultural artifacts, the notion of alternative culture used below probes such normalization and is not treated

as a supplement to historical recognition. How many times do we have to learn that historical judgments about art turn out to be political judgments as much as anything else? Also, instability is rampant: reading Pascal's *Pensees* is an "alternative" to contemporary indulgence in the confessional mode, just as Spiegelman's *Maus* is an "alternative" to a text-photo documentary narrative of political extremism. Yet these alternatives are also norms for other representations. Is the very distinction between historical normalization and alternative culture as alternative-to-a-norm misleading, in that so often in our cultural regimes what is alterntive becomes just an illusion of difference?

Discourses about truly complicated forms such as urbanization and the effects of such forms, as in concerns about the over-management of the arts, continue unabated. Discourses about modernization, as when someone says capitalism is Triumphal, and of modern art, as in surrealism's ongoing attractions, also continue; but to what end(s)? What, exactly, do we wish to learn from the transitions we invoke and project about, say, high-modern art/writing, as in the seductions of Beckett's work, and what is widely called the postmodern? We can normalize/represent anything—to what ends?[3] And who actually believes that in mentioning an artist's name—Beckett, for example—we are then justified in having that name open to us processes of all kinds? Shouldn't the artist's name be the last thing we are concerned with if we are engaged with understanding processes, functions, and outcomes?[4]

For anyone concerned with making a historical representation, such issues are never resolved: they just multiply, even if regularly suppressed, sometimes in the mode of *those public writings that come to be taken as representative* (i.e., the definitive book). More specifically, problems concerning art and the artist from the 1960s have continued, and questions as to how, or even why, "alternative" aspects of culture are historicized remain unsettled. How does one historicize practices that claimed to spurn the normal and conventional?

There are considerable stakes in placing anything deemed alternative in historical boxes or in familiarizing what was critical and perhaps excessive to convention. For example, when an art historian tells us that a history of the transition of painting from modern to postmodern pivots on a citation from Picasso—"painters don't talk about theory, they talk about turpentine"—the *form* of transition (an anecdote) and its matter (that painters are not theorists) ought to trigger alarms about historical representation. First, one reduces the artist to an embodied nonthinker, the negative sense of which then rebounds on one's discovery of the conditions of making art. When the historian doesn't ask what was *theorized when the painters 'talked' turpentine,* yet insists that *now* we can have a better because embodied history of modernism that moves on "by first moving back. . . . This is the purpose of history," then every intellectual alarm should awaken one's skepticism. Wasn't there a time when turpentine was part and parcel of multiple theories and discourses?[5]

In addition to interrogating the terms "normal" and "alternative," how is one to establish transitions, continuities, and discontinuities without distortion? It is a commonplace in some areas of the theory of history to pressure definitive narratives, especially their rationalizing absorption of past violence in rhetorical patterns that let us off the hook of answering for the past (i.e., by our continuation of dubious processes and

actions). Some critics put narrative in doubt because historical representation is made structurally possible by acts that separate present from past, inducing loss and the fictive tension between historical narration and its effects on both past and present. In a discussion of Michel de Certeau's theories of history, one of his most precise and cogent analysts has argued that

> the historian's sense of duration is defined by what is left behind, or registered as past. Once this "other" time is established, interpretation is legitimized, speculation develops, and writing is set in motion . . . historians posit death as a total social fact . . . but also, in their very act of indication, they deny its presence. A sense of loss is advanced, but its void is immediately filled with the knowledge the historian reaps from his division of past and present.[6]

In this rendering, to write history is a political act where every "other," or narrated subject, becomes so through language's imposition of an act of division or selection, so that narrative understanding is both definitive and unstable because it is selective. Making something a subject of narrative and history is what historical representation is mostly all about. Politics is opened to thought whenever we ask a narrative/history for details about its concoction of sense, its use and abuse of figures and logics that may enlighten and genuinely open one to ideas but that are also threaded to discourses that themselves involve, in de Certeau's words, "arcane crafts of resurrection, animation, and even ventriloquism."[7] Once readers pay attention to patterns of belief and consensus offered in language, including narrative's seductions, such readers become themselves dangerous to the circulation of narrative and its illusory social bonds, even if there is not too much room to challenge the "necessities" as illusions.[8] Historiography and its practices such as selection or inclusion and severance or filling are forms of an obsession with time. Such obsessions are (usually) politely transcoded into narrative patterns that allow a given present to familiarize itself; the past then becomes our foil (of the tin kind, as well). Finally, the suturing of historiography to connecting and separating past and present results in the circulation of specific ideological templates available to a given sector of a given society, which then form the boundaries of "the constancy of language that represents events and the contingency of their fabrication."[9] Normalization and alternative are such constancies.

As the essays in this volume attest, some of the *alternative* art making and writing in and from L.A., mostly covering the period from the later 1950s to the present, receive a periodization. Yet all such periodizations are already intellectual mongrels. In my version of the intellectual's relation to the act of giving history to something, of historicizing, the standard narratives of emplotment (romance, tragedy) are all too often excessive ideological smotherings of difference and displacement of uncomfortable similarities. I am merely trying to say that one antidote to historicizing is to make questions that pose problems as to the *integration* of alternative cultures. To resist historicization one should *a minimo* propose the time of something deemed alternative—its production of its own temporality—before imposing "before and after," a staple of many political formations in art and culture. In what follows, while a (mostly) distant observer of the formation known as FAR (Foundation for Art Resources), I try to elicit from some of the primary materials just what this formation proposed in relation to the ter-

rain known as both mainstream/academic cultures, AKA the public in all its enthusi-
asms and indifferences. In this regard, many of the essays in this volume also query the
force and effects of historicization or take the concept of alternative as deserving a non-
reactive interpretation.

For instance, Claudine Isé's essay on Los Angeles Contemporary Exhibitions (LACE)
notes that "from the moment of its inception to the present day, LACE has been an ideo-
logically contested space . . . the question of what an 'artist-run' 'alternative' space should
be was passionately debated." James Moran's essay on the L.A. Freewaves brings forth
that group's ceaseless need for "more inventive tactics," which asks commentators to
think about the temporality of the "intermittent, contingent, and beleaguered." Nithila
Peter writes of Vedanta in L.A. that it generated the temporality of "the marginal, sub-
altern, alternative centers of culture, community, and self," as if Vedanta was itself a work
of sculpture. In David E. James's piece, the temporality of Hollywood comes down to
its valorization of capital (repetition) and maintenance of its privilege (a second repeti-
tion), and he compares this to the revival in the 1960s and 70s of groups such as Oasis
Cinema, whose purpose was to make time for alternative cinema as a "nurturing
ground." Jiwon Ahn's essay on Los Angeles's strands of Korean audiences comes to the
conclusion that "the cultural configurations in the Korean immigrant community look
almost like a microcopy of the mainstream cultural topography." Eric Gordon's analy-
sis of Leimert Park similarly argues that a different not-yet "historical" temporality runs
through his materials: he links the community to the intense scrutiny it presently receives
in the media as a successful Black community and also as an "exportable concept" for
social consumption. These and the other essays in the volume, then, not so much con-
tribute to the practice of historical recuperation as they offer versions of singular cul-
tural experiences different from the autopsies we so frequently request from "history."
Alternative culture, as David Carroll has stressed, is an amazingly fragile concept and
practice; as long as it repeats the logic of "alternative-to," one is actually riveted to a
sense of opposition considered final, a dogmatism in its own right.[10]

Modernization and modern art evoke processes that are both similar and asymmet-
rical to each other: to modernization belong issues of its rationalizations and the nor-
malization of destruction, for example, the inability of public schools to actually ele-
vate large numbers of students within new modes of labor; to modern art belong issues
of its specialization, the latter at times confused with intensification, even unlimited
fetishism. In this, questions as to alternative culture(s) have persisted, forming a kind
of shadow, but also something of a pure resistance in the successes and failures of mod-
ernization/modern art. That is, modernization in general may well be an overall deba-
cle for democracy (i.e., popular participation) as it adds techniques for the prolonga-
tion of life (the telos of management), but modern art has no such built-in telos or goal.
In this regard, for many, alternative art and culture amount to little more than artworks
that are "excessive" to language or to the museum until the moment of some curator-
ial rediscovery (with extreme emphasis on *re*) including forgotten and/or overlooked
past works. It is also culturally instructive to consider the number of times in recent
American history that notions of alternative have found expression, along with vast
numbers of journals and other artifacts that have disappeared, or gone to the cultural

graveyard of representation.[11] Or, in another register, what exists today of the eighteenth century's extensive intellectual labor in threading discourse to object to institution to subject(s), not in terms of political seizure or aesthetic distance, but through questions of public debt and notions of the sublime? Might "alternative" suggest a way to gauge the experience of art set within frames of paradox and even art's "irresolvable duplicity," its intensification of experience and a deadening of it as well?[12] What does "alternative" actually mean, given such disparate senses of the concept?

For most of us, the University is now the primary sponsor of nearly every idea we have of alternative culture, a consequence of various cultural integration(s) that have occurred since the 1960s. Is it true that the idea of alternative art and culture is itself an offshoot of the research mania that has driven the High University since the early 1950s, especially in the arts and humanities, where alternative has kept alive the undeletable stratagems of avant-gardism that testify to the tolerance of the system? Deleuze taught us that the "outside" is a shaky concept; so too with alternative cultures. These are vexed issues. The collapse at Harvard two years ago of Anna Devere Smith's highly visible and funded alternative to the divide between academic and public that was to create public art/discourse fusions between different audiences is only one of the notable dissolves that seem to plague the concept of alternative culture as such. Or should we think of alternative in the terms proposed, not by mediators such as Smith, but by artists such as Larry Bell, who said in 1965 that "alternative" means, in the case of Andy Warhol, taking "a super-sophisticated attitude" and making that attitude the art?[13] Is the transiency of "alternative" intrinsic to cultural politics now because "attitude" is everywhere a device for making art? Does a sense of alternative come with the dissolution of the avant-garde, which embeds alternative in failure?[14] One sharp critic has observed that once upon a time Cubism and Abstract Expressionism were alternative art, at least for all those not deemed "artist's artists" (insiders) or lumped under the patronizing term "art for the masses." The concept of alternative has no clear boundary that separates it from other cultural relations. If it is true that "[art] school has absorbed the modernist self-critique," or if art is considered a mode of awareness of its own positionality, leaving in its wake language games inseparable from claims made about art that empty concepts like that of alternative of their sense, then we should be extremely careful.[15] In this regard, what is the gallery once it is turned into a living space? What was, is, or will be the gallery's status as an alternative to, say, the museum? What is the concept of alternative worth when it has become part of the trading zone where no separation is tolerated between "objects, people, money, press, camaraderie, gossip" lest one weak link harm the value of other categories and relations?[16]

There are people far better qualified than I who can write the necessary "on the ground" critical narratives of art movements and social institutions in Los Angeles since the 1960s. By now it should be clear that a purpose of this paper is not to write such a history or narrative of a particular formation but to put together some of the materials produced by the Foundation for Art Resources and to ask about FAR's syntactical forms, its presentation and display, its products/processes, so as to bring out some of the dynamics that one alternative group has attempted.[17]

FAR and Alternative Culture

The Foundation for Art Resources, Inc. started in Los Angeles, and from its self-constituting statements emphasized "new art and ideas in Los Angeles." A nonprofit organization, it presented itself as nearly genre-less, engaged in publishing, exhibiting, consulting, and so on "to provide a context for investigations into the theoretical and critical aspects of current cultural and art activity."[18] Words such as "investigation" are the discourse of the research model, embedded in, and disseminated from, the University. Some critics have called this embedding of art-as-experiment in academic units—with all the attendant "wars" from the 1960s to the present in which art, studio, art-history, new media, and more compete for research funds and recognition—a way in which art is domesticated.[19] Other terms are more diffuse: FAR presented itself as interested in making contact with "community" through a program that focused on reaching a "larger and more diverse audience than through a single organization," that is, partnering and sponsoring as many venues as possible for contemporary art and ideas.

FAR was created—or, better, put together—in 1977, by the gallerists Morgan Thomas, Connie Lewallen, and Claire Copley, each of whom had left by the end of 1978. Morgan Thomas handed FAR over to artist Dorit Cypis, who, two years after an MFA program at California Institute of the Arts, was full of questions about the function and meaning of art and artists. Cypis enlisted Christina Ritchie, and together they changed the FAR by-laws to assert that the board of directors had to be artists who would also be the working members of FAR. This new board added a board of advisers, including the artist John Baldessari, the architect Frank Gehry, and the dealer Rosamund Felsen. Artists had voting power, a difference from other L.A.-based groups such as the L.A. Institute for Contemporary Art, which also dates from the later 1970s, whose board of directors was not artist-based.

The inherited FAR came with an exhibition space at 814 S. Spring Street. After a year of programming in 1979, Cypis and Ritchie gave up the space, deciding to have FAR float through Los Angeles, collaborating with private and public institutions to present events specifically matched to the site chosen. Morgan Thomas has suggested that FAR was both a "bridge and mirror" in that the artists were the board out of which "the representation of art had to evolve along with the art. It was a time for experimentation and fermentation, and we were involved in a search for an appropriate production model." Thomas also noted that "the community participates in an event to the degree it produces it."[20] As Merle Schipper later commented, FAR was to be a version of the *artist-as-producer*—providing locations and spaces that not only featured the typical lecture series but also presented film, installations, videos, and performances. The producer-model was an affirmation of the notion of art-as-event, distinguishing FAR from other institutions that marketed artists' work.[21] No one can actually define the line between production and market, however. Event here means processes of expansion, as opposed to the finality of art treated as a consumer product. Initial verbal statements that emanated from FAR indicated that "we continued a policy of not owning our own space in order to maintain an attitude of flexibility toward responding to each

project with an appropriate and creative solution."[22] Was this the very blur between art/non-art that the philosopher Agamben speaks of,[23] or even a kind of parody toward the extraordinary increase of management *on the arts* that had taken place since the postwar proliferation of various art markets?

In the first five years, the art events FAR produced were quite extensive in their latitude and diversity: they ranged from something like an inaugural presentation by John Baldessari in October 1977 that consisted of a film, *Six Colorful Inside Jobs,* paid for by credit cards, which claimed to be a critique of traditional genres such as "action" painting, to Mike Kelly and David Askevold's "Poltergeist," a collaborative installation of their work and a performance by Kelly; from a book and performance, *Open America* by James Lee Byers, to a film performance at the Santa Monica Aero Theater by Louise Lawler; and from a reading at the downtown L.A. Public Library by Dan Graham, to the lecture series ArtTalkArt at the Pacific Design Center that gave local audiences a West Coast version of the postmodernism debates that were then raging in the New York art scene. Of particular note was a 1982 project called "Transitional Use" in which FAR put up site-specific artworks in the Los Angeles suburb of Lynwood, where yet another new freeway, the Century Freeway, was being thrust into a working-class community. As artist Candice Lewis pointed out, this freeway resulted in "a seventeen mile long and six block wide ghost town of abandoned houses and empty lots"; and the artists "utilized vacant areas between the abandoned houses, both the interiors and exteriors," to heighten the sense of paradox involved in the simultaneous creation and destruction of space.[24]

The sheer number of public spaces that FAR moved through and worked with is quite extensive: Dorit Cypis's *Fly by Night* performance took place at a Spring Street warehouse that also served as FAR's own space during 1979; films were screened at local theaters (including the infamous political art-house, the Fox-Venice Theater, which was finally dissolved in the later 1980s as Venice succumbed to another withering round of gentrification); and a cosponsored international exhibition with the title "Unforgettable Fire" (that included Japanese survivors of atomic blasts—and certainly a response to the Reagan administration antics that threatened to set everything ablaze) was held at Santa Monica Place. Over the years, FAR also sponsored art bazaars, located in huge public sites so as to present the work of artists all too often unseen by the conventional venues of display. The most recent of these, 1997's the FAR Safari, was described by one of its organizers as an attempt to meld installation and performance art with the Old L.A. Zoo in order to provoke a critical and multiple sense of place and site, history and memory, current art and the vicissitudes of society (Illustration 6.1).[25] Other key projects, presented under the rubric of "Outside Artworks" during the years 1988–92, supported painting, installations, and many diverse practices in various public venues. One public project, Media Shelters, from 1985, used FAR's own voluntary spacelessness to exploit the preexisting context of advertising provided by bus shelter light boxes and, interestingly, noted that the project was to join the "passive driving-eye" of art-viewers with shelter-as-architecture, overriding the all-too-familiar image of the use of advertising as a device to critique the commodity nature of art (with Barbara

ILLUSTRATION 6.1. FAR Zoo Safari, 1997. Photograph courtesy of the Foundation for Art Resources, Inc.

Kruger's use of billboards outside the gallery being a source of inspiration). Being, in this fashion, "anti" anti-art led, as artist Cindy Bernard noted, to some interesting constructions of the concept of art.[26] In all of this, the structural continuity with the university model of research and the visiting-artist predominated, the latter serving as "milieu, as spice, as supplement."[27]

"Art Talk Art," a series inaugurated in 1980–81 and extending into 1998, was perhaps FAR's most extensive public service. Over this twenty-year period, no group in L.A. did more to take academic discourse out of the classroom and make it available to that ineffable and yet always-invoked public. FAR also took its turn at translating the visiting-artist syndrome out of the classroom and into venues that might connect with more diverse audiences. Many of these talks were suffused with the notion that meaning in art was in "crisis" (this was, remember, the period of the presidency of Ronald Reagan) and ranged from Howard Singerman's "Artist as Enfant Terrible" to Douglas Crimp's somewhat ludicrous historicist argument that painting was "dead" (see Illustration 6.2).[28]

An internal memo about a panel discussion on mass culture and contemporary art in 1981 suggests that the board members were consistently concerned with the transformation of the function of the artist in contemporary society, but the group was

ART TALK ART

A series of lectures investigating issues of contemporary art,
produced by **FOUNDATION FOR ART RESOURCES,**
in collaboration with the **PACIFIC DESIGN CENTER,**
January—May 1981.

Wednesday **February 25** *7:30 P.M.*	**"THE END OF PAINTING",** *presented by* **DOUGLAS CRIMP***: New York based art critic;* *managing editor of "October", MIT Press, Journal of art criticism.*

Thursday **March 12** *7:30 P.M.*	**"THE ARTIST AS TEENAGER AS ENFANT TERRIBLE",** *presented by* **HOWARD SINGERMAN***: Los Angeles based art writer;* *former assistant editor of the "Journal"*

To be held at the **SEQUOIA ROOM** *of the* **PACIFIC DESIGN CENTER,**
8687 MELROSE AVE., LOS ANGELES.
For information and reservations call **657-0800.**
Admission to each lecture is **$2.00.**
Stay tuned to KPFK-FM RAIDO JORNAL 3 to 6 P.M. the day of each lecture for an over the air interview.
enter through parking lot entrance/valadated parking

funded in part by the National Endowment for the Arts.

ILLUSTRATION 6.2. FAR flier, 1981. Image courtesy of the Foundation for Art Resources, Inc.

ecumenical enough to invite L.A.'s now reigning anti-intellectual critic, Christopher Knight from the *L.A. Times,* to give a paper.[29] From 1980 through 1998, more than one hundred talks were given in L.A., presented by every kind of academic, intellectual, and artist one could not put together in the same room, given the rivalrous disputes between them. And in the mid-1980s, FAR even turned to fiction, issuing the stories of painter John Miller.

Reviews of FAR events in the Los Angeles press were more or less fair to such various projects as Tom Johnson's music performance *Nine Bells* at the Umbrella Loft in Pasadena in 1980; Jana Haimsohn and Mel Waldron's live jazz event at the Biltmore Hotel, merging word and sound in a near orgy of alliteration and atonality; or of the many lectures from 1977 on. The notices of FAR events often consisted of postcards such as the one for Louise Lawler's 1979 screening, "Movie Without a Picture," which was a blackened card with the words "A movie will be shown without the picture" as a line at the card's bottom, which probably goes some way as an index of the conjunction

ILLUSTRATION 6.3. FAR flier, 1980. Image courtesy of the Foundation for Art Resources, Inc.

of the absurd, the real, and the aesthetic. The promotional materials for Dan Graham's 1980 "Clinic for a Suburban Site" at the L.A. Central Library were visually arresting, as was the "Function Pleasure" show in downtown L.A. in February 1980, composed of the artists Peter Fend, Colen Fitzgibbon, Jenny Holzer, Peter Nadin, Richard Prince, and Robin Winters, that billed itself as "An art show about how to avoid useless work, work for yourself, rework anything," or artists released from their own subjectivity so as to promote the idea of what they wanted "pleasure and function" to do. The audience was invited to "tell us what you want, what you do so that the PLEASURE/FUNCTION show can be transferred to you by February 9, 1980."[30]

This show was also reworked by Jenny Holzer for the magazine Z/G, which reiterated what FAR had seen in the work: that artworks, like any other sort of text, "depend on the orientation of the reader. The 'morality' of an idea or statement lies not within itself but in how it is interpreted and the use to which it is put."[31] That's as good a statement as any as to the transformation from quasi-autonomous aesthetic relations to objects and audience; the artist is not an art-historian manqué, nor the investigative reporter of social ills, but rather someone who produces a different social order as art. In a statement by Holzer and Nadin in December 1979, the artist was enjoined to concoct "a practical methodology . . . an appropriate course of action."[32] The Graham project in April of 1980 at the L.A. Central Library, with local radio discussion, was also as thorough a statement of FAR's contribution as we are likely to get. Entitled "Clinic for a Suburban Site," it consisted of architectural models, documentation of past projects, and writings about aspects of "public" space. In negotiations with FAR over his extended project in L.A., Graham was mindful that this was not an ego trip of a well-known artist and quoted the architect Charles Moore on "Who is Dan Graham?" Calling for a meaningful discussion of issues that concerned artists and architects in L.A., Graham was clear that such interactions required "not just academic discussion."[33] Graham's paper brought to the surface much of the Conceptualist and Minimalist junctions that were prevalent after the 1960s, asking questions as much as creating artifacts, as in this proposition:

> If "Pop" art acknowledges the popular language of commercial signs which link it, as art, to the public sins in the immediate, mass cultural environment, can a work of "Pop" art be the carrier of subversive information (which disturbs conventional assumptions) from within the public, vernacular code . . . or is it only "subversive" only as "Art," whose "meaning" is accessible only to those who have learned the code?[34]

The questions raised by Graham in the context of FAR's attempt to make such questions and problems legible to different audiences have certainly not gone away; they are just more displaced and repressed in the current environment. Thus, for example, Jack Goldstein's 1977 film The Jump was shown in March 1979 to local acclaim, and in a very candid letter to one of the members of the board, he mused on the use of animation as a good machine for controlling visual ideas and went on to note that, for himself, the future was already filled with a "loss of spontaneity," which, unfortunately, segued into the hallucination of the artist as demonic: "Violence is the most beautiful thing that I can think of when performed with constraint which views the activity as a

DAN GRAHAM

is internationally known for his art and writings which question the position of the individual within the context of contemporary urban and suburban society.

CLINIC FOR A SUBURBAN SITE

An exhibition of his architectural models, visual documentation of past projects, and writings on issues including Public Space / Public Language and Art in Relation to Architecture / Architecture in Relation to Art will be available for view and reading:

April 7-19, 1980 at the **City of Los Angeles Central Library, 2nd Floor Main Lobby**, 630 W. 5th St. (at Grand), Los Angeles.
Call 399-4863 (evenings).

Dan Graham will present a discussion of his work and converse with the listening audience over **KPFK-FM Radio, 90.7 FM, Sunday, April 6, 5 p.m.**

Sponsored by Foundation for Art Resources, Inc. and assisted by City of Los Angeles Central Library and Space Bank.

ILLUSTRATION 6.4. FAR flier, 1980. Image courtesy of the Foundation for Art Resources, Inc.

'whole.' I have always felt sad when viewing the Natzies [sic] in world war 2 that they lost the war since their pomp, flags, banners, uniforms, music etc. were so beautiful to watch. Does that tell us something about the nature of war and that through aesthetics we can seduce the masses for whatever ends we have in mind???"[35] It is difficult, today, to imagine the distinction between object and motivation Goldstein played out in public film and private remarks, so obsessed are most of us with purifying our subjectivity as soon as it touches that holy ground called the public.

FAR was tireless in finding spaces, places, and sites for artists' work. In a letter to Robert Laemmle of the eponymous chain of movie theaters in L.A., the FAR board specified that its collaboration with artists necessitated a nonproprietary relation with both exhibitors and artists. But Laemmle's response to their request that Barbara Bloom's film *Diamond Lane* be shown with scheduled commercial releases was terse: "We found the short subject lacking commercial value . . . professionally constructed but little apeal [sic] to a general audience."[36] But after more negotiations, the five-minute film was, in fact, screened between scheduled features at a Laemmle theatre.

The most concentrated period of FAR's extensive collaborations with nearly every type of institution in L.A. and with nearly every aspect of art was June 1980 to August 1981, when eight public projects were presented in the guise of twenty-two public events. This was done with nearly zero funds.

The artist Matt Mullican's performance "outline" of April 1979 included his sending the FAR board artwork to be made into postcard announcements with these words, which every artist knows by heart: "If size is not right you may crop edges. it should go thru the mail as a post card. it may be too big but I think its regulation size. I'll pay the 8 dollars and sorry for the inconvenience. these things never seem to be easy." Artists such as Mullican seem to have absorbed Nietzsche's idea that modern culture aims to produce "small hearts" and that the alternative artist is really a kind of "heartsurgeon"; art becomes the addition of arteries to patients in need. Nonetheless, Suzanne Muchnic from the *L.A. Times* couldn't get past her perplexity over an artist deemed "encyclopedic" in his interests.[37]

Writing in 1978, Edit deAk and Walter Robinson said that FAR was conceived "in hope of providing patronage for art that increasingly denies the possibility of being sold."[38] But when Kevin Thomas reviewed *Six Colorful Inside Jobs* by John Baldessari (who was then known as an "artist's artist") in the *Los Angeles Times*, he picked up the issue of what the public could be sold or taught: he qualified his review by noting that FAR's sponsorship of this film at the Theater Vanguard was a "theatrical presentation," where the experimental aspects of Baldessari's film were bound to be perceived as "boring," while in a gallery the same film might be seen as more interesting.[39] Indeed, (doubting) Thomas's perplexity of where "art" was is a measure of FAR's initial—and continuous—strategy of adding some physical as well as conceptual perplexity to art and the city of Los Angeles. Tony Conrad's review of another film series in 1980 is significant. Noting that the same films presented at UCLA's Melnitz Theater only added to academic stupor, their presentation at a downtown loft were more "live performances" than films and operated, he insisted, as "nouns defective in the nominative

case," that is, changing the subject of film from objects to *ablative* instruments and actions, or the point where the distinction between art and non-art dissolve.[40] That was just too much for most critics (and still is).

A penetrating discussion in July 1979 used the occasion of "The Poltergeist" performance by Mike Kelley and videos by David Askevold to expand on the state of alternative art and culture. Noting that much of the art of the 1970s stressed a renewed self-expression, a kind of dependence on Abstract Expressionism's notion of the self (its use of social alienation, having made alienation something normal), one reviewer called FAR's offering of these artists a recontextualization of the overall politicization of art in the 1970s. According to him, artists found themselves in a "double bind" insofar as "self" and "expression" were not invoked in the manner of 1960s-style "demythologization of the artist" and demystification of art as magical, intuitive activity.[41] How does art that comes to its audience as a mode of critical awareness proceed, given the pressure of ongoing demythologization and the requirement for new visual representations? Now that the artist could attempt to occupy the roles of both author and subject, turning them inside out, after having been declared dead by writers such as Foucault and Barthes (Warhol being an obvious cultural blueprint), societal alienation made its return in the guise of being so natural as to be a birthright of artistic sensibility. Askevold and Kelley's collaboration was, negatively, directed against the vestiges of expressionism. But did it *naturalize* an earlier generation's different visual strategies and concerns, so that he and Askevold were merely lessening or shrinking the boundary between self-expression and selflessness in a cultural ecology where artists found themselves literally stuck in their disavowal of recent history and the art market? In their project, the methods of passive objectivity and deductive logic were employed as moves joining the subjectivity of the artist to the realm of "social flaws": Kelley's work said to "render the mundane arcane," Askevold's tapes loosening "identity" at every twist of image and sound. In both artists' projects, "there is a refusal to complain, a refusal to play God, to offer a single answer. [Yet] information, emotion and experience are dealt with in a manner so curiously uninflected ... that meaning can only be intuited and remains in a state of flux."[42] In a sense, FAR, like Kelley and Askevold, found itself in a quandary: once the artist has been demythologized, and art practices as well, what's left? In this, the master-provocateur of theory—of consumerism, display, and simulation politics—is certainly Jean Baudrillard, with his question "What are you doing after the Orgy?" (of objects, theories).

Writing a report on FAR in 1981, Dorit Cypis noted that the theoretical goals of the group—incorporating its idealism and irony—were incessantly rethought: "We have been very careful not to become a clearing-house for art just because it is art," she wrote, and then added that "although the public has no direct knowledge of this internal process," the public was the very point of FAR's existence. Cypis noted that the instant the board came to pay for a managing director, it hit the proverbial institutional wall: conflict ensued over money and control. In 1982, the second-generation working board—including Cypis, who since 1980 had served as managing director—dissolved. Before dissolution, they developed a mandate that thereafter, every two to

three years, the existing board members would elect a new working board composed of "young practicing artists ... most ... recent graduates from local art schools ... [with] little experience in administrative and group decision making" yet each perceived as having "commitment to the evolution of art theory and practice, to the integration of art and society."[43] "Integration" is, of course, one of those words necessary in any attempt to translate academic discourse to a nonacademic audience, and it certainly dates FAR in a scene where school, the art world, and the public could be thought of as mutually involved in making an alternative, committed to sustaining noncanonical but important works of art and language. This does not make such junctions reducible to the idea of transition, but FAR could be thought of as "all middle": premised on mediation, not between origin and goal, but as an end in itself. Rather than emphasize some historical moment, say FAR's moment of emergence, we could simply affirm the mechanics of connection that took place, an affirmation of FAR's own attempt to not separate art from non-art. As a kind of cultural stretcher between the art world, the school, and the public, subject to both dispersion and refiguration, FAR made its own positive critical blur.

For this sense of straddling different regimes or mixtures of subjectivity and institution, products and processes, continued arguments such as those put forth by the critic Charles Harrison, when he insisted that a purpose for critique or alternatives to all sorts of conventions, including radical ones, was to draw into the practice of art-making *certain questions*. Harrison had in mind questions of the type "What does the desire to make art actually pivot on?" especially since awareness of the obsolescence of aesthetic forms and/or functions might conflict with notions of the subjectivity of artistic desire.

FAR did not slip out of its initial statements; it continued to sponsor events in which art and science were threaded to the name—and called by the name—of criticism. The concept of "investigation" set forth in 1977 remained constant, pitched to include questions even as to the possible obsolescence of art, society, and subjectivity.[44] A structural melange before it is an historical one, the Foundation for Art Resources continues; it comes and goes according to rhythms and tempos not bound to the generational constructs that helped to create it, one of which was to apply the logic of the visiting artist—the working-artist, the artist-at-work away from home—to non-university environments. In this way, artists were encouraged, not so much to apply theory in their projects as they became agents, but to be agents of an unknown type. Poised at the moment when, at least in L.A., the issues raised by writers such as Agamben became acute—the proliferation of objects without subjects, subjectivity without the "face" of a subject, the soon-to-be-announced death of theory—FAR offered resistance to the now ubiquitous name of the artist having value just because the name is released from anonymity or placed on a pedestal—even, or perhaps especially, a repulsion-pedestal, as in the case of so many recent L.A. artists. To the demand that the artist's sensibility show itself in contemporary art, where the proper name of the artist is already understood to stand for the concatenation of "the times" in the name, FAR offered resistance—and we ought to value the temporality of resistance more than we do, not on moral grounds, but on those of a more intense life *for criticism*.[45]

ILLUSTRATION 6.5. FAR talk: Norman Klein, 1988. Image courtesy of the Founda-
tion for Art Resources, Inc.

Conclusion

So let me begin again by saying that FAR produced its own "historicity" in 1997,
which it called a "retrospective"; and in one of the semi-official statements in that look-
ing back, it is said that from 1977 to 1997, FAR has not only prevailed, but has grown
"stronger and wiser." Those are strange tags for a possible anti-organization that has
maintained itself over the years as a producer of culture-as-event rather than as an agent
of historical value in a competition with bourgeois and/or other mainstream institutions.
To say, in the same retrospective, that FAR's very telos was a "commitment to The New,
whatever it may be at any given moment"[46] turns a troubled narrative of modernism
into a reconfiguration of Ezra Pound projected onto the present. Once again, for empha-
sis: To locate FAR in the late 1970s as "emerging forces of full theoretical disclosure
[where] Structuralist and Post-Structuralist thought had begun to make significant
inroads into our [artists] formerly text-free curriculae" is to privilege a time-moment
and to misread, for there has been no moment in postwar education of artists that was

"theory-free."[47] We've just forgotten that art students used to read, say, Rudolf Arnheim and Georg Lukács before they read Michel Foucault. Again, one should not proceed with "normal" ideas of "historical" recuperation, but rather just make a strong reading. FAR, like the other movements and groups in this volume, shaped and was shaped by a cultural ecology that may elide our representational abilities. Morgan Thomas's statement that FAR was searching "for an appropriate production model" should stand on its own.

In this regard, and stretching as much as possible the chance to make some critical foci that are intended to elaborate stakes raised about alternatives, an idea by G. Agamben is useful. He makes the point that the distinction between art and non-art that was supposed to be so "fruitful" for the critic to contemplate, let alone as a model for "alternative" art itself, has for a long time been in a process of dissolution. The critic does not so much mediate between object and public because the critic's awareness (self-reflexivity) cannot deny that non-art objects force (Agamben's term) critical judgment to confront its own image in reverse. If non-art is subject to aesthetic categories, then criticism is not about separating art from everything else—criticism has no intrinsic "about." This parallels the indistinction between art and non-art. In a whirl of disruption of roles and positions, the critic's judgment of art and non-art is neutralized, the critic of non-art "art" limited to the act of making an ID check on the object presented. Objects called aesthetic do not necessarily convey this aesthetic otherness, just as our criticism is in eclipse because all sorts of objects have a life independent of discourse.[48] For Agamben, there is nothing to measure art by—which makes it even more difficult to assess alternative culture and/or art. Do we want to repeat the historicist cliches that the alternative is a "reserve-army" (my term) for the rivalrous emptying out (rewriting) performed by the so-called higher elevations of culture? Do we want to idealize alternative? These are all tangled relations, and our sense of alternative culture isn't helped if we make it a straightforward critique of dominant public culture or try to counter-historicize against dominant culture's faux-idealisms, of which, in this case, Los Angeles gives far too many examples.[49]

Now an artwork is a singular thing—regardless of how it may play on and off issues of identity, repetition, seriality, overcoding, and so on—and it serves to mark time for us, to give us a transition, a periodization. Such works become precise bits of some canon, not just because they survive their own time, but only because they are encoded in memory-machines of all kinds. As argued at the start of this essay, one way they survive is in being subjected to historicist discourse, a premise of which transforms what manages to be notable (itself a jumble of causes) into the memorable joined to the purported unforgettable, putting the scattered things of the world under the umbrella of shelter: giving a temporal identity of recognition signaled, for instance, in ongoing contestation concerning such works. Does Beckett's *Watt* mark the transition of a certain kind of ascetic/intense modernist practice giving way to something else? Is that something else primarily "history"? At one level, historiography can be considered the conventional system of time-norms that we muster so that we have a way of putting the

bodies of the past and present together with our cultural timings.[50] (It would be important, of course, to actually know when historical consciousness of art is able to meet, as it were, its own presence; that's not a fuzzy metaphysical statement, but a query as to our demand that history is given to us in writing.) Because we so completely *historicize* everything we make, is it not of some vital intellectual importance to know what we are doing to our cultural systems, let alone ourselves and new groups, when we turn things into history?

FAR is *not history:* apart from the fact that between April and August in 1998 it produced—concocted, made, or engineered—six venues for a discussion of alternative art in L.A. and so keeps going, the very project of this group is a good candidate for artists in resistance to the corporatizing of culture, now endemic to the University and society at large.

Notes

1. Thanks to Dorit Cypis for her trove of information and sense of art, and to Fandra Chang, who made another perspicuous assessment.

2. Lane Relyea, "It's The End of Art Criticism as We Know It (and the ArtWorld Feels Fine)" <http://www.core.mfah.org/show/assets_show/relyea_on line_lect.pdf>.

3. This sense of asymmetry between theory and reality I take as the main epistemic force of Jean Baudrillard's numerous books about the state of culture in social systems in which simulation, understood not as fake but as the complete autonomy of appearances linked to structures of social control, predominates.

4. See the interesting discussion of style-name, movement-name, period-name in Stephen Melville, "Aspects," in *Reconsidering the Object of Art, 1965–75* (Los Angeles: MOCA/MIT, 1995), 230.

5. See Caroline A. Jones, "Anxiety and Elation: Response to Michael Fried," *Critical Inquiry* 27, no. 4 (2001): 713.

6. Tom Conley, "For a Literary Historiography," in Michel de Certeau, *The Writing of History,* trans. Tom Conley (New York: Columbia University Press, 1988), viii.

7. Ibid.

8. See the remarkable analysis by David Farrell Krell in his *Infectious Nietzsche* (Bloomington: Indiana University Press, 1996), 5–6.

9. Conley, "For a Literary Historiography," x. See Hayden White, *Figural Realism: Studies in the Mimesis Effect* (Baltimore: Johns Hopkins University Press, 1999), 6–8. It is worth noting that de Certeau's sense of the function and purpose of historical discourse in a modernized society is much more critical than, say, White's notion of historical discourse as stemming from "extended metaphors," which favors evaluating historical writing already privileged as to its literary aspects instead of questioning its conceptual or philo-social problems.

10. David Carroll, *Paraesthetics* (New York: Methuen, 1987), 186.

11. See Barbara Rose, ed., *Readings in American Art, 1900–75* (New York: Holt, Rinehart and Winston, 1975), 24ff.

12. See Peter de Bolla, *The Discourse of the Sublime* (London: Blackwell, 1989), 6–14.

13. Larry Bell, "Andy Warhol," quoted in Rose, *Readings in American Art,* 175.

14. See the dripping cynicism/bon vivantisme of Peter Plagens, *Sunshine Muse* (New York: Praeger, 1974), 176.

15. See Katy Siegel, "Young Americans," in *Public Offerings,* ed. Howard Singerman (Los Angeles: MOCA/Thames and Hudson, 2000), 192–207.

16. See Lane Relyea, "L.A. Based and Superstructure," in *Public Offerings,* 262.

17. In this regard, see Yilmaz Dziewior, "Art Academies and Alternative Environments," in *Public Offerings,* 220–29.

18. Statement by the Board of Directors, 1979; see also Dorit Cypis, "Report of Activities (Practice and Theory) 1980/81" (unpublished ms.). Much of the FAR archives has been transferred to a CD-Rom, *FAR: 20th Anniversary,* available from <http://www.farsited.org>.

19. See Howard Singerman, *Art Subjects* (Berkeley: University of California Press, 1999).

20. Morgan Thomas, "Early FAR," <http://www.farsited.org>.

21. Merle Schipper, "Foundation for Art Resources," *ArtScene* 14, no. 1 (September 1994): 18.

22. Cypis, "Report of Activities."

23. See Giorgio Agamben, *The Man Without Content* (Stanford, Calif.: Stanford University Press, 1999), 50–51.

24. FAR website, 1998.

25. See Ming-Yuen Ma's comments on the FAR website <file:///dl/mg/features/safari.html>.

26. See Cindy Bernard's comments on the FAR website <file:///D|mg/features/mshelters/html>.

27. Singerman, *Art Subjects,* 176.

28. Kelley was a beneficiary. In the somewhat lurid terms proposed by John Welchman, Kelley's artwork represents an "avatar of processionality," the artist a "magi of conflation." One could also say that "processionality" turned into an end in itself is rather incoherent without the attending reinvention of the artist as sheer maniacal-producer, the artist returned as the point of the "process"; and one could further call "magi of conflation" a synecdoche of reductionism or an inadvertent oxymoron on Welchman's part. See John Welchman, "Mike Kelley and the Conceptual Vernacular" <http://wha.ucdavis.edu/1999/mike_kelley.html>.

29. Knight has championed obfuscation for more than twenty years in L.A. For example, in a discussion of a show on Pop, in Long Beach in 1997, Knight called it a "grizzly problem" that critics such as Thomas Crow complicated Warhol's art to the point where language on Warhol can "give your brain a charley horse." This was because Crow dared to suggest the commonplace that Warhol's project was threaded to a "critique of our deathly consumer culture," Warhol reduced to "lobbing smarty-pants critiques of consumerism from off on the sidelines." Against this "backward" reading, we are told that the real Warhol-effect is to be found in his negation of irony and in his very person as a "genius of the misfit-working class fop." An obfuscation like this is something one can hardly argue with. See Christopher Knight, "Andy Warhol, Properly Labeled," *L.A. Times,* 13 April 1997), 74. Readers might also note D. J. Waldie, the *Times*'s point man on the history of L.A. regularly denounces "theoretical" discourse as harmful to narrative, to the impact of stories.

30. Thanks to Dorit Cypis for showing me these materials.

31. Jean Fisher, "The Will to Act," *Z/G* 81, no. 2.

32. "Here to There," artists' statement by Jenny Holzer and Peter Nadin, December 1, 1979. Thanks to Dorit Cypis for showing me this material.

33. Dan Graham, letter to FAR Board, 18 October 1979.

34. Dan Graham, paper, "Art's Relation to Architecture," April 6, 1980.

35. Letter from Jack Goldstein to Morgan, n.d. Thanks to Dorit Cypis.

36. Letter from Mike Pade, Western Division Film Buyer for Laemmle theaters, to FAR, 17 July 1981.

37. Suzanne Muchnic, "Mullican: In Performance," *L.A. Times,* 20 April 1979, iv, 8.

38. Dorit Cypis, "Report of Activities."

39. Kevin Thomas, "Two by Baldessari at the Vanguard," *Los Angeles Times,* 28 March 1977, Calendar 4.

40. Tony Conrad, "At Last Real Movies: Super-8 Cinema from New York," *Journal: Southern California Art Magazine* 27 (June–July 1980): 53.

41. All quotes from Howard Singerman, "Self-Expression, Seventies' Style," *ArtWeek,* 14 July 1979, 3.

42. Ibid., 3.

43. Cypis, "Report of Activities."

44. See Howard Singerman, "From My Institution to Yours," in *Public Offerings,* 272.

45. Singerman, *Art Subjects,* 210: "the work as visual research or as critical uncovering."

46. Jan Tumlir, "Twenty years and Counting," FAR website <file:///Dl/mg/essay.0.html>.

47. Ibid.

48. See Agamben, *Man Without Content,* 50–51.

49. I am thinking of the entirely baleful dominance of the *L.A. Times* in creating aesthetic facts on the ground, notably its denunciation of intellectually inflected art; and I have in mind the writings of Dave Hickey who has singlehandedly, it seems, revived notions of "beauty" that if carefully analyzed, are instances of discursive enthusiasm cast in the signifiers of catachresis, this to simulate already overcoded instances of the self-same "beauty" that he claims to find in things. See my "Hide Your Commodification: Art Criticism and Intellectuals in Los Angeles, or Language Denied," *Emergences* 9, no. 2 (Fall 1999): 358–66.

50. The most thorough and stimulating treatment of this and related issues is Gilles Deleuze, *Difference and Repetition* (New York: Athlone, 1994).

Meiling Cheng

7 Highways Performance Space: Communities-in-Transit

For more than a decade, Highways Performance Space in Santa Monica has been a vital center for performance art, an intermedia visual art form that makes use of elements of theatre. Highways has served as a presenting venue for experimental performance and dance, a gallery to exhibit performative visual arts, and a teaching site that provides training in performance, writing, and movement techniques. In its most efficacious guise, Highways functions as a redressive agency to counteract the rampant sociocultural moods in its larger municipal site: Los Angeles, a postmodern "heteropolis" marked by a hegemonic entertainment industry; a dispersed, ethnically mixed, yet economically segregated urban geography; and a rapidly changing multiethnic and multinational demography.[1] The numerous strategies that Highways has developed to empower variously disenfranchised subjects and to cohere, or at least to bring into contact, diverse communities are instructive at a historical moment when making art for social change has (re)emerged as a primary concern for many cultural workers and organizations.

This essay modifies Michel Foucault's concept of the heterotopia to analyze Highways Performance Space as a hetero*locus:* a communal site that not only accommodates and displays alternative live art by nonnormative subjects, but proactively manufactures products of otherness for the benefit of diverse disenfranchised communities. I use the heterolocus as a geocultural paradigm to probe the artistic identity and cultural positioning of Highways within its metropolitan setting, one that often seems antipathetic to it. Since the heterolocus concerns the merging of human intentions and cultural necessity in a physical location, my analysis covers the agents responsible for constructing Highways, the motives that fueled their endeavors, the strategies with which they established Highways' reputation as a cultural center for intersecting com-

A substantially different version of this essay has been published as "Highways, L.A.: Multiple Communities in a Heterolocus" in *Theatre Journal* 53, no. 3 (October 2001): 429–54.

munities, and the practitioners and spectators who coalesce in this environment. High-ways' intervention into the cultural ecology of Los Angeles will become clear once we scrutinize the rationale and history of its particular practice.

The heterolocus serves as an overriding concept that finds its various configurations in the genealogy of Highways, which has undergone several transitions of artistic leadership. Although the current Highways is still committed to its founding mission, most of its community-building and audience-forming strategies were established during the initial formative period (1989–1993), which happened to coincide with the peak of multiculturalism in Los Angeles. My close analysis therefore privileges this period, evaluating the specific methods that this live art gallery has developed to create multiple communities. Since these methods represent to a large measure negotiations with various practical and theoretical issues surrounding diversity, otherness, and heterogeneity, this inquiry tackles the at-times-vexatious intersection of multiculturalism and performance art as it played out in the history of Highways. My objective for such an inquiry exceeds its retrospective nature, for it has the heuristic intent of scanning Highways as a case study for building theatre-based creative communities in the twenty-first century. What follows, then, is the unraveling of a locus fabled in contemporary cultural history and in Los Angeles.

Heterolocus as a Geocultural Paradigm

In his essay "Of Other Spaces," Foucault posits the quality of contemporary space as divergent sites, a spatial concept that replaces the medieval notion of the space of emplacement and the Galilean notion of the space of extension.[2] Foucault's concept of the site emphasizes relations among different spaces, shifting our spatial understanding from delineating a place's unique property to analyzing its positioning in a network of divergent spaces. "Of Other Spaces" makes no prediction concerning the transformation of spatiality and community in the Internet era; rather, Foucault uses the concept of site to introduce a new spatial type: the "heterotopia," which evokes another more familiar term, *utopia*. As Foucault notes, both utopias and heterotopias are external sites that "have the curious property of being in relation with all the other sites, but in such a way as to suspect, neutralize, or invert the set of relations that they happen to designate, mirror, or reflect." Whereas utopias are unreal, fantastic, and perfected spaces, heterotopias, in Foucault's conception, are real places that exist like "counter-sites," which simultaneously represent, contest, and invert all other conventional sites.[3]

Foucault's definition of the heterotopia as a counter-site informs my concept of the heterolocus. While a heterolocus is a heterotopia, a heterotopia is not necessarily a heterolocus. An active Web site, for example, may be considered a heterotopia, but it is not a heterolocus, which exists to facilitate live human encounters. My move to modify the Foucaultian heterotopia answers the quest to understand the formation of embodied communities, which requires a conceptual shift from the global to the local and

specific. I do not claim, as Foucault does for the heterotopia, that the heterolocus exists universally in every culture. On the contrary, I use the heterolocus as a more precise conceptual paradigm to define the sociocultural functions of a singular counter-site in Los Angeles: Highways Performance Space. Differentiating the heterolocus from the heterotopia, I latch on the double attribute of "locus" as a physical locality and a symbolic position, a geosocial type and a cultural attitude that intersects to produce a site of alterity for exhibiting and witnessing live art. As a theatre of, for, and about otherness, the heterolocus recuperates from the anonymity that prevails in the Foucaultian heterotopia two indispensable bases of live performance: the actor and the performing site. It restores agency, accountability, and immediate contacts to an abstract spatial typology. It also highlights Highways' sociocultural role as a venue that nourishes *heterogeneity* (i.e., representing diverse cultures), produces *otherness* (presenting artistic subjects from disenfranchised communities), and celebrates *time-animated, interactive locality* (people congregating during designated hours for performances, discussions, or workshops).

As a heterolocus—a contemporary heterogeneous site—Highways is localized but not hierarchical or exclusive in its management. It is a space of extension, yet its spatial qualities shift with different time-designated events. The very formation of Highways critiques the rigidity and commercialism of Los Angeles' cultural infrastructure, thereby contesting other normative art-exhibition sites. Even more importantly, Highways fulfills the proactive function of redress: providing a room for artistic expressions by those individuals who might not find any other presenter in L.A., Highways offers a malleable, multifaceted, affordable, and relatively permanent site for the recurrent, time-animated convergence of multiple communities.

A heterolocus is, in sum, a redressive heterotopia, utopian in its intent, activist in its modus operandi, heterogeneous in its contents, and productive in its service to display otherness and to form alternative communities. Highways is an exemplary heterolocus in L.A.

Highways: A Locus for Otherness

Highways was founded in 1989 by writer Linda Frye Burnham and artist Tim Miller. Based on archival research, I discern that three interacting forces converged at Highways' inception to establish it as a multifunctional geocultural node. The first two were deliberate forces driven by the distinct interests and cultural affiliations of its two founders; the third was the fortuitous trend of multiculturalism that swept through L.A.'s art world in the late 1980s and early 1990s.[4] Highways' focus on boundary-breaking, issue-oriented, and identity-centered performances reflected Burnham's preference for multidisciplinary experimentation and socially relevant art and Miller's commitment to queer cultural definitions and intercultural collaboration. The discourse of multiculturalism added the themes of ethnic diversity, dialogue, and community to Highways' artistic objectives. These initial goals continue to define the directions for Highways after

its decade-plus existence, as illustrated by the retention of similar thematic tropes in its current mission: "to develop and present innovative performance and visual art, interaction among people of diverse cultural identities and foster a critical dialogue among artists concerned with social issues and the communities they serve."[5]

The plan to start a space specializing in performance came from Burnham and Miller's common desire to rectify what they described as "the near-annihilation of what was once a thriving presenting infrastructure in Los Angeles."[6] Their remark conjured up a lost golden age of performance art in L.A.—the decades of the 1970s and 1980s when artists presented performances in parks, warehouses, downtown loft spaces, storefronts rented for a few nights, platforms at the beach, college studios, artist-run workshops, neighborhood cultural centers, art cafes, dance clubs, and Equity waiver theatres.[7] Most of these activities subsided toward the end of the 1980s due to a host of social problems, especially the economic recession and the AIDS crisis. By the mid-1990s, the few remaining experimental and multicultural art spaces, such as the Los Angeles Institute of Contemporary Art (LAICA), the Boyd Street Theatre, Los Angeles Theatre Center (LATC), and Los Angeles Contemporary Exhibitions (LACE), would have folded or ceased producing regular performance art programs.[8] Highways opened its doors as an alternative center of cultural production—an antithesis to both Hollywood and other mainstream entertainment institutions—precisely to remedy the lack of presenting venues for a large population of local artists who wanted to practice socially conscious or adversarial political art.

An artist-run, nonprofit organization, Highways is located within the 55,000-square-foot 18th Street Arts Complex, a community art center co-founded in 1989 by Burnham and artist Susanna Bixby Dakin.[9] Dakin purchased the property in the hope of bringing together a group of artists from diverse origins and multiple disciplines to live and work in proximity and collaboration. Dakin envisioned this artistic compound as, in her own words, "a place where no inalienable attribute—skin color, ancestry, culture, sex or sexual orientation—defines or limits one's value."[10] Dakin's statement characterized the prevailing themes of tolerance, diversity, and community shared by the various nonprofit organizations in residence at this progressive cultural enclave, echoing the then-burgeoning rhetoric of multiculturalism.[11]

The formation of Highways owed much to the aesthetic/cultural visions that its two founding artistic co-directors had cultivated independently over the years. Burnham had written and researched extensively on performance art in her capacity as the editor of *High Performance* magazine, founded by her in 1978 to cover performances that did not easily fit any preexisting performing arts categories. In its nearly two decades' tenure (1978–97) in Los Angeles, *High Performance* had provided invaluable archival and critical space for community-centered live performance. Miller had co-founded Performance Space 21, an alternative art venue in downtown Manhattan, and had had a successful performance art career in New York City for a decade before he returned to his native L.A. in 1986. Both had become highly politicized by the time Highways was founded: Burnham was critical of the Iran-Contra affair and U.S. involvement in Central America; and Miller had participated in the founding of ACT UP/L.A. (AIDS

Coalition to Unleash Power) and was performing agitprop demonstrations against government AIDS policies by getting arrested.[12] The political stances of the two against U.S. imperialism abroad and homophobic bigotry at home agreed with the ethical protocol of multiculturalism.[13] That Burnham and Miller would welcome the discursive impetus of multiculturalism with which they fused their divergent concerns and molded their representations of Highways is understandable.

The naming of their organization is a case in point, revealing how the two founders translated the nexus of multicultural diversity and geographic expanse in Los Angeles. Highways, an unassuming sign that promises fluency in transporting people and connecting places, offered an apt metaphor for the venue's artistic mission to serve as a bridge among different cultural constituencies. It also referred to the venue's physical location, which borders on the intersections of various highways: the east-west oriented Pacific Coast Highway and Interstate 10, which connect divergent cultural communities from the beach to downtown L.A. and beyond, horizontally linking the politically progressive Santa Monica beach towns with the Iranian-Middle Eastern and Japanese enclaves in Westwood, the Orthodox Jewish settlements in mid-Wilshire, the Korean Town to their east, the Chicano/Latino barrios in the Pico-Union district downtown, the Latino and African American neighborhoods in South Central, and the more recently established Chinese immigrant communities in Monterey Park and San Bernadino. This horizontal line of transportation is joined with the south-north oriented interstates I-405 and I-5, which link Los Angeles with Mexico in the immediate south and Canada to the far north.

Burnham pointedly laminated a layer of cultural significance onto Highways' geographic setting: "Los Angeles has looked to New York and to Europe for its artistic standards, and we'd like to add the north-south axis because we're interested in what's going on in Latin America."[14] Miller framed his interest in Highways in the context of politicized art. According to him, much of the highly visible multimedia performance in New York sported technical virtuosity and formalist elegance in a cultural vacuum, whereas performance in L.A. existed "in a social context, coming from cultural communities: Asian or Latino or lesbian or gay or whatever."[15] "There's John Malpede and the L.A. Poverty Department, Guillermo Gómez-Peña and the Border Arts Workshop," added Miller. "Multiculturalism is a very useful dominant metaphor right now. L.A. is the capital of performance art in North America."[16]

Highways' geographic *locality* (locale-reality) further inspired Burnham and Miller to pronounce the significance of *intersection* in their founding manifesto. The document dubbed by Miller as Highways' "birth certificate" placed the concept of intersecting (multicultural) communities at its center:

> Highways is an artists' community dedicated to the exploration of new performance forms. Highways is strategically located at the intersection of art and society. Highways is an interchange among artists, critics and the public. Highways is a crossroads, a place of alliances, a new collaboration among cultures, genders and disciplines. Highways is part of an international effort to articulate and work out the crisis of living in the last decade of the 20th Century.[17]

One of the measures of the venue's early success was the forming of "an artists' community" noted in the manifesto. As Burnham recalled, "the complex was filled regularly with artists, writers, musicians and creative people of all colors and persuasions discussing plans, talking about the artist as citizen, and reading new work to each other."[18] It is worth emphasizing that, unlike New York City, which supports various "neighborhoods" of artist communities, Los Angeles operates under a drastically different geo-economic logic. The excessive horizontal sprawl in its urban environment, aggravated by the extreme privatization of most livable spaces during the 1980s, turns public spaces into an ironic paradox. While the beach and other natural resorts offer enviable footage for public and tourist activities, public spaces within the urban matrix are relative rarities. This peculiar paradox means, practically, that cultural gatherings within the urban matrix have to take place in dispersed and often culturally isolated "nodes" or "spots," those specialized locations that become site-specific destinations. This regional factor underscores the crucial role played by a locus like Highways, whose opening served simultaneously to accommodate an emergent community of artists and to foster such a community.

This community of artists and supporters, many of whom had to travel substantial distances to reach Highways, became the venue's first group of performers, spectators, and commentators. The emotional and moral ownership of this locus by its formative group of constituents and their heterogeneous cultural identities palpably exemplified Highways' embodied multiculturalism. Their presence gave Burnham the confidence to say that Highways demonstrated the co-founders' "secure knowledge" about multiculturalism: "For us, [multiculturalism] did not mean two white people opening the door for minorities, and it did not mean charity work for the less advantaged. It meant we were turning to people from other cultural groups for vital information on the crises we found ourselves surrounded by. It would be a learning experience for all of us, an exchange."[19]

Enthusiastic as Miller and Burnham were in citing multiculturalism as an apt metaphor for Highways, the term would soon degenerate and become a porous linguistic vessel that could absorb all meanings, keeping none. At the turn of the 1990s, multiculturalism was touted as the most socially viable and grantworthy ideology in L.A.'s art world. In less than five years, however, the idealistic praxis of multiculturalism became unduly burdened by its acquired connotations of tokenism, evasive "political correctness," even "reverse discrimination." Before its professed goals of multiethnic coalition and remedial socioeconomic policies had been fully achieved, multiculturalism—at least the name itself, if not its vision—had lost its theoretical specificity and executive efficacy to join other once-faddish but now suspect terms in L.A.'s cultural inventory.[20] Nevertheless, multiculturalism had certainly shaped Burnham and Miller's articulations of their collaborative project—although in retrospect the two might choose to downplay its significance.

Through their permissive artistic policies and agenda-driven programming, Burnham and Miller instituted in Highways a set of remedial measures that zeroed in on the sociocultural problems of Los Angeles. Against the pervasive commercialism rampant in

Hollywood's movie-TV-music conglomerate, Highways countered with the specific anti-
dote of alternative theatre, which addressed the deeper questions of survival, civic exis-
tence, and social responsibility. Against the unrelenting urban experience of anonymity,
transience, and alienation, Highways offered a locus for self-empowerment, emotional
exchange, and community networking for both its performers and spectators through
weekly performance events and workshops. Against the xenophobic tension that threat-
ened to disrupt the façade of civility in this magnet city for immigrants and migrant
workers, Highways sponsored live artworks that fostered public affirmation of mar-
ginalized and dislocated subjects. These antidotes, I argue, not only capitalized on the
communal efficacy of live performance but also resonated with the democratic agenda
of multiculturalism. They were the quintessential cornerstones for building Highways
as a heterolocus, an agent and site for otherness.

As a remarkably longstanding nonprofit art organization whose survival requires
tremendous volunteer labors and sponsorships, Highways has seen periods of tri-
umphant growth, yet it has more often suffered from debilitating obstacles. The com-
plexity and high political stakes involved in the nexus called multiculturalism may, in
fact, signal some of the difficulties confronted by this radical space. Based on various
interviews that I conducted with artists involved with Highways, these difficulties
include: infighting, tribalist contests among groups, competing affiliations within indi-
viduals, the suspicion of ghettoization, art censorship against homoerotic representa-
tions, the grieving for comrades lost to AIDS, and the wavering of funding and audi-
ence support. Topping the list of Highways' perennial struggles are financial instability
and the exhaustion of a staff from thankless social activism and personal sacrifices.

These difficulties are aggravated by the fact that Highways does occupy an impor-
tant position for its service to L.A.'s performance art world, especially in a cultural cli-
mate ambivalent toward the agenda it supports. In a collaborative essay " 'Preaching
to the Converted,' " Tim Miller and David Román maintain that "queer-friendly and
supportive presenting institutions provide an invaluable service in the development of
an audience for lesbian and gay performance and in the nurturing of emerging and estab-
lished queer performing artists."[21] The comment applies to Highways' service to the
queer (gay, lesbian, bi-sexual, transgendered, and otherwise sexually-oppressed) com-
munities in L.A. It may also account for its aspiration to serve communities of artists
and audiences from the multicultural contingencies. An inevitable distance, however,
exists between its aspiration and achievement.

A critical dilemma that Highways had encountered in the past came precisely from
its divided commitment to the queer and the multicultural communities—despite the
fact that these communities are not mutually exclusive. Although both Burnham and
Miller had attempted to include queer empowerment as part of Highways' multicul-
tural agenda, the fact remains that the two causes often have different ideological pri-
orities and artistic focuses. Sexuality, for example, tends to be a subject of great inter-
est for queer artists and spectators, but it might not always appeal to those communities
who mobilize around ethnic cultural definitions and gender or class or age struggles.[22]
Whereas one cause may theoretically subsume the other (e.g., being "queer" as a way

of being "multicultural"), to balance their "quantities" in programming proved to be unsettling. In the face of differential audience demands and the lack of sustainable public funding, the difficulty of negotiating ideological priorities in programming also implied financial consequences. The venue's survival, then, depended disproportionately on those spectator communities that included the most ardent, vocal, and financially resourceful patrons—the queer, and mostly male and Caucasian, communities—who had the means of ensuring that their voices be heard. Thus, during periods when Highways went through the most intense economic and managerial struggles (the mid-1990s), the dictate of majority audience preference at times overwhelmed the venue's more broadly defined multicultural mission. Nonnormative artistic expressions were still seen at Highways, but diversity might not always prevail.

To some local artists, especially artists of color, Highways' midway turn from being openly multicultural to being overtly queer meant a certain betrayal of its founding mission. Their frustrated high hopes brewed acrimonious opinions against Highways, contributing to the dubious reputation that the space once held. But, we may wonder, who/what was ultimately culpable for this situation? Did the deficiency in Highways' performance as a heterolocus reflect the innate difficulty in carrying out its radical cultural practice, or did it rather indict a state system for abdicating its responsibility toward radical cultural practice to a private presenter?

As a heterolocus, Highways was designed as a communal site where the ethical protocol of multiculturalism was conscientiously pursued. Thus, not only irreducible differences among people are acknowledged as potential assets for the heterogeneous communities that come into contact in the heterolocus, but their commonality is also assiduously uncovered. For given their heterogeneity, the communities that intersect in the heterolocus share similar concerns of their own otherness, whether such perception of alterity is based on class, race, ethnicity, age, physical ability, gender, and/or sexual orientation. To stress unconditional tolerance for any such perception of alterity was the incipient basis that contributed to the early success of a multicultural experiment at Highways.

With fluctuating emphases over the years, the staple cultural products at Highways have revolved around the multifarious expressions of otherness in live performance as the performers, together with the spectators from their own divergent cultural communities, expose and interrogate their subaltern identity (being de facto subaltern subjects), queer sexuality (being sexually minoritized), economic and political subjugation (being poor and disenfranchised), and/or cultural invisibility (being consistently neglected and discounted by the mainstream society). My summation brings into foreground the heterolocus as a site of action. This action is, in substance, a cultural event; but in practice, it is theatrical. A heterolocus transforms from an architectural vessel into an animated locus at the point when a theatrical activity begins. The quality of *collective being-thereness* unique to a live art event and conducive to community formation is the animus that quickens and enfleshes a heterolocus.

I examine below how Highways established itself as a heterogeneous site where an active inversion of normative ideology is taking place and various manifestations of

otherness are minted as cultural currencies among performers and spectators. We will focus especially on the various ways in which Highways has managed to discover, generate, and sustain diverse voluntary, or self-selected, communities.

Traffic Reports at Highways

My concept of the heterolocus annotates the idealistic potential of Highways' manifesto, which has custom-made the space into a place (*locus*) for otherness (*hetero-*). While Highways still honors the founding goal, its longstanding efforts to execute and maintain the corresponding agenda have often plunged it to the verge of extinction. Since its founding mission drew inspirations from multiculturalism, Highways' tumultuous tenure in L.A. points to the dilemmas and pleasures of practicing multiculturalism.

For the sake of discussion, I divide the space's history into three phases, roughly corresponding to the changes in artistic leaderships. Highways' current publicity flyer notes that Burnham relinquished her duty as co-director in 1992, leaving Miller solely at the helm. But the archival records indicate that Burnham was listed as artistic co-director until September 1993. This initial phase (1989–93), when Burnham and Miller co-directed the space, was the most vibrant period of Highways—one that generated much media buzz and public fascination for this heterolocus. It remains unparalleled, especially in terms of the scope and variety of communal and performative activities.

The intermediary phase (1993–95) was one of transition, search, and re-formation. Amidst a grilling touring schedule, Miller continued his role as the sole artistic director of Highways—an arrangement that contradicted the founders' original goal to have the organization always headed by "at least two artists, at least one man and one woman."[23] Miller's duty was somewhat alleviated in 1994 when Jordan Peimer and Nicole Werner were hired as associate artistic directors. In the winter of 1995, because of the slashed budget, the two associate artistic directors were reduced to part-time positions. Peimer and Werner resigned the next spring when Miller had to cut down his touring schedule in order to run Highways.

The precariousness characteristic of the intermediary phase betrayed itself in the drastically changed format of Highways' performance calendars. During the initial phase, Highways' calendar was included in *Traffic Report,* which was and still is the quarterly calendar publication of the 18th Street Arts Complex. Both Burnham and Miller regularly wrote columns for *Traffic Report,* documenting and reflecting on the past and coming seasons. Their voices as founders/artistic co-directors in an exciting, ongoing experiment turned *Traffic Report* into a valuable resource for L.A.'s cultural history in the early 1990s. Burnham's personal affiliation with *High Performance,* for which her husband Steve Durland then served as editor, also enabled many activities happening in Highways to reach national, even international exposure. The discursive circuit that interconnected Highways with Los Angeles' cultural communities and the international performance art scenes was irretrievably interrupted when Burnham, out of despair and exhaustion, left Highways and Los Angeles in the summer of 1993.

Around the time of her painful departure, Highways' performance calendar no longer featured artistic directors' commentaries. A couple of issues later the calendar—now a poster called simply *Highways Performance Schedule,* with images and blurbs about upcoming shows—became independent from *Traffic Report,* foreshadowing the space's administrative split from the Complex during financial crisis in 1995.

With Miller's efforts, Highways entered its third and present phase (1996–2001): one of relative stabilization. Miller served as the sole artistic director until mid-1999, when he invited Danielle Brazell, a California Arts Council artist-in-residence at Highways since 1999, to become co-artistic director. Miller stepped down from his position in early 2000, leaving Brazell to spearhead Highways, but he remains connected with the space as founding director. Since Brazell assumed artistic leadership for a relatively short period, most of Highways' characteristics that I trace in this phase were shaped by Miller.

Miller's programming continued to reflect the inaugural vision that he shared with Burnham: that of making Highways not just "an anonymous artspace that would function like an empty tube through which 'art' would pass," but a proactive center with specific sociocultural missions.[24] Yet a subtle shift had occurred, resulting from the difficulty in negotiating multicultural and queer agendas. In the initial phase, multiculturalism was the conceptual umbrella underneath which diverse performance and community activities were programmed. Queer performance, an area to which Miller has devoted his passion, was subsumed under the larger multicultural affirmation for diversity, otherness, and subaltern liberation. As Burnham stated, "Tim and I are always very careful to make sure gay/lesbian culture is included in any multicultural discussion we take part in."[25] I find such argument both ingenious and compelling, for it defies the arbitrary, if implicit restriction of linking multiculturalism solely with race/ethnicity-related issues and includes the spectrum of sexuality as a significant aspect in Highways' quest for diversity. In practice, however, any subcategory under the theoretical auspices of multiculturalism (be it race, class, gender, or sexuality) may have the potential to usurp the attention due to all others. Thus, queer cultural definition emerged as the dominant cause in Highways' post-Burnham phases; it became the sift through which diverse works passed. The broader principle of multiculturalism was therefore displaced from its central position as a principle to be a mere aspect—one that continued to vouchsafe diversity—in Highways' programming.

Such transposition between multiculturalism and queer empowerment practically translated into the change of thematic emphases in Highways' performances, which in turn influenced the kinds of audiences attracted to the shows. During the initial multicultural phase, Highways included many ethnic minority and class- or age- or sex-marginalized artists, who produced a wide range of materials for their diverse spectator communities. When Miller assumed sole leadership, these so-called multicultural artists continued to be included, yet their presentations were increasingly focusing on queer or queer-affiliated materials, which most directly addressed queer communities. Thus, otherness as a fluctuating performative expression has never disappeared from this heterolocus, but it has indeed "suffered" a few sea changes. "It became clear," Miller wrote in our email correspondence, "that Highways was not going to serve every single

community or solve every single vexing problem of our society. As an artist-run organization, the interests and the commitments of the people making the place run naturally made certain of the mission priorities come forward more."[26]

Perhaps for the same reason suggested by Miller, the scope of cultural activities sponsored by Highways in this phase had been reduced to three main aspects: performance presentation, gallery exhibition, and artist-led workshops. Each aspect represented the concerted efforts and interests of certain artists; each brought to the heterolocus some particular constituencies from Highways' revolving spectator communities.

In my observation, four specific genres have developed over the years to be strong programming features at Highways: queer performance, (postmodern) dance, feminist performance, and Asian/Pacific American performance. The first three genres reflect Miller's special interest and commitment; the last has been nurtured by performance artist Dan Kwong, who has, in numerous capacities, maintained a decade-long association with Highways, as has Brazell. The Highways Gallery became more visible in recent years due to the curatorial direction by Mary Milelzcik, who also serves as the space's administrative director. A most notable growth during the third phase has been the expansion of pedagogical activities through artist-led workshops. This educational wing of Highways provides a unique service to L.A.'s performance art communities, which include both artists who desire to perform live and nonartists who use performance for self-betterment.

The pedagogical aspect of Highways' mission is a tradition initiated and valued by Miller, who has been teaching performance workshops there since the very beginning. In one of the earliest extant calendars, Miller listed a description of his workshop, which focused on "autobiography, objects, visual sense, media, the body talking/ dancing."[27] During the early 1990s, when the AIDS epidemic had brought down a great number of artists, Miller's free performance workshops for gay men were literally life-saving occasions for many participants, offering an open forum, a communal shelter, and a spiritual home for those inflicted with, or mourning from, the effects of AIDS.[28] The workshop activities have expanded tenfold at Highways, led by many different artists and including courses on writing, movement, singing, and production for live performance. In 1996 Miller symbolically affirmed the educational valence of these workshops by christening them as curricular offerings in "Highways Performance University." To match this symbolic decoration, he further fostered the space's connections with academic communities—those, for example, from Cal State L.A., UCLA, and USC—through his various academic teaching positions and his friendly relationships with local performance scholars and critics, who often come from the faculties of these institutions.

At the present stage, Highways continues to command attention as a heterolocus for performance art in L.A. While the scope of cultural activities it sponsors has been reduced, the extent of its influence on its communities of artists, disciples, spectators, and volunteers may in fact be greater—however immeasurable and deferred the influence is. Such an influence, similar to that gained by cumulative knowledge and practice, may one day come to be recognized as a cultural heritage by those who have been touched.

Producing Multicultural Communities

An ideological priority of multiculturalism is to stress the multiplicity and plenitude of diverse cultural heritages and human resources in a multiethnic country such as the United States. Abundance and variety therefore characterized Highways' programming during the initial multicultural phase, producing a multitude of eclectic events, variegated in their subject matters, expressive modes, and targeted audiences. The events presented in the September and October 1989 season, for example, were organized under the title, "I-5 Live," billed as "a series celebrating contemporary West Coast art, alive and well along Interstate Highway 5, the lifeline connecting the U.S. with Mexico and Canada." The calendar was designed like a highway map, mimicking its own nominal conceit. Each event was made into a green traffic sign, linked to others like interconnected freeways, which in turn led to seven "locations" marked as "performance art," "lecture," "visual art," "dance," "music," "literary," and "classes." The biographical makeup of selected artists complemented the profusion of these events with added diversity. In keeping with the concept of cultural trafficking, these performers were introduced in the calendar by their geographical identities, including, for instance, Guillermo Gómez-Peña from San Diego/Tijuana; Alice B. Theatre from Seattle; Jo Carson from Tennessee; Dan Kwong, Linda Burnham, and many others, from Los Angeles.

But how do these multiple events, along with the audience communities they bring, interact with one another? The "intersections" promised by Highways' manifesto, I suggest, could happen in at least three possible ways: conscious alliance, contiguous association, and physical convergence. The first points to the *will* of the participants, who choose to perform or attend the events; the second indicates the recurrent *chance* meetings among participants who might develop more substantial relationships in the future; the third centers on the *occasional* character of Highways as a heterolocus. In the context of L.A.'s urban-built and cultural environment, the third factor seems to me especially noteworthy, because Highways' physical presence allowed for the congregation of people from those cultural communities that might not have other opportunities to meet.

While these human intersections may not distinguish Highways from any other theatrical site where an audience gathers to witness a live performance, what set this radical space apart was the multicultural politics it practiced, which simultaneously instigated the selection of artists based on their cultural identities, coordinated the contents of its performative offerings, and mandated a relatively low entry fee for easier and wider public access. The populace base implied by the last thesis seemingly resembles the pricing custom of movie theatres, which can afford to keep a lower entry fee because of the motion picture's possibility for mass distribution and circulation. Highways, however, has been a presenter of live performance with very limited circulation, especially considering that most performances there are scheduled for one or two showings only. Highways' effort to charge a lower price (about one third more than a cinema ticket but much less than that for most live performances) has actually been one of its idealistic policies that aggravated the organization's financial struggles.

I have identified five particular strategies—some deliberate, others fortuitous—with which Highways attempted to maximize the types and numbers of its spectator communities while facilitating their intersections: community rituals, diversified presentations, themed festivals, self performance, and discursive circuit. Although each strategy addressed a specific area of concentration, all five worked together in a mutually implicated web of interconnections to establish Highways as a heterolocus.

Community Rituals

In order to carry out its objective to be a multicultural center rather than a mere art venue, Highways produced a series of open and free ritualistic events that involved a diverse community of artistic and spectator participants. These public rituals had the potential to build and expand Highways' cultural outreach by creating civic ceremonies of interchange and communion shared by a temporary community.

On May 1, 1989, International Workers Day, the space began operation symbolically with a blessing by Malcolm Boyd, a gay Episcopal priest who had been collaborating with Miller to pair religious sermons with performance art.[29] Witnessed mostly by artists, Boyd evoked spirits from four corners to bless the space. Highways' first large-scale community event (on Shrove Tuesday in February 1990) attracted people of all ages and backgrounds. Joyously dubbed *Mardi Gras,* the event, directed by San Diego/Tijuana artist Hugo Sanchez, featured a neighborhood procession with giant puppets and people in masks and costumes walking down Olympic Boulevard and back into the 18th Street Arts Complex for a festive party. In contrast to the jubilation of *Mardi Gras,* on March 1, 1990, Highways co-sponsored, with ACT UP/L.A., a long march on Wilshire Boulevard from L.A. County Art Museum to the downtown Federal Building in protest against government censorship of the arts. Calling themselves the "Artist Chain Gang," the marchers, dressed in striped prisoner outfits and carrying a huge black chain, proclaimed themselves criminalized by the Helms amendment, rallied for reauthorization of the NEA, and effected an "arrest" of the Federal Building for crimes against art and expression by binding themselves to its pillars with chains.[30]

Diversified Presentations

A crucial method to serve Highways' multicultural agenda was to diversify its performance offerings. Diversity as a programming principle not only allowed lesser-known and rarely shown artists to produce works at Highways but also multiplied its spectator communities, who appeared in different combinations for different artists/groups.

Highways' first season (May–July 1989), for example, opened with an ensemble piece by a collective known as an L.A. original: Los Angeles Poverty Department (alias LAPD), a multiethnic and multigenerational troupe consisting of homeless or formerly homeless people founded by John Malpede in 1985. *Jupiter 35,* the piece collaboratively written by Sunshine Mills and LAPD and directed by Malpede, Kevin Williams, and Elia Arce, was based on actual events surrounding September 6, 1988, when LAPD

ILLUSTRATION 7.1. *Jupiter 35*, by LAPD. Performers from left: Ed Rodriguez, Sunshine Mills. Photograph by Lukas Felzman, courtesy of LAPD.

member LeRoy Mills was pushed and thrown out of a window on L.A.'s Skid Row. Mills was given the name "Jupiter 35" on his medical chart because he was too disoriented to identify himself when he woke up in L.A. County General Hospital. Praised by Burnham and Miller as "the finest example of collaborative contemporary art arising from a community enmeshed in one of the most significant social problems of our [twentieth] century,"[31] LAPD was later selected by the 1990 Los Angeles Festival to restage *Jupiter 35* at Highways in its July to September 1990 season.

LAPD's local output was followed by an Irish/English performance series in which Highways hosted British artist Shaun Caton and Belfast artists Tara Babel and Andre Stitt. Caton created an eight-hour endurance piece in the midst of an installation constructed with organic materials such as dirt and plants. The piece critiqued the desecration of the environment and closed with an ecological cleanup by a scientist. Babel's nonverbal piece *Outpatient* incorporated visual metaphors to suggest the mental and physical alienation of a dislocated subject. Stitt went through repeated mock-suicide attempts, including immersing his head in a bucket of detergent, vomiting fluorescent fluids, and ingesting baby powder for his *Covert Activities: (Hardcore Ackshuns/Live Mix)*, which left him with a severe eye injury.[32]

Before the season was over, two more ensemble projects enabled Highways to expand its audience base beyond the regular performance art crowds, who were mostly

educated, upper middle-class Caucasian Americans drawn to the more adventurous experimental art. An audience of union workers and labor supporters came for a documentary piece presented by TheatreWorkers Project. The work, entitled *Steel Blue Water: The Shipbuilders' Play*, was written and performed by workers from Todd's Shipyards in L.A.'s seaport San Pedro. Similarly, a largely African American audience showed up for a staged reading of Silas Jones's *Night Commander* by the Hittite Empire, an all-male African American intergenerational troupe directed by Keith Antar Mason. When Jones objected to the director's experimental approach and withdrew his permission after the first reading, Mason led the Hittite Empire to improvise five evenings of different performance pieces. The Hittite members portrayed the images of luck, Africa, a black griot, and a skeptical teenager, juxtaposed with Mason's autobiographically based texts that explored the themes of school, work, human needs, and self-image affecting the African American communities.[33]

I-5 Live, the performance series celebrating West Coast art presented in Highways' immediately following season, brought its audience attention back to the artists and residents along the Interstate Highway 5. The series began with a lecture and performance on binational dialogue and border culture by Guillermo Gómez-Peña of San Diego/Tijuana. Impersonating his composite character "Border Brujo," Gómez-Peña sat in a make-shift holy/phony site, a faux altar lined up with kitsch memorabilia from American pop culture and Mexican tourist commerce. Shifting among different accents and stereotypical costume items (wig, sunglasses, Pachuco hat, necklace of banana and plastic teeth), the artist literally wears the surface peculiarities of those border characters who both occupy and split asunder the voice and body of Border Brujo. Like imploded fragments, at once authentic and synthetic, parodic and earnest, the partial personas in *Border Brujo* seemed to have commuted through various border towns on an episodic train, throwing out their stories like free perfume samples, peddling their hybrid tongues and glued-together ideologies through the hazy windows.[34]

Themed Festivals

As a heterolocus devoted to issue-oriented works, Highways negotiated its self-imposed obligations to its multiple cultural communities by producing performance festivals that centered around particular themes. These festivals generally reserved certain times of the year for projects with themes of ethnicity or sexual identities. At times the themes appeared multivalent, eclectic, and broad, deriving from the conceptual rubrics of multiculturalism. At their best, these themed festivals appealed to the interests of a particular (underrepresented) community, encouraging its constituents to create or to witness cultural expressions revealing their rarely exposed concerns. Some of these projected participants in the festivals, however, might reject the opportunities for the suspicion of ghettoization.

Two longstanding annual performance and visual arts festivals began at Highways in this period: *Ecce Lesbo/Ecce Homo* (1989–present), a national gay and lesbian per-

formance festival hosted by Highways every summer; and *Treasure in the House* (1991–present), the Asian/Pacific American performance festival curated by Dan Kwong. During the first *Ecce Lesbo/Ecce Homo* festival, Highways Gallery installed its visual symbol and memorial for the devastating effects of AIDS on its community of artists. Outlines of fallen bodies were drawn on the floor, which was open to audience members to inscribe the names of their family and friends who died of AIDS. In addition to its activist and commemorative responses to AIDS, the second *Ecce Lesbo/Ecce Homo* (1990) festival presented the New York artist Holly Hughes shortly after she suffered from the infamous "NEA Four" incident, in which unanimously recommended solo performance grants to Hughes, Tim Miller, John Fleck, and Karen Finely were rescinded by then-chairman of the National Endowment of the Arts, John Frohnmayer.[35] Against this topical background, the second *Ecce Lesbo/Ecce Homo* festival became a politicized oppositional forum, contesting government censorship against live art with explicit sexual contents. But even more significant and sustaining than such an overt stance of cultural protest, both *Ecce Lesbo/Ecce Homo* and *Treasure in the House,* framed as "special interest" festivals, functioned as constructive forces to ferment and display some hitherto underrepresented subjects. Just as *Ecce Lesbo/Ecce Homo* had nurtured the community of queer-identified artists, so *Treasure in the House* had stimulated the growth of Asian American performance art in L.A.

There were also several one-time-only festivals. The widely attended *Sex, God & Politics Performance Festival* (February–April 1990) took on spiritual concerns, political oppression, sexual repression, and "all the things we aren't supposed to talk about at the dinner table or try to get funding for at the National Endowment for the Arts."[36] The festival closed with an innovative multicultural ritual called Passover Performance Art Seder, organized by Doug Sadownick. Taking place on the second night of Passover, the ritual was designed as a "feast of liberation," offering manifestos, art actions, food, and music by multiethnic artists (including Jews, Arabs, Africans, and others), who evoked "the story of oppression of the Jews in ancient Egypt as a starting point for a ritual-invocation of freedom for all people."[37] The multicultural seder was so successful that it became an annual event independent from its original festival.

All Souls Performance Festival (November 1990), curated by Marcus Kuiland-Nazario, was billed as "a multicultural feast of performance about death and rebirth, featuring artists with roots in El Salvador, England, Costa Rica, Mexico, Japan, Puerto Rico, and the U.S."[38] Voodoo, Santeria, suicide, madness, sadomasochism, and other macabre matters were explored. A terrifying moment in this festival threatened to make life imitate art when Curtis York, hanging nude by his heels from a 14-foot ladder, almost fell and took the front row of the audience with him.

Black December (1991), a month-long festival organized by Joyce Guy, Keith Antar Mason, and Kuiland-Nazario, offered performances, visual artworks, community happenings, story-telling, and funk and blues concerts by African American artists. Through this festival, Highways forged new community links with two co-sponsors, the Pontifex Media Center and the California Afro-American Museum.

Self Performance

If there was a Highways performance specialty known to L.A. audiences, it was the genre of autobiographically based solo performance that came into prominence during the space's multicultural phase. "Self performance," an abridged appellation I have coined for this genre, often concerns the artist's self-representation as a subaltern individual who has been turned into an "other"—being named as "multicultural," "ethnic," "feminist," "queer," "poor," "old," or "foreign"—by his or her acculturation in this country. The genre therefore most closely demonstrates the products manufactured and displayed in a heterolocus: otherness, heterogeneity, and the profound longing for an affective community, a home-site, to which the performer may belong. As a mode long taught at Highways by Miller, self performance features direct address; story-telling via a mélange of images, texts, music, and movements; and the fearless excavation of one's individual and cultural identifies. Ideally, self performance not only empowers the artist to recognize her or his own cultural community (or communities), but may also manage to create an immediate, if transitional, community of sentient civic subjects.

Spurred on by Highways' formative ethos, many artists adopted self performance as a paragon vehicle for multiculturalism because it positioned the author-performer as an emblematic subject in symbolic—and, at times, literal—dialogues with a live audience. Characteristically, this audience either came from the same cultural community as that of the artist, or it was inclined to empathy for the performer. The performance artist's autobiographical journey might trigger the mechanism of surrogacy (the "I" of the performer taken as the "I" of the spectator), which would likely galvanize the spectators to confront, define, and reinvent themselves. A dynamic of interchange conducive to building a community was thus established.

There was no festival designated for self performance at Highways. Most works in this genre were scattered among different themed festivals and regular programming.[39] Together with the artist-performer, Los Angeles emerged as a character in two self performance pieces presented in the *Witness L.A./Testigo L.A. Festival* (November–December 1990). Luis Alfaro tackled his conflicting triple identity as a gay Chicano Catholic in *Downtown,* which opened with drive-by film shots of downtown L.A. streets projected onto a scrim, with soundtrack from Petula Clark's pop song "Downtown." The noise of a police helicopter circling overhead rudely invaded Clark's light-hearted soundscape as Alfaro first merged with, then detached himself from, the black-and-white pedestrians in the projection to deliver a rapid series of narrative snapshots about the boisterous Pico-Union district, a densely populated and impoverished Latino/a neighborhood, where he grew up. In *Tearsheets,* Joan Hotchkis uncovered an utterly different aspect of L.A.: the 26,000 acre Rancho Los Alamitos in Long Beach owned by her mother's family, the ultra-wealthy Bixby clan (Illustration 7.2). While Alfaro traveled like an urban cowboy commuting among his multiple *familias,* between the homophobic Catholic Chicano family and the racist Anglo gay friends, Hotchkis reminisced about those horse-riding cowboys who raised women and children like cattle and traded racist and sexist jokes for sport.

ILLUSTRATION 7.2. Joan Hotchkis in *Tearsheets*. Photograph by Ron Peterson, courtesy of Tearsheets Productions.

Bigotry is a harmful attitude and behavior that may cause real damage to real people in a real place like L.A. Tim Miller defied this phantasmic and material source of ill-will with *My Queer Body* (1992), which flaunted his own queerified male body as both evocative of, and deviant from, the hegemonic standard for the white male body reified in Western cultures (Illustration 7.3). Exposing his naked flesh as the prime target of bigotry, Miller nevertheless affirmed the desire and integrity of that body as the symbolic measure of his queer-centric nation. Amidst his triumphant seizure of queer agency, Miller simultaneously turned his self performance into a touching memorial for all his lovers, comrades, and friends who had died of AIDS. His body became a carrier of an individual life who remembers and honors multiple others that enriched and particularized his selfhood.

The complexity, fluidity, and volatility of one's bonds with family, community, and nation were the themes examined in three self performance projects by Asian American artists. But is there really an Asian America? To Shishir Kurup, who was born in India and raised in Africa and the United States, Asian American could not but be a partial and diasporic identity into which he migrated. In *Assimilation* (1990), Kurup humorously dissected the ingredients of his multiple identity as contingent episodes in

an ongoing game of assimilation, which affected not only the "guest" (the ethnic minority subject) but also the "host" (the earlier settlers to this land). For Dan Kwong, Asian American might be an apt denomination for his identity category, but it could not resolve the internal conflicts between his Chinese and Japanese double heritage, nor could it explain why he was so fascinated with the TV. Kwong both divulged and poked fun at these contradictions in *Monkhood in 3 Easy Lessons* (1993), throwing cultural stereotypes, self-help fashion, do-it-yourself manuals, predigested TV infomercials, and alternative American history all in a witty multimedia spin. In Denise Uyehara's mem-

ory, Asian American was once an identity category too broad to save her Japanese American grandmother from the trauma of internment during World War II. Uyehara's *Headless Turtleneck Relatives* (1993) departed from another trauma, the grandmother's suicide by fire, which became the catalyst for the artist to move in between the world of flesh and that of spirit to recontextualize a family's history as a national tragicomedy.

Discursive Circuit

As I mentioned earlier, Highways' early history had benefited from an active discursive circuit that connected its quarterly newsletter, *Traffic Report,* with the magazine *High Performance* and with the local press. The existence of this discursive circuit offered a forum for the two artistic co-directors to document the performance works they curated and to examine the controversies in which the space often became embroiled. Burnham's and Miller's prolific writings elsewhere concerning their joint project further extended the discursive circuit to reach a virtual community of readers who followed the Highways experiments in print. Thus, the presence of this heterolocus was at least doubled: it was an actual location for alternative cultural productions as well as a utopian/deviant laboratory owned by a virtual audience—both contemporary and posterior—who might not have seen any live performance there.

Traffic Report for the February to April 1990 season, for instance, cited critical acclaims from Lewis Segal of the *Los Angeles Times:* "Highways proved its point in a promise-crammed opening season: There *is* a lot more major work out there than local presenters previously showed us"; and from Tom Stringer of *Los Angeles Reader:* "In Los Angeles, 1989 was a year in which performance art outshone the conventional theater, especially in confronting the more challenging crises of our time: homelessness, the AIDS epidemic, and ethno-racial conflict. Much of the credit goes to Highways . . . their multicultural and sociopolitical mission is already serving as a model for other artist-run spaces around the country."

Despite local critics' enthusiasm, the September 1990 issue of *Traffic Report* included a single editorial commentary by Burnham concerning the NEA Four defunding incident mentioned earlier. The NEA furor ushered in a decade that would become known for its "culture wars"[40] and forecast the various struggles that Highways would have with government censorship. The February 1992 issue of *Traffic Report* published an open letter by Burnham to John Frohnmayer, questioning the NEA Council's defunding of Highways' visual arts program and of New York's Franklin Furnace as "a rejection of artistic discussion of sexuality."

While such news of woe and rage placed Highways at the center of a national debate, the discursive circuit also served the local scene by occasionally playing itself out as a performance-community-literature continuum. An excellent example was *Blue and Black* (February 1991), a "Hip Hop Dance Party" organized by *High Performance* to celebrate its African American "Blues Aesthetic" issue, guest-edited by Keith Antar Mason. Featured performers included Mason and the Hittite Empire, LAPD, Akilah Nayo Oliver, Roger "Hollywatts" Gueneveur Smith, and the sports team from UCLA

in a frolicking dance party. The series continued at Watts Tower Art Center with a panel of African American artists discussing the Blues aesthetic.

Flipping through the early performance schedules, I noticed that the Hittite Empire was one of the most visible ensembles to be affiliated with Highways. In the October 1991 issue of *Traffic Report,* the editors openly congratulated "the success of Black artists connected with Highways, particularly Keith Antar Mason and The Hittite Empire." The Hittite was, nevertheless, also the most controversial group. Burnham and Miller spent two consecutive issues of *Traffic Report* (April–July, July–September 1990) on reviewing the tumult caused by their production of *Prometheus on a Black Landscape: The Core.* Written by Mason, the play centered on his perspective as a black man to interpret the 1989 "wilding" incident in New York City's Central Park, where a white female jogger was sexually assaulted and severely battered by a gang of black men. Having choreographically depicted the gang rape, Mason submerged into the mind of one of the rapists to explore the history of "black male silence."[41] Audience outrage ensued: most were offended by the Hittite's blatant misogyny; some deflected such accusations of sexism from feminist criticism to be racism against African American men. A long, heated, but fairly handled discussion between the concerned spectators and writer-director Mason followed the performance. According to *Traffic Report,* the occasion exemplified the need to deal with painful issues head-on rather than "to let rumor and suppression of emotion do their damage to a community."[42]

A Heterolocus in Process

To focus my assessment of Highways' community-building strategies on its initial multicultural phase is both arbitrary and reasonable. It is arbitrary because Highways is an existing organization with a continuous and continuing history that is essentially indivisible into artificial periods with different missions. Moreover, any strategy that it developed in the past, if effective, is inherited by the new artistic teams, while other strategies that emerged later are eclipsed in this investigation. I must, then, stress that my study exists within a dynamic historical stream: not only would Highways' past affect its present state of operation, but its future directions would also change our interpretations of its past. If I may call Highways a heterolocus, then as long as it is alive, it is a heterolocus in process.

The periodization followed by my assessment is also reasonable, however, because it marked a drastic and saddening transition in Highways' history: the departure of Linda Burnham. The excitement of Highways as a locus for multicultural performances had much to do with the match between Burnham's and Miller's dedications and drives. Burnham's exit caused a tremendous loss to the Highways community, not because her vision for multiculturalism became dissipated, but because the circumstances of her departure indicated how turbulent the practice of multiculturalism could be.

In fact, Burnham's separation from Highways (and simultaneously from L.A.) seems to have become a taboo memory, for most people I interviewed were reluctant to retrieve

ILLUSTRATION 7.4. Publicity photo for *The Warriors Council.* Artists shown from left: Francisco Letelier, Linda Frye Burnham, Michelle T. Clinton, Dan Kwong, Keith Antar Mason. Photograph by Aaron Rapoport, courtesy of Dan Kwong.

it. The only source concerning this lost history that I have found so far is an unpublished exposé entitled "Multiculturalism and the 18th Street Arts Complex," written by Dan Kwong as a proposal sent to the Getty Museum. "In those early years," Kwong recalls, "we [artists at Highways] had some extraordinary success and some splashy failures with multiculturalism." He traced the biggest effort in implementing multiculturalism to *The Warriors' Council,* a collaborative project conceived by Burnham in 1991, developed by participating artists in the summer of 1992, and eventually performed at Highways in November 1992 (Illustration 7.4). Based on the concept of "artist as warrior for social justice and change," the project engaged several activist-leader-artists

from various (ethnic-sexual) communities in L.A., with a goal to create "an expression of healing, of mutual support and alliances between communities and constituencies."[43]

The goal was urgent, well-intentioned, and promising, considering that L.A. was haunted by the recent specters of the South Central civic unrest (29 April 1992). Unfortunately, the process of reaching such a goal was traumatic for all involved, especially for Burnham, who was invited by the participants to join the development and performance. Because of intense racialized conflicts among participants, Burnham felt compelled to drop out of the project at the last minute. This ambitious and high-profile multicultural experiment spelled the beginning of Burnham's emotional and physical severance from Highways.

The incident of *The Warrior Council* suggests that any project in creating a coherent community involves certain risks and personal compromises. The project becomes exponentially more difficult when it aims to facilitate exchange between agents from within and among diverse communities, even as it might also bring the satisfaction of interpersonal collaboration. A shared ideal—be it multiculturalism, queer empowerment, or the heterolocus—might guide the interacting subjects toward a common destination. The less-glamorous day-to-day skills of negotiation, however, are the flesh and spine that substantiate and uphold the collective body of the individuals who are, after all, the irreplaceable faces in an affective community.

Notes

1. Urban theorist Charles Jencks coins the term *heteropolis* in "Hetero-Architecture and the L.A. School," in *The City: Los Angeles and Urban Theory at the End of the Twentieth Century*, ed. Allen J. Scott and Edward W. Soja (Los Angeles: University of California Press, 1996), 47–75.

2. Michel Foucault, "Of Other Spaces," trans. Jay Miskowiec, *diacritics* (Spring 1986): 22–27. Subsequent quotations from Foucault are based on this source.

3. Ibid., 24.

4. I stress that the statement reflects my own observation because Burnham and Miller might not agree with my analysis. In the same light, the genealogy of Highways traced here reflects my own syntheses rather than the consensus of those involved. I express my appreciation, however, for the following people who have generously offered me their recollections and access to archives: Tim Miller, Dan Kwong, Danielle Brazell, and Mary Milelzcik. I should also disclose that I served on the board of directors for Highways from 1997 to 2000.

5. See Highways' current publicity flyer distributed in its gallery.

6. Jan Breslauer, "Performance Space to Open Where Highways Meet," *Los Angeles Times*, 4 May 1989, VI:3.

7. See Elizabeth Zimmer, "Out of Left Field," *Dance Magazine* (September 1989): 52–53.

8. For a historical survey of Los Angeles performance art world from 1960s to 1990s, see Meiling Cheng, *In Other Los Angeleses: Multicentric Performance Art* (Berkeley: University of California Press, 2002).

9. I am indebted to Joan Hotchkis for the information concerning Dakin's contribution to the 18th Street Arts Complex because Dakin had preferred to remain anonymous in the past. I had

an interview with Hotchkis on 10 July 1999, in Santa Monica. Special thanks to Jan Williamson, the current co-director of the 18th Street Arts Complex, for answering my phone inquiry. See also Burnham's "Getting on the Highways: Taking Responsibility for the Culture in the '90s," *Journal of Dramatic Theory and Criticism* (Fall 1990): 269.

10. Susanna Dakin, "The 18th Street Arts Complex as Anti-Ghetto Art?" *Traffic Report: A Publication of 18th Street Arts Complex* (June 1996): 6.

11. The first tenants in the 18th Street Arts Complex included High Performance/Astro Artz; the Electronic Cafe, The Empowerment Project, Community Arts Resources/CARS; Parents International Ethiopia; The Bhopal Justice Project, numerous individual artists studios, and Highways. See Burnham, "Getting on," 269.

12. Ibid., 268.

13. For an excellent in-depth study of multiculturalism, see *Mapping Multiculturalism*, ed. Avery F. Gordon and Christopher Newfield (Minneapolis: University of Minnesota Press, 1996).

14. Breslauer, "Performance Space," 3.

15. Miller, "Tim Miller," in *California Performance, Vol. 2/Los Angeles Area*, ed. Thomas Leabhart (Claremont, Calif.: Mime Journal), 123.

16. Quoted by Zimmer, "Out of Left Field," 52.

17. Burnham, "Getting on," 270. Miller called the "wildly ambitious manifesto" Highways' "birth certificate" in his reflection on Highways' first five-year history, in *Traffic Report* 1.1 (Summer 94): 44.

18. Burnham, "Getting on," 270.

19. Ibid., 271.

20. For a more extensive engagement with the history of multiculturalism in L.A., see my monograph "Otherness Naturalized: Multicultural Performance Art in L.A." at <http://sc2.usc.edu/sc2/pdf/cheng.pdf>, sponsored by the Southern California Studies Center at the University of Southern California.

21. Tim Miller and David Román, " 'Preaching to the Converted,' " *Theatre Journal* 47, no. 1 (1995): 175.

22. Kate Davy reflects on a similar conflict between representing ethnicity and sexuality in "Outing Whiteness: A Feminist/Lesbian Project," *Theatre Journal* 47, no. 1 (1995): 189–205. Davy's essay focuses on the difficulty of recruiting African American practitioners and spectators to the WOW Café, a feminist/lesbian theatre collective in New York's East Village.

23. Burnham, "Getting on," 270.

24. Ibid., 268.

25. Ibid., 274.

26. Miller's email message dated 6 July 1999, a response to the author's email query dated 5 July 1999.

27. See *Traffic Report* (October 1989), no pagination, in Highways' archive.

28. See David Román's excellent study concerning the relationships between performance and the AIDS crisis in *Acts of Intervention: Performance, Gay Culture, and AIDS* (Bloomington: Indiana University Press, 1998).

29. Burnham, "Getting on," 272.

30. For both Mardi Gras and the Artist Chain Gang events, see *Traffic Report* (February–April 1990) and (April–July 1990). See also, Román, *Acts of Intervention*, 192–96.

31. *Traffic Report* (July–September 1990).

32. See *Traffic Report* (October 1989).

33. *Traffic Report* (September–October 1989). See also, Burnham, "Getting on," 273–74.

34. See *Traffic Report* (August 1989). For a more extensive study of Guillermo Gómez-Peña's border performances, see Cheng, "Otherness Naturalized," at <http://sc2.usc.edu/sc2/pdf/cheng.pdf>.

35. See a detailed documentation of these government art censorship furors in Richard Bolton, ed., *Culture Wars: Documents from the Recent Controversies in the Arts* (New York: New Press, 1992).

36. *Traffic Report* (February–April 1990).

37. *Traffic Report* (July–August 1990).

38. *Traffic Report* (November 1989–January 1990).

39. See Chapter 5 of my *In Other Los Angeleses: Multicentric Performance Art* (Berkeley: University of California Press, 2002) for an extensive study of all the self performance pieces cited here.

40. I am citing from the title of Bolton's *Culture Wars*.

41. I had interviews with Keith Antar Mason on 17 December 1997 and on 15 May 1998. He did not dwell on his early history with Highways but focused on the consequences of the South Central "insurrection" (his term) on African American artists in L.A. No video archive of the Hittite Empire's performance work is available to me.

42. *Traffic Report* (July–September 1990).

43. Original participants in *The Warrior Council*, funded by several foundation and government grants, included Tim Miller, Michelle T. Clinton, Francisco Letelier, Keith Antar Mason, and Dan Kwong. They invited Burnham to join the group of performers. Miller dropped out early in the process, and Burnham was later replaced by Colette Jackson. All quotations concerning *The Warrior Council* are based on Kwong's unpublished document. I thank Kwong for sharing this invaluable document with me. Some details are not disclosed to respect his wish.

Jiwon Ahn

**8 Signifying Nations:
Cultural Institutions and the
Korean Community in Los Angeles**

Of the numerous cultural sites in Los Angeles, the Miracle Mile—Wilshire Boulevard between Fairfax and La Cienega—is arguably one of the most outstanding. Navigating this street, one encounters all sorts of unusual cultural venues, from the prestigious Los Angeles County Museum of Art (LACMA) to the artificial mammoths trapped in the La Brea Tar Pit, from the now-closed vintage coffee house Johnie's to drag queens in line for the Makeup Club in the El Rey Theater. Next to the theater an unfamiliar flag flutters on the facade of the Korean Cultural Center (KCC). Within it, a wide variety of exhibits may be found: replicas of old crowns, samples of early printing techniques, and even Nam-June Paik's contemporary video artwork "Scott Joplin as the First Digital Composer"—all from the far-away nation of Korea.

With the highest percentage of foreign-born immigrant population in the United States and its pivotal position within a "majority-minority state" of California,[1] Los Angeles is rich in polyethnicity and multiculturalism. Accordingly, it contains several kinds of official foreign representations: consulates and trade missions; cultural centers, including the KCC (founded in 1980), Germany's Goethe-Institut (founded in 1983), and the Italian Cultural Institute (founded in 1986); and a large number of non-governmental, nonprofit organizations that negotiate between other immigrant groups and the cultural hegemony. Los Angeles, then, is a virtual laboratory for studying how these institutions differently utilize culture in creating communities and in forming relations with other communities.

In this essay I will examine some of L.A.'s national or ethnic cultural organizations, focusing especially on the KCC and the Korean community. Considering three prominent national cultural organizations—the Mexican Cultural Institute, the Japanese American Cultural and Community Center and the Goethe-Institut—I will describe the different ways each utilizes the concept of culture. Then I will examine in greater detail

ILLUSTRATION 8.1.
The Korean Cultural
Center, Miracle Mile,
Los Angeles. Photograph
by Jiwon Ahn.

both the KCC's activities and programs, and those of other nongovernmental cultural organizations within the Korean community. Finally, I will explore how the actual users of the various cultural centers form relations with the national culture, regardless of the government institutions' own intentions. Together, the studies of all these forms of negotiations among cultural institutions, their home governments, and the local communities will provide a general understanding of the institutional use of national cultures.

Since people of Mexican heritage comprise the largest ethnic group in Los Angeles, we may reasonably start with the Mexican Cultural Institute of Los Angeles (MCI), which was established in 1991 as a California nonprofit corporation whose principal goal is "to create a better understanding between the people of Mexico and the U.S. through art, culture and education."[2] Appearing on most of its printed materials, MCI's mission statement reads as follows:

> We wish to be a catalyst for building bridges between ethnic groups in our part of the country and those people in Mexico who have a direct and special interest in the life and events of Southern California. We are also especially interested in strengthening the bonds between U.S. born Mexican Americans and immigrants from Mexico, and beyond that, we want to promote a greater understanding and communication between them and the rest of the population of Southern California.[3]

To these ends, the major activities at the MCI include exhibitions of the work of Mexican and Mexican American artists, academic conferences on Mexican culture and history, practical seminars and educational programs for Spanish-speaking adults, and music and dance performances to celebrate various Mexican historical events and folk traditions.

Structurally a binational organization, the MCI is governed by a board of directors with eight members, three being officials of the Mexican government and the rest Los Angeles business and community leaders. Even though it uses the original national culture of Mexico, the MCI is run by the idea of a partnership between the Mexican government and the Mexican American community in Los Angeles.[4] As a result of this partnership with business, the MCI appears to be more commercial and self-advertising than completely governmental cultural institutions. Located among the numerous Mexican craft shops and restaurants at the heart of Olvera Street, MCI has its own artisan shop and bookstore on the first floor, where people who shop around on Olvera Street naturally tend to drop in. If their cultural interests cannot be satisfied by merely purchasing some of the products, they can use the library next door or go upstairs to learn about Mexican culture. This actually happened most of the times that I visited the Institute. Many of the shoppers wanted to go upstairs and check out the facilities or ask questions, for despite the commodifying of Mexican culture, the institute's strategic location near a commercial area seemed to work effectively in attracting people to the cultural community formed around it.

More importantly, the MCI's unique principle of partnership and its consequent enthusiasm in reaching out to a broad audience seem to be consistent with its willingness to embrace and address the diverse interests of the Mexican American population in Los Angeles. As Leticia Quezada, MCI's president and chief executive officer, states, "The first audience of the Mexican Cultural Institute is Mexican American people in Los Angeles, although other ethnic groups are no less important audiences." She remarked that its role is particularly significant for Mexican people in Los Angeles in enhancing the self-esteem of immigrants and the education of American-born children of Mexican origin. Reflecting this recognition and the institute's goal to cater to practical needs of the Mexican American people, each of MCI's educational programs seems to be designed for very specific audiences to convey more substantial information: free English as a Second Language (ESL) and Spanish literacy classes for Spanish-speaking adults, seminars on Mexican history and culture for bilingual educators and parents, an annual conference for bilingual scholars, and even consumer information seminars like "Buying Your Own Home" for Mexican immigrants in Los Angeles. Even if these specific objectives might limit the range of people who can participate in such programs, I believe it actually creates deeper involvement and a stronger sense of community.

The culture promoted at the Mexican Cultural Institute is similarly broad and far-reaching, and it includes many elements of popular culture. For example, central events are often organized around cultural festivals that celebrate popular historical memories or folk traditions such as Cinco de Mayo, the celebration of Mexican Independence Day in September, Mardi Gras, the celebration of the Mexican Revolution, the founding of the City of Los Angeles, the Day of the Dead, and so on. These festivals feature various entertainment programs for the general public, arts and crafts events for school

children, and performances and themed parades on the streets. Besides the festivals, the MCI frequently presents or supports performances at the plaza on Olvera Street so that more people can share the cultural experiences even if they are just relaxing shoppers or tourists.

Although the staff at the MCI are also concerned about presenting the more prestigious and canonized "high art" aspects of Mexican culture—Frida Kahlo's surrealist paintings, for example—they readily incorporate less conventional forms of culture, such as fashion shows and craft workshops like piñata-making and tortilla-painting. In 1997 they awarded the Mexican-born Hollywood star Salma Hayek an "Estella de Nuestra Cultura," a recognition for contributing toward a positive image of Mexican culture in Los Angeles. Any forms of culture could be used, according to Quezada, as long as it has a Mexican origin. And "since about one third of population in Los Angeles consists of people of Mexican origin, the relation of Mexican culture to the whole of L.A. culture is not just a Mexican question," she said. Thus, I would argue that the MCI's open embrace of a wide range of culture, which has been generated by the partnership between the Mexican government and the Mexican American community, works positively in connecting more people in Los Angeles as well as in Mexico to the collective cultural experiences of the "Mexican origin" and in negotiating the community's position between cultural majority and minority.

Another model of an organization that mobilizes a national culture is the Japanese American Cultural and Community Center (JACCC). Founded in 1971, it is one of the most prominent cultural organizations in the Japanese American community, itself one of the oldest ethnic communities in Los Angeles. Unlike the MCI, whose community is constituted primarily of working-class immigrants, the JACCC's community includes an economic elite that has become a "discreet but major player in city politics."[5] Like the MCI, the JACCC also uses culture to create a sense of community, but it mobilizes different economic factors.

The JACCC is "a nonprofit, charitable organization that seeks to present the best of Japanese and Japanese American culture to as wide an audience as can be reached," explained Katsumi Kunitsugu, the executive secretary of the center.[6] That JACCC started from the recognition that the perception of Japan determines how Japanese Americans are perceived and treated in the United States—a lesson Japanese Americans learned during World War II—indicates a certain propagandistic component within its cultural activities. Accordingly, the JACCC presents and supports numerous fine arts exhibits and traditional (as well as contemporary) music, dance, and theater performances that can showcase prestigious aspects of Japanese national culture, just as other ethnic cultural organizations do but on a larger scale in terms of the number and budget of the events.[7]

The JACCC's facilities were funded initially both by the U.S. government through its Little Tokyo Redevelopment Project and by the Japanese government, but otherwise the center has never received any ongoing operational support from any government. Instead, it is funded from various cultural institutes, foundations, and business corporations in both the United States and Japan. Even more than the MCI, it appears to be organized in a vigorous, self-advertising, and entrepreneurial manner; and the aggressive fundraising by George J. Doizaki, the founder of the American Fish company and

its first president, which enabled the construction of its $14 million facilities, is one of its best-known legends.[8]

Every year the staff at JACCC compose annual reports that not only describe its activities and financial situation but also evaluate their own efforts to improve its operations. The competitive edge that results from JACCC's financial structure seems to play a significant role in maintaining its prominence as the largest ethnic cultural center in the United States. Experienced in art management, the center's professional staff have made it renowned for acclaimed performances and exhibits from Japan—such as the "Living National Treasures of Japan" exhibit—and for original works by local artists of different ethnic backgrounds.

The JACCC also places a high priority on serving the Japanese American population in Los Angeles, especially in helping the younger generations appreciate their cultural heritage. This solid orientation toward the community makes its activities more clearly defined and closely connected to the lived experiences of the participants. For example, the JACCC presents annual events celebrating the traditional Japanese holidays of "Oshogatsu" (New Year's) and "Kodomo no Hi" (Children's Day) "in an effort to preserve traditions inherited from Japan but also to define and present uniquely Japanese American traditions and values for younger generations."[9]

As Katsumi Kunitsugu, the executive secretary, suggested, what culture means is completely dependent upon its users;[10] thus, the culture JACCC uses cannot be separated from the lives of the people who participate in the community formed through the center. Accordingly, although they present numerous fine arts exhibitions and traditional music, dance, and theater performances, the JACCC also embraces less conventional and more popular kinds of culture by presenting pop music performances, karaoke nights, old-time Japanese tunes (called enka), variety shows, cooking demonstrations, and so forth. It also participates by supporting the annual Nisei Week Japanese folk festival. Similarly, its educational programs, such as cultural workshops or field trips for children that feature programs such as hands-on crafts, Japanese folk dance, games, and stories are organized according to the principle of defining and enhancing Japanese American cultural experience.

The JACCC's unusually frequent collaborations with other cultural organizations within and without the Japanese American community seem to indicate its more flexible view on culture and more practical approach to it. Whether they are joint projects with other cultural organizations or collaborations between individual artists of different ethnic backgrounds, these cross-cultural collaborations are possible only when the groups involved are open to, and respectful of, each others' cultures. Its successes in these areas have made the JACCC a telling example of how a community cultural center, operated voluntarily by the community members themselves in an independent, contractual relationship with governments and business corporations, may enrich and empower a minority ethnic group.

A third model of cultural organization is the Goethe-Institut of Los Angeles. Unlike the two organizations discussed above, the Goethe-Institut is a governmental institute, founded by the German Ministry of Foreign Affairs "to foster appreciation for the

German language and culture in [the] host countries, to contribute to international understanding and to enhance the intercultural dialog with other countries."¹¹ There are about 170 branches of Goethe-Institut in many metropolitan areas in 80 countries around the world. Established in 1983, the Goethe-Institut of Los Angeles focuses on its two major functions: cultural cooperation with its local partners, and the operation of its information center that comprises a library and a video archive. The German language courses that most Goethe-Institut branches have are no longer offered at the Los Angeles branch because of the low enrollment. Instead, it concentrates its efforts on organizing diverse cultural events like art exhibitions, theater productions, film festivals, conferences on various topics, and music events.

The Goethe-Institut of Los Angeles is located on the Miracle Mile within a few blocks of the KCC and major museums like LACMA, the Petersen Automotive Museum, the Kaye Museum of Miniature Art, the Craft and Folk Art Museum, and the Page Museum. This location might indicate that both the Goethe-Institut and the KCC are not as concerned with their own ethnic communities as are the MCI and JACCC, which located themselves within the geographic or symbolic boundaries of their ethnic communities. Along with the Italian Cultural Institute in Westwood and the Alliance Francaise in Beverly Hills, the locations of the German and Korean institutions suggest that they are concerned to propagate their national cultures to broader, mainstream audiences in Los Angeles. Thus, it is not surprising to find the Goethe-Institut's program coordinator, Margit V. Kleinman say, "We are not here to entertain the German community. We do not and should not care [about] the German community if there is anything such. We are only here to import German cultural events in cooperation with local partners." The Institut staff, Kleinman continues, are keenly aware of their specific cultural emphasis:

> Our programming is isolationist by nature. Intellectually, the culture we deal with here does not appeal to many people. It is not fast food. . . . Yes, we bring only high art. Our program reflects an elevated idea of culture. The nature of art is something elitist by itself, which needs sophistication and a certain degree of education to be appreciated. It is because the product we are selling is a kind of elitist product.¹²

This clear recognition that the institute's mandate is the promotion of Germany's national high art may explain its willingness to include in its programs politically radical and even antigovernmental cultural products as long as they are aesthetically sophisticated. Adding an invigorating diversity to the city's cultural scene, this orientation is most manifest in its film programs. Its proclamation—"The Goethe-Institut Los Angeles operates in the movie capital of the world, therefore special attention is paid to film and media-related topics"—recognizes its desire to enhance exports of German cultural products by presenting German films—a European avant-garde—as an alternative against Hollywood.¹³ The Goethe-Institut's provision of a noncommercial elite artistic culture in the world's capital of the culture industry is a good example of the way government institutions may mobilize national culture to create a mainstream community around it for public relations' purposes.

In positioning themselves toward both American mainstream audiences and their ethnic communities, the three institutions examined so far mobilize the concept of

national culture differently: the MCI's more practical and commercial approach, the JACCC's distinctive community orientation, and the Goethe-Institut's self-consciously PR-based operation. Their close neighbor, the Korean Cultural Center, shows yet another orientation, which can be considered an interesting mixture of all the above three.

On the face of it, the KCC is most comparable to the German Goethe-Institut. A governmental cultural institute organized and located quite similarly, it also has the goal of appealing to the mainstream audience rather than to its own ethnic community.[14] Its art exhibitions, library, film archive and screenings, language courses, and other programs are very similar; and the kind of high culture it emphasizes is parallel to the Goethe-Institut's. Nevertheless, there are considerable differences. The KCC is under the jurisdiction of the Ministry of Culture and Tourism of the Korean government, whereas the German institute belongs to the Ministry of Foreign Affairs, and the Mexican and Japanese cases are only partly funded by the governments. Even though the Korean and German organizations are involved in PR for their home governments, the KCC's propagandistic quality differs from the Goethe-Institut's export-oriented cultural politics. For example, in 1999 the Ministry of Culture and Tourism of Korea announced "Twenty Images of Korea," including *hanbok* (traditional dress), *Pulkuksa* (a Buddhist temple), Mt. Sorak, *taekwondo* (traditional martial art), *kimchi* (traditional food), ginseng, and so forth, which it wants to project specifically as Korean culture.[15] These highly iconized images of national culture, although they might be effective for publicity, suggest that the range of culture KCC mobilizes is necessarily limited.

More importantly, while the Korean and German institutes proclaim the "mainstream" public as their primary audiences—unlike their Mexican and Japanese counterparts, which prioritize their local communities first—they are in different situations regarding their "secondary" audiences. For whereas it is hard to find a coherent German community in Los Angeles, a very large and distinct Korean community exists, especially visible around the commercial core of Koreatown.[16] Thus, unlike the German center, which has few problems in deprioritizing its own ethnic group, the KCC has to deal with the Korean community. Especially since the large and distinct Korean community is a relatively recent formation of the still-fluctuating and unstable post-1965 new immigration wave,[17] its cultural and economic situation is much more complex. The way the Korean Cultural Center, as a governmental cultural institution, uses national culture to negotiate relations among the hegemonic society in Los Angeles, the Korean community, other ethnic groups, and the Korean government or homeland is therefore particularly interesting.

The Los Angeles branch of the KCC was established in 1980 as a part of the Consulate General of the Republic of Korea in Los Angeles. According to a former consul, Kyu Hak Choi, as the political and economic relationship between the United States and (South) Korea became closer throughout the cold-war period of 1970s, the Korean government recognized the need to present positive images of Korea to its ally and so established cultural centers in New York and Los Angeles.[18] Their mission was defined as "serving the general public by providing information about and performances of Korean culture."[19]

Although KCC also supports Korean Americans' efforts to cherish Korea's cultural traditions, Rick McBride, its present cultural consultant, understood its primary goal

as being "to reach out to the large mainstream non-Korean population the best ways it can and to help people have good experiences in learning something about Korea so that they might want to go to Korean restaurants or go on tour in Korea."[20] Its major activities and resources include art exhibitions, music and dance events, publication of the quarterly *Korean Culture* magazine, research facilities of library and video archive, school field trips and group packages, monthly Korean film night events, and educational programs such as Korean language and traditional music classes. I will exmine these in more detail below.

Art exhibitions held at KCC are quite varied. The following exhibitions, for example, were held between December 1997 and October 1999:

"Passive/Aggressive" (contemporary art works by four feminist artists of diverse ethnicities)

"Korean Rare Book Exhibition"

"Treasures of Korea" (contemporary clay, metal and fiber art works by fifteen Korean or Korean American artists)

"The Circle Game" ("round things" interpreted by six L.A.-based artists of diverse ethnicities)

"Common Ground" (paintings, plastic arts and mixed media works by eleven multiethnic artists)

"Korean Calligraphy Show" (8th & 9th annual exhibitions of Korean American Calligraphy Association)

"From Seoul to LA: Korean American Architects Bridge the Pacific" (works of four L.A.-based Korean American architects)

"The 30th & 31st Annual Exhibitions of the Korean Artists Association of Southern California"

"Individual Identities" (contemporary works by five multiethnic artists)

"Korean Fan Painting by 50 Artists"

"Spring Fever: a Cultural Celebration with Korean and Mexican Artists in L.A."

"Seoul Home/L.A. Home" (works by Do-Ho Suh, winner of 1999 KAFA Award for Visual Arts)

"Modern Korean Embroidery,"

"Art & Issues: an Exhibition by Korean American & African American Artists"

Although it is hard to generalize any common themes or overarching principles from this list, these shows fall into roughly four different categories according to the organizers, participants, and purposes of the shows—"roughly" because some of the categories obviously intersect with each other. First, there are fairly regular (about biannual) themed exhibitions of contemporary artworks by several American artists, some of whom are Korean American; these present Korean American artworks as a part of the mainstream Los Angeles fine art scene. Second, some other exhibitions feature more traditional aspects of Korean culture; these are mostly imports from Korea that supposedly introduce "authentic" taste of the national culture to foreign audiences. Third, there are exhibits held by local (Korean American) art groups, for which the KCC merely provides its gallery space; while KCC has a policy to prioritize shows that "help foreigners

ILLUSTRATION 8.2. Exhibition of Nam-June Paik's works at the Korean Cultural Center Gallery, 2002. Photograph by Jiwon Ahn.

understand Korean culture easily,"[21] local art groups tend to use KCC's space for their own practical reasons to address to mainstream crowd.[22] Finally, there are cross-cultural exhibitions that were started in the late 1990s as a way of forming cultural and social alliances with other ethnic communities, especially with Mexican Americans and African Americans. (I will discuss these in detail below.) The music or dance performances that KCC occasionally presents or supports also fall into these four categories, showcasing both traditional and contemporary high culture to general audiences in Los Angeles.

KCC functions, then, to present either traditional (Korean) or contemporary (Korean and Korean American) fine arts, or mixtures of both, to the mainstream public; for as McBride noted, the Korean government wants to present both "traditional images of society" and contemporary images of "society in the leading edge of avant-garde or modern technology."[23] Do-Ho Suh, one of the artists who participated in KCC's art exhibition "Seoul Home/L.A. Home," explained the reason why he hung his work, "L.A. Home," above the spiral staircase of the KCC building:

The staircase at the Cultural Center links the first floor, where some Korean archeological artifacts and traditional folk culture are exhibited, and the second floor, where contemporary Korean art by Korean American artists in the Los Angeles area is shown. The staircase connects the space of the past, memory, and nostalgia of the first floor to the space of the present of the second floor. It is a passageway establishing the close proximity and yet the

ILLUSTRATION 8.3.
Spiral staircase at the
Korean Cultural Center.
Photograph by Jiwon Ahn.

immense gap between the original culture of the past and the immigrant culture of the present. Installed in this multi-transitional space of the staircase through which the viewers transit, my work attempts to create an experience of transition in space, time, and culture.[24]

Metaphorically speaking, KCC operates like this spiral staircase, mediating traffic between different spaces, times, and cultures and spatializing in a visible and comprehensible way the ambiguous entity named Korean culture.

KCC's quarterly publication *Korean Culture* reflects the same kind of perspective on the national culture. Titles of articles or special series featured between Spring 1998 and Winter 1999 include:

"Special Issue: Korean American Fiction"
"Performance Traditions: *Ch'angguk* ... and *P'ansori* in Trans-National Context"
"The 1988 Seoul Summer Olympic: a Legend Grows"
"Hidden in Full View: Shamanism in Korea"

"Hopes and Aspirations: Korean Decorative Painting"
"Special Feature: Ko Un, Korea's Poet Laureate"
"Opera in Korea"
"Logging on to Inyon: The Hit Film *Chopsok*,"
"The Ancient Korean Constellations"
"Early Masters of Modern Korean Fiction"
"The Korean Galleries at the Los Angeles County Museum of Art"
"The Daily Life of Commoners: Changing Images in Late Choson-Dynasty Genre
 Painting"

While these titles include the latest blockbuster films and other current popular issues in Korea, *Korean Culture* consists mainly of articles on tradition and high culture. Its cover usually features a beautiful picture of a Korean natural scene or an old work of art that, like the pictures in in-flight magazines, encourage an essentially touristic fascination.

The KCC's cultural tours and field trips present a package of Korean culture to school children or other civic groups all over Los Angeles–people who have in most cases been exposed to hardly any aspect of Korean culture. The tours are tailored differently according to the needs of the audience, yet they normally consist of a screening of an introductory video, a short lecture, and an art project. The videos screened are short documentaries on Korea that show highly iconized images of Korea like old Buddhist temples, natural scenery, national treasures like Koryo celadon or metal type printing, traditional music and dance performances, *hangul* (Korean alphabet), or *taekwondo* (traditional martial art). Then the cultural consultant, an American (white male) spokesperson for KCC, who is wearing traditional Korean clothes for the occasion, gives a short lecture on Korean culture and a tour of the exhibition hall. Children have an arts and crafts event in which they make Korean fans or some other traditional crafts, and at the end of the tour, they say good-bye in Korean and leave perhaps with certain images of the country in their minds.

The KCC's major activities focus, then, on traditional, mostly premodern aspects of Korean culture as well as on contemporary dimensions of the fine arts. In other words, it promotes mainly high classical culture as Korean national culture, presenting very conventional and standardized images of Korea. While it is effective for the purpose of public relations, this emphasis on canonical culture is somewhat problematic, since it has scarcely any direct connection with the lives of the majority of Korean or Korean American people. Separated from the context of its original formation and isolated from the collective experiences of Korean people in both countries, the "Korean culture" used at KCC functions as a superficial, touristy, and propagandistic instrument that caters mainly to the aesthetic pleasure and stereotypical ideas of white audiences in Los Angeles. Furthermore, considering the complicated class configuration of the Korean American community with which KCC inevitably gets involved, the KCC's cultural legitimization of only one type of culture and its exclusion of all others becomes more questionable.

The majority of the Korean immigrants, especially those who immigrated after the 1965 Immigration Act removed national quotas and accepted professionals in undersubscribed categories, have experienced tremendous shifts in their social status, mostly

downward.[25] As a result, large numbers of educated, white-collar, middle-class immigrants suddenly became members of the working class. The culture of this immigrant group is consequently composed of multiple layers in which diverse elements constantly fluctuate so that the culture of the Korean American community in Los Angeles is profoundly different from the kind of Korean culture defined and promoted by KCC.

The fact that only a few cultural organizations operate visibly in the L.A. Korean community intensifies the necessity for established cultural organizations like the KCC to work with a broader sense of national as well as community cultures in order to accommodate the cultural needs of the large immigrant population. It is necessary, then, to look briefly at the ways in which other nongovernmental cultural organizations function within the Korean community in Los Angeles and to examine their alternative potentials.

Within the Korean community in Los Angeles, several nonprofit organizations have engaged in cultural activities to a certain extent. Yet most of them are merely gatherings of people who have the same interests in arts or similar occupations related to arts, primarily for socializing and networking purposes. Thus, even though some groups, like Koreatown's Federation of Korean Artists' Cultural Organizations USA, take eminent positions within the community and have substantial power over it, I do not take them into consideration in the current essay unless they organize cultural activities in which the general public in and on the edges of the Korean community may freely participate.

Among organizations providing cultural venues for the general public, we may first consider the Korean American Museum. Established in 1991 as a historical society, the Korean American Museum aims to "serve the public by promoting Korean American history and culture," to "recognize Korean contributions to America" and to provide "a cultural and educational forum for the exchange of ideas and experiences relating to Korean and Korean American people."[26] The museum has held several exhibitions on the history of Korean immigration, including three shows scheduled between 1999–2003: "Storefront Live: Korean American Small Businesses," "Snapshot: A Portrait of Korean American Adoptees," and "Spiritual Practices: Rituals, Icons and Faith." Since 1997 the museum has offered an educational program, KAM/CARES, for public school students in the greater Koreatown/South Central area, which includes visual art projects, workshops, and tours of local museums and private art studios to encourage cross-cultural social communications through art. It has an ongoing project with the University of Southern California to build a digital archive that will include collections of oral histories, photos, catalogues of Korean American arts, and research papers on Korean Americans and their genealogy. These cultural activities of the Korean American Museum are remarkable in that they mirror the institute's engagement in the actual lives of diverse people around the Korean American community. However, practical difficulties in operating such nonprofit cultural organizations among the large number of economically insecure immigrant workers in the Korean community make it hard to regard them as a true alternative to governmental institutes like KCC. For example, for many years the Korean American Museum was prevented from having its own building by problems in realizing its plan to build a community center that would also house four other Korean American organizations, including the Korean American Coalition and the Korean Youth Community Center.[27]

As well as the Korean American museum, several other public organizations in the Korean community work efficiently in helping immigrants with problems associated with youth, domestic violence, and illegal immigration, although their activities seem to hardly meet the cultural needs of the Korean American people. For example, the Korean Immigrant Workers' Association (KIWA) is a nonprofit public benefit organization that helps immigrant laborers who have been treated unfairly in their work places. Usually, KIWA consultants counsel the workers on due procedures to solve the problems, whether they are Korean immigrant workers or other Asian or Latino immigrants who are employed by Korean employers.[28] Thus, even if KIWA has not yet tried any culturally oriented activities, community service organizations of this kind have a great potential as primary sites of popular culture since they are deeply involved in the actual experiences and concerns of the Korean American people, especially those of the subordinate classes.

Other community centers have a similar cultural potential. The Korean Youth and Community Center (KYCC) in Koreatown provides economically disadvantaged youth and families (including 56 percent of Latino origin) with clinical services, academic services, and educational programs on alcohol, drugs, tobacco, and HIV/AIDS; while the Pio Pico Koreatown Branch Library operates as another kind of community center. One of sixty-seven branches of the Los Angeles Public Library, Pio Pico Library is unusual in having Korean immigrants as more than 60 percent of its patrons; consequently, it began to organize cultural activities aimed at the whole Korean community, even beyond its geographic boundaries. First it organized numerous reading campaigns; and every year on the 9th of October, they celebrate the invention of *hangul,* the Korean alphabet, with cultural events, including a writing competition for school children. Their bimonthly book clubs for housewives have also become very popular, and librarians plan to offer classes in Korean language, knitting and embroidery, folk games, and ESL when their new building is completed. Like the JACCC, which successfully combines the two jobs of community center and cultural center, Pio Pico Library has a real potential to function as an alternative community cultural center, where the enormous cultural desires of the underprivileged population is met by hardworking librarians who want to "help people enjoy any kind of culture meaningful in their lives."[29]

Among other, smaller-scale attempts by grassroots cultural groups to organize cultural activities closely tied to lived experiences of Korean Americans in Los Angeles is the L.A. Chung-ang Korean Music Group, a small group that focuses on *samul-nori* to express their experiences as minority immigrants in Los Angeles. One of the important traditional Korean folk music forms, *samul-nori* can be easily related to contemporary political meanings. Especially in the 1970s, this formerly marginalized form of popular music was suddenly picked up by Korean nationalist political movements and rapidly spread as a resistant cultural tradition.[30] In the United States, *samul-nori* was similarly introduced as an alternative popular cultural form in the late 1980s, but it soon lost its political implications and became popularized as just another Korean cultural convention.[31] L.A. Chung-ang Korean Music Group also operates regardless of any political notions, instead emphasizing its project to redefine Korean American identity through the traditional form of Korean music. Without an official space, its members

practice in video stores, taekwondo halls, or zen centers and perform at various public places, including Catholic churches. They also offer lectures and classes on Korean music, hoping to deliver more correct and detailed information than that provided by the KCC's own music classes. The group also composes their own music and plans on creating fusion music with Latinos.[32] Though L.A. Chung-ang Music Group's attempts to create a distinct Korean American culture through *samul-nori* are valuable, the group needs to be better supported to be able to function as an alternative popular cultural organization that reaches to the general public in Los Angeles.

Han-nuri, another group that uses the *samul-nori* music form, is more related to political causes. Han-nuri started as part of the Korean Resource Center (KRC), a community service organization established in 1983 by Han-Bong Yoon, a political refugee from Korea. Since then, the KRC has been providing disadvantaged Korean immigrants with useful services that range from social services programs like a low-income tax clinic, voter education projects, and immigrant rights projects to educational programs encompassing Saturday "Roots" programs, Korean language classes, Korean history classes, social issues classes, and summer camps.[33] As KRC's cultural counterpart, Han-nuri's primary activity is thus concerned with performing for various occasions, many of which are allied demonstrations among different ethnic groups to protect immigrants' rights in the United States. Han-nuri organizes several public events, such as Jishin Balpgi, a Lunar New Year street festival, in which performers visit local businesses in many areas like the L.A. Garment District (another commercial core of Korean immigrants), performing and wishing good luck, in an effort to sustain valuable folk traditions. Another important activity of Han-nuri is music classes for younger generations of Korean people in Los Angeles.

Han-nuri's executive director, Seung-il Shin, emphasizes that they use *poongmul*, a broader, more casual and popular concept of *samul-nori*, with a view to forming a community out of diverse Korean people who lead busy and fragmented lives.[34] Since *poongmul* is a cultural form that originated from the labor traditions of a preindustrial agricultural economic structure, it is believed to have an intrinsic ability to generate communal unity.[35] Created from the harmony of several percussion instruments that when played alone produce nonmusical noises, *poongmul* may have an inherent tendency to bring people together. By teaching it to younger generations in Los Angeles, Han-nuri is consciously disseminating the motivation to form a communal unity out of diverse "Korean" people—including the "1.5," second, or third generations of Korean immigrants; Korean students in Los Angeles; illegal immigrants from Korea; Korean adoptees; and many others.

For similar reasons, several other Korean American organizations have been formed around *poongmul* groups: for example, UCLA's Korean American cultural troupe, Hanullim, and UCSB's Han-Yul have joined Han-nuri for Lunar New Year festivals. According to Ji-hyeong Kim, executive director of L.A. Chung-ang Korean Music Group, an increasing number of Korean American church organizations are also creating their own *poongmul* groups in order to tighten the relationship between their members and satisfy their cultural needs.[36]

Indeed, it is critical to understand the role of Christian churches in the cultural formations of the Korean community in Los Angeles, since they have functioned as unique

sites where most Korean immigrants have their main cultural activities. Although Christianity is not a religion of the majority in Korea, Christian churches have functioned significantly in encouraging and facilitating the American immigration of Korean people and have therefore become one of the most important parts of Korean American life.[37] In addition to religious functions, immigrant churches have provided fellowship for Korean immigrants and maintained Korean cultural traditions.[38] Most Korean American churches offer Korean language classes for children and teach them Korean customs and traditions through cultural activities. As Young-man Kwon, a 68-year-old second-generation Korean American said, "All I know about Korean culture, I learned from my Korean church, because my parents were busy with their business and preferred to speak in English in the family to make their children perfect American citizens."[39] Perhaps the fact that Korean American Christian churches have been so strong and so important in reproducing Korean American cultural identities explains why other cultural practices have been so rarely pursued.

Another possible explanation for the scarcity of alternative cultural activities that address the real concerns of diasporic people in the Korean community might be the immigrants' intense aspiration for economic and social mobility.[40] As is often testified by younger generations of Korean Americans, many of the first generation of Korean immigrants moved to the United States because of their belief that their children would have better chances for education and economic achievements. Many Korean American parents very specifically expect their children to become highly skilled professionals such as medical doctors or lawyers, rather than culturally interested community workers. These expectations are evidently reflected in the Korean American media, which frequently carry stories of young Korean Americans who have received high scores on their SAT exams or made some remarkable accomplishments in renowned schools. Even if some Korean Americans could become successful artists or cultural workers, the strong presence of the entertainment industry in Los Angeles might draw them from their community and inhibit their commitment to fostering cultures that are very different from the mainstream.

Whatever the reason, the possibilities of truly popular cultural formations within the Korean community in Los Angeles do not appear to be plentiful. Rather, the cultural configurations in the Korean immigrant community look almost like a microcopy of the mainstream cultural topography, with the culture of the power bloc imposed and not many popular cultural movements visible. This paucity raises the question of whether a genuinely popular culture is actually possible in this systematically disenfranchised immigrant community. Can a culture of the oppressed, marginalized, subaltern classes really be created in the site of the immense power of the global culture industry centered in Los Angeles?

To find something like an answer to these questions, I return to the Miracle Mile, to the Korean Cultural Center, where I started this inquiry, for some significant points need examining in respect to the role of cultural centers in the cultural formations of ethnic communities. First of all, there seems to be a growing awareness within the KCC and the Korean government that they need to broaden their vision of culture to be able to operate efficiently in the multidimensional cultural environments of the age of global economy. According to the "Korean Cultural Policy for the 21st Century" announced

by the Korean government in 1998, they now recognize the necessity to "cease the narrow practice of confining culture to the realm of professional art, and establish a broad, dynamic concept of culture through a diversity of styles and practices to bring about cultural consciousness and the cultural potential of the people."[41] In a similar vein, Consul Kyu Hak Choi explained that the KCC has expanded its main target of activities from a limited number of "opinion leaders" who mostly work in mainstream institutions like universities and museums, to more general audiences who can be introduced to Korean culture at the often-vivid multicultural events and festivals held in the Los Angeles area such as the Lotus Festival and the Celebration of 150 years of L.A. County.[42] In fact, in the late 1990s, the KCC began to participate in and organize more and more cross-cultural events.

For example, KCC first organized a joint art exhibition, "Spring Fever: A Cultural Celebration with Korean and Mexican Artists in L.A." with the Mexican Cultural Institute in May 1999, in celebration of Cinco de Mayo. The two institutions share the belief that culture is a common ground on which people can appreciate and understand one another, so the KCC staff approached the MCI, not only because the Latino community in Los Angeles comprises the largest nonwhite population willing to cooperate with other ethnic groups, but also because Mexican people have some values and experiences similar to those of the Koreans: the importance of family, respect for tradition, the emphasis on children's education, and the diasporic experiences of living in Los Angeles in general. More importantly, it has been noticed that interactions between the two peoples have been significantly increasing around Koreatown, as between neighbors, schoolmates, employers and employees, and husbands and wives. Thus, the two cultural centers agreed that the experiences of learning about each other through art would provide good opportunities to enrich the two communities socially and economically as well as culturally.[43]

Of his participation in the exhibition, Carlos Vargas, one of the five Mexican artists said, "I never thought we had anything in common with Koreans. But it makes all the sense in the world. We're all pretty much the same [in sharing the immigrant experiences in Los Angeles]."[44] Similarly, one of the five Korean-born participants in the event, Eun Young Kim, exhibited two of her mixed media works that criticize gender constructions in contemporary society and commented that the joint project was enlightening because the absence of a single "ethnic theme" left her free to explore multiple experiences of ten different immigrant artists.[45] Reassured by the success of this joint exhibition, the KCC has continued to organize more cross-cultural events, such as "Art and Issues" (an art exhibition of various works by Korean American and African American artists) in October 1999; another Cinco de Mayo celebration with the MCI in May 2000; and a cross-cultural performance event composed of Indian, Russian, Spanish, Indonesian/Javanese, and Korean music and dance groups in celebration of the twentieth anniversary of KCCLA in Spring 2000. Learning from the 1992 uprising that no one ethnic minority group can prosper without embracing relationships with others, governmental agencies have generated cross-cultural alliances among different ethnic communities leading to significant dialogues, understandings, and celebrations of diversity in the experiences of Los Angeles.

Another important dimension to the cultural relations formed by the KCC is the heterogeneous ways in which people make use of its cultural programs, especially the Film Nights and the Korean language classes. Held twice every month, the Film Nights show Korean films with English subtitles. Film titles screened for the two years between January 1998 and December 1999 include: *My Mother and Her Guest* (*Sarangbang sonnim kwa omoni*, 1961); *Iodo* (1977); *Why Has Bodhi-Dharma Left for the East?* (1989); *Sopyonje* (1993); *Ghost Mama* (1996); *The Day a Pig Fell into the Well* (1996); and *301/302* (1996).

These titles are truly varied, ranging from the latest box office hits in Korea to older classical films, from critically acclaimed contemporary works to purely commercial genre movies. According to the staff in charge of this program, the films are selected by Korean government officials.[46] Therefore, it is not very likely that the radical or oppositional Korean films of the 1980s and 90s that have played an important role in rejuvenating Korean cinema and heightening political consciousness of the people would be encountered at these screenings. Yet considering the impoverished cultural conditions of Los Angeles, with only a limited number of venues for screenings of international films, the KCC's screenings are valuable and offer the Korean immigrants who frequent them more than just the chance to watch exotic films.

As Hamid Naficy has suggested regarding Iranian exiles' use of Iranian television programs in Los Angeles, exiles, immigrant, or diasporic people who are physically located in one place and dream of impossible returns to another create, through their media, "a symbolic and fetishized private hermetically sealed electronic communitas infused with home, past, memory, loss, nostalgia, longing for return, and the communal self," while they use the media as a means of acculturating themselves to the dominant culture of the hosting society at the same time.[47] This use of ethnic cultural texts to create a "symbolic fetish" that reinforces exiles' sense of communal self appears to happen at Korean Film Nights to the Korean immigrants who long for a homeland to which they cannot return. As Sung-woo Park, the coordinator of this program observed, with the exception of the very few white viewers, most of the approximately sixty attendees at KCC Film Nights are Korean immigrants over age 35, mostly in their 40s and 50s.[48] Since the KCC is almost the only place where Korean films are regularly screened,[49] it functions as an important site where exilic Korean people negotiate their diasporic identities and reinforce their imaginary connections to their homeland. For example, when KCC screened *Ode to Death*, a contemporary film on Yoon Shim-duk, a famous singer in the 1920s, the Korean viewers in their 50s, 60s, and 70s watched the film while commenting out loud, crying, and singing along to familiar tunes. This vision of a collective experience and memory, this sense of belonging, consensus, community, and shared nostalgia for homeland, generated through KCC's film programs, seems to play a significant part in negotiating the cultural identity of Korean immigrant people in Los Angeles.

Another interesting project carried by KCC is its educational programs, especially the Korean language classes (Illustration 8.4). Available to anyone who is interested in learning the language, these classes have become the most popular program at KCC, with a long waiting list. According to my survey, most of the students in these classes belong

to one or two of the following three groups: (1) young (in their late teens or early 20s) second- or third-generation Korean Americans who are relatively familiar with Korean culture and tradition and who want to learn the language to be able to communicate properly with their family members; (2) young or middle-aged (mid- 20s through 40s) non-Korean people who are married or engaged to Korean spouses and thus want to learn the Korean language and culture to be better connected to their spouses and their families; and (3) non-Korean people of various ages who want to learn the Korean language and culture primarily because of their cultural and intellectual curiosity—who, in most cases, became interested in Korea after having been exposed to some aspects of Korean culture through their Korean friends, coworkers, or neighbors.

Even if all these people learn about the same language and culture, the way they imagine the object of their study and their relations with it are inevitably varied. Talking with many of the students, I realized that from the same information given at the classes, they each imagine a different Korea. For example, Yumi Yashida, a 29-year-old Japanese woman living in L.A, said that after taking classes at KCC she began to consider Korea as her neighbor and friend, even though she did not know a single Korean person. When people speak of Korea, Mariaus, a 28-year-old Armenian, thinks of his own motherland because he found many similarities between the two countries; while Scott MacMullen, a 37-year-old white man from Las Vegas, pictures the Korean food, music, and films he discovered. Young-man Kwon, a 68-year-old second-generation Korean American, decided to learn the Korean language only after he had visited Korea and recognized his awkward unfamiliarity of the customs of his people. Serge Djang, a 30-year-old from Cameroon, came to learn the Korean language in order to travel to Korea and Japan for the World Cup in 2002. Learning the Korean language, a 27-year-old Japanese film student feels Korea is closer to him now in L.A. than when he was in Japan; and a 27-year-old Caucasian woman can now teach some Korean words to her Korean American fiancé who knows less about the language than she does.[50]

Indeed, Korea can be many different things—a taste, a melody, a color, a sense of blood, anything. Stuart Hall once argued, "What matters is not the intrinsic or historically fixed objects of culture, but the state of play in cultural relations."[51] What seems to me to matter here is not the possibly limited quality of cultural information provided by KCC, but the miraculous diversity of the ways in which people use the cultural information in conceptualizing their relationship to the imaginary community of Korea.

So far, I have examined how ethnic or national cultural institutions in Los Angeles mobilize the concept of culture in forming communities around them and negotiate their positions among their own communities, other ethnic groups, hegemonic society, and their homelands. As is specifically the case of the Korean Cultural Center and the Korean community in Los Angeles, cultural formations within diasporic ethnic communities do not appear to be clearly connected to people's experiences of living as minorities in Los Angeles. However, somewhere in the myriad visions people create out of the cultural programs provided by cultural institutions, and somewhere in their passionate efforts to embrace the multiple visions of each other's cultures, there exists the potential for a truly collective popular culture of the marginalized immigrant people in Los Angeles. After all, as Benedict Anderson wrote, "Communities are to be distin-

ILLUSTRATION 8.4. Korean language class at the Korean Cultural Center. Photograph by Jiwon Ahn.

guished, not by their falsity/genuineness, but by the style in which they are imagined."[52] The eclectic, dialectic, dialogic, boundary-crossing styles of immigrant cultures in Los Angeles could supply the very power to imagine an alternative community of diasporic minorities in which the diversity of people is joyfully celebrated.

Notes

1. "Changes in State's Ethnic Balance Are Accelerating," *Los Angeles Times*, 20 October 1999, A-3.

2. Interview with Leticia Quezada, president and chief executive officer of the Mexican Cultural Institute, March 2000. All quotations from Quezada are from this interview.

3. The Mexican Cultural Center's "Calendar of Events 1998."

4. Interview with Leticia Quezada.

5. Mike Davis, *City of Quartz: Excavating the Future in Los Angeles* (New York: Verso, 1990), 104.

6. Interview with Katsumi Kunitsugu, executive secretary of JACCC, August 1999.

7. According to JACCC Annual Report 1997–98, the Japanese American Theater of the center had put on its stage the most performances of any theater outside of Japan.

8. *The Japanese American Cultural and Community Center: 10th Anniversary Commemorative Book 1980–1990* (Tokyo: Japanese American Cultural and Community Center, 1990), 5–8.

9. *Japanese American Cultural and Community Center: Annual Report 1997–98.*

10. Interview with Katsumi Kunitsugu.

11. From the "Goethe-Institut" brochure, 1996.

12. Interview with Margit V. Kleinman, program coordinator at the Goethe-Institut Los Angeles, August 1999.

13. "Goethe Los Angeles" brochure.

14. Interviews with Consul Kyu Hak Choi and Rick McBride, cultural consultant at KCC, March 2000.

15. *Facts about Korea* (Seoul: Korean Information Service, 1999), 206–14.

16. According to the report by the Consulate General of the Republic of Korea in New York, the number of Korean people in L.A. and Southern California was 653,500 by the end of 1999. This comprises 31.7 percent of the total Korean population in the United States (*Korea Times*, 29 March 2000, 1).

17. Although Korean people have lived in Southern California since the early twentieth century, Koreatown was not formed until the 1970s. For the formation of Koreatown, see Nancy Abelmann and John Lie, *Blue Dreams: Korean Americans and the Los Angeles Riots* (Cambridge and London: Harvard University Press, 1995), 99–108.

18. Interview with Consul Kyu Hak Choi at the Korean Cultural Center, March 2000.

19. "KCC's Mission" in the *Korean Cultural Center* booklet.

20. Interview with Rick McBride, cultural consultant at KCC, August 1999.

21. Interview with Consul Kyu Hak Choi.

22. Interview with Hak Sik Son, chairman of the Award Committee of Korea Arts Foundation of America (KAFA), August 1999. Hak Sik Son clarified that KAFA held annual exhibitions of its awardee's works at KCC mainly because as a nonprofit public benefit corporation, KAFA had to use a public space for exhibition. Also, since KAFA awarded certain Korean American artists, having exhibitions at a "neutral" space like KCC was the best way to protect the artists from conflicting interests of many private galleries. "Besides," added the chair, "KCC shares a common goal to incorporate our [Korean American] artists into the mainstream."

23. Interview with Rick McBride.

24. Brochure for "Seoul Home/L.A. Home," June 1999.

25. For the class configuration of Asian immigrants in Los Angeles after 1965, see Paul Ong et al., eds., *The New Asian Immigration in Los Angeles and Global Restructuring* (Philadelphia: Temple University Press, 1994).

26. "KAM Mission Statement" from the Korean American Museum's webpage <http://www.kamuseum.org>.

27. Interview with Eugene Kim, director of education and research at the Korean American Museum, April 2000.

28. Interview with Roy Hong, director of Korean Immigrant Workers' Association, August 1999.

29. Interview with Muyungcha Miki Lim, senior librarian at Pio Pico Koreatown Library, August 1999.

30. This project, called *Talchum* (mask dance) Revival Movement, was started by nationalist activists in the late 1960s as a way of rediscovering and reclaiming Korean cultural identity in the marginalized popular cultural tradition and countering the increasing dominance of foreign influences. For an example of theorization of this cultural impetus, see Dong-il Cho, *History and Principle of Talchum (talchum-ui yuksa-wa wonri)* (Seoul: Hong Sung Sa, 1979).

31. Interview with Ji-hyeong Kim, executive director at L.A. Chung-ang Korean Music Group, August 1999.

32. Ibid.

33. *Korean Resource Center Newsletter,* Vol. 1, Nos. 1–5.

34. Interview with Seung-il Shin, executive director of Han-nuri, at Korean Resource Center, March 2000.

35. For this community-forming ability of *poongmul,* see People's Gud Association, ed., *People and 'Gud' (minjok gua gud)*(Seoul: Hak Min Sa, 1987).

36. Interview with Ji-hyeong Kim.

37. About 70 percent of Korean immigrants were reported to regularly attend Christian churches, mostly Korean ethnic churches (W. M. Hur and K. C. Kim, "Religious Participation of Korean Immigrants in the United States," *Journal of the Scientific Study of Religion* [1980]: 19). By the late 1980s, there were more than five hundred Korean American Christian churches in the Los Angeles area alone; see Eui-Young Yu, *Korean Community Profile: Life and Consumer Patterns* (Los Angeles: Korea Times, 1990). For the function of the Christian churches in the Korean American immigration, see *Blue Dreams,* 69–70.

38. Pyong Gap Min, "The Structure and Social Functions of Korean Immigrant Churches in the United States," *International Migration Review* 26, no. 4 (1992): 1370–94.

39. Interview with Young-man Kwon, August 1999. I interviewed Mr. Kwon when he was taking a Korean language class at the Korean Cultural Center.

40. See "Diaspora Formation: Modernity and Mobility," *Blue Dreams,* 49–84.

41. "Korean Cultural Policy for the 21st Century" (Seoul: Overseas Culture and Information Service, 1998).

42. Interview with Consul Kyu Hak Choi.

43. Ibid. and interview with Leticia Quezada, president and chief executive officer of the Mexican Cultural Institute, March 2000.

44. George Ramos, "A Unique Cultural and Artistic Twist on Cinco de Mayo," *Los Angeles Times,* 30 April 1999, B-4.

45. Interview with Eun Young (Kimmy) Kim, March 2000.

46. Interview with Sung-woo Park, coordinator of the monthly film series and film archive at KCC, March 2000.

47. Hamid Naficy, *The Making of Exile Cultures: Iranian Television in Los Angeles* (Minneapolis: University of Minnesota Press, 1993), xvi.

48. Interview with Sung-woo Park.

49. There is a Korean movie theater in Koreatown, which is run by *The Korea Times.* The films shown in this theater (without English subtitles) are mostly the latest commercial film products for younger audiences (in their teens or early 20s) in Korea, which can hardly appeal to older immigrant audiences in Los Angeles.

50. I surveyed thirty students in two out of the four classes, asking mainly about students' ethnic and cultural backgrounds as well as motivations for, and experiences of, taking the Korean language classes at KCC, March 2000.

51. Stuart Hall, "Notes on Deconstructing 'the Popular'," in *People's History and Socialist Theory,* ed. Raphael Samuel (London: Routledge & Kegan Paul, 1981), 235.

52. Benedict Anderson, *Imagined Communities: Reflections on the Origin and Spread of Nationalism* (London: Verso, 1991), 6.

James M. Moran

9 All Over the Map:
A History of L.A. Freewaves

At a roundtable held in July of 1999 as part of the L.A. Freewaves 10th Anniversary Project, discussion among the participants ranged from nostalgia for the past and hopes for the future to very mixed feelings about the contemporary state of independent and experimental media in Los Angeles. Certainly, there were many accomplishments to applaud over the previous decade. Although ten years earlier few formal venues had offered media-makers the opportunities for networking, since then dozens of workshops, panels, and seminars had encouraged collaboration and increased access to resources. Whereas earlier the region's youth were offered little more than the passive consumption of mainstream, commercial cinema and television as their primary outlets for creative expression, now media literacy programs sponsored jointly with public high schools and libraries had begun to enable young people to determine and produce their own self-representations. Most importantly, in a city where Hollywood has threatened to squelch alternatives to the feature film as potential threats to its local and international hegemony, L.A. Freewaves curators had programmed seven festivals celebrating the rich diversity of unconventional video and multimedia works created by artists narrow-mindedly perceived by "the Industry" to be amateur, marginal, or insignificant.

Despite these achievements, the never-ending quest for relevance dominated the roundtable's discourse. As public funding for the arts diminished while stockholders invested in burgeoning entertainment conglomerates, the function of media would continue to narrow in the service of profit rather than aesthetics, politics, or personal expression. The spectrum of mass-mediated images representing the region's increasingly heterogeneous population remained either homogenized or ghettoized, determined less by indigenous cultural communities than by indifferent corporate committees. Even public institutions that had previously championed freedom of speech—museums, higher education, public access cable—had fallen subject to censorship and conservatism. These obstacles, faced by L.A. Freewaves ten years earlier, had unfortunately not been

overcome, but rather they had been magnified to proportions that at the turn of a new millennium demanded even more inventive tactics.

The history of L.A. Freewaves (LAF), like many grassroots media organizations, was shaped by resistance in two directions: resistance by corporate capitalism to the work of media-makers outside its industrial model, and resistance by LAF to the commercial methods and conservative ideologies that would seek to suppress any experimentation beyond the sanctioned norms of the Hollywood entertainment industry. Born from the margins and amidst the myriad fragmented practices of independent artists, curators, and educators, LAF would struggle to nurture and maintain a community with a level of success best described as intermittent, contingent, and beleaguered. The tenets of its mission (outlined in detail below) were conceived in the utopian terms of the "video revolution" of the late 1960s and early 70s, whose idealistic rhetoric may have rung somewhat naïve in the 90s, when the climate of ubiquitous corporate sponsorship and promotional tie-ins made notions such as "sell-out" and "nonprofit" appear anomalous and naïve. Yet the 1990s also introduced the broad cultural diffusion of the Internet and its own brand of utopianism: the vision of free, worldwide, democratic access to information and modes of creative self-expression. Yet even the staunchest supporters of this dream were rudely awakened when, in early 2000, Time-Warner, the world's largest entertainment conglomerate, merged with America Online, the world's largest Internet service provider, to consolidate and monopolize new media content and delivery systems. Like 8mm film, videotape, cable TV, and the VCR, the Internet had begun to pass through the cycle typical of new technologies from revolutionary potential to commercial incorporation.

As an advocate of video, cable TV, and the Internet, LAF was forced to navigate the waves of these cycles, sometimes riding high on the crest of public support, at other times gasping in the undertow of private indifference. To reflect this movement, I have shaped this history along similar contours, beginning with a description of the organization's inception and accomplishments within the context of its utopian mission, and ending with a more realistic appraisal of its goals within an ever-encroaching corporate sphere. At the time of this writing, LAF continues to find public funding and to program events; thus, a complete rendering of its history is impossible. Nevertheless, given socioeconomic trends toward increasing global commodification, one can expect that the future will hold more of the same obstacles, and, one might hope, some of the same successes.

What Is L.A. Freewaves?

L.A. Freewaves is a growing, sprawling democracy of arts organizations, libraries, cable stations, programmers, and media-makers committed to the production, distribution, and exhibition of independent and experimental video and new media. Its historical origins can be traced to the motivations of its founder, Anne Bray, whose experiences as an artist, teacher, and arts administrator inspired her to bring to some concrete realization

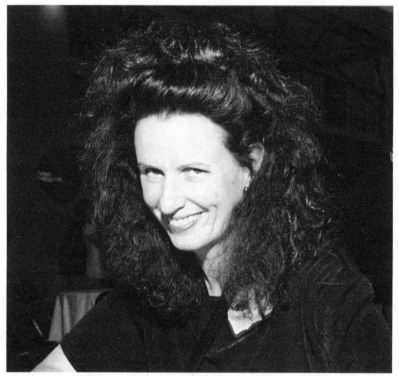

ILLUSTRATION 9.1. Anne Bray at the opening of L.A. Freewaves
Fifth Festival, 1996, at the Museum of Contemporary Art. Photo-
graph by Wei Chang and courtesy of Anne Bray.

the communal spirit that flickered amidst the shifting arts coalitions of Los Angeles (Illus-
tration 9.1). Bray had been no stranger to collaboration before moving in 1982 to Los
Angeles from Boston, where she had lived in a commune, believed in leftist collective
practice, and worked regularly with other artists, city officials, and community mem-
bers to present public art events—in particular, MIT's Center for Advanced Visual Stud-
ies, which fomented annual municipal art festivals.

During her first several years in Los Angeles, Bray produced such projects as the L.A.
Street Scene Festival,[1] feminist performance artist Suzanne Lacy's *Dark Madonna* at
UCLA,[2] and several works with her regular collaborator, Molly Cleator. Four years of
art administration at Los Angeles Contemporary Exhibitions (LACE) from 1985 to 1989
brought her into greater contact with the media arts community: in particular, at LACE
she oversaw a program providing artists with access to commercial postproduction
facilities at reduced rates and allowing visiting curators to review archives of recently
produced work. Soon Bray discovered that these various colleagues throughout Los
Angeles County, many of whom shared similar aesthetic and political goals, were
strangers to each other both personally and professionally. At the same time, the
National Endowment for the Arts (NEA) began requesting demographic statistics about

the ethnicity of audiences and exhibited artists at LACE, which in turn generated an active search among LACE programmers to include minority artists and to advertise LACE events to their constituencies.

During her research, Bray realized the need for greater concerted action. In early 1989 she and Ken Kirby, at the time the coordinator of the American Film Institute (AFI) Video Festival, called upon virtually everyone they knew from regional arts and community organizations to meet at the AFI for roundtable discussions funded by grant money from the Department of Cultural Affairs. There they identified the need for a democratically run, pluralistic festival celebrating the diversity of independent video in Southern California. By October of the same year, LAF officially debuted with the launch of the 1st Celebration of Independent Video.[3] (For a concise history of L.A. Freewaves, see the Appendix.)

Over the course of three weeks, works by regional, national, and international artists of all races, creeds, ages, sexual orientations, and reputations, representing all forms of video application screened their works on fourteen cable channels and thirty sites throughout Southern California, including museums, galleries, cafes, and community centers. The unprecedented scope of these events and the dynamism of their public reception were widely recognized. *The Independent,* a journal devoted to alternative film and video production, identified it as the nation's most extensive video festival and "a valuable model for the media arts organizing around the country."[4] Two years later, in March of 1991, the 2nd Celebration of Independent Video, with triple the budget of the first,[5] established the tradition of programming a festival biannually—a tradition, that is, with one very significant exception.

In the spring of 1992, the civil uprising beginning in South Central and Downtown Los Angeles and the subsequent violence that spread throughout the city soon mobilized the growing network that Bray had been nurturing for several years. In 1989 video artists and activists had been more or less scattered and segregated. Yet three years after LAF had instituted a visible network capable of creating a broad-based response, so many media-makers were on the scene shooting the events around the uprising that Bray decided to curate their footage into specific programs.

The tapes produced provided views of the uprising that were less privileged and more direct than the monolithic perspective of mainstream media, whose coverage of the crisis served the needs and fed the fears of the status quo. Even George Holliday's videotape of Rodney King's beating at the hands of the Los Angeles Police Department (LAPD), initially heralded as a model of amateur video's potential for political commentary and mobilization outside the institutions of broadcast journalism, had soon been circulated and observed only through television distribution and exhibition. There its meaning and radical potential were drastically transformed, and its political and moral significance was recast by professional commentators more concerned with the criminal culpability of King and less with the institutionalized racism that the tape documented.

LAF's programs were intended to comprehend and mend the information gap generated by the mainstream media, which incited so much of the telecast misinformation, omissions, and distortions. LAF's tapes were personal instead of institutional and were

edited in a more thoughtful, less sensational manner. For example, a two-part program entitled *Hands On the Verdict* aired nationally via Deep Dish TV in September 1992 and in Los Angeles in October 1992. Part One, subtitled *Devastating Blows,* compiled short videos examining the densely woven issues surrounding the rebellion, including the persistence of police brutality and the various social meanings set in play by the media's designation of the uprising as a "riot." Highlights of the first program included an analysis of the George Holliday videotape that demonstrated that the LAPD officers incited King to react with aggression so that they could rationalize an excuse to perform a ritual racist beating, which they later covered up by abusing their positions of authority. Another highlight of the compilation was a discussion of Darryl Gates, former LAPD chief, that indicts him as the personification of institutionalized racism, a public official who as a matter of policy supported and encouraged racism within the ranks of the LAPD. Part Two of the program, entitled *Sentence of Fire,* featured *The Truth* (Matthew McDaniel), a series of interviews on the day of the "not guilty" verdicts with African American residents of South Central L.A. who voiced the rage and revolutionary spirit that would fuel the violence to come; *Diary* (Shawn Chok and Chris Pak), a brief, personal examination of Korean victimization amidst the conflagration defined by the media predominantly as an African American issue; *Ahora, Si* (Liz Canner and Julia Meltzer), a critique of the harassment of illegal Latinos who, during the uprising, were detained, incarcerated, and deported through the illegal conspiracy of the LAPD and the IRS; and *Beyond the Color of Authority* (Rachel Fielding), a portrait of an L.A. County deputy sheriff of Native American descent who brings his daughter for a driving tour through South Central L.A. as he compares the hopeless conflict between gangs and the police to his tour of duty in Vietnam.

Perhaps the most memorable event ensuing from the uprising was *Beyond the Color Line: Reflections on Race,* a program of videos hosted at the Barnsdall Municipal Art Gallery, where an intense two-hour live Q & A session following the screenings demonstrated the enormous impact that both the uprising and the program's response to it had made on those in attendance. Similar reactions occurred at various screenings throughout the city. Oddly enough, the 1992 uprising was thus a "happy accident" in the most ironic sense for LAF, both mobilizing the nascent network of media-makers and fueling their passion for creating work with timely political urgency.

By 1994 the wealth of tapes being produced in the Los Angeles area encouraged Bray to repackage the festivals for traveling exhibition, cable broadcast, and media education. Expansion of this nature would continue over the next ten years. In 1996 LAF launched its Web site, www.freewaves.org, curated nine artists' CD-ROMs at Inscape (*Live Nude Artists*), and donated tapes to seventy-four Los Angeles libraries and forty public high schools. Such diversity of programming moved far beyond the traditional venues typical of video art to provide access to populations rarely served by established institutions, such as the Los Angeles County Museum of Art and the Getty Center. Indeed, by the fall of 1998, the 6th Celebration of Independent Video and New Media featured single-channel video programs at the Museum of Contemporary Art (MOCA); installations and performances at the Long Beach Museum of Art, the Montgomery College, and the

ILLUSTRATION 9.2. L.A. Freewaves finale at Grand Performances (John Fleck, David Schweizer). Photograph courtesy of Anne Bray.

Electronic Café International in Santa Monica; six video bus tours traversing Los Angeles; transportable CD-ROMs; and a Web site accessible to audiences worldwide. Like Los Angeles itself—decentered, sprawling, shifting on the fault lines of a hundred flowering subcultures—the festival truly lived up to its title, *All Over the Map.*

As venues for the public display of formally and socially challenging video increasingly disappeared, LAF continued to buck market trends. *Air Raids,* the organization's seventh festival, held through the month of November 2000, testified to the commitment and imagination of Bray to ferret out alternative exhibition spaces throughout Los Angeles. For instance, the Rose Bowl, a stadium better known for staging sports events, hosted the *MacadamFest,* a drive-in for experimental film and video. Beamed from video billboards on Sunset Boulevard opposite the Hyatt Hotel in West Hollywood, Tony Cokes' *Ad Vice,* a parody of video billboards typical of the "Strip," appropriated the language of advertising slogans to critique the interactions of desire and commerce in a capitalist culture. And the Festival Finale occupied a traditional Norae Bang (karaoke) club in L.A.'s Koreatown, equipping each room with a video monitor and a menu from which patrons could choose video fare by Korean American artists (Illustration 9.2).

Defying expectations, several festival exhibits dispensed with television monitors, typically the conventional vehicles for video art, to display works in unusual venues.

For instance, an installation entitled *Images We Want to See Big* encroached on the larger-than-life stimulus of cinema by projecting video images made by a variety of artists onto the walls of the MOCA Geffen Contemporary. For example, in Shawn Chapelle's *Far Reaches,* science and the occult merged in a cabala of colliding images traversing the outer limits and internal recesses of time, space, religion, technology, and anatomy. Elaine and Basinski's *Fountain* made literal the metaphor of electronic flow by amplifying images of water to refract a prism of rainbow colors undulating in abstract meditation. And Steina's *Warp,* a delirious exercise in digital manipulation, transformed the pedestrian movements of the human body into an exotic, hyperbolic dance of uncommon grace.

Moving from the interior spaces of the museum to the virtual communities of the Internet, *Street Action on the Superhighway,* hosted by UCLA, presented an intellectually stimulating and politically provocative live demonstration, Net Art & Activism, that was simultaneously streamed on the Web. Invited guests included Mervin Jarman, creator of the Container Project in Jamaica; Cornelia Solfrank from Germany's Old Boys Network; Ricardo Dominguez from Electronic Disturbance Theater (EDT); and representatives of the Bordergames collaborative. These "hacktivists," who specialize in electronic civil disobedience, discussed their various projects that earned notoriety for trespassing virtual spaces fraught with social and political controversy. For example, Dominguez presented a free Web-based software called "FloodNet" that, once directed at its target Web site, repeatedly attempts to contact the site so that it must temporarily deny service to other potential users. EDT first used FloodNet in support of the Mexican Zapatistas by targeting the Web sites of Mexican President Zedillos, the White House, the Pentagon, and the Frankfurt Stock Exchange. In response, the U.S. Defense Department launched a counterattack that brought media attention to the Zapatistas themselves, the desired effect of the disturbance. This type of subversive media activity illustrates how raiding the spaces dominated by traditional media and entertainment would continue to be a hallmark of LAF's mission.

The Mission of L.A. Freewaves

In her review of the second LAF festival for *The Independent,* journalist Barbara Osborn speculated:

> If there is so much independent video going on, why has L.A. kept such a low profile? The answer lies in the unique nature of L.A. The lights of Hollywood blind people to other media production. They beckon thousands of would-be producers, directors, production designers, actors, and other hopefuls each year. Local film schools churn out students primed for the mainstream movie industry, which commands the attention of virtually all media press and colors all coverage. The emphasis on entertainment is inescapable.[6]

As Osborn correctly observed, for the vast majority of media-makers who live in Los Angeles or who consider migrating to the region from other locations throughout the

world, it is Hollywood that beckons rather than the relatively invisible experimental media movement that has been flourishing in the region since the 1920s. If Los Angeles is "some place"—a very real, heterogeneous multitude of subcultures—Hollywood is "no place," an imaginary, ideological realm that misidentifies itself as interchangeable with L.A. at the same time its media productions transcend municipal boundaries in their efforts to colonize imaginations worldwide. Hollywood's hegemony has not merely reproduced Los Angeles in its own image for the rest of the world, it has also seduced the city itself to conform to its dictates. This emulation has not been limited to spectators of Hollywood's media productions but includes all those who contemplate careers as media producers. In a town where the feature film and broadcast television declare themselves the only legitimate mediums, independently produced video suffers as the illegitimate bastard. As Osborn noted, "The phrase 'independent video community,' when used in Los Angeles, is laced with contradictions and impossibilities. In L.A. 'independent' denotes projects not affiliated with the film studios. 'Video' refers to a medium that receives little support and less notice, and 'community' implies a connectedness that doesn't exist in the city's hefty sprawl."[7]

The problem of "community" as defined by Hollywood is twofold: first, Hollywood is constituted purely in industrial rather than geographical terms; and second, its workers are therefore sequestered from realities of time and place:

> Undeniably there is a Hollywood community in the sense that the people engaged in the production of pictures have the center, the focus, of their lives engaged in the industry and are bound together by the nature of the industry itself. Living over wide areas of Los Angeles, "picture people" ... constitute their own community, separate and distinct from the neighborhoods in which they reside and quite apart from Los Angeles proper.[8]

Because of their autonomy from the very places they inhabit, members of the Hollywood community may have little to no identity as representatives of their neighborhoods, neither advocating nor creating representations that reflect the everyday existence of their neighbors. It is precisely this industrially based apathy that LAF reacted against and that motivated the most fundamental, overarching tenet of its mission: *to develop and promote Los Angeles as a center for media production and exhibition entirely independent from the hegemonic commercial and sociocultural ideologies of Hollywood.*[9]

This mission would not only inform the very basis of the organization but would frequently manifest itself as a theme in individual works. For example, premiering at the fifth festival, *Urban Myths and Legends* presented several videos exposing the limitations of Hollywood ideology. Seventeen-year-old Jesse Waugh's *El Angel* (1995), a parable about the corruption of art and commerce by the onset of greed, chronicles the birth, climax, and death of Los Angeles, personified by the haunting figure of El Angel. Shot like a silent film from cinema's earliest days, using tableaux images and inter-titles rather than continuity editing and dialogue, the work's form illustrates its content: Waugh portrays the birth of Los Angeles by using techniques from the birth of cinema, both of which ultimately would be corrupted by Hollywood's desire for profit. Jennifer

Reeder's *The Adventures of White Trash Girl* (1995) parodies a movie trailer whose unattractive characters are the antithesis of the types conventionally marketed to mainstream audiences and whose setting amidst sewers and urban detritus presents Los Angeles as a wasteland. In *The Waking Dream of Elizabeth Montgomery* (1994), Tom Vick challenges the banality of Hollywood celebrity, which he compares to the sun setting over Beverly Hills, whose effect evokes a sense of loneliness and hollow complacency. Considering the value of a television series such as *Bewitched*, whose protagonist represents the witch as ideal woman, Vick critiques the capacity for popular entertainment to mirror real human culture and record history for future generations. And finally, in *Drive-By Shoot!* (1993), Portia Cobb deconstructs the meaning and mythology of inner-city violence perpetuated by commercial television. Using her camera rather than a gun over the course of her drive-by shoot, Cobb captures images of street life, buildings, pedestrians, automobiles, and advertising messages not very different from the neighborhoods usually televised, except that people of color predominate. Accompanied by connotations of "drive-by" repeated in voice-over like a mantra, "newsworthy" accounts of drive-by shootings from major newspapers scroll at the bottom of the frame, including a revealing quotation from the *Washington Post*: "Richard Cohen comments on the tendency of the news media to take the rare close calls of life, such as carjackings and drive-by shootings, and give them prominence, which makes people feel vulnerable."

Although provocative work of this nature would be instrumental to combating conventional ways of thinking about media representation, Bray realized that alternative media alone could not make headway against the Hollywood community without a substantial group of artists and activists organized in their efforts at resistance. This motivates the second tenet of the LAF mission: *the formation of an alternative media community*. This tenet has two operating components: (1) to network independent media-makers, curators, cable operators, public television programmers, faculty, students, and administrators of equipment access programs; and (2) to share resources in order to foster ongoing informational, administrative, advocative, curatorial, and educational infrastructures for individuals and organizations in the video medium. In a heteropolis with many centers and vast commuting distances, such an aspiration would prove to be an intimidating task. Nevertheless, undaunted by sprawl and dispersal, Bray exploited, even celebrated, the region's collage of resources as a strength rather than a disadvantage. After all, one very significant connotation of the "Freewaves" appellation asks "avid video enthusiasts to travel the freeways to various neighborhoods in search of the medium, a trip that encourages the cognitive mapping of a city whose size and urban geography discourage such activity."[10]

A second significant connotation of the name "Freewaves"[11] refers to "the relative freedom of public access as well as to the radical potential of the format: public access producers encroach on network control of images and begin to reverse the traditional flow of images."[12] In more general terms, the organization's *emphasis on the democratization of media access* is the third tenet of its mission. Industrial strategies to limit public access to television production, in particular the monopolization of distribution

channels (such as subscription cable services), exert tremendous control over, and containment of, alternative media practices. Because the profit orientation of commercial producers transforms media artifacts into increasingly expensive commodities in an insistently competitive and privatized market, grassroots organizations cannot afford to finance and operate the technologies necessary to introduce messages into broad social circulation. These obstacles militate against pluralistic communication catering to minorities in particular.

Because a hallmark of LAF's philosophy of access would advocate anti-elitist, anti-hierarchical programming, and because broadcast, cable, and satellite distribution had failed to find room for experimental media, Bray turned to the Internet, toward the latter half of the 1990s, as a potentially more democratic network for video exhibition. With increasingly affordable advancements in digital video recorders, home computer editing systems, downloading software, and streaming capabilities, integrated video and Internet technologies, if introduced in a series of free educational workshops to communities of every ethnic and class affiliation, might take one step closer to an integrated Los Angeles. Thus, a fourth tenet of the LAF mission would be *to advocate personal, political and artistic expression through a proliferation of multicultural voices.*

This philosophy of programming diversity would be well articulated by the curating process that Bray fine-tuned over the years. At the first festival, approved submissions were put into four categories: action, idiosyncrasies, youth, and narrative. Yet, as Bray observed in a personal interview:

> When we took these four shows everywhere in the city, people weren't interested in seeing everything: Latinos wanted to see Latino work, African Americans wanted to see African-American work, Asians wanted to see Asian work, and so on. Audiences would come to watch the program related to their own community, then leave the auditorium to chat with their friends in the hallway when work not specifically about them was screening. This indifference was originally a problem.[13]

Bray searched for solutions. For the second festival, although there were still independent curators, a group started meeting to look at the work and comment on it together. They saw what was missing and then solicited more work. They initiated a dialog about what was appropriate and inappropriate, progressive and regressive, original and clichéd.

Bray eventually formalized this group orientation as a single curatorial committee in 1994. Nominated and elected by a board of trained video artists and professionals, the ten women and men who have since curated the festivals' programs—a cross-section of all age groups, ethnicities, creeds, and sexual orientations from artistic, activist, and academic backgrounds—reflected Bray's mission to represent the independent L.A. scene in microcosm. From about four hundred entries received during open call and screened over the course of four long weekends, each curator would develop a unique program unified by an aesthetically or politically motivated theme, chosen carefully to avoid predictability and stereotype. The result: provocative programs featuring a diversity of artists, themes, and formats. Media-makers of local,

ILLUSTRATION 9.3. *Media Bust* (Eric Saks). Photograph courtesy of Anne Bray.

national, and international reputations—including Tran T. Kim-Trang (*Ocularis*, 1997); Sherry Milner (*Unruly Fan, Unruly Star,* 1996); George Kuchar (*The Inmate,* 1997); Jesse Lerner (*Mexopolis,* 1997); Cecelia Condit (*Oh, Rapunzel,* 1996), Janice Tanaka (*Who's Going to Pay for These Donuts, Anyway?* 1992); Cheri Gaulke (*Pillar of Smoke,* 1992); Skip Arnold (*Punch,* 1992); Nancy Buchanan (*Developing: The Whole Picture,* 1996); Marlon Riggs (*Affirmations,* 1990); Tony Cokes (*Fade to Black,* 1991); Sadie Benning (*If Every Girl Had a Diary,* 1990); Eric Saks (*Media Bust,* 1996); Rea Tajiri (*Off Limits,* 1989); Rubin Ortiz (*How to Read Macho Mouse,* 1991); and Maxi Cohen (*Anger,* 1987) among hundreds of others—have screened their work at LAF events.

This list is hardly exhaustive, but it demonstrates how many of the most important video artists to emerge over the last three decades have showcased their work at LAF events. Themes these artists have typically explored include political activism, historical revisionism, cultural stereotypes, spirituality, sexuality, the environment, health and the body, youth culture, and formal experimentation. Formats have represented the entire spectrum of genres, lengths, and technologies available for experimentation: documentary, essay, fiction, autobiography, biography, animation, feature, short, single-channel, multimedia, installation, and performance.

As conventional distinctions between genres blurred and technologies merged in new configurations, hybrid formats steadily increased over the years that LAF mounted exhibits. A prime example is *Milkstained,* performed as part of the 1998 Festival by M.A.M.A., a collaboration of artists who had also recently become mothers. Staged at the Electronic Cafe in Santa Monica, the performance incorporated pre-recorded video segments, functioning in part as an installation. Furthermore, the event was broadcast on the Web through audio and video streaming technologies, at once live and mediated. This unusual work addressed the contradictory cultural meanings that surround not only breast-feeding but also the dual role of artist/mother. Punctuated with the sounds and images of milk as a bodily fluid with the power to subvert phallocentric predispositions about the proper place and function of maternal nurturance in our culture, the performance reacted against public censure that defines breast-feeding as indecent, questioned the Oedipal paradigm displacing all acts of sensuous body contact onto genital sexuality, and contested the notion that love between a mother and her child belongs only in the realm of medicine and anthropology, rather than in literature, drama, and art. By exploiting the advantages of performance, videotape, and Internet access, *Milkstained* was able to address breast-feeding women throughout the world, not in isolation, but as a community with common interests.

This *empowerment to represent one's own community* stands as a fifth tenet of LAF's mission. Thus, while the form of the works presented could be eclectic, their content was often curated into programs pertinent to the communities in which they were exhibited. As the culture industries would impose and implant social definitions according with the dominant or preferred culture, it became essential to LAF, particularly in an era of increased migration, that immigrating minorities be given opportunities to see representations of themselves produced by themselves. Although the cable and Internet "revolutions" promised a wealth of channels, media standardization brought on by corporate mergers with bottom-line agendas often rolled out cookie-cutter variations of the status quo. Television in particular "tends to compress the world into simplified equations in which everything is designated as either similar (dominant) or different (other). In this order, universality is ascribed to the dominant's characteristics whereas qualities that belong to the other are marginalized and objectified. The other does not represent but rather is represented."[14]

While the struggle between dominant and alternative forms of culture would remain decidedly unequal, for LAF video served as the finest medium for tactical intervention—turning the passive consumption of broadcast television back on itself as an act of production, which in the process might establish more direct knowledge about self and communal identity. Throughout its history, LAF curated many programs specifically catered to various communities who find their representation in the mass media reduced to negative caricatures: African Americans (*In Visible Colors,* 1991); Asians (*Freewaves from J-Town,* 1992); Latinos (*Idiomas Indigenas/Native Tongues,* 1992); women (*Girl Hood, Dis-ordered Women,* 1996); gay men (*De/Re Constructing Masculinities,* 1996). Usually such groups have been defined by race, ethnicity, class, gender, and sexual orientation. Often overlooked and sometimes dismissed by even the most sensitive social

ILLUSTRATION 9.4. *Brains on Toast: The Inexact Science of Gender* (Liss Platt, Joyan Saunders). Photograph courtesy of Anne Bray.

activists have been distinctions of age. In particular, our nation's youth—a subculture catered to, and exploited by, corporate entertainment and advertising—has generally lacked any significant forum to represent themselves outside of acts of consumption: fashion, music, TV ratings, and box office receipts.

Even more problematic for Bray and her organization was a concern that the standardized, formulaic entertainment promulgated by media corporations could condition younger audiences to the extent that their incomprehension of truly alternative media forms would limit their curiosity to seek out or produce the sort of independent media advocated by LAF. Video critic David Antin has explained the problem in terms of relative contrast and familiarity: "Videotapes are boring if you demand that they be something else. But they're not judged boring by comparison with paintings or sculpture, they're judged boring in comparison with television, which for the last twenty years has set the standard of video time."[15] And art critic Stuart Marshall has further noted that video itself, although often championed by progressives as inherently revolutionary, must extricate itself from its historical origin as a supplement to television:

> Unlike the media and practices of painting and sculpture, video technology and dominant televisual practices do not "belong" to the artist. The technology was not developed with

him or her in mind and televisual "literacy" was established and is controlled by the television industry. Video's attempt to produce a modernist practice therefore produced a second unexpected consequence, the establishment of a critical relation to dominant technology and its representational practices.[16]

It is this critical relation to television and all other dominant media forms that LAF developed in the sixth tenet of its mission: *to provide education in media literacy.* Through acts of intervention, LAF would seek to fracture attempts at monolithic standardization, to build new audiences by the introduction of alternatives to children at an early age, and to teach spectators to discern the difference between historical and mediated reality. Bray recruited two of the most important public institutions to assist her in this mission: libraries and high schools. Beginning in 1995, more than seventy libraries accepted some of the most challenging videotapes she had collected in accord with their long history of support for free speech. In addition, through a series of referrals and recommendations, tapes and a curriculum guide were mailed or delivered directly to some of the more radical teachers in more than forty high schools. In particular, Humanitas, a group of teachers working within the public school system to develop interdisciplinary programs within the language arts and social studies, successfully integrated tapes she provided into their classes on topics including immigration, racism, gender formation, and labor issues.

The results of these media literacy interventions may be difficult to judge in terms of their broadest social effects, but in terms of videos produced by youth specifically for the LAF festivals, they were remarkable, generating some of the most arresting new work in the organization's history. For example, at the 1998 festival, *Youth Media Explosion* premiered tapes by high school students and participants in youth development programs who, coming of age in an era of information control, attempted to represent images of youth according to their own points of view rather than the custodial perspectives typical of work produced about them by adults. In *Media Control . . . Out of Control,* students revised, re-envisioned, and in some cases reembraced the electronic age of information processing through clever strategies of satire and critique. In *Life Lessons,* young subjects told their own coming-of-age stories, laced with humor and pathos, about the defining rites of passage in their lives. Works such as these required that audiences rethink their prejudices against youth, just as they have been expected to do regarding race and sex. For if Sigmund Freud once made the radical claim that children have a fully developed sexuality, LAF has made an equally radical claim that they have a fully developed creativity deserving of equal opportunities for distribution and exhibition.[17]

With the explosion of multimedia technologies in the 1990s, education in media literacy became a concern not merely for young people but also for adult artists intrigued by the aesthetic possibilities of new cutting-edge techniques. To this end, Bray organized several events. In January of 1995, *Digi Days,* held at the AFI, expanded new technology's accessibility by presenting two low-cost weekends of panels, lectures, demonstrations, and hands-on workshops that brought new digital and interactive media to a spectrum of artists, community media organizations, and media activists from

throughout Southern California. In October that year, *Artist & Activist CD-ROMS*, held at the USC School of Cinema-TV and Leavey Library, featured two days of workshops that focused on the production and distribution of CD-ROMS and panel discussions regarding the aesthetic and sociocultural effects of this technology on artistic production. By the following year, LAF produced its first organizational CD-ROM, which was distributed freely to people unfamiliar with multimedia and the Internet. The disc contained manifestos, copies of Web sites, shareware for Web browsing and Web authoring, and an updated list of Southern California media arts resources, including low-cost new media services and the new wave of youth access centers. Beginning in 1998, *Open Studio/LA* would launch a series of free workshops on Internet and Web design targeted to visual artists, writers, and musicians. Presented at ten venues throughout the L.A. basin in collaboration with LAF, OnRamp, and Visual Communications, this partnership would be committed to building an effective training program and a diverse online communications network among Los Angeles arts communities by assisting media-makers to overcome technical hurdles and to discover the creative and professional benefits of the Internet.

L.A. Freewaves in the Next Millennium

Even though Bray and her organization had made great strides in supporting the independent scene in Los Angeles, creating a network of media-makers, widening access, advocating multiculturalism, empowering indigenous communities, and educating people of all ages in media literacy, it often seemed, at the turn of the century, that the goals of LAF were more like mission impossible than mission accomplished. As Bray put it, "For every two steps forward, there's always one step back."

Of most immediate concern was decreasing sources of funding. Nonprofit in status since 1994, LAF has had to rely on the unpaid work of volunteers and grants from city, county, state, and federal agencies, in particular the City of L.A. Cultural Affairs Department. In the late 1990s, however, three of its foundation grants first awarded in 1994 withdrew support all at once, if only because of policy changes: the Rockefeller Foundation would fund only individuals; the Irvine Foundation would grant only to large organizations; and the MacArthur Foundation would limit its resources to the Chicago metropolitan area. While contributions from the Getty Center and the Warhol Foundation kept LAF afloat, Bray worried that each festival would be the last.

In the absence of public funding, Bray attempted to make alliances with for-profit sponsors, but she had almost no success except during the second festival, when five of L.A.'s smaller independent video rental stores each donated $500. Thereafter, she considered encouraging commercial media-makers to attend events as audience members; and at one point, she had even been willing to entitle one festival shamelessly as "Come and Rip Off Your Ideas Here Fest." In addition, she fruitlessly sought in-kind donations from corporations to supply paper for publicity, tapes for duplication, and equipment for projection. Commercial ventures, including the press, continued to disappoint.

Although Bray encouraged journalists to engage with the cultural and social issues in current independent media and to publicize independent video programming more widely, interest in LAF grew inversely proportional to the number of years the organization had been in existence. Bray rarely could depend even on local alternative publications such as the *L.A. Weekly* to provide more than a few inches of promotion space. Instead, she spread the word through approximately 35,000 posters mailed to virtually every art organization in the area and hung at about 250 sites, including cable stations, schools, cafes, and art centers.

In tandem with decreasing press coverage, audience support wavered. Whereas 29,000 people attended live events of the first year, only 2,000 showed for the festival in 1998. Bray explained the smaller numbers in part by pointing to an economy that required workers to take exhausting multiple jobs in order to maintain a reasonable standard of living—one that, ironically, only allowed for one evening a week spent in leisure pursuits; Saturday events, for example, consistently drew the largest crowds. The 1998 festival's record low attendance may also be explained by the decision to house all screenings at MOCA, rather than dispersing them throughout the region as had been Bray's strategy in the past. While using a prestigious auditorium served to legitimize the festival, get more funding, create pride in the media-makers, and make it easy for audiences to attend back-to-back programs in the same convenient location, many spectators failed to make the trip downtown at all. For the seventh festival, Bray counteracted waning attendance by once again diversifying exhibition sites across live events, Web sites, and broadcast television. This strategy proved so successful that audiences reached record numbers.[18]

Indeed, imagining and implementing new forms of exhibition would become a source of creative pride for Bray. To date there have been four predominant modes of exhibition: (1) funded, culturally mixed, thematically tight programs shown on cable systems in all locales; (2) programs curated, funded, and exhibited by the same site; (3) shows programmed by an independent curator, funded by LAF, and exhibited at a favored site; and (4) traveling shows at a venue that has no strong cultural alliance to the program. Of the dozens of organizations and institutions that have hosted LAF events, the most supportive has been, not surprisingly, MOCA, where three of the six festivals were anchored. On the other hand, its location downtown may have limited potential audiences. Although Bray felt it important to get large institutions and grassroots organizations to work with each other—since both have much to gain if each can be flexible—budgets, timing, and ways of operating are so opposed that it makes cooperation difficult. For instance, the Los Angeles County Museum of Art on Wilshire Boulevard's Miracle Mile is more centrally located to both west side and east side populations, but it requires at least three years of advance notice for all video programs and installations, a policy too rigid and bureaucratic for the more spontaneous events organized by LAF.

Even more problematic and disturbing was the rise of censorship on public access cable catalyzed in 1994 by legislation passed in the state of California allowing for community standards to determine content appropriate for broadcast—in effect sanctioning

censorship according to arbitrary local criteria. While some television stations—including Palos Verdes, Pasadena, West Hollywood, and Wilmington—were able to maintain their progressive agendas, employees at others were threatened with termination for airing LAF programs. Nor was public broadcasting immune to such restrictive trends, as KCET, the local PBS affiliate that had annually provided LAF an audience of up to 25,000 for one hour of programming, unceremoniously dropped the association once the procedure to write the necessary proposals became too costly.

While the number of KCET viewers had always been record-setting for any single LAF program, Bray realized that audiences could multiply rapidly, given proper exploitation of the Internet as a more accessible form of broadcast. Yet she also understood that, like the Sony Portapak, the Internet would eventually be appropriated and standardized to serve corporate interests. Until that day arrived, however, Bray planned to continue to exploit the Web to transform LAF's local festivals into a global auditorium, so to speak. In a world made smaller by Internet links, the great expense of time and money of a trip to Los Angeles for media-makers was no longer necessary in order for them to participate. Simply by logging onto the LAF Web site, visitors could access Joyce Dallal's *Finding Home,* Jody Zellen's *Ghost City,* or Joe Rabies' *Iceland Sundaes,* to name a few of the interactive works that both redefined what "video" means and illustrated how the Web had begun to surpass cable television as a medium of public access.

The advent of these global links, however, begged an essential question: Would the festival lose its indigenous connection to Los Angeles once it was displaced into the uncharted regions of cyberspace? The answer would likely be affirmative, thus undermining one of LAF's primary missions: to create a public, Los Angeles-based community. The Web's privatized, home-based terminals would disperse such a community. The individual acts of Web browsing themselves would compromise the live, face-to-face communal events sponsored by the festivals in the service of bringing people of different backgrounds and identities together. Instead, like commuters driving through unfamiliar neighborhoods with no intention to stop until they reach the comforts of their own domestic havens, Web surfers may easily bypass the works of media-makers perceived as "different"; or even more insidiously, they may take voyeuristic pleasure at the expense of "others" in the absence of live Q & A sessions that offer educational perspectives on the works themselves. In short, would these Web audiences form meaningful communities, or would they simply mimic and exacerbate the isolation and alienation brought on by the passive consumption of mainstream, commercial media?

In an effort to preserve communal events that would continue to attract live audiences, LAF's most inspired programming efforts to date occurred as part of the 1998 and 2000 festivals: a series of video bus tours, transporting spectator-passengers on various routes around Los Angeles while they viewed curated video programs screened on board. This double viewing experience was most refreshing: the spectacle of L.A. was restored to locals, as if seeing its familiar terrain for the first time with new eyes.

Although the tours had been organized with different purposes and itineraries, each one foregrounded common experiences, such as the voyeurism inherent in mass transit, the oscillations between the distracted glaze and the active gaze, and the simple notion that all passengers are tourists in neighborhoods other than their own. For example, the *L.A. Voyeurism Bus Tour* (1998) highlighted various forms of voyeurism prevalent in Los Angeles, such as touring Hollywood landmarks, street walking on Sunset, gay cruising in Griffith Park, and stalking the stars in Beverly Hills. As passengers observed such activities on the outside, they in turn were watched by fellow passengers on the inside, taped by a hidden surveillance camera, and broadcast on monitors on board. This uncanny effect exposed the shifting power relations between spectatorship, objectification, and performance.

The bus tours demonstrated how Bray and her associates have had to harness their creativity to modes of distribution and exhibition in a cultural climate that would readily squelch such invention. Unlike "culture jammers" who use guerilla tactics to subvert the art establishment, Bray would continue to work within existing art institutions, if only because her experience had proven that artists and curators reap more benefits in the long run when arts administrators nurture and maintain, rather than disrupt, working relationships with museums, galleries, and schools. Instead, LAF has looked for the spaces between the cracks, so to speak, when conventional venues have had excess time and space available to alternative work that would not threaten their own operations.

Sometimes these tactics have succeeded. For example, a three-day event hosted in 1996 by MOCA occurred only because of the unusual circumstance that the museum's installation space was idle over a long weekend after a major show had just closed and before another major show would be mounted. Bray contacted MOCA's curator, Julie Lazar, to inquire if LAF could program one of its shows in that space in the meantime. With no reason to deny access, Lazar agreed and issued impromptu press releases, while Bray contacted local artists already working on similar themes that could be curated into a coherent program. By using the existing walls and projectors left over from the previous installation, and with a budget of a mere $500, *Private TV and Public Living Rooms* opened to respectable audiences and excellent notices. Such extemporaneous programming is virtually unheard of in a major metropolitan museum.

Unfortunately, happy accidents like this would be rare, and more often than not, similar tactics would fail. In 1996 when Bray had suggested to the management of Dodger Stadium the idea for a "Video Night" during which artists' videos would be projected onto the stadium's large screen monitors between innings and during commercials, she ran into a Catch-22 situation: she could only receive a permit once the content of the videos had been reviewed and approved by the management, who would review the tapes only after LAF had been issued a permit. Needless to say, Bray struck out. In 1994 when she attempted to secure the Centinela Drive-in to use its outdoor screen for a "Video Drive-in Night," the owner, Henry Casden, a wealthy Beverly Hills businessman and vintage car collector, set the rental fee at $10,000, in effect blocking her out.

Thus, even when Bray risked compromise by seeking out commercial affiliations, corporate interests would have nothing to do with her.

Bray has admitted that LAF's resistance to corporate models may indeed betray a lack of planning that would guarantee the organization's longevity. She has considered but ultimately rejected the idea of requiring membership dues, of charging higher admission fees to events and workshops, and of inflating entrance fees for festival submissions. Instead, she has remained committed to the notion, however outdated, that public art should be funded publicly and administered by volunteers and that any profits earned by LAF should go first to the participating artists, especially since, unlike film festivals, video and multimedia festivals are not markets where artists may make deals to secure themselves or their work financially.

This policy, of course, in no way protects the financial health of LAF itself. Thus, its history of resistance to "corporate contamination" may ironically be the seed of its own destruction. The very contingent, month-to-month, "clutching by its fingernails" existence of L.A. Freewaves puts the entire notion of independent media into question if the most likely alternative to the mainstream is extinction.

Appendix: A Concise History of L.A. Freewaves (1989–2000)

1989: The 1st Celebration of Independent Video launched in October and November at the American Film Institute (AFI) National Video Festival, with the participation of 35 L.A. media and arts organizations. During the three-week festival, events were mounted at 30 sites, while four thematic programs, called "Road Shows" traveled throughout L.A.

1991: The 2nd Celebration of Independent Video became the largest of LAF's festivals in terms of artist participation. It convened in March at one hundred arts organizations, cable stations, media centers and schools. Forty-four thematic programs and 150 tapes from high school and college media-makers were exhibited. The first L.A. media access guide was created.

1992: The 3rd Celebration of Independent Video, held in September and October, included 75 programs curated by 60 independent and affiliated curators. Eight cable programs were broadcast on 29 cable stations. A live-video-installation-performance event, *October Surprise,* was held at California Plaza. LAF was able to bring together a broad-based response to the Los Angeles civil uprising through this festival.

1993: LAF produced a *Catalog of Southern California Youth Media Programs* and a video entitled *Three Strikes: The Justice System* with support from the Rockefeller Foundation and VIDKIDCO. LAF distributed the video program, *Hands on the Verdict: The 1992 L.A. Uprising,* by Liz Canner and Julia Meltzer.

1994: The 4th Celebration of Independent Video, held in September, included *TV at Large,* a video projection and live performance event at the John Anson Ford Amphitheater, five shows at the AFI Video Festival, and five programs broadcast on cable television. A media resource guide was published along with the festival schedule. The festival curatorial committee was formalized. LAF received its nonprofit (501C-3) status and its first foundation grants.

1995: In January at the AFI, LAF hosted *Digi Days,* a weekend of low-cost workshops, panels, lectures, and demos on digital video and interactive media. In October, at the University of Southern California, LAF hosted *Artist and Activist CD ROMs,* another weekend of workshops and demos that focused on the production and distribution of CD-ROMs. Throughout the year, LAF freely distributed eight video programs to 66 L.A. libraries and 40 L.A. Unified School District (LAUSD) high schools.

1996: LAF launched its Web site (www.freewaves.org) and produced and distributed its own CD-ROM. In April at Inscape, LAF hosted *Live Nude Artists,* which featured 9 CD-ROMS by local artists. The 5th Celebration of Independent Video was held in August, including videotapes, CD-ROMS, and Web sites by 140 artists, and *Public TV, Private Living Rooms* showcasing 15 installations by L.A. artists at MOCA's Geffen Contemporary. Programs also traveled to 15 art centers and 32 cable stations.

1997: LAF distributed 8 video programs free to 74 L.A. libraries and 40 LAUSD high schools, along with curriculum guides developed with high school teachers.

1998: From February through June, LAF conducted a series of 25 free workshops on Internet and Web design targeted to video makers, visual artists, writers, and musicians. In September and October, the 6th Celebration of Independent Video and New Media, entitled *All Over the Map,* included video screenings, installations, performances, and CD-ROM and Web site exhibitions, as well as six video bus tours.

1999: In partnership with On Ramp and Visual Communications, LAF launched the *Open Studio/LA Program,* a series of free workshops on Internet and Web design followed by an in-depth residency for 30 artists and arts organizations. In July, LAF marked its 10th anniversary with a roundtable panel discussion of its past and future mission.

2000: In November, LAF held *Air Raids,* the 7th Celebration of Experimental Media Arts, that hosted 65 events at 35 locations. The events included thematically curated single-channel exhibitions, multimedia installations, video bus tours, video billboards, half-hour programs on public television, online exhibitions and artists' CD-ROMs at MOCA, panel discussions, and a video finale at a karaoke club.

2001: LAF secured funding to distribute *TV or Not TV,* three half-hour videotapes featuring interviews and excerpts from works sponsored by LAF since 1989.

Notes

1. The L.A. Street Scene was a festival run by the General Services Department of the City of Los Angeles each year in early October. It contained more than a hundred booths of food and arts and crafts, and thirteen stages of dance and musical performances attended by approximately one million Angelenos over the course of a weekend. Bray supervised the arts and crafts in the summers of 1984 and 1985 while earning an MFA in New Genres Art at UCLA.

2. *Dark Madonna,* a performance art piece presented at the UCLA sculpture garden in May 1986, was conceived by Suzanne Lacy and produced by Bray under the auspices of the UCLA Wight Art gallery. The pre-production process involved six meetings of discussions among women concerning their personal experiences of racial difference.

3. The $15,000 budget was funded by the City of Los Angeles Department of Cultural Affairs.

4. Barbara Osborn, "Off Hollywood Boulevard: The LAF Video Festival," *The Independent* (August/September 1991): 16. Unlike many media journals that have provided extremely limited coverage of LAF events, *The Independent* has maintained a close relationship with the organization and has regularly encouraged its readers to submit work and attend festivals.

5. The budget for the second festival was $45,000. With each subsequent festival, the budget increased. The budget for the seventh festival has been estimated at $100,000.

6. Osborn, "Off Hollywood Boulevard," 14.

7. Ibid.

8. Carey McWilliams, *Southern California: An Island on the Land* (Santa Barbara: Peregrine Smith, 1973), 339.

9. This and subsequent references to the LAF's mission are abstracted from "L.A. Freewaves' Mission Statement," a document similar to those prepared by all nonprofit organizations.

10. Holly Willis, "Off-road Vehicles: LAF Festival," *Afterimage* (January 1993): 3. Willis, an advocate and critic of experimental media, has worked with LAF in various capacities, in particular as a festival curator.

11. The name "L.A. Freewaves" was conceived by Michelle Hirschorn, staff member at LACPS, and was advanced into regular use by video artist Art Nomura, a member of the communication faculty at Loyola Marymount University.

12. Willis, "Off-road Vehicles," 3.

13. Interview with Anne Bray, July 1999, during Freewaves 10th Anniversary Project.

14. Doug Hall and Sally Jo Fifer, "Introduction: Complexities of an Art Form," in *Illuminating Video: An Essential Guide to Video Art,* ed. Doug Hall and Sally Jo Fifer (New York: Aperture, 1990), 21.

15. David Antin, "Video: The Distinctive Features of the Medium," in *Video Culture: A Critical Investigation,* ed. John G, Hanhardt (Rochester, N.Y.: Visual Studies Workshop Press, 1986), 155.

16. Stuart Marshall, "Video: From Art to Independence," *Screen* 26, no. 2 (March/April 1985): 69.

17. As Marina Rosenfeld has written in her review of the 1996 festival: "Overall, an exhibition that shows the work of, say, Guillermo Gomez-Peña alongside the output of students of Pacoima Middle School demands a certain reassessment of the criteria by which art is usually judged" ("The Waves: Many, Many Videos at Many Sites," *L.A. Weekly,* 30 August–5 September 1996, 45).

18. The numbers were as follows: 7,656 attendees at live events; 20,000 Web site visits; and 202,000 TV viewers.

10 Self-Help Graphics:
Tomás Benitez Talks to
Harry Gamboa Jr.

Introductory Note

Self-Help Graphics was founded in 1971 by Sister Karen Boccalero, a Franciscan nun who studied art under Sister Corita Kent. Located in a garage, the center offered silk-screen workshops. Subsequent activities would blend Sister Karen's knowledge of modern art history, commitment to political radicalism, and orientation toward cultural specificity and Catholic spirituality. In 1972 Self-Help Graphics initiated an annual Day of the Dead celebration that would bring the community together around the new institution. Inspired by a Charles and Ray Eames film on the Mexican festival, the event combined cultural nationalism and spiritual syncretism, while also serving as a staging ground for the Chicano avant-garde. In the process, it also made various unacknowledged gestures toward mainstream culture: U.S. secular rituals (Halloween), modernism (the Eames's influence), and performance art.

Throughout the 1970s, Self-Help Graphics initiated several important community-based programs designed to make art and art making accessible: the Photography Workshop, the Barrio Art Mobile, and the nonprofit Galleria Otra Vez. Beginning in 1982, Self-Help Graphics started a master printer program, inviting Gronk to work with Stephen Grace to pull ten prints. The next year the program evolved into its present-day form: an annual atelier open to Chicano and non-Chicano artists and funded through the endowments and philanthropic sector. The prints are sold to the community in order to generate income for the center as well as to provide affordable fine art for the home; the artists retain a portion of the print run for their own purposes. When Sister Karen died of heart attack in June 1997, Tomás Benitez, a longtime administrator at Self-Help Graphics, became the new director.

From one perspective, Self-Help Graphics follows in a tradition of L.A.-based fine arts printmaking since the 1920s, when master printer Lynton Kistler first started

collaborations with local artists. In the 1930s, Guy Maccoy and Geno Pettit introduced serigraphy to the region. These individual efforts were followed by arts institutions that at once popularized graphic arts within Los Angeles and established ties with the New York-based art world: Western Serigraph Institute in the 1950s, Tamarind Lithography Workshop in the 1960s, and Gemini G.E.L. in the late 1960s and 70s. From another perspective, Self-Help Graphics breaks with the tradition just described. As a grassroots organization located in and serving the Chicano community of East Los Angeles emerging out of the cultural nationalism of the Chicano civil rights movement, Self-Help Graphics is often associated with the history of Mexican rather than American graphics, following a didactic and revolutionary tradition from José Guadalupe Posada (1852–1913) through the Taller de Gráfica Popular (1937–1977).

In the final analysis, both American and Mexican printmaking traditions have an influence that is perhaps more "invented" and retrospective than organic with respect to the artists who have produced worked at Self-Help Graphics. Interestingly, Jean Charlot, whose disciples founded the Taller de Gráfica Popular, does provide a link between these two traditions, having moved from Mexico to Los Angeles, where he spent most of the 1930s working with Kistler. For the most part, Sister Karen represented the major connection between Self-Help Graphics and both fine arts traditions. As a community-based institution, though, Self-Help Graphics operated more within the context of other Chicano arts centers in Los Angeles: Mechicano, Goez Gallery, and Centro de Arte Poeblico. To this extent, it served as a focal point for Chicano art groups (Los Four and Asco) as well as for two generations of individual artists. Self-Help Graphics also joined in common cause and collaboration with other Chicano graphic arts centers across California: Galeria de la Raza (San Francisco), Centro Cultural de la Raza (San Diego), RCAF (Sacramento).

Chicano art historians regularly distinguish between the politics-driven activities of the other Chicano arts centers and Self-Help Graphic's emphasis on access to fine art by and for the community. The distinction is accurate, but it is also somewhat misleading, since Self-Help Graphics upheld the same movement-era tenets about the necessity of art for community building. Rather than subordinate art to politics, or form to content, Sister Karen understood art itself as a social practice that could build and sustain community— through the active making, buying, and experiencing of art within the community. Located in East Los Angeles, Self-Help Graphics operated at a geographic and racial distance from the art world nestled in the culture industry on the west side. But it has also served as a platform from which Chicano artists could either return to the community or venture out toward the commercial art world.[1] (Chon A. Noriega)

The Interview

Harry Gamboa Jr. interviewed Tomás Benitez at Self-Help Graphics on 17 April 2002.

GAMBOA: *Maybe you could tell us how you came to be involved with Self-Help Graphics?*

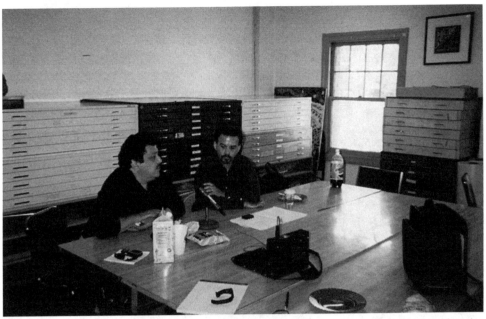

ILLUSTRATION 10.1. Tomás Benitez *(on left)* talks to Harry Gamboa Jr. at Self-Help Graphics, April 2002. Photograph by and copyright © David E. James.

TOMÁS BENITEZ: I like to tell people that I started out as a child getting thrown out of here, and it was a great irony now that I make a living here. When I was a kid, this was the Community Youth Organization. I used to be in the boxing program over at the park down the street. I'd come over and try out what I learned that day, and the brothers would throw me out.

Self-Help's been in this building since 1979, 80, or thereabouts. I came about ten years later after the big earthquake. The building had been condemned by the county, and Sister Karen began an aggressive campaign to find resources to do the retrofitting to stave off being demolished. I'd been floating around as a manager and grant-writer; and Dolores Guerrero Cruz, who was then an artist-in-residence, invited me down. I wrote a couple of grants in exchange for art. We were lucky; we found $150,000, and I spent a couple of hours talking with Karen and going over the history of Self-Help and doing the work that I was supposed to do to prepare the proposals. At the end of it, I realized that I wanted to work with her all the time. I was juggling a couple of other jobs, but I was getting married and I needed a place to settle down. I pitched Karen for a job, she hired me, and I've been here since about 1991.

GAMBOA: *Maybe you could tell us a little about Sister Karen and your relationship with her, how she might have influenced you?*

TOMÁS BENITEZ: Karen was one of the most humane people I've ever met in my life. She had a tremendous spirituality, but she was also quite human, susceptible to cussing,

ILLUSTRATION 10.2. Self-Help Graphics, February 1991. Photograph courtesy of and copyright © Self-Help Graphics.

chain-smoking, and she could be moody or grumpy. She was also absolutely brilliant, quite visionary in some ways. I found her to be fascinating. I grew to love her as a friend and mentor, and I had great respect for her intellect as well as for the fact that, even though it might be maternal or from a missionary point-of-view, I think she really felt privileged to be part of creating opportunities for artists.

A week before she died, I had driven her to an interview, a process that made her reconcile her thought processes. She was saying that the three life lessons she had learned were that she had been fortunate to be surrounded by the thousands of artists who were the real heart of Self-Help Graphics; that she was upset by the fact that no matter how far we had come, we still had far to go because there was still a struggle for people to truly understand and appreciate what the context of art from this community was; and that she had great hope in the fact that the best was yet to come. But she really got me when she said, "If I had any regret in my life, it was that I never had children." And I said, "Well, you being a nun, that would have been a problem, but you in essence were a mother for a couple thousand people." And she liked that— because there were plenty of times when she didn't want to be a mother, just as there were plenty of times when she couldn't help being so.

She was an artist, and she was creative. She was a thinker, and she was articulate; her name Boccalero means "talker" in Italian, and that was very true. She was moody, grumpy, nasty, and downright mean at times when we were fighting. But I can't think of anybody who influenced me more intellectually in terms of understanding creativity in the context of its contribution to community than Sister Karen. I still miss her.

GAMBOA: *How about the Day of the Dead events that would take place here (I guess it began in 1972, and I think it's one of the events that really brought Self-Help Graphics to not only local but national attention)?*

TOMÁS BENITEZ: I think so. The Day of the Dead is almost in the arena of apocrypha. It's like *Rashomon;* you can talk to four people and get four different versions! A couple years ago I was talking to the director of the Galeria de la Raza, who said, "Well, we thought you started it." And I was saying, "You know, I had always thought you started it."

I think it was started by artists; that's the bottom line. It was started by artists who figured out that this kind of celebration could be used for public demonstration or performance art—this is before it was called such. As you know, the group Asco was involved in creating Day of the Dead as part of their portfolio of groundbreaking performance art. In that period there was a need for cultural expression, public participation, and public demonstration—a hybridization of Chicano-Mexicano culture. One could stretch that and say that it was apropos of the times, because so many of our young people were coming home dead from Vietnam and there was the police problem and fratricide. A way to overcome the specter of death in our community was to embrace it symbolically, and there was a cultural spirituality attached to that. Self-Help was critically involved in this, being a place where artists were supported in the endeavors, which led to the Day of the Dead celebration. In the communal context of the workshops, things were created for the procession, and at its peak from the early to the late 70s, we had processions ending with both indigenous and Catholic celebrations in the church cemeteries, and El Teatro Campesino coming in and adding to the theatricality of it. We had artists like Harry Gamboa, John Valdez, and Leo Limón taking pictures of these events; and now the photographs have become the expressions of those artists and themselves *objets d'art.* It was that kind of a nascent stage when people really didn't know how significant it was.

It kind of bottomed out in the mid-80s because even in the start-up phase of nonprofits there are always cycles where you have that burst of energy that levels out, and then you have a burst of energy that takes it to the next level. Sometimes it comes as a result of conflict; and it's no surprise that in the mid-80s Self-Help's profile began to wane as did the political movement, and you saw the advent of other things, like individual galleries and print shops, or the advent of other organizations that reformulate the careers of artists who were reacting or responding to what Self-Help had done. Our programming also reflected that, and we certainly had individual curators coming in and being a lot more particular instead of embracing things in which many people were involved.

And then things really changed again in the early 90s because of the Los Angeles riots, Chiapas, and then the "Godfather" of the new Chicano Movement, Pete Wilson, and his politics of absurd racism. The Day of the Dead also reflected these and changed with the new generation. One of the intriguing things was that artists who had been involved since the beginning of Self-Help and who were seeing another generation take over started to feel a bit anachronistic. We're still seeing that generational struggle taking place. But Day of the Dead remains an exemplary paradigm of a large body of artists participating in a public art demonstration in the United States. Chicano artists were at the heart of it.

GAMBOA: *How about the other programs that have taken place here?*

TOMÁS BENITEZ: The Barrio Art Mobile Studio was essentially a response to a lot of money. In the late 1960s, the Democrats were trying to buy out the people-of-color communities and keep their 80 percent voting bloc intact. The Model Cities federal program came to Self-Help with a $100,000 opportunity, and we had to organize ourselves into a 501 nonprofit to receive the dollars and come up with a program. The Barrio Art Mobile Studio was a converted van with a photography studio and a printmaking studio that could go into parks, community centers, and schools. It was a very timely

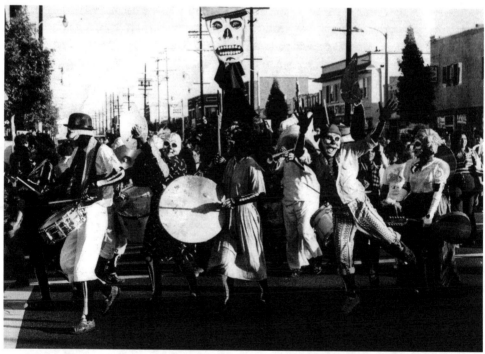

ILLUSTRATION 10.3. Day of the Dead festivities with El Teatro Campesino outside Self-Help Graphics, 1978. Photograph courtesy of and copyright © Self-Help Graphics.

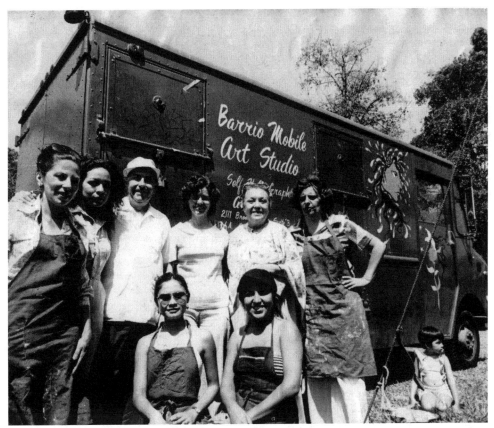

ILLUSTRATION 10.4. Sister Karen Boccalero and other artists from the Barrio Mobile Art Studio, 1977. Photograph courtesy of and copyright © Self-Help Graphics.

and convenient model that worked in terms of quality art making that reflected the community that was being served by artists who reflected the community, a training ground for those artists. It became the first success that took Self-Help to its next six-figure level.

The problem was that it became the sole focus. Self-Help had started with a group of artists who were printmakers working together, who later opened a public space. The problem with the public is that when you invite them, there's a chance they're going to show up! The Barrio Art Mobile Studio became more of a formalized program that took on all the accoutrements of follow-through, paperwork, and organization; and the all energy was focused on that. When the chance came to move to this building, the chance also came to make a decision about refocusing Self-Help's professional services in terms of creating art. And so with great regret, Sister Karen almost entirely on her own made the decision to do away with the Barrio Art Mobile Studio and refocus on creating a communally organized print studio. That's where the Atelier came about, and it has been the flagship and the engine of Self-Help ever since: limited edition, silk-screen, fine art printmaking. When we first came into this building, the real sense of this place

was that it was a locus specifically for artists because we had several artists in residence here. That's no longer the case.

Over the years, the artists have matured, needs have changed, space has become so precious, and the need for serving a larger public has come. In the case of this room, which used to be Leo Limón's studio, when he left, we didn't replace an artist, we replaced him with a new function. The room next door, when Dolores Guerrero Cruz left, we didn't replace an artist, we replaced her space with a new function. We've expanded the printmaking; the Atelier remains the flagship and has generated over four hundred editions, making us the most prolific Chicano art printmaking place in the world. We've expanded to include a number of methods in printmaking, which has given us a tremendously diverse menu for the different artists who have come through here and worked in etching, plate-monoprint, monoprint, and so on. That's the core, and it has also lead to the Exhibition Print Program: we keep one print of each work that's done here, frame it, and we send editions of the same print out to different places and organize exhibitions that extend the impact of the work. It's also led us to collaborations and residencies where we have artists come in specifically to do printmaking—doing what the hell he or she wants to do. We still do intergenerational, hands-on, community-based workshops that lead up to the Day of the Dead. And then we have the whole world of technology before us in terms of expanding the type of printmaking as well as the investment in the Internet and cyberspace.

We've yet to develop anything sophisticated in terms of publications—that's a sore spot for me. Karen didn't throw anything away, and because people have begun to realize that in Chicano art, the artist, the artwork, and the epoch are all part of the same movement, we have a lot of archive. The other program that is so important is the Gallery Otra Vez, which started at the old space and continues there now. It has been a place for artists from this community to show their work as well as for artists from other communities that are important to this community to show their work. But the demands on us are so great with the debacle of the Latino Museum in Long Beach and the ups and downs of small spaces. We still have a tremendous amount of demand. So we end up with the occasional solo show, some small group shows, plus other programming demands like the Day of the Dead annual print show. We try to balance these and make sure we are paying attention to young artists with spray cans, cameras, and the like. It takes about two years to really have a repeat pattern in our cycle because there's such a demand.

GAMBOA: *What do you think has influenced the approach to printmaking in your program here? Would you say it's sort of the local, L.A.-based organizations or the Mexican tradition related to prints? What do you feel is the primary focus and the purpose of making the print in the first place?*

TOMÁS BENITEZ: The primary focus and purpose has changed. At the outset there was very much a sense of communal orientation and spirituality: creating a print because it is the egalitarian way of disseminating art and image. This related to the history of agitprop in the Chicano movement, which was influenced by the art of the Spanish Civil

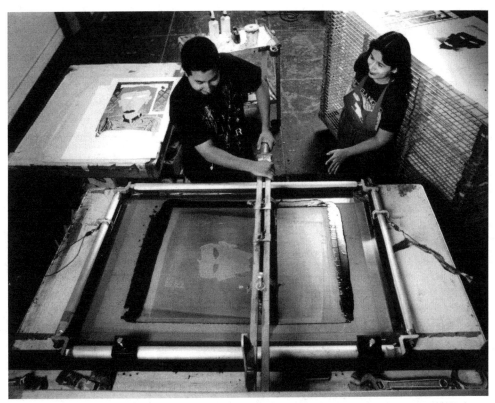

ILLUSTRATION 10.5. Master-Printer José Alpuche working with artist at Self-Help Graphics, 1992. Photograph courtesy of and copyright © Self-Help Graphics.

War, Eastern Block propaganda, and the poster art of the Cuban Revolution. The idea of art articulating politics also goes back in Mexican tradition, but the fine-art tradition was also highly influential from Taller de Gráfica Popular. The concept, if not the actual application of the Great Three, was to create big, broad murals, communal images that showed history to a relatively illiterate population—that vision of art's utilitarian profile influenced our printmaking. Then there was a maturation and a change. The climate in the late 1960s and 70s was wonderful and exciting and sexy and fun and rancorous. And we all got a little bit older, and we won more battles than we lost, but we all began to reach a different point by the late 70s where some of our individual needs began to play a more prominent role. Not that the need to keep struggling was any the less, but you began to see some more individual emphasis. The idea that a Chicano artist is compelled to use only Chicano iconography or colors or approach is ridiculous.

In terms of influences, Karen was absolutely critical in terms of her proclivity for printmaking. In the history of American printmaking, right about the time that productivity began to peak and the market declined, Chicano printmaking picked up— which is like the worst possible envelope to fit into. But it was also very convenient

in terms of who we were, how we served; and it took on the egalitarianism of history. Later on, it's become a matter of sustaining a productivity that would be prohibitively expensive unless approached communally. It's also been very good for artists early in their careers, when a print can help expand an artist's exposure. But we haven't entirely put away our earlier emphases. We still have just finished six prints created in protest against the displacement of poor people along the Alameda Corridor. We still have that agitprop awareness, but the respect for individual expression is also strong. Particularly with women, the personal narrative has really become the preeminent influence and capacity.

Since Karen's death we've really felt her absence. I come from a theatre and writing background. I'm sensitive to this community, and my philosophy is art- and culture-based community building, but I'm not a visual artist. There's no way that you get the body of knowledge that Karen had from sitting all day smoking cigarettes and talking to artists and being a mentor, so there's been a vacuum there. Not having a particular direction or vision in terms of the specifics of printmaking, we've gone in a variety of tangents responsive to the artists who've come forward. We've become this republic of different stops and starts of what people want to do, a really practical approach. But all things being equal, there's not been enough women involved, so I've developed an institutional initiative by which no less than a third of our activities are specifically directed toward women, and that's been successful.

So by giving up some of the power, we've seen some of the other ideas flourish. But otherwise, in terms of overarching initiatives, it's getting harder and harder: technology-wise, the waning interest and influence of prints, the advent of cyberspace. It's harder and harder to sustain the effort, and we're finding that we're trying to correct a decline rather than invigorate a new direction. I have a great need for professional counsel to see what's happening next.

GAMBOA: *I think what you're referring to here is the lack of an artistic director. What would change if you were to get one? Would that send Self-Help Graphics into an absolutely different trajectory? I think you are referring to things that are somewhat pragmatic in nature. I've sat on many panels where you have all these different organizations doing a very good service for the community, and yet only one grant is going to be given away. We live in an environment where money for arts organizations is very limited, and to have one individual directing the organization could either steer [an organization] toward more funding or completely remove them from the possibility of receiving funds.*

TOMÁS BENITEZ: It's a very challenging time because you're trying to keep the lifeblood of your organization in tandem with the creativity of the community, and sometimes they're not in step. The whole idea of experimentation, of opportunity for people to come in and develop their work sometimes translates to mediocre work; it may not be that artist's final expression, but for him to develop, it's necessary for him to have the opportunity to fail. That's something that we have to deal with right now, when we

have really become oriented toward making sure that the programs we present are also sellable and buyable. We're never going to be fully commercial. We're a nonprofit, and if we became commercially oriented, we would no longer be Self-Help Graphics. But we don't have to be ruled by that Franciscan suffering model; there was some of that attached to what Self-Help was, and it wasn't a detriment to the sacrifice and spirit of the founding vision. But there's less need for humility now and more need for practical success.

The next person who comes in must be more of an artistic manager than a director, provocative not only to Self-Help but also to the artists themselves. We have to have a person with the courage to provoke our artistic development. What I'm able to do practically is allow a little bit of chaos and control it—have Diane Gamboa come in and curate a suite, have Barbara Carrasco come in and curate a suite. These are artists who have earned their accolades, and now they are in a position where they can begin to have some of that oversight. It's not chaos as much as it is affording opportunity, and it's not necessarily a single-vision-directed thing. What we are doing now is not bad, but what we have to do next is unclear; and I think that's where I need to see somebody in a provocative position who can nurture, but at the same time kick butt, and get out of the way of what might be articulated from a larger portfolio vision.

In our reorganization and development, we're speaking to artists from the 70s and saying, "Look, you've been there, you've gone through your highs and lows; some of us are at mid-life crisis and some of us are still at the forefront of challenge; let's organize into a group and let's take on the advocacy job together. Let's develop a dialogue that can develop a critical mass that leads to what's going to be the next chapter in invigorating and infusing new thought and idea and process in Self-Help." So if that turns out to be the Maestros, a group of twenty-five artists that we organized that has the trappings of a more diversified leadership, so be it. But we've got to tap into that wisdom that has been through survival and living and thinking. Self-Help has at times been important in developing that wisdom; we also need to be open to accepting it and nurturing Self-Help with it. We went from a single vision and one person, but the next step is to have more diversified leadership. But what an exciting opportunity!

GAMBOA: *In Los Angeles, the largest center of Chicano population, you really don't find other arts organizations taking Chicano art into consideration.*

TOMÁS BENITEZ: I think you find people who are purposely stepping away from us, and I don't think it's accidental. The major institutions like MOCA [the Museum of Contemporary Art], for example, should be ashamed of themselves. The curator of that initiative is a nice person to have lunch with, but the fact is that she said in a public conference that there are no good Chicano artists in L.A. And for the founder of MOLA [Museum of Latino Art] to say that Chicano artists are not part of the Latin American envelope! The truth is that establishment museums willing to present Chicanos are very few and far between. I vilify the establishment for not recognizing that it is ignoring us. But I'm not taking the victim role. I'm saying, "Fuck you. I may not be as big as

you are, but I'm not stupid and I'm not going to stop talking about it." If we open up a book on art history at UCLA or USC and we don't see the Chicano art movement in there, that book is a piece of crap. I think we have to be really arrogant about this, because it can make you neurotic. I know artists who wake up as a Chicano artist and say, "I don't want to be a Chicano! Every time someone calls me a Chicano, it means I don't get a job. Just call me an artist." I can understand that. The older I get, the nastier I'm getting, because I'm frustrated; but I don't like the idea that I'm still sitting there shaking my fist at a door, and the door's closed.

GAMBOA: *So maybe these doors that we're talking about, some of them being shut, some of them bolted tight, which are the doors you'd like to knock on?*

TOMÁS BENITEZ: Well, I first should tell you that I'm not disposed to knock on a door until my knuckles are bloody. We have discovered friends that are really sensitive to the idea that outreach means more than just borrowing our mailing list, and they are looking to work in collaboration with us. The Autry Museum, I think because they had to go through a whole trial by fire with people laughing at them for either trying to be a Hollywood cowboy museum—they've actually grown, and they've actually taken into consideration culture in the Southern California hemisphere, Hollywood cowboys being part of it. Their leadership has been really active with integrity.

We're also in collaboration with friends like the California African-American Museum, the Chinese-American Museum, the Japanese-American National Museum, all these ethnic-driven institutions that understand that being very specific doesn't mean being exclusive. And we're not frightened of participating and exchanging information and influencing each other. So those institutions have been friends. I think LACMA as a public institution has to be held accountable for its lack of responsiveness to this city, which for the rest of this century is going to be seen as the first stop in art and culture. The Getty has made a commitment to being high on the hill and being the repository of Western civilization; but they're not stupid, and so they've done a lot of other programs and activities throughout the community without giving up the fact that they're really going to be looking at sixteenth-century Florentine illustrations and that's okay. I can live with that, they're not bullshitting me. But MOCA telling me they're in L.A., and they get public money to bring Andy Warhol to share him with Southern California, and the first thing they do is jack up the ticket prices! They need to be taken out and given the birch stick, or as my grandfather would do say, "Dalé la chancla."

And MOLA, now that they've decided to go public, that means they've got a public responsibility. In their neighborhood, they're surrounded by a barrio, but how many of those people are invited to that place? I want these local majors to recognize us the way they recognize Cirrus and the way they recognize Tamarind, and the way they recognize Gemini, because everyone else in the fucking world has done so, and it's their responsibility. They will benefit from recognizing the art movement of Chicanos, in print, through Self-Help and other institutions.

GAMBOA: *So this environment in East Los Angeles, the second largest community of people of Mexican descent in the world . . .*

TOMÁS BENITEZ: And the third right behind us, Tijuana. We're only a hundred miles from Tijuana.

GAMBOA: *With all this many people, do you receive any financial support from the community, or is it just social support? And on the other hand, the reputation of what East L.A. represents through the media, what do you think that does to affect the perception of what Self-Help Graphics is all about, being dependent on public funding, and yet being surrounded by such an incredible community that doesn't seem to support their organization financially? How does that work in the sense that probably the Chicano community at large, if you consider all the money in tax dollars it has donated to the county and the city, has given a huge amount of money to LACMA and MOCA and yet have not benefited whatsoever from that donation?*

TOMÁS BENITEZ: I'd be willing to take ten percent of that tax base and we'd be four, five times the size we are now. You have to start with yourself first: we do good work, but the question of how we present it needs to be broached. And you kind of have to build your support in spurts and in different places; you can't just put all your investment into marketing without having substance, and you can't do vice versa. What we do first is create good art, and if the work wanes because we're not creating the environment for that creativity to be stimulated, we have to take responsibility. I think we're still doing good work, and I think that we're always going to be in a situation where if we're asking people to take risks, we assume responsibility for it, even though it's not always going to be the most popular, well-received art. There's going to be some well-intended failures or misfires. I wish people would respect that a little bit more; however, in terms of the grant-making world, I get it. We have to do a better job of marketing ourselves. It's difficult because our core audience are those people from my generation who say, "I'm *from* East L.A., but I live somewhere else now," but still come back.

We also have the huge immigrant population still coming in from environments in which the tradition is to stay away from institutions. Most of the monolingual, Spanish-speaking people that come here do so because they feel safe; they see some things they recognize. The immediate community is conservative and has no tradition of giving, except to the church. And they also have very low incomes: everybody works, but they barely get enough. Trying to build a membership base out of the next four square miles from here is a joke. So it's a challenge to find resources. Going back to some of that old agitprop history, we had a nun and a bunch of radical Chicanos, so the giving was mostly public, without a great deal of attention being paid to corporate donors. So when I came in, we had essentially no corporate profile. That's still being nurtured, and now we're beginning to see more and more Latino program officers at Wells Fargo, Washington Mutual, and other corporations. I think we're seeing more responsiveness.

But we've got to earn it, and we've got to recognize that those people want something from us and that trade always has to be negotiated.

We're still not dealing with the beer campaigns and cigarette companies, although I think they should be the first people to pony up, because they have such impact on our market and they kill so many of our people. In terms of who we are, we've still got to deal with the perceived notion of East L.A. in the traditional media, and I hate to say it, but also in some of our own media-makers who perpetuate those mythologies; and they do it with remarkably bad writing, and I know you appreciate that because you and I are writers who don't get hired to do those scripts. So we end up with horseshit that just extends a more surreal version of who we are. There isn't a week that goes by that I don't get the occasional, "Is it safe for me to go down there?" That comes from a history of misperceptions of who we are. We do have fratricide in this community. It's a terrible thing, but how that's presented remains a purposeful distortion of reality. We have to suffer that impact. I love this community. I grew up five minutes from here, I went to school fifteen minutes from here, and I know where I'm going to be buried. I love this community, and yet I tell you right now I live in Monterey Park, and I'm very happy there because you don't worry about some of the things that have to do with poverty and the crime that results from that. So there are challenges within the community; it's not just perception. But general distortion does have its impact.

I also think the whole thing about grassroots is very tough. Grassroots does not equate to lack of professionalism. Grassroots does not equate to laissez-fare. Grassroots does not equate to only wild-haired, agitprop types, because the only radical in this place happens to be its director. Everybody else understands, they're a lot more calm about things, but I'm an old pirate. And a lot of people are successful and they're doing fine and they really appreciate Self-Help for its art. What we have done, in fact, is add a very interesting and unique facet to printmaking in the United States, and that needs to be extolled on a professional level. Whether it comes from a grassroots environment or it comes from a Gemini or a Cirrus is beside the point. So some of that is still image, and I don't see us having a $50,000 fundraiser at the Biltmore as being the solution to the perception of who we are. This building itself is a landmark, but it's suffering the cost of reuse. There is a need to really examine Self-Help in terms of its future vis-à-vis everything from where we are located to its structure and its infrastructure. Self-Help's done some pretty sexy and exciting things lately, but we're still trying to outgrow the fact that it's hard to keep the dirt off an old building that's in the middle of two freeways. I think fundamentally image is sort of generated in terms of self-image, and that's where we have to start and make sure that people recognize who we are. It's hard when you do that and they still don't recognize you. The *L.A. Times* has yet to come out and do a review; we've been reviewed in *Art News,* but we can't get the *Times* to come out and pay attention.

GAMBOA: *Maybe we can talk a little about the media's relationship with Self-Help. The same mafia seems to operate the museums and the media. What does it take to cross that barrier? Does one have to be indebted to these cooperating ventures between these*

museums and the publications that define fine art, what is good fine art, what is bad fine art? Does participating in Self-Help Graphics affect the artists and cause them to be viewed as simply Self-Help Graphics artists? Even the title of Chicano art was created as a form of self-identity, but depending on whose hands it's in, it could also be used as a badge to identify the enemy.

TOMÁS BENITEZ: I think that it does have to do with that. I think that a lot of times what happens is that we get in a situation of where we are very committed to defending that which we know and dismissing that which we do not know. And so, in the first place, trying to get somebody who has a learned perspective of how to really and truly analyze the expression and recognize its volume of dichotomies and dualities as well as its simpleness and its presentation is very difficult. It's still something that few people are prepared to undertake. I don't know that if you walk out of an art school nowadays, and you train as a journalist, that you are able to develop without really paying attention and humbling yourself to learn. In our contemporary media scope, there are only a few people who really have paid attention to Chicano art and have really tried. I don't think it happens in the larger newspapers such as the *L.A. Times.* And then you have the other situation when they send out the B-team. Otherwise they say, "We don't do community galleries." But they do if the work is attractive, if it's work they understand because of some kind of string of relationship to who they are and what they do. So I would rather that the journalists were more honest that way. It's always a subjective relationship, but in general, we have an insular media supporting an insular expression and, in turn, an insular expression responding to an insular media; it's a closed environment that's hard to break into. I think what we desperately have to do is call upon our resources and develop more and more our own critical mass. We have to send out our own to write about our own, and to be highly critical about those things that are needing it and highly supportive of those things that are needing it, and fair and objective otherwise. You know, I'd rather read an article by you of an exhibition in Gallery Fifty in the *East Side Sun* than one in the *L.A. Times;* you will be more honest. So I think it's incumbent upon us in getting that knowledge and in sharing it, but also in giving credit to the fact that there are people who are not Chicanos that know very much about Chicano artwork, and there are people who are Chicanos who don't know shit about Chicano art. It's unfair if you sit there and go, "Well, this Latino, because he is Latino, knows." Not necessarily! "This non-Latino can't possibly understand." Not necessarily! It doesn't matter to Self-Help that much. The real damage is to the individual artist, Harry. What happens is that no matter what, if that artist isn't receiving the attention they deserve, it doesn't help them, or if they receive negative response because of their association with us, it doesn't help them.

It hurts us, but I think the real damage and the real disservice that's being done is being done to the individual artists. We have to be careful not to label and damage our own folks. We can't sit there and be so broad in calling Chicano artists Chicano artists without recognizing the impact of that, but we also have to recognize that the media's going to respond in a certain way, and you have to be true to who you are. There's so

many permutations in terms of how we are perceived, so I think that media, in address-
ing the labeling, needs to really examine its responsibility, because it can truly damage
the careers of those artists. Self-Help doesn't really matter; we're gonna get work, we're
gonna get support depending on what we do in terms of the people we contact.

GAMBOA: *Where do you see Self-Help ten years from now?*

TOMÁS BENITEZ: From corner to corner. I see the need to expand the space physically
and in vision.

GAMBOA: *Would that be razing this place and building that from scratch?*

TOMÁS BENITEZ: That's a possible scenario. There might be another scenario, which is
to acquire space nearby. The great irony is that five years from now, if we do what we're
planning to do, we will have maxed out this space in terms of its most efficient use. If
I'm able to get the gallery from downstairs to upstairs, have a flex space here that's
accommodating readings and galleries and screenings, have a parking structure, and a
sculpture garden, we'll be out of space, so we have to think in terms of bigger space.
Some people consider satellite, some people consider cyberspace; the practicality is
what we know in the nonprofit world is that when you lose your face you lose your
place. So if we raze, it's got to be with a great intention of being in the same location
to rebuild. Ten, twenty years from now, the state of California's going to be over 52
percent Latino. The majority of that population will be in Southern California, the
majority of that will be in L.A., and the majority of that will be in East L.A. We are in
the heart of East L.A. Why move?

Note

1. For further information on Self-Help Graphics, see Bolton Colburn, *Across the Street: Self-
Help Graphics and Chicano Art in Los Angeles,* Exhibition catalogue (Laguna Beach, Calif.:
Laguna Art Museum, 1995); and Shifra M. Goldman, "A Public Voice: Fifteen Years of Chicano
Posters," *Art Journal* 44, no. 1 (Spring 1984): 50–57.

Nithila Peter

11 **Unorthodox Mystics:
Swans That Flock to the Vedanta
Society of Southern California**

A sprawling megalopolis with many centers, Los Angeles is host to a variety of neigh-
borhoods, from Watts in the South to Hollywood in the North, from East Los Ange-
les through downtown across Echo Park and Silverlake to Venice and Pacific Palisades
in the West. Mammoth freeways along the southern extensions of the megalopolis draw
the suburban sprawls of Santa Anna, Anaheim, and Irvine back into the city's purview.
The cultural and community structures commonly associated with the space of these
neighborhoods are largely outgrowths of an industrial, production-centered ethic
focused on the creation and marketing of commodities infused with the peculiar fla-
vors that signify the city's name and subjectivity for the world: ethnic diversity, exper-
imental hybridity, media hype, slick packaging, glossy superficiality, speculative dreams,
boundless ambition, endless profitability, and so on. The city also nurtures Hollywood,
the recording industries and television studios that together shift time, history, and
memory and that in their matrix sustain the ubiquitous power of the American media
through the techno-literate spaces of the globe. Poised strategically between the East-
ern and Western Hemispheres, the city is a frontier space where the limits of human
subjectivity, history, and community are challenged.

 Beyond the space of the city is the abyss of unknown peoples, cultures, and nations.
To these the mainstream cultural networks turn a blind eye, choosing instead to embrace
with a spirit of light-hearted hysteria an eccentric hotchpotch of ideals, not particularly
true to the history of either the Orient or the Occident. The city is a liberal marketplace:
"spacey" possibilities, psychedelic visions, trance-induced "isms," pop-gurus, power
yoga, and herbal infusions—and above all, the chance of being a star. But over the past
century, enclaves with different aspirations have developed a history for themselves in
Los Angeles, though whether they have grown in the kindness of the city or in its indif-
ference, who can tell? These other communities exist, not in blatant opposition to the

city's mainstream cultural institutions, but as separately individuated. Their structures do not in any overt way resist the dominant streams of culture and capital that encompass their milieu; rather, their emphasis has been to keep their precincts clear of practices that might contaminate the forms of subjectivity and historical awareness they espouse. These alternate cultures and communities with modest ambitions and little pomp exist for different reasons: some offer ways of recognizing alternate modes of subjectivity; others teach a relationship to the body, mind, and sense-fields more subtle than that advocated by the forces of consumer culture that otherwise pervade the city.

Headquartered in Hollywood at 1946 Vedanta Place, the Vedanta Center of Southern California is one such alternative enclave, where a radically liberal view of spirituality, of the mystical process in world religions, and of a nonsectarian understanding of divinity within the self may be found. Instruction in these ideals may today be regarded as controversial, particularly since so many places are marked by intense religious division and sectarian violence—where any sense of spiritual integration can be imagined only within the restrictive confines of sectarian, ethnic, and national identity; and where even seeking permission for interpretation or personal verification is prohibited for the average devotee. The Vedanta Center, on the other hand, welcomes the ordinarily curious and still offers the religious person a chance to exercise his or her inquisitiveness in developing a divine perspective on the mystical heart of world religions, renowned saints, classical scriptures, or sacred events. Every kind of scriptural study maybe undertaken at the center, and some instruction in the orientation of study and practice may be obtained so that the Vedantist may discover some of the pathways that lead to a fully conscious, intelligent sensibility of what, if anything, is divine about the human condition. This center is by no means the only place in Los Angeles or Hollywood that offers such an opportunity, but it is one of the oldest and still perhaps the most modest. Despite a century of significant and indeed path-breaking initiatives that found a home here, Angelenos may still access a mode of Asian religious wisdom that cannot be commodified or bought and sold. Here no one discriminates in respect to ethnicity, race, nationality, sect—or even the creed of a particular religion.

Cultural Factors that Give VSSC Form and Context in L.A.

In his seminal account of the history of socioeconomic power relations that both built and ruined Los Angeles, Carey McWilliams perhaps went too far in his essay "Mecca of the Miraculous," where he offered a sweeping critique of the religious cults that thrived in Southern California.[1] The region benevolently supports many loony cultists—about this he is not wrong—but his sensibility could never get close to understanding the more subtly religious frames of mind that also flourish here. His analysis was more sensitive to issues of funding, investment, sociological profiles, and timetables than to less material or visible processes of transformation. He overlooked the epistemological, ontological, or philosophical paradigms that shape the several more authentic spiritual cultures, those that are not invested in mystery, hierarchy, or the occult. Though he rec-

ognized that at the Vedanta Center there could be "cultic implications against the background of present-day Hollywood,"[2] and though he did not explain what separated the Vedantists from the cultists, still he acknowledged that it would be unfair to call the Vedanta Society a cult.

While the star system and the financial interests behind Hollywood would have no problem with any cult status that came with money or fame, Vedanta as a philosophy could not tolerate such values. A liberal-hearted openness that allows for radical inquiry into many diverse religious texts, classical rituals, and ancient traditions are some of its core tenets, which for cultists would be quite alien. Within the temple at Vedanta Place are many objects that are charged with sacred value, but little to nothing is spoken about these objects by the Vedantists; and over the sixty years that the center has existed, these have never had to suffer the ignominy of publicity or hype. They are treated with great delicacy as indicators or suggestions to point the Vedantist in the direction of intensifying his or her personal understanding. Senior monastics at the center may refer to them in advising about questions of spiritual practice, but never are any cultic reassurances given that ritual worship of them could produce any sense of belonging to Vedanta Place. Those who seek such a sense of belonging are inevitably disappointed with the center.

> The very word *Vedanta* means the end of all knowledge. It is composed of two simple Sanskrit words, *Veda* and *anta*. *Veda* is derived from the Sanskrit word *vid*, to know; *Veda* means knowledge. *Anta* means the end. *Vedanta* means the end or goal of all knowledge or wisdom, the finality of all things, the great conclusion of all arguments.[3]

This is the definition given by Swami Trigunatitananda, the Indian monk who commuted back and forth between San Francisco and Los Angeles to mentor many Californian Vedantists between 1902 and 1914 and who built in San Francisco the earliest known Vedanta temple. Vedanta, in short, is not concerned with the authority of dead knowledge or the memory of scriptural lore or the wisdom of religious dogma; instead, it discusses the freedom necessary to discover for oneself the truth of the Vedas, some of the oldest scriptures of the human race. Indian monks brought Vedanta to Southern California in the winter months between 1899 and 1900, and ever since, the organized collective called the Vedanta Center has been a haven for a marginal community of Californian Vedantists. Despite being in exile from the nation of their birth, many of them found a home in Los Angeles; they dropped their individual anchors in the spiritual, communal, and cultural life provided by Vedanta and worked in the surrounding neighborhoods—which for some of them who were artists, musicians, writers, and actors included working in Hollywood.

Yet, since the ideals of Vedanta attempted a definition in a historical sense at the center at 1946 Ivar Avenue, it would be appropriate to evaluate the site's success in embodying its ahistorical ideals in a contemporary lived sense. The center has provided the materials—the books, myths, legends, pictures, events, festivals, lectures, and a temple—required to deepen an understanding of Vedanta in terms that are also articulated by some of the more seasoned monastics who live at Vedanta Place and who serve for a few hours every day as facilitators, archivists, historians, teachers, or priests. The site

also functions in relationship to thirteen other sites across the United States and the seven other Vedanta centers around the world.[4]

The headquarters for all these centers is at Belur Math in Calcutta, and every center is viewed as an autonomous enclave by the administration of this monastery. The international centers do have to conform to a few key core guidelines for the initiation of monastics, the performance of worship, and so forth formulated by the parent monastery in India, but situations repeatedly arise where the centers debate even these core guidelines and request permission for individual autonomy that will permit the initiation of practices in keeping with the cultural milieu specific to their local region. For instance, the Vedantists at Hollywood argued against the segregation of monastics by gender on the grounds that they found it unnecessary to divide monks from nuns when as Vedantists they were committed to a life of sexual continence. And so today the Vedanta Center at Hollywood is a mixed community of monastics, both nuns and monks, who service the temple and the day-to-day running of the Vedanta Center; whereas most sites are serviced either by nuns or by monks in conformity with the traditional segregation still practiced at Belur Math.

In the hedonistic cultural milieu of Los Angeles, particularly the city of Hollywood that aggressively advocates indulgence, the Vedanta Center's ban on sex, narcotics, intoxicants, stimulants, and every other kind of grossly sensate thrill gives it a quaint aura of distinction. Vedanta does not necessarily mean such a ban on indulgences of flesh and spirit; none of the center's rules define the right way to be a Vedantist, and whatever restrictions are found are historically peculiar to the site. In fact, no indulgence would be considered sinful by the Vedantist, and for many it is this aspect of Vedanta that is most attractive: the view it has of the human being, not as a sinner, but rather as "heir to immortal bliss"—the words in which Swami Vivekananda often referred to the promise of human birth—and some of the most beloved disciples of accomplished Vedantist masters have had enormous sensual appetites. Once, after a night of revelry, Christopher Isherwood recognized the peculiar benevolence in the area of sensual life of Swami Prabhavananda, his mentor at the center in Hollywood, who was principally responsible for his lifelong allegiance to the service of Vedanta. Reflecting on this occasion, he wrote, "You aren't shocked by the camping of the publicans and the screaming of the sinners. You didn't condemn—you danced with the drunkards."[5] And Ramakrishna Paramahamsa, the deified saintly figure whose benediction comprises the heart of the Vedanta temple, himself accommodated the sensual excesses of his many devout friends in late-nineteenth-century Bengal; he seized them to his oceanic heart, asking neither repentance nor confession from them, instead releasing them from the snares that kept them from their journey of transformation into higher states of consciousness.

Many erstwhile hedonists have come to Vedanta Place and begun to study seriously there, accommodating for a year or so the vow of abstinence from sex and other sensory intoxicants. Some of these discover no sense of home and leave to resume their search elsewhere; others return to a modified version of their previous lifestyle while remaining committed Vedantists at heart. Only a few make a full commitment, entirely abandoning their previous lifestyle and joining the community as monastics. No mat-

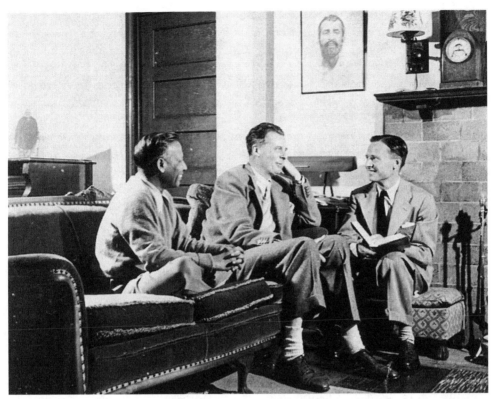

ILLUSTRATION 11.1. Swami Prabhavanda, Aldous Huxley, and Christopher Isher-
wood in the living room of the Vivekananda House at Vedanta Center, in the 1940s.
The picture on the wall above the heads of Huxley and Isherwood is of Ramakrishna
Paramahamsa's face blissfully transformed in samadhi. Photograph courtesy of
Vedanta Archives, Vedanta Society of Southern California.

ter, for the center's success lies in the benevolent spirit of accommodation it breathes
on all sorts of folk, from whom it sifts the core community of Vedantists who support
and are in turn supported by Vedanta Place. Its apartments and cottages are all in great
demand, and there is currently a waiting list more than two years long for Vedantists
who wish to move in. Rented out by the center at reasonable rates with the proceeds
recycled back into maintenance of the site, the accommodations allow residents to live
in close proximity to the temple, which encourages their active participation in the rou-
tine of secular and sacred rituals that give the Vedanta Center its character.

While communal living at the Vedanta Center is meant to be realized in selfless ser-
vice to others, in practice Southern Californian Vedantists are more focused on their
individual growth than on their bonding as a community, and those Vedantists who are
individuated while still being dependent on others for their practice and growth are in
fact few. The center de-emphasizes events where the personal practice of individual
Vedantist are discussed; more general are group discussions of scriptural texts from the

several major religions of the world. Though individual spiritual progress may be discussed in private with the Vedantist's chosen mentor, any public display is perceived to run the risk of encouraging exhibitionistic inclinations (tales of Vedantists dramatically faking states of awakened mystical experiences at Belur Math in the late nineteenth century are partly responsible for the caution with which the revelation of inner processes are allowed at the center). The restraint at times appears extreme, for even the inner lives of monastics that have served the center for decades are unknown to most. For instance, the center has recently released for sale a series of oil paintings by an elderly Californian monk, Swami Tadatmananda. Interpretations of photographs of Vedanta's prime luminaries, the paintings are vivid in otherworldly detail and resonance; but it would be considered improper to discuss the inner state of the monk while he labored over them, and some murmured speculations were all that the archivist Joanne Euler and I were able to elicit.[6] Though the community sustains their practice, Southern Californian Vedantists are notable for the individual path each member has found to intensify his or her spiritual perspective, and the challenges and insights of their inner life are usually shared only with the mentor. In fact, most Vedantists share their individual spiritual process of growth with no one!

Respect for the privacy of a contemplative life achieved within the communal setting of the Vedanta Center is peculiarly Occidental, whereas in the East the cultural vocabulary for intimacy and the sharing of deeply personal experiences that open the heart to codependent communal living are held to be treasures. But the attitudes held by Californian Vedantists may yet be regarded as virtues rather than as limitations, for in matters of the integrity of personal practice, the westernized Vedantist may have much to teach the Asian Vedantist. Initially, the center primarily attracted Caucasian contemplatives with an interest in the mystical heart of the religious impulse, and gradually people with a similar disposition from the other races who had found a home in Los Angeles began to be drawn to the center. Since the immigration laws for South Asians desiring to set up permanent residence in the United States changed in the mid-1960s, the center also began to attract a sizable body of progressive Vedantists from this region whose allegiance to the nonsectarian basis of Vedanta has, over the past three to four decades, generated distinctly Indian flavors at the center.

Though South Asians have no more unique access to Vedanta than Europeans have to knowledge of quantum physics, their cultural backgrounds can give them a greater familiarity with Vedanta's ideals; nevertheless, their freedom to pursue Vedanta with a devoted heart and expansive mind is as seriously hampered as that of any other person born to traditional sectarian families and communities. Los Angeles, though, does grant the South Asian immigrant, as it grants to other foreigners and natives, the twin illusions of freedom and anonymity from both the gaze of tradition and the burden of roots. The fear of social surveillance is distinct in the racial memory of most South Asians, and we inherit the community of our ancestors' constraints over our lifestyle choices. A combination of the influences of caste, language, religion, region, class, and gender provide the hidden foundation on which every relationship with the self and the world is built. For many of us, leaving oppressively sectarian or communal situations for the freedom of Vedanta would be a distant dream at home. But under the Californian sun,

the divisions of categories and subcategories inherited at birth that separate South Asians from one another and from foreigners appear altogether less serious, and newer possibilities of attitude and outlook suffer no more than few murmurs of disapproval from even the sternest of social monitors.

But if the aridity of Los Angeles dries out the differences among the traditional sectarian divisions that immigrant Californians bring with them from the countries of their origin, Los Angeles culture imposes other divisions that separate one Angeleno from another. For instance, the city sustains "star power": hierarchies based on youthfulness, sexiness, and entertainment value as well as on a quasi-religious dedication to the better body fit for the better life. For residents who measure themselves by these criteria, the Vedanta Center's ideals must appear an alien, even dangerous deterrent to their motivation to succeed L.A. style. The Californian interested in Vedanta has to have the disposition of a renunciate, for the center does not itself attempt to persuade a person soaked in worldliness to attempt a life of renunciation. The transformations of consciousness Vedanta Place engages in are small ones: expanding the Vedantist's mind to allow contemplation and perhaps comprehension of the sacred scriptures in a universal sense; teaching the heart to perceive the presence of divinity within oneself; and developing a catholicity of outlook toward the religious paths followed by all people.

Friends of mine working for Hollywood as producers, animators, and performing artists often mention the strange split they experience when, weary after daily competitive battles for survival, they leave their worldly selves outside in the car park behind the Vedanta temple and step inside for an entirely other kind of instruction or meditation. The Vedanta Center does not reconcile this split and has few answers for those visitors for whom the outer and inner life are divided. The center best serves those who are in a deep sense free from such conflicts, those who temperamentally have already reconciled themselves to the futility of worldly gains, social mobility, and the pursuit of pleasure. For such Vedantists, inner meditation and outer action are integrated into their personalities. These unorthodox mystics of Indian, Australian, American, and English origin, along with younger devotees of different races "yet to be hailed by a Sanskrit name," set the tone and ambience at the Vedanta Society of Southern California (VSSC).

A close friend and longtime resident of Los Angeles who is also of South Asian origin first alerted me to the Vedanta Center. For her it had been a homecoming, somewhere she could put her spiritual bags down. Vedanta Place had played a critical role in introducing her to the feminine aspect of divinity as the ideal that would inform her spiritual journey. Prior to her building a quiet but firmly loyal relationship to the center over decades, she had never considered that her spiritual practice would involve contemplating the figure of God as mother. Over the years, her activity-filled days of running a household, nurturing a family, and negotiating an intercontinental life between Los Angeles and the rest of the world have all been blessed, she affirms, by the few hours of meditation she daily steals to share with her divine ideal, both in her shrine room at home and in the center's larger shrine. Studying the influence of Vedanta on the writings of J. D. Salinger for her Ph.D. dissertation at the University of Texas at Austin, she had been little aware that several years later, through the many seasons of her life as a

resident of Los Angeles, she too would consider the anchor of Vedanta indispensable for the peace she enjoyed within.

The English writers Christopher Isherwood and Aldous Huxley had similar encounters with the unusual benevolence of Vedanta, one that demanded from them no confession of sin but accepted the most liberal turns of their hearts and minds. Their works had already created quite an impression within me in high school during the summer afternoons in India spent in the company of their journals, essays, and novels. As an adult, negotiating the disruptive dislocation from India to my life as a student and a householder in Los Angeles, the news that accessible to me twenty minutes from home by car might be found the very same center that had launched both Huxley's and Isherwood's journey into Vedanta came like a predestined coincidence. The borrowed experience of the journey of these two writers had made my knowledge of Vedanta second-hand; I knew no other Vedantist, practically speaking. The few facts from the lives of South Asian saints that we had memorized for our history lessons in school rarely discussed their philosophical inclinations or method of spiritual inquiry. When I ventured a visit to the center, I was propelled not only by a curiosity about the site that had inspired these European writers' literary works and cross-cultural experiences, but also by a nostalgic longing for India's mystery, warmth, emotional sensibility, and spiritual maturity. My memories of India were proving to be of little comfort in Los Angeles. At the Vedanta Center I hoped to "find India," and I fancied that perhaps Vedanta would be powerful enough miraculously to transplant to the Hollywood Hills some of India's dust, heat, complexity—even her chaos. As far as I was concerned, any sign would do!

As you drive north on Highway 101 as it cuts through the chaparral of the Hollywood Hills, the three minarets that adorn the Vedanta chapel's rooftop sparkle modestly in and out of view, an odd cultural juxtaposition against the city's skyline. Even today, sixty odd years since the many celebrated European cultural expatriates first approached the center, it has refused to become more easily accessible. Shyly dipping off Vine Street with little warning, the gully, Vedanta Terrace, that leads up to the center is hard to spot. Whether heading toward or away from the center, its narrowness accommodates no more than one vehicle at a time, almost imitating the hint of danger always imminent on the barely formed roads that lead to places of great spiritual merit in India. In fact, the major thoroughfare Vine Street itself vanishes north of Franklin, reappearing east of its better-known, robust form, considerably toned down in size, as an upwardly inclined pathway branching off Argyle Street. The only other street that also leads to Vedanta Place is Ivar Avenue, but during the construction of the Hollywood freeway in the 1950s, it suffered a fate similar to Vine Street, and today it lies broken up and semi-displaced in two dissimilar pieces, one south and the other north of Franklin. Thus, ironically, all the pathways that lead to the Vedanta Center in Hollywood have been scrambled, and it allows no easy access for the uncertain visitor who thinks of casually hopping in and out.

North of Franklin Avenue the broken-off fragment of Vine Street quietly arches over the frenetically noisy Hollywood freeway, offering a more detached view of the sprawling cityscape and the teeming flow of motorists on Highway 101 below. Poised and still in character, it lifts the California motorist above the discordant commercial rhythms

of the city and almost imperceptibly (for the road signs can be scarcely seen) nudges him or her to the two small by-lanes that circle the Vedanta Center, which were baptized in 1953, the very year the Hollywood freeway was open to the public for the first time, as "Vedanta Terrace" and "Vedanta Place."

The Vedanta Center has never sought to become really popular, though in the 1960s it did attract hundreds of Americans involved in the counterculture, and the enrollment figures quadrupled at the Southern California Vedantist monasteries. But the center never actively sought to appeal to these crowds, nor did it once capitalize on the publicity Eastern mysticism gained from America's embrace of South Asian spiritual imports in the 1960s. So the particular shifts of the urban cityscape that conceal more than reveal the temple's profile work more or less to its advantage, since it has fought shy of publicity from the start. There is no real historical evidence of the center's ever having marketed itself, and all the members involved seem to have arrived by word of mouth, by the compulsions of their own searches—or perhaps, like me, in some misguided fashion, looking for India.

For my limited imagination, Vedanta belonged exclusively to the spiritual culture of South Asia, so at first the entire neighborhood of Vedanta Place was thoroughly but narrowly evaluated for the extent to which it had credibly transplanted the Indian ethos of Vedanta into the heart of Hollywood. My parochial expectations, my nostalgia for my home and the nation of my birth were certainly addressed and accommodated at the center. Within this experiment in a hybrid transplantation of the mystical genius of South Asia onto the rock of Hollywood Hills, I found many refined cultural expressions and, refreshingly devoid of the paraphernalia of commodity culture, it seemed to breathe with the gentle life of an Asian sensibility that for millennia has valued the cultivation of the inner life over the outer. Everything at the center was free: the counsel of senior monks and nuns, discussion sessions on the scriptures, classes in Sanskrit, singing sessions, membership at the Vedanta library, an occasional meal at the monastery when my visit coincided with their lunch or dinner time, and so on. Many Vedantists respectfully indulged my quest to find India at the center, and to the best of their capacity answered my many probing questions about their relationship to South Asia. But many of them, apparently anxious about India as a hotbed of disease, exhaustion, and pollution, confessed to having at best feeble ties with the continent and preferred to be Vedantists in Southern California. For many of them, India was not their country of birth, yet the more senior Vedantists among them displayed a familiarity and devotion to the ideals of South Asian culture and spirituality that rarely failed to move my heart. Even my religious background among the relatively small sect of the Eastern Orthodox Church that occupies a small portion of the southwest coastline of India was greeted by them, to my surprise, with both recognition and knowledge. If Vedanta was willing to be classified as a progressive Hindu center in Los Angeles, I rapidly began to understand that the term *Hindu* was being interpreted in the broadest and most catholic way. Their subtle turns of mind displayed the ease with which any other of the major faiths— Islam, Buddhism, or Christianity—could replace Hinduism.

After months of extensive interaction with the monks, nuns, and lay devotees at the center, after absorbing volumes of books from their intelligently stocked bookstore

(books are selected, categorized and displayed by senior Vedantists), and after participating in several significant annual spiritual events, I began to realize that while birthed by South Asian seers, the universal spirit of Vedanta belongs to the City of Angels as much as it does to every other city in the globe. While the best ideals of India live in Vedanta, the physical, social, and cultural manifestation it adopts is dependent entirely on the milieu and persons among which it has been transplanted.

Yet on the physical plane, there are many uniquely South Asian features to the process of being transformed as a Vedantist. If the aspirant does not have objections, he or she is given a Sanskrit name, then at the time of initiation is given a *mantra* (an incantatory syllable or word) that reveals the divine ideal selected to facilitate his or her spiritual journey as a Vedantist. Many Californian Vedantists go further and adopt an Indian style of dress as well as observe fasts and festivities according to South Asian traditions, tailoring their routines to achieve an ethnic metamorphosis and become racially hybrid-Vedantists. The gay flavor and spirit of cross-cultural experimentation that these rituals give the center have provoked a fair share of controversy. Many western Vedantists have repeatedly complained of being mildly irritated with the "Indianizing" drama all around and have expressed a strong preference for their Vedanta to be served at the center shorn of these frills. Celebrities have often been particularly loath to be hailed by any name other than the one for which they have earned renown. Isherwood mentions himself as one such example; he steered himself clear of any Sanskritization of his routine or personality. Aldous Huxley also never took formal initiation, even though he acknowledged having been profoundly influenced by Vedanta and reveals his debt to it in the ideas that shape his novels, essays, fictional characters, and Hollywood screenplays from the time he set up residence in Southern California. Huxley had chosen to live in Los Angeles in exile from Europe during the war, with some intention of earning a living working for Hollywood. By uncanny coincidence, he found himself in the same period being introduced to the mystical process of Eastern religious traditions via some of South Asia's foremost seers who had also sought residence in California: chief among them being Krishnamurti at Ojai and Swami Prabhavananda at the Vedanta Center. These influences also entered his works, including his marginally popular novel *After Many A Summer Dies The Swan*.[7] Set in Los Angeles, it contains one slightly offbeat character, Mr. Propter, who, though not really a Vedantist, holds an eclectic amalgam of many Oriental religious ideas that dangerously influence an idealistic intern working for a genetics laboratory that lead him to turn to the higher calling of spiritual liberation. Distracted by the compelling power of Propter's ideals but entirely ignorant of the power hierarchies waiting to exploit his life and labor, the innocent intern meets a horrifyingly corrupt death at the hands of his employer (whom he never perceives as evil incarnate, lost as he is in spiritual musings). Through the dystopic plot line and absurd characterizations of his novel, Huxley wrestles with the question of the relevance of a Vedantist approach to the world in the event that it should turn malevolent. Though extreme, his novel issues a just warning to the many swans who flock to VSSC, inspired by Vedanta's ideals, blind to the knowledge of the corrupt forces that move the socioeconomic parameters of our world as well as of their City of Angels.

Christopher Isherwood had left Britain for the United States a few months before the outbreak of the Second World War, having exhausted the inspiration that had sustained his contributions to the international literary avant-garde in the 1920s and 30s. Having lost all faith in left-wing polemics, he was also painfully aware that his homosexuality had no positive place in any of the available political camps. On the eve of the war he had lost his German lover to the Nazis, resulting in a pacifism to which he was no less committed even though he found it politically untenable. Finding himself in such a major crisis, he accepted the invitation of the Huxleys and Gerald Heard, friends in Southern California who, sympathetic to his dilemma, invited him over from New York so that he might become acquainted with the differently defined pacifism of Vedanta. In fact, the Oriental sanctuary at 1946 Vedanta Place turned out to be a near-perfect answer, occasioning his personal renaissance both spiritually and artistically. It offered him an opportunity to translate, provide commentary, and imaginatively retell significant Vedantic myths for international audiences in a mode that added yet another dimension to his career as a man of letters. While the community of literary skeptics among whom he found himself vacillated in their convictions about this Oriental philosophy, Isherwood discovered for the first time in his life the birth of something within himself that he could term as faith or perhaps as devotion for God.

Isherwood subsequently introduced other great sensualists to Vedanta Place, including Henry Miller, Tennessee Williams, and Greta Garbo. All professed to be star struck in their own way by the center's low-key nature, its complete acceptance of all the processes—the "sins"—of living, and its curiously unaffected swami. Once when Isherwood brought Garbo over for lunch, he affectionately describes how she had gushed to the women monastics, "How wonderful it must be to be a nun!" Her tone, he notes with considerable irony, somehow implied "that all her fame was dust and ashes in comparison!"[8]

Seers, artists, and intellectuals who worked in more austere styles, including Krishnamurti, Frank Lloyd Wright, James Whitney, Edmund Teske, the Huxleys, and Somerset Maugham also visited the center now and then to verify some truth or clarify a question pertinent to their highly individualized spiritual paths of study and practice. During this period Somerset Maugham and Isherwood exchanged correspondence about the exact translation of a verse from the *Katha Upanishad* that was to serve as the title for Maugham's new novel, *The Razor's Edge*. For Isherwood, their exchange was fraught with subtle misunderstanding, but their conceptual differences ended on an enlightened note about eleven years after their first exchange of letters around Maugham's novel, when he at last accepted all the corrections Isherwood made to the philosophy informing an essay he had written entitled "The Maharishi." Maugham rewrote the essay and, retitling it "The Saint," published it in 1959 along with four other essays in a book called *Points of View*.

But there were also for Isherwood unpleasant encounters with peers from the international avant-garde who viewed with suspicion his burgeoning faith in "Oriental Mysticism." Some of these were never quite resolved. Isherwood, for instance, records with some drama his meeting with Bertolt Brecht, his actress wife Helene Weigel, and the composer

Hans Eisler: "My position, as a member of a religious sect, was about to be judged according to Marxist law. My judges were polite, but beneath their politeness was contempt. To them 'religion' meant ecclesiastical politics—politics of the capitalist front."[9] His longtime collaborator, the poet W. H. Auden, was even more dismissive: "All this heathen mumbo-jumbo," he opined. "I'm sorry, my dear, but it just won't do."[10]

More than the intrinsic alienness of Vedanta, perhaps history played a role in marginalizing anything Asian or Eastern, for at that time the West appeared to be the seat of material, technological, and political power. Isherwood himself acknowledges that as a famous European intellectual he did enjoy many privileges at the Vedanta Center, even as his mentor, Swami Prabhavananda often indulged in the pride of teaching lessons in spiritual cultivation and humility to what he called "citizens of the enemy race"! India had at that time barely won her independence, and her nonviolent methods of political struggle had gained little publicity, intoxicated as the world still was with the might of Western technology and its successful suppression of the violent menace of Hitler. Other Asian tigers in this period, Japan and China, were also being blasted away, shamed and routed as premodern powers with too many problems and too much disorder to pose as any real threat to Western faith in material and technological progress.

The Sacred Heart of VSSC:
Ideals, Events, Festivals, and Personalities

If Sufism is the great mystical apotheosis of Islam, then Vedanta is the pinnacle of Hindu genius. Vedanta is concerned in nonsectarian ways with the possibility that every human being can follow the path of his or her personal inclinations and find God as true and real within himself or herself, within every other human being, as well as pervasively present in the heart of every variation of phenomenal reality. More than just being nonsectarian, it actively embraces the truth-claims of divinity made by every sect concerned with spirituality; it balks at any weak notion of tolerance that is indifferent to what is different but true about other religious ideas. The century-long history of the Vedanta Center in Southern California may be divided into four phases.

The first phase began with the visit of Swami Vivekananda to the city for more than eight weeks in the period between December 1899 to February 1900, a stay he divided between families of friends in downtown Los Angeles and Pasadena. Swami Vivekananda has been crowned as Vedanta's greatest nineteenth-century luminary. He was discovered, initiated, and literally unleashed on the world by the nineteenth-century Bengali saint Sri Ramakrishna Paramahamsa—a modern day Vishnu-avatar (or incarnation of Vishnu) whose life ended the decline and shame suffered by the spiritual culture of the Indian nation over 800 years of colonization. During Vivekananda's visit to Los Angeles, he addressed small groups of people in salon-like settings and in large crowds that numbered from eight hundred to a thousand persons at a time. He taught more than thirty topics to elucidate the science, psychology, and religious ideas of Vedanta. Though he never formalized his efforts or gathered his audiences into any kind of

ILLUSTRATION 11.2. Celebration at the VSSC monastery in Trabuco Canyon on the day that commemorates both American Independence and Vivekananda's attainment of Mahasamadhi, 4 July 1998. Photograph by Nithila Peter, courtesy of Vedanta Archives, Vedanta Society of Southern California.

organization under the banner of Vedanta, his spontaneous lectures and leonine presence are credited for planting a vigorous and uncompromising view of Vedanta and its ideals for turn-of-the-century Californians.

Vivekananda had a style of oratory that refused clichés and platitudes. With authority and wit, he articulated the history of a four-thousand-year-old philosophical practice, never shying away from inserting his temporality, nationality, and ethnicity into his explanations of the process of realizing the wisdom of the Vedas. In his presence the scriptures no longer seemed dead objects from the past for which he was providing second-hand publicity. The ideas in his public talks were clear and luminous for listeners of every background and history. Marie Louise Burke, one of the key historians of the impact of his presence and message on the West wrote, "He worked with his mind always in a state bordering on profound meditation. His was the power to act with hurricane intensity from a level of intense stillness—a power (and an agony as well) given only to World Teachers and World Movers."[11]

The second phase began when Swami Trigunatitananda, Vivekananda's brother monk and like him a direct disciple of the teacher Ramakrishna Paramahamsa, visited Los

Angeles from San Francisco from 1903 and 1904. His greatest accomplishment was to lay the foundations for Vedanta in Northern California, and he is credited with building in San Francisco one of the city's historic landmarks, the first Vedanta-Hindu temple in the Western Hemisphere. In Los Angeles, he introduced many formal methods for reviving study circles around Vedanta for those influenced by Swami Vivekananda's visit to the city. While he exhorted Southern Californians to sustain their inner ties with Vedanta, he freed them of any obligation to create a center for its study and practice. Swami Trigunatitananda's 12-year tenure in California was tragically terminated by a suicide-bomber who gutted himself, his former teacher, and portions of the sanctum within the Vedanta temple in San Francisco during service on December 28, 1914. The two years prior to Swami Trigunattitananda's arrival in California between 1900 and 1902, a quiet, introspective brother-monk, Swami Turiyananda, nourished Vedantist ideals in a distinctly Asiatic style. Instead of hosting classes like the more extroverted monks did, he introduced long silent retreats of prayer and meditation. His service to California ended in 1902 when Vivekananda called him back to serve Vedanta's parent monastery at Belur Math in Calcutta.

The third phase, which a traditional history might regard as the most influential or legendary, lasted for more than half a century. This was the period of Swami Prabhavananda's tenure in Los Angeles (1923–1975), when he expanded and consolidated the opportunities for the study and practice of Vedanta along the Southern California coast from Los Angeles to San Diego. Here he built temples, monasteries, retreat centers, bookstores, and a small branch of the North American Vedanta Press, structures that have stood unstained by scandal for over sixty years. Charismatic and visionary, Swami Prabhavananda attracted the talent of extraordinary literary and cultural personalities to the study of Vedanta in Los Angeles. Some of these figures collaborated with the swami to produce cultural works of lasting spiritual merit for the Los Angeles center and for the community of modern-day Vedantists worldwide, including 70 percent of the book list that to this day is prescribed for a novitiate seriously wishing to engage with Vedanta.[12]

The society began in this time as a household of Vedantists, when in 1928 Mrs. Carrie Mead Wyckoff handed over her home in Hollywood and her income to Swami Prabhavananda to begin a center for the study and practice of Vedanta. Wyckoff (whose Sanskrit name was Sr. Lalita, a handmaiden of Krishna at Vrindavan, mythological site in North India) was one of California's earliest Vedantists. Her family had hosted Vivekananda when he visited at the turn of the twentieth century. Their first member was a dynamic Englishwoman they called Amiya, who functioned as the "lady of the house." In time, two or three more Vedantists joined the household. Until 1932 Sr. Lalita's modest annuity maintained this small community. Swami Prabhavananda in the meantime advertised and gave a series of lectures about Vedanta in rented halls. Discovering that this method rarely attracted sincere spiritual seekers, he discontinued all advertisements for public lectures and held classes and meetings in the living room of the home at Ivar Avenue that the newly formed community of Vedantists appropriately christened the "Vivekananda home."

ILLUSTRATION 11.3. The "Household of Vedantists" in front of the Hollywood temple: swamis, monks, nuns, and other devotees flank Swami Prabhavananda (seated second from right). Photograph courtesy of Vedanta Archives, Vedanta Society of Southern California.

This small community of Vedantists at 1946 Ivar Avenue in Hollywood survived the Great Depression of the late 1920s and 30s often in miraculous ways. Some well-wisher or friend of the Indian swamis in America would drop by unexpectedly to visit the swami and his community of Vedantists, and during their visits make a donation that uncannily fulfilled the need of the moment. For example, one Sunday, when funds to pay property taxes that were due the following Monday had run out, Mrs. Josephine MacLeod, the great friend and benefactor of Swami Vivekananda[13] arrived at the center from New York and expressed her desire to make a donation; it was the exact amount required to square off accounts with the tax collector!

By 1934 Swami Prabhavananda officially registered the Vedanta Society of Southern California as a nonprofit corporation "to promote harmony between Eastern and Western thought, and recognition of the truth in all the great religions of the world."[14] The first money for the Vedanta temple at Hollywood came from Sr. Lalita's inheritance, from which she had bequeathed tens of thousands of dollars for the building of the

temple. Before it was finished, the money ran out, but a new student began to attend the lectures at the center and offered a donation of $2500, the amount required for completion. Swami Prabhavananda had asked the architect for a building that reflected by inspiration the Taj Mahal, the costly wonder constructed by Mughal emperor Shah Jahan to honor a Sufi idealization of earthly love as the human opportunity to experience the rapture of divine love. But the interior of the Hollywood Vedanta temple more resembles a chapel than a temple or a mosque; it is carpeted and has pews where the congregation can sit during the Sunday lecture-service as they do in churches.

Over the past twenty-five years, the fourth phase of Vedanta's growth in Southern California has been graciously led by the benevolent presence of Swami Swahananda. He has expanded retreat opportunities for Californian Vedantists, adding properties in New York State to the monasteries at Santa Barbara and Trabuco Canyon. Under Swami Swahananda's leadership, the Los Angeles Vedanta Center has also begun to foster communities of Vedantists who are "regular folk," in contrast to the Californian cultural and literary "glitterati" who nurtured the center during Swami Prabhavananda's tenure. Today the center also attracts generations of Indian immigrants intrigued by the liberal spirit of Vedanta. In the heart of Hollywood Hills, free from the sectarian gaze of elders and peers from their communities of birth, they feel at liberty to shed their inhibitions and indulge in their mystical quests.

The leadership of the center faces the challenge of harnessing the creativity of the many diverse ethnicities attracted by Vedanta today. Swami Swahananda currently places special emphasis on giving Western Vedantists leading roles in conducting seminars, events, discussions, and lectures to ensure they are justly regarded and ensured their place at VSSC. Many senior monastics have also been encouraged to take assignments at university campuses and interfaith dialogue seminars within Los Angeles as well as abroad.[15] Today, when a group of Vedantists congregate at the Vedanta Center in Hollywood, the experience is one of being amidst an intimate household where earnest relatives and friends are bustling about being of service, stretching their slender resources to feed the many people who might be stopping by. Though there is a great air of seriousness, a benign informal code of introductions, meetings, and interviews reigns most of the time. Formal protocol is maintained only to the extent necessary to keep the chaos of many tongues and many peoples from disrupting the sacredness of a ritual or special event.

What place do ritual, festivals, myths, deity-worship, and daily *pujas* (rituals performed as prayer) have, then, for a community of Vedantists who celebrate the realization of God and who scorn efforts at a sterile accumulation of knowledge that bears no consequence to the practitioner's lived reality? Why would Vedantists need a temple if its ideals are so unrelated to the dead weight of brick and mortar? The temple serves to evoke several historically specific ideals particular to Vedanta. It helps the community to join all together in one place several times a year. Internally, it may be reconfigured to serve the practice of devotees who display a variety of inclinations and tendencies. Those who select a more contemplative style of realizing Vedanta's ideals use the space to meditate privately, sometimes more than three times a day. Others visit the temple congregational-style, when its interiors take the form of a chapel; each Sunday they listen to the hourly lecture delivered by any one of the resident

swamis on their meditations, on Vedanta and its ideals, and on the relationship between spirituality and the everyday reality of modern-day Southern Californians. Still others attend only intermittent sessions, given in yearly cycles, that emphasize devotional experience in rituals and festivities that last for several hours. On these occasions, the interior of the temple is transformed Hindu-style; cross-legged seating on the ground is permitted, and the chapel's pew-like seats are arranged in open circles along the sides of the walls. At these festivals, the primary activity is staged at the heart of the temple's inner shrine, where the gods and goddesses are awakened to energize the temple's precincts. The swamis continually recite the prescribed texts and prayers in Sanskrit for hours, while the community of Vedantists keep vigil with periods of singing, chanting, quiet prayer, and meditation.

It is not any one monolithic sense of community that is fostered at the Vedanta temple at Hollywood. Every system of practice performed within its precincts creates a distinctive community, different flavors that flourish, honoring Vedanta's supreme ideal. Not any single way, but a myriad of ways are empowered for the human realization of divinity.

In 1939 Swami Prabhavananda boldly initiated at the Hollywood temple a yearly worship of Kali, the feminine aspect of God. Today, more than sixty years since he created this devotional ritual, the festival of Kali flourishes as one of the great annual highlights of 1946 Vedanta Place. Every year an anonymous local Southern Californian sculptor is commissioned to build a statue of her that is slightly over three feet high. For this festival Kali is embodied in her terrifying aspect, and reality is granted its great lustrous night of victory over the demonic forces of delusion and ignorance. Most of the sculptors consider the opportunity of creating her an ideal practice for an intensification of their spiritual imagination and of their experience of God as the Great Mother. With no consideration of public recognition or reward other than that of personal emotional purification, they manifest her idealized form for the Vedanta Center's worship. After they build her in strict accordance with the specifications and dimensions prescribed by the Vedas, they place her within the space of their personal shrine, enjoying the bonus of charging their intimate space of worship with her holiness before handing the Great Goddess over to the temple a few days before the festival so that monastics and householder devotees may have the time to salute and garland her with many carefully selected offerings.

Once completely adorned, the Great Mother takes her place in the heart of the temple in readiness for the terrifying new moon night of her worship. During an eight-hour ritual, life is first given to her sculptural likeness, then withdrawn from it, and finally distributed amongst her "children." Within the week or fortnight annually dedicated to her festival, Kali gives away all the energy embedded within her likeness. Her lifeless form is then lifted off the shrine, carried by ferry into the Pacific Ocean, and cast away. At the time I write this article, there are probably more than sixty statues of the Great Mother Kali asleep on the Pacific Ocean bed that girds the coast of Southern California.

After establishing the yearly worship of Kali at the Hollywood center, Swami Prabhavananda proceeded to introduce the worship of Siva in the early 1940s. Siva-Ratri, the night of Siva, falls on the night of the new moon that marks the end of winter and the coming

ILLUSTRATION 11.4. Swami Tadatmananda's oil painting of Vivekananda with his fifteen fellow Vedantists in late nineteenth-century Bengal confronts the community of Vedantists at the turn of the twenty-first century, gathered to listen to a classical performance of Indian vocal music at the Vedanta Temple at Trabuco Canyon. Photograph by Nithila Peter, courtesy of Vedanta Archives, Vedanta Society of Southern California.

of spring. The night-long worship is divided into four vigils; story-telling sessions and informal exchanges of the myths of Siva from the *Puranas* (the long religious verse narratives) fill the recess time between the hours of worship and incantation. In recent years, the final vigil for Siva concludes with a theatrical performance that transforms the interior spaces of the Hollywood temple into the landscape of Mt. Kailash, Siva's celestial home in the heart of the Himalayas, with the sound of icy winds and howling storms all around. While Siva's greatness is sung by the young Californian Vedantists, a resident monk covered in ashes with matted hair enters the shrine and, with a few classically representative *mudras* (hand-gestures) and *bhavas'* (emotions), brings to life the great ascetic, Siva: Lord of the Himalayas, Lord of Yogis, Lord of Dance and Theater.

Thousands of years of a devotional theater tradition with all its informal Indian flourishes are evoked within the confines of the Hollywood temple. Whereas in India devotional theater is almost always performed outdoors in open spaces or along major thoroughfares, this event is a hybrid manifestation that borrows as much from Western antecedents as Indian ones. And Siva, played by a monastic swami of the Holly-

wood temple, strikes several poses and whirls around the temple interiors with gentle gestures that are more those of Western ballet than the forceful dance routines of Bharata Natyam or Kathakali', the schools of classical Indian dance created and codified for the scriptures by the inspiration of Siva and his consort Parvati.

Amidst these and many other hybrid cultural manifestations, an old and radically liberal practice of spirituality takes root in the City of Angels, drawing to its community a rare flock of Vedantists. Here they display the subtle possibilities of the mind and the limitless spaciousness of the heart to blur boundaries of caste, creed, and nationality and so to create an international community of sensitized human beings, joined by their commitment to no authority other than the individual truth of every form of faith and practice. In a world traumatized by the militancy of Islamic and Hindu, Jewish and Christian religious groups seeking power under the banner of extreme sectarian zeal, the relevance of this phenomenon at Vedanta Place cannot be overestimated.

Notes

1. Carey McWilliams, "Mecca of the Miraculous," in *Fool's Paradise: A Carey McWilliams Reader,* edited by Dean Stewart and Jeannine Gendar (Berkeley, Calif.: Heyday Books, 2001).

2. Ibid., 25.

3. As a philosophical process and spiritual practice, *Vedanta* is often translated as "the perennial way of righteousness." If there is one feature that distinguishes the culture of the Vedantist, it would be this radical inclusiveness of the scriptures from every historical place and people. Vedantists have a paradoxical relationship with time: on the one hand, the spiritual laws of the Sanathana Dharma ("the Perennial Way of Goodness, Righteousness and Benevolence") they study are ahistorical and transcendental in terms of being outside of time, place, and causal agency; on the other hand, they gain validity only if realized in the context of human history. Such a temporal paradox is the very heart of the challenge faced by any organization created to house Vedanta, for in truth it cannot be housed; it belongs to no nameable framework, institution, or organization. In fact, most of the renowned Vedantists—Vivekananda, Nivedita, Pamananda, Krishnamurti, Nisargadatta, and Rammanna Maharishi to name a few—rarely attempted to house Vedanta within the confines of an organizational framework; their lives were the only testimony they sought to leave behind. As Swami Trigunatitananda wrote, "Vedanta is neither a philosophy nor a theology nor a religion, neither a science nor a system of faith nor a theory; neither is it a scripture, nor a code of laws nor a discipline; neither an object nor a subject nor an idea. Neither is it made by man, by sage nor by prophet. It is not made at all; it is ever existent. It is neither of the age, nor of the bygone golden age alone. It is neither of this world alone, nor of the sun or the moon, nor of even heaven alone"; see Marie Louise Burke (Sr. Gargi), "The First Hindu Temple in the Whole Western World," in *Swami Trigunatita: His Life And Work* (San Francisco: Vedanta Society of Northern California; 1997), 176.

4. In the United States they are in Boston, Washington, D.C., New York, Rhode Island, Seattle, Sacramento, San Francisco, San Diego, Santa Barbara, Oregon, St. Louis, Chicago and Michigan; and internationally, in Argentina, Canada, England, France, Japan, Russia, and The Netherlands. Each site is distinct in terms of the extent of properties it holds and the calendar it generates each year for lectures, events, festivals, and seminars as well as in terms of the character of the principal monastics and the lay Vedantists of that region.

5. A diary entry made after a party in Los Angeles that Isherwood described to have been a "massacre." He invited the saint, Ramakrishna Paramahamsa, to share the intoxication and abandon of that night. He further notes, "Ramakrishna had been known to get out of a carriage to dance with drunkards on the street. The sight of their reeling inspired him because it made him think of the way a holy man reels in ecstasy. He danced with his friend G. C. Ghosh, a famous dramatist and actor, when Ghosh was drunk, Ramakrishna encouraged him to go on drinking. Ghosh took advantage of the saint's permissiveness and visited him at all hours of the night, sometimes on his way home from a whorehouse." For Isherwood's imagination, Ghosh was his patron saint. But he never managed to commit himself to his spiritual teacher—Prabhavananda at the Vedanta Center, Hollywood, like Ghosh had done with Ramakrishna—"Ghosh dared to reveal himself shamelessly to Ramakrishna, thereby making a sacrifice of his own self-esteem and self-will and submitting totally to Ramakrishna's guidance. That was his greatness. I am sorry now, that, throughout my long relationship with Swami P. I never once came into his presence drunk. Something wonderful might have happened" (Christopher Isherwood, *My Guru and His Disciple* (New York: Farrar, Straus and Giroux, 1980), 196–97.

6. Joanne Euler manages the Vedanta Archives full-time. While selecting historical photographs together at the archives for the purpose of this essay, our discussion meandered into issues like the lack of discussion allowed about the interior life of Vedantists at VSSC.

7. Aldous Huxley, *After Many a Summer Dies the Swan* (New York and London: Harper & Brothers, 1939).

8. Isherwood, *My Guru,* 132.

9. Ibid., 137.

10. Ibid., 207.

11. Marie Louise Burke, *Swami Vivekananda in the West, New Discoveries* (Mayavati, India: Advaita Ashram, 1987), 304.

12. Vedanta Society of Southern California, <http://www.vedanta.org>, 8 March 2002. Translations mentioned in the reading list formulated for the Vedantist at the Web site that Swami Prabhavananda co-authored with Isherwood include *The Wisdom of God* (Srimad Bhagavatam); *Shankara's Crest-Jewel of Discrimination, The Song of God: Bhagavad-Gita* (this translation hit the Times bestseller list for over six months in 1956); and *How to Know God: The Yoga Aphorisms of Patanjali.* With Frederick Manchester, Swami Prabhavananda co-authored *The Upanishads* and *The Spiritual Heritage of India.* He also independently authored several other books for the Vedanta Press at Hollywood; the more well known among them are *The Eternal Companion: Brahmananda His Life and Teachings, The Sermon on the Mount According to Vedanta, Religion in Practice, Yoga and Mysticism,* and *Vedic Religion and Philosophy.*

13. Mrs. MacLeod had accompanied Swami Vivekananda back to India in 1897 after his triumphant four-year-long trip to the West. She, along with Ole Bull and Margaret Noble, were the first female Occidental-Vedantists. Margaret Noble, also known as Sr. Nivedita, the Irish friend and foremost disciple of Vivekananda, was cherished in the North and East of India for her efforts in reviving educational institutions for women and girls that were guided by ideals that did not alienate Asians from their cultural and spiritual legacy. The visionary impetus she gave many of India's radical nationalists who sought freedom from the British Empire has yet to be appropriately chronicled, though oral tales among those familiar with her legacy abound.

14. Pravrajika Varadaprana, *Vedanta in Southern California: A Brief History* (Santa Barbara, Calif.: Vedanta Society of Southern California: 1993), 3.

15. For instance, the VSSC's assistant minister-swami, Swami Sarvadevananda, currently serves as the representative for South Asian Religions at the University of Southern California.

David E. James

12 Popular Cinemas in Los Angeles: The Case of Visual Communications

Though Hollywood was the culturally dominant force in Los Angeles, recurrently through-out the twentieth century people in the city sought alternatives to the form and func-tions of the capitalist cinema and found other purposes for film, using it to create alter-native cinemas and through them to nourish other forms of community.

Before World War I, the resources needed to begin a filmmaking company were mod-est. Though the larger studios formed the Motion Picture Patents Company (MPPC), popularly known as "the Trust," and otherwise attempted to monopolize production, smaller studios were able to make and distribute films, some of them connected to spe-cific interest groups. During the Progressive Era, for example, Socialist culture was suf-ficiently powerful in Los Angeles to oppose the Trust by making a counter-cinema of Socialist-themed films and also of a Socialist-controlled production system and screen-ing facilities. Two years after the failure of Job Harriman's campaign for mayor, labor in Los Angeles had recovered enough to make a film, *From Dusk to Dawn* (1913), that fancifully reversed the election, portraying, not the catastrophe that had actually hap-pened, but a Socialist triumph in which the union leader becomes governor of Califor-nia on a working-class ticket. Made by Frank E. Wolfe, a union organizer and jour-nalist, *From Dusk to Dawn* featured Harriman, Clarence Darrow, and other Socialist leaders playing themselves, with the scenes of strikes, mass meetings, and demonstra-tions being shot at the May Day Socialist picnic and the Labor Day parade, and peo-pled by as many as ten thousand of the local workers who had initially participated in them. Though produced in Hollywood, much of the film's human and financial resources were drawn from Llano del Rio, a workers' soviet ninety miles away in the Antelope Valley that Harriman had left the city to found.[1]

Like the community of Llano itself, *From Dusk to Dawn* exists now more as a myth than a reality, and achievements like it—a genuinely popular cinema, with films made by, for, and about the people themselves—became impossible in the years after World War I. The Red Scare that followed the success of the Soviet Revolution on the one hand,

and on the other the consolidation and massive expansion of the industry itself and its assimilation by East Coast financial establishments, ensured that Hollywood would continue to denigrate working-class community and self-consciousness. Nothing comparable to the Socialist cinema of the early teens has existed since in Los Angeles, where, as in the United States generally, popular cinemas have generally been rather the preserve of much smaller local communities.

The possibilities of these essentially amateur cinemas were greatly enlarged in the early 1920s with the introduction of 16mm film, which became popular as a consumer item, almost exclusively for the more privileged social sectors.[2] But as well as making home movies, amateur filmmakers in the 1930s produced documentaries and domestic reproductions of Hollywood-style narratives. Amateur filmmaking became a serious, disciplined, and skilled avocation for large numbers of people, with a substantial institutional and social infrastructure. By the late 1930s there were approximately two hundred thousand amateur filmmakers joined in 250 clubs in the United States. Most were amalgamated in the Amateur Cinema League (ACL), and its monthly journal, *Movie Makers,* sustained the national network. Following the Los Angeles Amateur Cine Club (LACC), founded in 1931, more than a dozen of these clubs flourished in the Los Angeles area in the 1930s, including the North Hollywood Cine Club, the South Bay Camera Club in El Segundo, the La Casa Movie Makers of Alhambra, and the Sunkist Movie Makers of the San Gabriel Valley. In fact, as late as 1953 a new club was formed, the Crenshaw Amateur Movie Makers. Typically the monthly meetings of these clubs combined dinner and socializing with talks on various technical matters and the exchange of expertise and equipment. But the main events were screenings of films, those exchanged with other clubs and especially the members' own. Membership varied from club to club, but with LACC events regularly attracting between 100 and 130 members and guests, it is not unreasonable to assume that in the 1930s, for perhaps several thousand people in the region, amateur filmmaking provided a privileged combination of aesthetic and social activity.

In the early 1930s amateur filmmakers from quite contrasting social positions also grouped together in the Workers' Film and Photo League (WFPL) to make agitprop documentaries to assist in the popular struggles of the Depression era. These were inspired by the Soviet avant-garde culture of the 1920s; and in their various manifestoes and essays in journals like *Experimental Cinema* and *Film Front,* the WFPL celebrated the non-narrative editing of fragments of documentary truth as a vanguard film practice. Aesthetic and political radicalism, they believed, should reinforce each other to create an antidote to "the subtle propaganda of Wall Street dished out by its Hollywood poison factories."[3]

Beginning in New York, the WFPL eventually formed branches in most major cities, but none was more active than the Los Angeles group. As well as participating in all forms of working-class organization, they made more than a dozen short films about the Los Angeles unemployed and then about the labor actions of the early New Deal. In 1933–34, the years of great working-class offensives across the nation, they expanded their purview to the maritime workers and peace marches in San Pedro and the agri-

cultural workers in the San Gabriel, San Joaquin, and Imperial Valleys. The films they made linked these movements to the international struggle against fascist aggression in the Spanish civil war and the Japanese invasion of China. L.A. WFPL members took their works out to strike zones in other cities and in the agricultural valleys to encourage the strikers and to facilitate organization. In early 1934, for example, three of the Los Angeles films were taken on a tour through the Central Valley, where they were seen by 4,400 striking agricultural workers. And a screening in a San Diego courtroom of a Los Angeles WFPL newsreel about a police riot during a demonstration there secured the release of workers who had been charged in the incident.[4] As late as 1937, when the WFPL had ceased activity elsewhere, the Los Angeles office was still announcing new films and still working to promote self-consciousness and solidarity among working people worldwide. In a city whose working class has been catastrophically divided by ethnic difference, the interventions they mobilized, many of which were led and sustained by women, remain an object lesson in egalitarian community organization.

The progressive cultural movements of the Popular Front period were destroyed after the Second World War. Nowhere was the assault on cultural populism fiercer than in Los Angeles, where the studios almost immediately capitulated to the House on Un-American Activities Committee's persecution of the Communists in the film industry and allowed the blacklist to devastate the liberal community. As a result, the great explosion of populist experimental filmmaking in the United States in the late 1950s, known first as New American Cinema and later as Underground film, flourished most in San Francisco, New York, and other cities, even though until the late 1940s Los Angeles had been central to alternative film culture.

The overwhelming power of the industry and the effects of the blacklist ensured that in L.A. this movement would result rather in innovations in film style and modes of production on the edge of Hollywood rather than in independent cinemas opposed to it. But by the early 1970s, many attempts to create alternative communities based on experimental film had been mobilized. These were mostly screening societies, and for a few years they flourished, usually supported by state and federal grants. They included the Pasadena Filmforum, Encounter Cinema, and Oasis Cinema, as well as many other smaller or short-lived initiatives. Dedicated to giving public currency to the rapid filmic and social innovations of the time, these micro-communities of approximately fifty regular attendees and perhaps three times that number of people peripherally associated were also linked to similar communities in other American cities and, indeed, all over the world.

Though organized as screening societies, these groups—especially Oasis Cinema—were primarily sustained by filmmakers and served as the nurturing ground for alternative filmmaking in L.A. One of the groups that emphasized production, the Los Angeles Newsreel, was a direct descendent of the WPFL, and though the immediate object of its own filmmaking efforts was the Los Angeles branch of the Black Panther Party, it attempted to use cinema to build an international working-class alliance, first to end the U.S. invasion of Viet Nam, and then more generally to work toward Socialist political organization. But the others, reflecting the difference between Old and New Left

politics, were organized, not around the working class and so not in opposition to cap-
italism and capitalist culture per se, but mostly by members of ethnic and sexual iden-
tity groups. This development was of course an international one, and in at least one
case—that of feminists—revolutionized the way we think about cinema. Radial femi-
nist cinema began in Los Angeles, and the city also saw important gay and lesbian com-
munities form around film; but the ethnic cinemas were even more successful, and indeed,
the most important in the nation.

Their chief crucible was the University of California at Los Angeles, and in particu-
lar the Ethno-Communications Program founded in 1968 in the wake of the 1965
Watts rebellion and the civil rights movements and in immediate response to student
complaints about the racial exclusivity of the film school itself. Its aesthetics initially
modeled on the Third World cinemas of the time, this program provided a matrix from
which several minority cinemas grew. In general, the contrary pulls between commu-
nity and industry that defined previous avant-garde organizations were lived in these
chronologically, with in general an initial period of community-based agitational doc-
umentary and/or experimental practices modulating into independent feature produc-
tion and thence into Hollywood itself. But the specific conditions of Chicanos and
African and Asian Americans in Los Angeles—and especially their different histories of
relation to cinema—were so various that the three cinemas coalesced in different ways,
at least through the mid-1980s. Of them, the Asian American initiative was most
strongly oriented toward community documentation and organization, and its center
was a community cinema called Visual Communications.

Visual Communications

Parallel to the Black and Chicano civil rights movements, the concept of Asian Amer-
ican gained currency in the late 1960s among activists aiming to give public voice to
the communities of marginalized and disenfranchised people of Asian ancestry. To allow
them to assert their own self-expressivity, create narratives of their own history, and
participate in the production of their own self-consciousness and public identity, Asian
American filmmaking, like the other independent cinemas, emerged within what were
fundamentally community-based projects. But Asian American cinema was not pro-
duced autonomously in the communities in question so much as engendered in inter-
action with surrounding social and cultural institutions, especially the established media
industries, whose non- or mis-representation of Asian Americans were an especially cru-
cial point of reference. However, the history of the concept of Asian American and of
the cinemas marshaled under its aegis differs from the parallel itineraries of other eth-
nic groups in consequence of the enormous changes in Asian immigration into the
United States during the period when the cultural identity was being most actively
forged through cinema and other cultural activities.

In the history of the social realities implied by the term *Asian American,* two main
phases may usefully be distinguished. Initially the concept invoked people of Chinese,

Japanese, and Filipino ancestry who had lived in the United States for several genera-
tions (as many as seven in the case of Chinese), almost entirely as exploited agricul-
tural, railroad, or other manual workers, and whose recent engagement with the mother
nation had been, at most, distended or sporadic.[5] In the early 1970s, proactive mem-
bers of the most recent generations undertook to mobilize a sense of solidarity within
these groups and to recover the history of their earlier participation in the nation. These
projects entailed a confrontation with both past and present social marginalization, with
Japanese Americans' internment in the World War II concentration camps being an espe-
cially crucial and emblematic figure for the often traumatic history of becoming Amer-
ican that they shared. Though the young people who undertook these projects were
almost all of working-class backgrounds, the racism that had framed the histories of
their communities, combined with the absence of any widespread progressive politics
oriented specifically to the working class, resulted in their mobilizing themselves essen-
tially in ethnic, rather than class, terms. In this first period, the concept of Asian Amer-
ican was relatively unproblematic. Differences in national origin were subsumed within
a Pan-Asian commonality and the shared struggle against the hegemonic power struc-
ture that was supposed to have indiscriminately exploited people of all Asian ances-
tries. This deliberately inclusive Asian American identity sustained a multicultural per-
spective that emphasized commonality with the adjacent Black and Chicano community
initiatives and their civil rights struggles. Though specific filmmaking projects in this
first phase were undertaken in collaboration with various state and federal apparatuses,
they were nevertheless understood as fundamentally autonomous, community-oriented,
and community-dependent—and, of course, as categorically distinct from mainstream
commodity film production, from Hollywood, which was correspondingly understood
as entirely imbricated in the overall systems of social repression.

Around the mid-1980s, different conditions came into dominance: global restructuring
of capital and changes in the U.S. immigration laws produced new population move-
ments throughout the Pacific region that transformed the commonalty designated as
Asian American and hence any cultural activity associated with it. The new immigra-
tion brought an influx of people from Asian and Pacific countries that had previously
been hardly represented, some of them very wealthy and others extremely poor, but all
without the longstanding history of integration in the U.S. economy or immersion in
U.S. culture. These new Asian Americans had a more direct and yet more flexible rela-
tionship to the mother country; and, especially for the wealthy among them, their
unprecedented freedom in movement back and forth between Asia and the United
States gave them newly complex territorial identifications. As new ethnic identities were
asserted, and then within these, gender and also degrees of class difference, the com-
monality of Asian Americans was destabilized and eventually became fragmented and
dispersed. The transformations in this social and cultural history were reciprocated in
Asian American cinema. Beginning from attempts to create autonomous community cin-
emas in the 1970s and 1980s, Asian American culture subsequently developed many
forms of cooperation and integration with the dominant media industries outside the
scope of the initial drives to sheer alterity and activism.

Though some people of Asian ethnicity had been active in Los Angeles as filmmakers earlier, the roots of an assertively specific Asian American film culture were planted at UCLA in the late 1960s.[6] Asians, especially Japanese Americans, were recruited from the university's newly formed Asian American Studies programs into the Ethno-Communications Program. Their early student films were all low-budget documentaries that reflected the initial shaping of a multiethnic coalition on the model of black civil rights militancy and black culture generally. *Yellow Brotherhood* (Brian Madea, 1970), for example, was a study of Japanese American motorcycle gangs that referenced the internment of Japanese Americans in World War II but also Martin Luther King, soul music, white rock and roll music, and Hollywood motorcycle movies; and *Homecoming Game* (Danny Kwan, 1970) documented a communal living, mutual support group, Asian American Hardcore, who were trying to deal with the members' drug abuse, attempted suicide, and overall loss of self-esteem.[7]

While they were beginning the UCLA program, four of the students—Duane Kubo, Robert Nakamura, Alan Ohashi, and Eddie Wong—also assembled, in Nakamura's living room, a collection of photographs about the internment called "The Camp Cubes Photo Display." The Japanese American Citizens League (JACL), a local community group, encouraged them to establish a committee to produce further educational materials of this kind and to build an archive of still photographs of Asians in America. To do so, the film students incorporated in 1970 under the umbrella of the Southern California Asian American Studies Central, a nonprofit organization working to establish Asian American educational programs. Taking the name of Visual Communications (VC), they opened an office at 3222 West Jefferson Boulevard, with the intent of depicting the history and culture of Asian and Pacific people in America and of training media-makers from the respective communities.[8] With their initials clearly broadcasting their political sympathies, VC was the first of the several community-based Asian American media organizations that emerged in the 1970s.[9] Their initial project was to turn the Camp Cubes display into a traveling photography exhibit, now titled "America's Concentration Camps." And in 1971, Nakamura and Wong completed their UCLA Super-8 film projects, respectively *Manzanar* and *Wong Sinsaang*.

One of Japanese Americans' first attempts to come to terms with the concentration camps, *Manzanar* documents Nakamura's return to the Owens Valley site just below Mount Whitney where, as a 6-year-old twenty-five years earlier, he had been had been interned with his family. Apart from the entrance of the long-abandoned camp, the strands of rusted barbed-wire marking its perimeter, and a few shards of pottery and other kitchen equipment, little remained to testify to the internment. Accompanied by *shakuhachi* and other classical Japanese music, long tracking shots through the landscape where the barracks once stood are momentarily arrested by the fragments that remain from the people who lived here—a well pump, for instance, or a remnant of concrete inscribed with the date and a Japanese name. Though the camera seeks evidence of the camp, its attention is rather caught by the chaparral that has reclaimed the site and by the snow-topped Sierra Nevada that rises behind it. To tell the historical story that this gorgeous but mute panorama cannot tell, the landscape shots are inter-

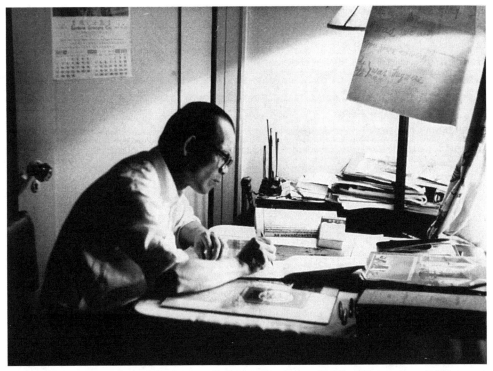

ILLUSTRATION 12.1. Production still, *Wong Sinsaang* (Eddie Wong, 1971). Photograph courtesy of Visual Communications, Los Angeles, Calif.

cut with newspaper headlines and black-and-white photographs from the period—abandoned businesses, the relocation process, and the camp itself as it once was—while in his voice-over, Nakamura recounts his recollections of the camp's atmosphere and anecdotes about his childhood confusion there. But as with the Nazi extermination camps in Resnais' *Night and Fog,* the atrocities cannot be retrieved from the site's present appearance. Instead of representing the physical dislocation or its psychic scars, the burnished leaves of the trees and shrubs shimmering in the autumn light, photographed with a visual richness and subtlety reminiscent of Stan Brakhage's photography of his Colorado mountain home, summon an elegiac wistfulness to hallow the historical memory that the Japanese American community shares but had so long repressed.

Wong Sinsaang is a study of the filmmaker's father, a laundryman (Illustration 12.1). He is seen in his small shop in Hollywood, repairing and operating the washing machines, ironing, keeping his accounts, and interacting with his white customers. Though there is no sync sound, a snatch of a particularly condescending remark by one of the customers and his father's subservient response to it is looped over visuals of the exchanges, leading into the filmmaker's own voice-over describing his alienation from his father and his inability to know him except via the stereotypes of the docile Chinese worker. Invoking

Malcolm X's analysis of the way minority people internalize colonialist social relations, he admits that he has seen his father only through the eyes of his oppressors. To confront his contempt for his "daily humiliation from obnoxious white customers" and to break through the degrading stereotype, he photographs the elder Wong studying Chinese paintings, doing his own calligraphy, and practicing martial arts—all evidence of his rich interior life and the cultural heritage that have enabled him to endure his work and bring up his family. The immigration history that links together the two parts of the elder Wong's life and that explains their biographical bifurcation is reconstructed through scrutiny of the traces of his cultural dislocation: the immigration papers designating his birthplace, and photographs of him as a young man in the United States. Finally, the film returns to the shop, but this time images of Wong Sinsaang's daily work are intercut with shots of his cultural pastimes. As well as envisioning the healing of his father's own estrangement, the filmmaker attempts to heal the rift that separates the two generations, and the audio concludes with a conversation between them. Though when the son asks his father what he thinks about his twenty-one years as a laundryman, he can only reply, "Can't think about it, just make a living," nevertheless the film has enabled the son to confront the stereotype and reconnect with his own cultural heritage, bridging the different forms of alienation that previously isolated him.

Both *Manzanar* and *Wong Sinsaang* are student films, technically and formally rudimentary, yet immensely important. In them and one or two similar works, Asian Americans began to create a cinema of and for themselves, to claim their own history, and to contest the racist caricatures of capitalist culture. The independent Asian American cinema they inaugurated resolutely oriented itself toward family history and the local and immediately known community. VC's films were almost all documentaries, cheaply made and screened in schools and other community centers, and the filmmakers understood their function in terms of their community origin and relevance. Looking back several years later, Nakamura recalled how this orientation—rather than, for example, an attempt to make feature films—had coalesced: "After some thought, we realized that what community-based filmmakers are blessed with is the passion and persistence of our communities. Without a doubt, our stories and our people are our greatest strength."[10]

Reflecting the filmmakers' own sense of their project, Nakamura's observation reflects the social aspirations that engendered the Asian American community cinema, but it overlooks supplementary enabling conditions. However strong an essentially working-class community's drive for self-expression in cinema may be, the medium's expense and its social and material complexity necessitate the assistance of institutions on its edges or outside it that have some connection with more established filmmaking. In VC's case, the agency that allowed the new cinema its realization was the state itself, the UCLA program that sustained its initial members' projects and with which Nakamura has had a career-long engagement.[11] Kindred public educational institutions were instrumental in VC's subsequent development. Once established, its nonprofit status allowed it to seek public funding under the Comprehensive Employment and Training Act (CETA), which provided for early staffing and also support from private foundations, the National Endowment for the Arts, and later the California Arts Council (CAC), which

allowed the organization to grow into a film distribution and eventually an ongoing production collective.

The community print projects were continued, but most effort was put into films. Between 1972 and 1977 ten films were completed, several of them funded by the U.S. Office of Education under the Emergency School Aid Act (ESAA). These included *I Told You So* (Alan Kondo, 1974), a documentary about Japanese American poet Lawson Fusao Inada; *Pieces of a Dream* (Eddie Wong, 1974), a documentary about Filipino workers in the Sacramento Delta; *Cruisin' J-Town* (Duane Kubo, 1974), a documentary about the Los Angeles jazz-fusion band, Hiroshima; and *Watariodori: Birds of Passage* (Robert Nakamura, 1976), a history of the *Issei*, first-generation Japanese Americans.[12]

Pieces of a Dream is one of the most ambitious and accomplished of those early films. Shot in 16mm in color with sync sound, it begins with a visit to Angel Island and the ruins of the buildings through which immigrants from Asia were initially processed and then explores the social and economic history of the Sacramento River Delta, which they farmed over the last century. The earliest period is documented by still photos of Chinese migrant workers in conditions of virtual slavery in the nineteenth century, then by newspaper illustrations of the race riots that culminated in the 1882 Exclusion Act to halt new immigrants. The subsequent history of the communities that endured is sketched, first the Chinese, then the Japanese, and in the 1930s, the Filipinos (who were not covered by the Exclusion Acts until much later than other Asians). Prevented by restrictive land laws from owning their farms, Asians worked as tenant farmers, though later some of the Japanese were able to own farms and in turn began to exploit the newer Filipino immigrants. Bringing the story of these workers to the present, the film shows small farmers dispossessed by agribusiness and besieged by economic uncertainty. Many of them now are elderly bachelors who had been prevented by anti-miscegenation laws from beginning families; others have been deserted by their young people who have moved to the city. Either way, the dwindling communities are struggling to survive the area's transformation by the tourist industry.

In its recovery of a neglected social history of Asian American workers, this and similar early VC films corresponded to the specific idea of Asian American identity that was being most powerfully formulated in cognate attempts to recover the history of Asian American literature, notably in the first collection of Asian American writing edited by Asian Americans, the ground-breaking, *Aiiieeeee!: An Anthology of Asian American Writers*.[13] *Aiiieeeee!*'s editors argued that Chinese, Filipino, and Japanese American identities were structurally parallel to each other and that all were distinct from either Asian or (white) American forms—and especially from any model of a bifurcated identity split between the old and the new homelands:

> This myth of being either/or and the equally goofy concept of the dual personality haunted our lobes while our rejection by both Asia and white America proved we were neither one nor the other. Nor were we half and half or more one than the other. Neither Asian culture nor American culture was equipped to define us except in the most superficial terms. However, American culture, equipped to deny us the legitimacy of our uniqueness as American minorities, did so.[14]

VC's equivalent role in this wider cultural initiative is explicit in *I Told You So,* the documentary about the Japanese American poet, Inada. Born in Fresno in 1938 and interned during the war, Inada was the author of *Before the War: Poems As They Happened* (1971), the first volume of poetry written by an Asian American to be published by a mainstream publisher, and was himself one of the four editors of *Aiiieeeee!.*

A *Sansei* (third-generation Japanese) with no immediate knowledge of Japan or its language, Inada grew up in Fresno's polyglot communities, living among its German, Armenian, and Basque neighborhoods and in especially integral closeness with the Chicanos and African Americans who supplied the cultural vernacular for all of them. In the film, as the camera pans over Fresno's multiethnic street life, he recalls his high-school Chicano friends and the *pachuko* dances he attended with them as well as his love for black music. As he came to maturity in this environment, the crucial event that crystallized his identity as a Japanese American was his discovery of *No-No Boy,* John Okada's novel about a Japanese American who refused the loyalty oath and so was imprisoned during the war.[15] *No-No Boy* disappeared after its 1957 publication until it was rediscovered by Inada and the *Aiiieeeee!* group in 1970 and was promoted by them as a foundational text for Asian American literature.

The final sequences of *I Told You So* begin during an *Aiiieeeee!* editorial meeting: Inada recounts to his fellow editors a trip he made with his wife and children to *No-No Boy*'s locations in Seattle, where he bought ethnic groceries; and he reads a poem dedicated to Okada that he wrote during his return drive, a poem in which he asserts that the novel and the groceries are equally supplies that "must reach the people." A subsequent excursion takes him to the Tule Lake camp where the No-No Boy was interned. As in *Manzanar,* shots of the present deserted state of the camp are intercut with stills of the relocation proceedings (some of them, in fact, recurring from *Manzanar*) and, as his son plays among a group of ruined buildings, the film ends with Inada reading another poem.

VC's documentation of the entrenched Asian American communities was continued in the work of a new member, Linda Mabalot, a Filipina American activist from the Sacramento River Delta who had been trained in filmmaking by VC and who became a core staff member and eventually executive director. Mabalot's film *Manong* (1978), a documentary about the Filipino bachelor communities of prewar agricultural workers, was composed of interviews with the old men and illustrated by photographs and drawings of their experiences in America.

Meanwhile, the Japanese and Chinese American staffers turned their attention to projects concerning more recent immigrants. In 1977, an ESAA grant provided them with funds for a series of videos made in cooperation with Samoan community leaders, including *Omai Fa'atasi: Samoa Mo Samoa* (Takashi Fuji, 1979) and *Vaitafe: Running Water* (Foe Alo Jr. and Takashi Fujii, 1981), both documentaries about youth in the Southern California Samoan communities.

By the late 1970s, then, VC had successfully sponsored a substantial corpus of both community documentaries and historical recovery projects, and in so doing it had firmly established itself as an ongoing media-producing collective sustained by a cadre of staff

members committed to social change. Most of the staffers were grant-supported, primarily through CETA, who alternated periods of paid and unpaid work, and some were concurrently enrolled in local colleges. Patterned on UCLA student assignments, their filmmaking projects were not inaugurated or determined by the group as a whole, but by individual members who formulated and directed their own films and raised the necessary funds; but other members were recruited as crew and in editing, so that all projects eventually involved the participation of several people. Since work was inevitably correlated with funding cycles, periods of intense activity alternated with grant writing or periods of waiting for grants to be awarded. Despite individual control over projects, the collective had weekly staff meetings, some lasting more than eight hours. In these meetings, tensions between activist and more aestheticist factions emerged (as indeed they have in virtually all radical cultural organizations of this kind, since and including the WFPL).[16]

During the decade, the early activist documentary emphasis inspired by Latin American theories of "imperfect" guerilla cinema that privileged rough-edged immediacy was gradually supplanted as the filmmakers' own growing formal sophistication coincided with an emerging desire to reach wider constituencies. Up to this point, VC had worked entirely without professional actors (for even when Screen Actors' Guild members would agree to work for minimum wages, they met resistance from industry agents); but at the end of the decade, the community objectives subtending the documentary projects were reconstructed in the conventions of fictional narrative in *Hito Hata: Raise the Banner* (1980), which shifted VC's production and distribution to an unprecedentedly ambitious scale. Directed by Kubo and Nakamura, it reworked Nakamura's short, *Watariodori*, a dramatization of the experiences of Japanese immigrants through the century. It was the first full-length feature made by and about Asian Americans.

Set in present-day Little Tokyo among a group of elderly *Issei* (first-generation immigrants) who came to the United States as laborers, *Hito Hata* interweaves incidents illustrating the nearly three-quarters of a century of Japanese American history with the *Issei*'s present-day experiences. Intending only to earn enough to return and raise their family's banner in the home villages, the first immigrants instead stayed, and with women unavailable, have come to their old age in a bachelor hotel, where they are sustained by the community around them. But Little Tokyo is being transformed by urban reconstruction, and when the men drink beer or listen to ballgames on the radio, they are surrounded by the sounds of jackhammers and demolition. Corporate managers—some them also Japanese Americans—are working hand-in-hand with a venal community redevelopment agency to bribe and pressure the old men to move so their hotel can be knocked down to make room for a shopping center.[17] The narrative focuses on one of them, Oda (played by veteran Japanese American actor, Mako), a man of stalwart community spirit who vigorously and optimistically resists the corporate incursion. Incidents in this contemporary narrative prompt a series of flashbacks for Oda—his arrival in Little Tokyo during Nisei Week celebrations in 1935 (where he gets a glimpse of Charlie Chaplin), the community's enforced diaspora in the wartime internment, his time as a laborer on the Pacific Railroad in the 1920s and later in the fields

ILLUSTRATION 12.2. Frame enlargement, *Hito Hata: Raise the Banner* (Duane Kubo and Robert Nakamura, 1980): Oda looks out over Little Tokyo. Photograph courtesy of Visual Communications, Los Angeles, Calif.

of the Central Valley—so that the film as a whole is a mosaic of past and present, a weave of the obstacles and the achievements across which through the century Japanese immigrants have become Japanese Americans. It emphasizes the quotidian texture of community social life—especially relations across generations in the local grocery store, the hotel lobby, and during Nisei Week—while the larger city that surrounds it is alien, and its incursions present the community's major threat.

The main narrative comes to a crisis with the murder of Oda's friend Tatsumi, whom he has known since his arrival in Los Angeles. Tatsumi believes the community's destruction is inevitable, and he accepts relocation to a skid row hotel outside it, a foreign and isolated environment where a few days later he is killed by a thief. The loss of Tatsumi crystallizes Oda's sense that his attempts to save the neighborhood are futile, and this almost destroys him. He gets desperately drunk, has a stroke, and is placed in a convalescent hospital. Only the support of Haru, the young woman who manages the hotel, persuades him not to succumb to despair, and he regains his will to live. Though still sick, he leaves the hospital and walks in the dawn back across the Los Angeles River to Little Tokyo, nestled at the foot of the financial megaliths that now comprise the city center. He arrives in time to join Haru and other community leaders who have themselves raised a banner, even if it is not the one that Oda hoped to take back. Display-

ing the slogan "Little Tokyo Is Our Home," their banner is a symbol of the community's fight against corporate redevelopment.

With ambitious production values, elaborate historical recreation, period costumes, and epic narrative sweep, *Hito Hata* was a major development for VC's project of community self-expression. Though written by VC members Nakamura and John Esaki, the story was developed communally, and the film was communally produced. It involved most of the people connected with the organization as well as many inhabitants of Little Tokyo, including the merchants who allowed First Street, its central artery, to be closed for the recreation of the Nisei Week celebrations. But as well as enabling and mediating the Japanese American community's confident self-assertion, in this case VC attempted a wider social intervention and a wider distribution of the film. Only two years before, the *No Movies*—extra-legal performances at the Music Center by the Chicano art group Asco—had dramatized Chicano exclusion from the city's elite culture. But *Hito Hata* premiered there, at the city's most prestigious cultural venue, the Dorothy Chandler Pavilion, and from there it left for a national road tour, with benefit screenings held in New York, Sacramento, Seattle, Denver, and Honolulu. In its scale and its pitch for general public acknowledgment, *Hito Hata* announced a

ILLUSTRATION 12.3. Frame enlargement, *Hito Hata: Raise the Banner* (Duane Kubo and Robert Nakamura, 1980): the community banner is raised. Photograph courtesy of Visual Communications, Los Angeles, Calif.

new stage in Asian American filmmaking. Though it did not achieve the wide recognition garnered by the next year's *Chan Is Missing,* Wayne Wang's neo-noir film set in San Francisco's Chinatown, it marked the beginning of the shift in emphasis in Asian American filmmaking from community-based documentaries to crossover independent feature production that eventually became popular enough to move Wang into the mainstream Hollywood production system, most successfully with his dramatization of Amy Tan's cross-over Asian American novel, *The Joy Luck Club.*[18] But even as it foreshadowed this transformation of Asian Americans' place in U.S. culture generally, *Hito Hata* occasioned crises in VC and in the social formations in which it had matured and thrived.

The emphasis of early VC projects on historical recovery reflected the filmmakers' roots in long-established communities. Isolated over the course of several generations in America and deprived of new immigrants by the exclusion acts, these communities had become socially and culturally homogenous and largely independent of their origins in Asia. But in the mid-1960s, their homogeneity and autonomy were undermined by changes in Asian America. The combined effects of the demands of cold war propaganda, the social displacements caused by U.S. imperialism in Viet Nam, and other factors reflecting U.S. global interventions in the post–World War II era had made the racist immigration policies of the midcentury counterproductive; and in 1965 a new comprehensive Immigration Act removed national-origins quotas and ended systematic discrimination against Asians.[19] The effects, essentially unexpected, were remarkable. Before 1970, the majority of immigrants to the United States came from Europe; but since then, most have been Asian or Latino. Between 1971 and 1989 more than four million Asians immigrated, and currently half of all immigrants entering annually are from Asia, growing from 6 percent of the total in 1950–60, to 36 percent in 1970–80, and 48 percent in 1980–90. This Asian immigration was radically recomposed: before 1965, Asians in the United States were almost entirely from Japan, Mainland China, and the Philippines; but since then, there has been very substantial immigration from other parts of China—Hong Kong and Taiwan—and from Viet Nam, Korea, and India, with others coming from Thailand, Iran, Cambodia, and various Pacific Island states. In the 1980s, immigration from China and the Philippines approximately quadrupled from the 1960s level to almost 400,000; Korean immigration increased by a factor of ten to reach 300,000; Indian increased by a factor of eighty to reach 250,000; and Vietnamese increased by a factor of ninety to reach 350,000. Only Japanese immigration remained constant at less than 40,000 in each decade.[20] More of these immigrants come to the Los Angeles area than to any other destination. Eighty-eight percent of the inhabitants of Los Angeles Chinatown, for example, are foreign-born, and many of these and other Asian American immigrants speak little English.[21]

Coinciding with and created by interdependent capital restructuring in both the United States and Asia and by the consequent movement of finance capital in all directions throughout the Pacific Rim, these changes transformed Asian American communities in the last quarter of the twentieth century. Where the older communities had been primarily working-class, the newer ones contained diverse class elements, ranging from

impoverished and lumpen to professional, managerial, and entrepreneurial, some of whom even brought venture capital to the United States rather than coming here to acquire it. Where the older ones had become stabilized in their hybridity, the newer ones were essentially de-territorialized, often retaining trans-Pacific return mobility and active economic connections with the previous homelands. With virtually no tradition of social and cultural integration in the United States, they similarly lacked the commitment to the new nation that had, however inadvertently, been imposed on the earlier immigrant laborers. And where the older ones had subordinated national specificity to the commonality of Asian Americans, the class and nationality differences among the newer immigrants and the greatly increased proportion of women amongst them radically undermined it. As a result, twenty years after the formation of VC, the concept of Asian American was destabilized; the initiatives it had once subtended had diversified and substantially dispersed into the flexible, mobile, and often monadic identities of late capitalism. The consequent crisis in the epistemological capacity of the concept of Asian American created vertiginous complications in the theorization of structural social division and new obstacles to the building of social commonalities.[22]

The artist-workers at VC were not unaware of these social transformations, and indeed *Hito Hata* anticipated them in its depiction of the changes in the local urban fabric since VC had begun a decade before. Like the early documentaries, VC's feature focused on one of the oldest immigrant communities and was still preoccupied with recovering both historical trauma and the lived cultural traditions of the working class; but its narrative pivoted on the quite different present-day threats to the community. The film is structured antiphonally between representations of the effects of contemporary urban development and of the persecution previously faced by the immigrants presented in the interpolated flashbacks of their heroic resistance to racist bosses on the railroad, racist vigilantes in the Central Valley, and racist soldiers during the internment. But it emphasizes that the contemporary form of those historical threats to the community is not vulgar racism so much as the incursion into it of trans-Pacific financial capital that includes both Japanese and Japanese American components. Oda comes face to face with these corporate interests when he goes to a public hearing on the redevelopment plans, and the Little Tokyo he sees on his walk back from the convalescent home is dwarfed by the city's downtown financial sector. With its historical vision framed in ethnic rather than class terms, *Hito Hata* cannot reference the threat that Pacific Rim development poses to all working people, not just to Japanese Americans; but the film unequivocally reaffirms the old working-class community, and Oda's recalcitrance symbolizes the continuity between its earlier struggles and its present-day resistance to corporate capital.

However prescient *Hito Hata* was, VC itself could not afford to endorse its political analysis. Unlike Oda, the organization had to make some negotiations with the new economic forms of Asian America; and in doing so, the community base that had been its *raison d'être* was rearticulated into the mainstream, if only on its edges. Through the 1980s, as VC attempted to sustain its commitment to working-class Asian and Asian Pacific communities and to accommodate the newer ones, it found that it could

ILLUSTRATION 12.4. Visual Communications' staff circa 1980; left to right, Nancy Araki, Linda Mabalot, Steven Tatsukawa, Karen Ishizuka (with son, Tadashi), Duane Kubo, John Rier, John Esaki. Photograph courtesy of Visual Communications, Los Angeles, Calif.

do so only by reaching accommodation with the new social manifestations of Asian American capital and by seeking third-party corporate sponsorship.

Hito Hata came close to destroying VC. Though the project had been initially funded by a grant of $70,000 from the U.S. Office of Education, and though most of the professional actors returned their salaries, the film expended all the organization's resources and left it deeply in debt at a time when the new presidency of Ronald Reagan was ending the CETA program that had previously covered office workers' salaries and when the NEA and CAC funding were much diminished. In response, between 1981 and 1983 the organization reassessed its direction, committing itself to being a comprehensive Asian Pacific media center rather than essentially a production group, and underwent a major restructuring. An active fifteen-member working board of directors was established with subsidiary executive, finance, grants, archives, and legal affairs committees; and the full-time paid staff was cut from thirteen to two. For support, the organization turned to private philanthropy and to corporate largesse. Early in the 1980s, the John D. and Catherine T. MacArthur Foundation made several grants, as did the Atlantic Richfield Foundation (ARCO). To become eligible for such awards, VC had to formalize and institutionalize its own bureaucracy.

Relocated in 1981 to the Japanese American Cultural and Community Center, VC remained centralized in Little Tokyo under the capable leadership of Steve Tatsukawa (who remained on the board of directors until his death in 1984). To sustain the financial regrouping, a Friends of Visual Communications committee was established, and in 1984 the committee began publication of *In Focus,* a quarterly magazine that published comprehensive news about the group's activities. In addition to *In Focus,* by 1990 VC had several other ongoing departments. The Photographic Archives housed over 300,000 historical images that were made available for research, media, and community projects, as were VC's own photo exhibits, such as "Planting Roots: A History of Filipinos in California" and "Little Tokyo: One Hundred Years in Pictures." The latter, funded by the Little Tokyo Centennial Committee, was a multimedia presentation and publication containing more than two hundred photos. VC's Community Production Services department comprised a staff of media producers and writers that created multimedia presentations, videos, posters, and publications for nonprofit community organizations in the L.A. area; and its Artists and Community Access Program linked media workers with community organizations.

The filmmaking and screening programs continued, but rather than attempting to take advantage of the developing Asian American feature market by mounting other large-scale productions, VC maintained its commitment to low-budget documentaries and to community education, offering annual courses in documentary, animation, screenwriting, directing, and cinematography. The Filmmakers Development and Fellowship Program, funded by the NEA as late as 1984, produced a series of Super 8 documentaries and animations.[23] Meanwhile, VC's own film and video productions continued to explore its earlier constituencies: *Yuki Shimoda: Asian American Actor* (John Esaki, 1985), for example, traced the minority actor's thirty-year career from his childhood in Sacramento, through the internment, and eventually his success in dramatic roles in television movies. But the greater number of new works featured the more recent immigrant communities. One of the best received of these was a festival prize-winning film, *Pak Bueng on Fire* (Supachai Surongsain, 1987)—the title refers to a Thai dish in which greens are set aflame in a wok—a film about the Thai community in Los Angeles. And, reflecting the social and economic integration of the Rim and the new ease of trans-Pacific communications, VC staffers also worked in Asia, initially on Super-8, but with video quickly becoming the main medium, on documentary projects that included in *Shimon* (Kaz Takeuchi, 1990, video), about discrimination against ethnic Koreans in Japan, and *You Can Still Hear Me Singing* (Linda Mabalot and Antonio DeCastro, 1990), about poverty in the Philippines.[24]

Coordinating its activities with other community arts organizations, VC also gave new prominence to distribution and screening. First, in an ongoing series called "Pioneering Visions," preprogrammed packages of Asian Pacific films were shown throughout Los Angeles County and made available for wider distribution. And in 1985, VC began a collaboration with UCLA Film and Television Archive, the Mayor's Asian Pacific Heritage Week Committee, and the UCLA Asian American Studies Program to stage a Los Angeles Asian Pacific American International Film Festival. Growing out

of an earlier Asian American Film Festival sponsored by the JACCC, the festival became an annual event, the premier world showcase for Asian American productions, where they were presented in the context of the newly ascendant Asian cinemas from the People's Republic of China, Taiwan, Hong Kong, and eventually Korea. Though this festival was successful in giving prestige and a degree of popular visibility to groundbreaking works from both the United States and Asia, including some of the most important feature films made anywhere in the world in the 1990s—the works of Taiwanese filmmaker Hou Hsiao-Hsien, for example—it also became instrumental in the institutionalization of multiculturalism. Where earlier VC films had been so powerful and socially resonant because they incorporated into their aesthetic structure a clear vision of the relationship between oppressive social conditions and the forms of cultural production that emerge from them, when presented under the aegis of corporate sponsorship, these often very beautiful features were remade into cosmetics that served interests fundamentally alien to those of working people on both sides of the Pacific.[25] VC had changed from being a small, informal, and essentially ad hoc production association to being a comprehensive regional media arts center and eventually an integral component in the international culture market, affiliated with the surrounding business community and Pacific Rim capital.

Traces of these developments inevitably appeared even in the resolutely low-cost films that VC sponsored, and *Pak Bueng on Fire,* the fictional short about illegal Thai immigrants, reflects these changes in the imaginary construction of the community of Asian Americans. Set mostly among the concentration of restaurants in Hollywood's Thaitown, the narrative revolves around two Thai youths, Charlie, a poorly paid employee in a convenience store, and Ron, an architectural student at UCLA who cannot complete his degree because he is ineligible for financial aid. Reluctant to return home where he would have to work as what he thinks of as a mere draftsman, Ron illegally buys a Social Security card and looks for a position in an architect's office, while Charlie tries to help him pay his fees but loses his money gambling on a football game. The film ends in a double failure, with Ron's deceit discovered by INS agents and Charlie attacked in the convenience store by an African American who calls him a "buddha-head."

On the one hand, *Pak Bueng on Fire* continues many of VC's traditions: it centers on the struggles between an Asian immigrant community and an unsympathetic social environment; it was written, directed, and edited by Surongsain as his M.A. thesis film at UCLA under Robert Nakamura's supervision; and in fact, it allegorizes Surongsain's own situation in the film school before he eventually became a VC staff member. But the film's emphasis on the new ethnic differences allows it to repress the class differences among post-1960s immigrants, and it can find no place for the trans-ethnic, working-class solidarity that VC maintained in its early 1970s studies of the older communities. It is racially structured on a distinction between a Thai commonality that includes both the underprivileged Charlie and the distinctly privileged Ron (who are both supposed to be burning in the fiery wok of American racism) and the social hegemony of the American state. UCLA, the film implies, is victimizing Ron by expecting

him to pay tuition, and the INS agents are oppressive because they search out illegal immigrants—and African Americans rob convenience stores and commit racist violence against Thais! Where VC's early films had constructed multicultural communities across racial divides and had privileged the cultural and other forms of resistance of African Americans, the most abused and exploited of all American immigrant groups, this shallow and self-righteous film is pivoted on a reductive ethnic stereotyping of African Americans as exploitative as anything in Hollywood. And it was funded, not by working people, but by capital, initially by local Thai businessmen, then by completion monies coming from three local banks—Bangkok Bank, Ltd., Siam Commercial Bank, Ltd., and Thai Farmers Bank—and from Thai Airways International. By the 1990s, the new Asian American identities, made flexible and mobile[26] by their role in the expansion of Pacific Rim capital and variously funded by it, surrounded the older communities. VC chose to accommodate them.

In November 1990, to mark the twentieth anniversary of the founding of Visual Communications, a celebratory event was held at the Japan American Theater in Little Tokyo that included the screening of *Claiming a Voice: The Visual Communications Story,* a video documentary commissioned by VC and containing excerpts from many of its productions. A concurrently published special double-issue of *In Focus* called *Moving the Image*[27] illustrates the degree to which VC had been transformed from a small filmmaking collective to a full-fledged media center but also the degree to which the community it invoked had been even more extensively transformed. The issue contained a complete listing of the fifteen films and the fourteen videos produced by VC and of the twenty-six works produced in the Filmmakers Development Program as well as partial listings of the Community Media Presentations, the film-strips, the print publications, and the photographic exhibits. It also contained essays on the grant situation and, addressing the generational divides, on the differences between native filmmakers and the new foreign-born immigrants. A collage of community voices testified to VC's role, and the publication ended with a list of the sixty or so people who then comprised the organization—board officers and members, legal counsel and accountants, staff and interns, instructors and editors—and several pages of congratulatory advertisements from a roster of benefactors that included Aihara Insurance Company, Anheuser-Busch Companies, and Toyota Motors. The small, economically self-contained group of working-class students and the immediate community of parents, families, and friends that the first films addressed had grown to include, not just the newer Asian American communities in Southern California, but people of Asian descent all over the world. The connections consolidated in the sponsoring fundraisers for *Hito Hata* and similar links with parallel cultural initiatives in other cities integrated VC into the nationwide network of Asian American media centers and cognate initiatives that accompanied the growth in visibility of Asian American culture in many social spheres, both domestically and, as the film festivals restored connections with cultures of the mother countries, internationally. As founding member Eddie Wong noted in a brochure published on the occasion of the organization's thirtieth anniversary, in the public mind "VC" had come to denote, not Viet Cong but Venture Capitalist.[28]

Throughout the 1990s, Visual Communications had extensively reorganized its internal operations and its mission to address the combined effect of the transformations in Asian America and in the global media industries, and had regularly reshaped its board to accommodate the social needs and aspirations of the new communities. As the success and the diversity of Asian American feature production assuaged the urgency of community filmmaking projects, VC concentrated on its workshop and other educational programs, incorporating the new forms of digital production and distribution, and prepared young people for industry careers. The tools and the methods had changed, but the commitment to sustaining alternative public media remained, facing a new world of globalized media conglomerates but also of global, working-class opposition to them.

Notes

1. For an account of the production of *From Dusk to Dawn*, see Steven J. Ross, *Working-Class Hollywood: Silent Film and the Shaping of Class in America* (Princeton, N.J.: Princeton University Press, 1997).

2. On the history of amateur filmmaking, see Patricia R. Zimmermann, *Reel Families: A Social History of Amateur Film* (Bloomington: Indiana University Press, 1995).

3. C. O. N[elson], "The Film Is a Weapon," *Left Front*, May–June 1934, 15. On the Workers' Film and Photo League generally, see Russell Campbell, *Cinema Strikes Back; Radical Film-making in the United States 1930–42* (Ann Arbor, Mich.: University of Michigan Press, 1982).

4. See, respectively, *The Western Worker*, 29 January 1934, 5, and "News and Notes," *New Theatre*, February 1934, 23.

5. In 1939 the *Writers' Project Guide to California* (New York: Pantheon Books, 1984) mentioned communities of 21,000 Japanese, 3,000 Chinese, and 3,000 Filipinos in Los Angeles, though the Chinatowns of New York and San Francisco or the Japanese communities in Hawaii had even longer histories of cultural cohesion.

6. Beginning with *Ethero* (1968), Fu Ding Cheng, for example, made a series of films within the general idiom of Los Angeles psychedelic spiritualism, screening them at underground venues such as the Pasadena Filmforum. Asian American and Asian Pacific American filmmaking in Los Angeles dates back at least as far as 1938 and *A Filipino in America*, written and produced by Doroteo Ines, a student at USC film-school, and featuring a student crew. In it an immigrant works his way through the university to complete a degree in mining engineering, but, prevented by racism from pursuing his career, he finally returns home. On this film, see Roland Tolentino, "Identity and Difference in 'Filipino/a American' Media Arts," *Amerasia Journal* 23, no. 2 (1997), 137–61.

7. For an overview of the works of all the Asian American filmmakers in the Ethno-Communications Program, see Abraham Ferrer, "The Truth at 24 Frames Per Second," *In Focus* 5, no. 2 (Summer 1990): 5, 12.

8. My thanks to Abe Ferrar and Linda Mabalot from VC for their assistance, and to Jiwon Ahn for her initial research on VC. VC periodically published distribution catalogues in the 1970s and 80s listing all its productions. VC's own quarterly journal, *In Focus*, records activities after the mid-1980s, with issues 5, no. 2 (Summer 1990) and 6, no. 3 (Fall/Winter 1990) containing extensive retrospective surveys. See also Stephen Gong, "A History in Progress: Asian

American Media Arts Centers, 1970–1990," in Russell Leong, ed., *Moving the Image: Independent Asian Pacific American Media Arts* (Los Angeles: UCLA Asian American Studies Center and Visual Communications, 1991), 1–9. In 1990 Arthur Dong directed a video for VC, *Claiming a Voice: The Visual Communications Story,* that traced the organization's first twenty years and included interviews with staff members and excerpts from their films.

9. Others included Asian Cine Visions (ACV) in New York, the King Street Media Works in Seattle, the Asian American Resource Workshop in Boston, and Asian American Arts and Media in Washington, D.C. At the first conference of Asian American filmmakers and producers, held at Berkeley in 1980, these affiliated to form a nationwide network, the National Asian American Telecommunications Association (NAATA) with regional chapters, which continues to function as a center for the promotion of minority cinema and television.

10. Karen Ishizuka and Robert A. Nakamura, "Conversations: An Experiment in Community-Based Filmmaking," in Leong, ed., *Moving the Image,* 38.

11. By 1978 Nakamura had a faculty position at UCLA, and eventually he was awarded an academic chair, the first in the United States devoted solely to the field of Japanese American Studies.

12. Others were *The Journey* (Glen Akira Iwashi and Pat Lau, 1972); *To Be Me, Tony Quon* (Pat Lau and Don Miller, 1974); *City City* (Duane Kubo and Donna Dietch, 1974); *Chinatown 2-Step* (Eddie Wong, 1975); and *Kites and Other Tales* (Alan Ohashi, 1975).

13. *Aiiieeee!: An Anthology of Asian American Writers,* edited by Frank Chin, Jeffrey Paul Chan, Lawson Fusao Inada, and Shawn Hsu Wong (Washington, D.C: Howard University Press, 1974).

14. Frank Chin, Jeffrey Chan, Lawson Fusao Inada, and Shawn Hsu Wong, "Fifty Years of Our Whole Voice: An Introduction to Chinese and Japanese American Literatures," in *Aiiieeee!: An Anthology of Asian American Writers* (New York: Mentor, 1991), xii.

15. *No-No Boy* was first published in 1957. Unlike his protagonist, Okada himself served in the U.S. Army. Inada wrote the introduction for the 1976 edition and many subsequent reprintings; see John Okada, *No-No Boy* (Seattle: Combined Asian American Resources Project/University of Washington Press, 1976).

16. On the tension between VC's aesthetic and political factions, see Janice Tanaka, "Visual Communications—The Mid-Period Years," *In Focus* 6, no. 2 (1990): 7.

17. This narrative component is a reworking of one of the most important political events involving Asian Americans in San Francisco; in 1977 downtown real estate redevelopment called for the destruction of the International Hotel, home of many elderly Filipino immigrants. Their resistance, forcible removal from the hotel, and the community's protests became the subject of Curtis Choy's documentary, *The Fall of the I-Hotel* (1984).

18. Shot for $25,000 on 16mm, *Chan Is Missing* (1981) was so well received at the 1982 Los Angeles Film Exhibition (Filmex) and other festivals that it was blown up to 35mm and in this format enjoyed wide and influential distribution. Its success enabled Wang to move through other increasingly well-funded and widely distributed Asian American–themed features—*Dim Sum: A Little Bit of Heart* (1984), *Eat a Bowl of Tea* (1989), and *The Joy Luck Club* (1993)— and eventually to international joint-productions, including *Chinese Box* (1997). On the emergence of the Asian American feature industry and its early negotiations with Hollywood, see Renee Tajima, "Moving the Image: Asian American Independent Filmmaking 1970–1990," in Leong, ed., *Moving the Image,* 10–33.

19. For a general account of Asian immigration, see Ronald T. Takaki, *Strangers From A Different Shore: A History of Asian Americans* (New York: Penguin, 1989); for the effects of the

1965 Immigration Act in Southern California and the relation between Asian immigration and the transformations in global capital generally, see Paul Ong, Edna Bonacich, and Lucie Cheng, eds., *The New Asian Immigration in Los Angeles and Global Restructuring* (Philadelphia: Temple University Press, 1994).

20. For exact figures, see Ong et al., *New Asian Immigration,* 41.

21. For a survey of recent Chinese immigrants to Los Angeles and the new Chinatown in Monterey Park, see "Chinese: Rapidly Changing Demographics in Southland," *Los Angeles Times,* 29 June 1997, A1 and 32.

22. For the case of overseas Chinese, these changes in territorial identification have been examined by Aihwa Ong in "On the Edge of Empires: Flexible Citizenship among Chinese in Diaspora," *Positions* 1, no. 3 (Winter 1993): 745–78. For their reverberation in Asian American literature, see especially Lisa Lowe, "Heterogeneity, Hybridity, Multiplicity: Asian American Differences," in her *Immigrant Acts: On Asian American Cultural Politics* (Durham, N.C.: Duke University Press, 1996); and Susan Koshy, "The Fiction of Asian American Literature," *Yale Journal of Criticism* 9, no. 2 (1996): 315–46.

23. These included *Jose: The Artist* (Evangelina Galicia, 1986), a documentary on the career of the Filipino American dancer after his debut in West Side Story; *E-Z Rock* (Stann Nakazono, 1985), a profile of an Asian American break dancer; and the animations, *Mochi Monster* (Troi Pang, 1985); *Reptilian Brain Function* (Stuart Iwasaki, 1985); and *Little One Inch* (Kelly Takemura, 1985). Like many of VC's earlier productions, these were transferred to video for distribution.

24. Video's cheapness not only made documentary much more feasible but also gave artists the ability to sample earlier Hollywood features so as to expose and analyze more or less submerged themes in them. Rea Tajiri's Japanese American macaronic *History and Memory* (1991), for example, creates a critical dialogue between images of Asians in Hollywood films and the reconstruction of the filmmaker's mother's experience of internment. In Los Angeles, however, the Asian American use of video to interrogate Hollywood was most productive in the work of Bruce and Norman Yonemoto, especially their parodic video reconstructions of soap operas, commercials, and other genres of broadcast television (e.g., *Green Card,* 1982; and *Vault,* 1984).

25. The acme of these contradictions was reached with the 1990 Los Angeles Festival of the Arts that brought a wealth of performances of Pacific Rim cultures to the city but that concealed actual social conditions and especially the unequal and often exploitative power relations in the region. For a nuanced critique of the festival, whose implications extend to all corporate exploitation of Asian and Pacific culture, see Lowe, *Immigrant Acts.*

26. Like his protagonist, Surongsain wanted to obtain immigrant status so that, like Wayne Wang, he could go back and forth between the United States and Asia; see Cheng-Sim Lim, "Not Just a Matter of Apples and Oranges," *In Focus* 6, no. 3 (Fall/Winter 1990): 15.

27. *In Focus* 6, no. 3 (Fall/Winter 1990). The title was also used for a book-length collection of essays, coproduced by VC and the UCLA Asian American Studies Center, *Moving the Image: Independent Asian Pacific American Media Arts,* edited by Russell Leong (1991), that documented and evaluated Asian American moving-image culture over the previous twenty years.

28. "From Viet Cong to Venture Capitalist," *Neomedia World* (Los Angeles: Visual Communications, 2000), 20.

About the Contributors

JIWON AHN is a doctoral candidate at School of Cinema-Television, University of Southern California. Her main interest is the process of globalization and its relation to media environments and cultural discourses, particularly in the context of East Asian cinemas and popular cultures.

MEILING CHENG is an Associate Professor and Director of Critical Studies at the School of Theatre, University of Southern California. She is the author of *In Other Los Angeleses: Multicentric Performance Art* (2002).

SANDE COHEN is the author of *Historical Culture* (1986), *Academia and the Luster of Capital* (1993), *Passive Nihilism* (1998), and coeditor of *French Theory in America* (2001), as well as numerous essays in cultural criticism. He teaches at California Institute of the Arts.

HARRY GAMBOA JR. is an L.A.-based artist and author of *Urban Exile: Collected Writings of Harry Gamboa Jr.*(1998). His Web site, <http://www.chicanovista.com>, features the works of various Chicano artists and writers.

ERIC GORDON is a Ph.D. candidate in Critical Studies at University of Southern California's School of Cinema-Television. His dissertation focuses on the historical interplay between new media and the design and production of city spaces. Most recently, he edited a special issue of the journal *Spectator* entitled *Spatial Experience: Media and the Production of Place.* He currently teaches multimedia skills to undergraduate humanities and social science students through USC's Institute for Multimedia Literacy.

CLAUDINE ISÉ is an assistant curator at the UCLA Hammer Museum in Los Angeles. She received her Ph.D. in Film, Literature, and Culture from the University of Southern California. She has written frequently on contemporary art and culture for the *Los Angeles Times* and magazines such as *Teme Celeste, Art Issues,* and *Res.*

DAVID E. JAMES teaches in the School of Cinema-Television at the University of Southern California. His most recent book is *Power Misses: Essays Across (Un)Popular Culture* (1996).

LAURA MEYER is a doctoral candidate in art history at the University of California at Los Angeles and author of "From Finish Fetish to Feminism: Judy Chicago's Dinner Party in California Art History," in *Sexual Politics: Judy Chicago's Dinner Party in Feminist Art History,* ed. Amelia Jones (1996); and "Constructing a New Paradigm," in *Parallels and Intersections: A History of Women Artists in California, 1945–2000,* ed. Diana Fuller and Daniela Salvioni (2002).

BILL MOHR's work has been published in more than four dozen magazines, including *Antioch Review, Sonora Review, Santa Monica Review, Blue Mesa Review, Poetry Motel, Onthebus,* and *Zyzzyva.* In addition, he edited two collections of Los Angeles poets, *The Streets Inside* and *Poetry Loves Poetry.* His poems have appeared in several anthologies, including *Stand Up Poetry;* and a collection of his new and selected poems, *The Splendor of Late Swimmers,* is forthcoming from the Cahuenga Press.

JAMES M. MORAN is a writer and teacher based in Los Angeles. His book, *There's No Place Like Home Video,* was published by the University of Minnesota Press in 2002.

CHON A. NORIEGA is Professor in the UCLA Department of Film, Television and Digital Media and Director of the UCLA Chicago Studies Research Center.

NITHILA PETER studies subjective aural and visual vocabularies that represent South Asian spirituality for World Cinema. She is currently completing her dissertation at the School of Cinema-Television, University of Southern California. Her previous experience as a short-feature and documentary filmmaker in India has been transferred to digital art projects in the United States that feature issues of subjectivity, history, and myth.